The Stupa

The Stupa
Sacred Symbol of
Enlightenment

Crystal Mirror Series
Volume Twelve

CRYSTAL MIRROR SERIES

Library of Congress Cataloging in Publication Information

The Stupa : Sacred Symbol of Enlightenment

 p. cm. -- (Crystal Mirror Series ; v.12)

Includes bibliographical references and index.

ISBN 0-89800-284-2 (pbk.)
1. Stūpas. I. Cook, Elizabeth. II. Yeshe De Project. Editorial Team.
III. Series.
BQ5125.S8S88 1977 295.3'435–dc21 97–12563 CIP

Director and general editor of the Crystal Mirror Series: Tarthang Tulku. Manuscript prepared by Elizabeth Cook and the editorial team of the Yeshe De Project. Photographic credits on p. 403.

Typeset in Palatino, with heads in Avant-Garde Gothic. Printed and bound by Dharma Press, 2910 San Pablo Avenue, Berkeley, CA 94702.

10 9 8 7 6 5 4 3 2 1

NYINGMA · ANCIENT ONES

CRYSTAL MIRROR

The Crystal Mirror Series

Introductions to the Buddha, Dharma, and Sangha
created by Tarthang Tulku
for Western Students of the Dharma

*Dedicated to the Future of
Buddhism in the West*

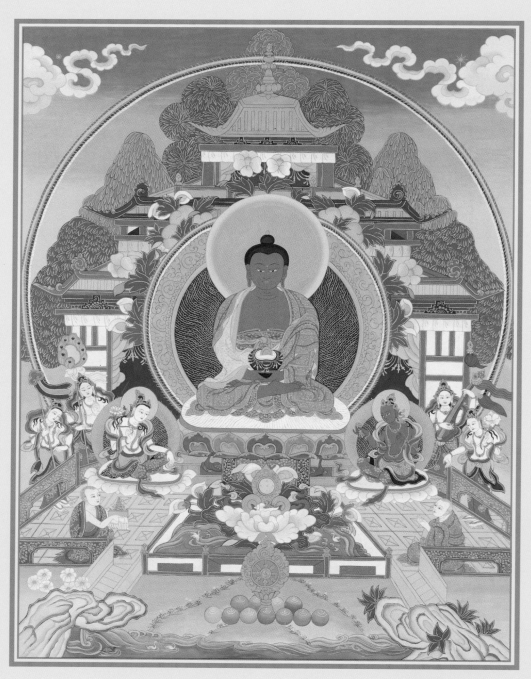

Homage to Amitābha, Buddha of Boundless Light

Contents

Illustrations

Introduction

Unique among all forms of sacred architecture, the stupa is the quintessential symbol of enlightenment, the primordial sacred structure for all Buddhist traditions. More than a symbol, the stupa is a powerful catalyst for activating past, future, and present blessings simultaneously. Its form, luminous and pristine, communicates directly to subtle levels of consciousness and calls forth the potential for enlightenment. While the stupa has historically appeared in different shapes, all of its forms connect the inner realm of experience with the outer physical cosmos. Constructed and empowered according to the sacred texts, the stupa becomes a gateway joining inner and outer, merging the innermost heart of enlightenment with the infinite Dharmadhātu.

This connection is forged through the mandala, which serves as the blueprint for the stupa's foundation, symmetry, and orientation. Focused by the stupa, the mandala's universal principles of harmony and balance attract the heart and mind of living beings and bring them home to the quiet center from which flow all enlightened qualities.

The Stupa

Out of compassion for beings confined within the small world of the self, ignorant of the beauty and vastness of their inherent enlightened nature, the Awakened Ones have always found ways to open doors to understanding. Their offerings may take the form of texts, art, or soaring monuments; the spark that enlightens may be coded in mantric syllables or even within the shape of a single letter. Imbedded in all sacred symbols—in sound and language, in sacred teachings and images—these codes transcend the limitations of language to activate enlightened knowledge. The stupa is part of this heritage: Its structure expresses the manifold dimensions of consciousness and mirrors a comprehensive analysis of mind. Embodiment of the ceaseless compassion of the Buddha, the stupa also symbolizes the eightfold path, the six perfections, all the stages of enlightenment, and the qualities of ineffable Dharmadhātu: For those who can read these symbols, the stupa illuminates ways to transform ignorance, frustration and pain.

Stupas are empowered with relics of the Buddhas, the Great Guru Padmasambhava, Arhats, and other holy beings. Relics of the enlightened ones are symbols of the Dharmadhātu that permeates space and time; illuminating darkness and dispersing all negativities, they continue to emanate blessings and spiritual power long after the physical body has passed from view. Stupas may also hold statues and paintings, mantras, and prayers that represent the body, speech, and heart of the Buddha. All of these sacred objects activate the power of enlightened compassion embodied by the Buddhas and Bodhisattvas, releasing pain and suffering, eliminating obstacles, and bringing peace and contentment to the world.

The uncreated nature of the stupa is indicated in such texts as the Bal-yul-rang-byung-mchod-rten-chen-po'i-lo-rgyus, the history of the Svayambhū Stupa. In this text the Buddha relates how previous Buddhas of our aeon came to the great lake that filled the Kathmandu Valley. Here they evoked the radiant qualities of Dharmadhātu, which were then compressed into a form visible to living beings. This form is Svayambhū, the self-arisen, associated in our time with the Svayambhū Stupa of Nepal.

The Dharmadhātu represents the Buddha's heart, the meaning of enlightenment, and the enlightened state of being. It activates what could be called a mystical code that opens all gateways to enlightenment. The account of the Dharmadhātu manifesting as stupa, precious wish-fulfilling gem, reveals how the great compassion of the Buddha transforms even the most ordinary aspects of existence into the ground of enlightenment. This transforming power pervades the universe; it embraces the subjective mind and objective world in a way that removes artificial distinctions and changes the very nature of mind and ordinary substance.

The transforming power of stupas affects not only our human realm, but radiates throughout the six realms of existence, even into the heaven realms that extend far beyond the physical dimensions of the world as we know it. Beyond the rūpadhātu, this physical world, are the formless realms of the arūpadhātu, where beings are invisible to human eyes and consciousness cannot be described in human terms. When properly constructed and empowered, stupas bring into the universe energy of such peaceful virtue and strength that all beings become happy and natural forces grow harmonious and balanced.

Great masters who understand and embrace the Dharmadhātu actualize the Bodhisattva's power to enlighten. The inner light of the stupa shines through their being, their actions, and their writings. After the death of such extraordinary realized beings, this light appears in their ashes as rings-srel, clear crystal relics that project the full spectrum of colors, just as the open center of the mandala gives rise to innumerable forms. Enshrined within stupas, these crystalline relics empower the stupa with blessings, perpetuating the light of realization and illuminating the minds and hearts of all beings.

The Svayambhū Stupa is a veritable treasury of such relics. From ancient times until this present century, small rings-srel, formed from the spontaneous multiplication of relics inside, have periodically rained down from the Svayambhū Stupa. Anyone touching these relics experiences great blessings.

Blessings of the Stupa for the West

More than 2,500 years ago, the Buddha Śākyamuni demonstrated the stupa's essential form and explained the merit of building and honoring these symbols of enlightenment. Drawing on these guidelines, masters of all Buddhist traditions have given detailed instructions for the construction and empowerment of stupas. Recently this tradition has been brought to the West, where stupas have been built by Buddhist communities in the United States and Europe. In 1980, our Nyingma community centered in Berkeley had the good fortune to participate in the creation of an enlightenment stupa at Odiyan, in northwestern California, symbolically bringing the blessings of the Dharmadhātu to this land. Rising 113 feet high, the Odiyan Enlightenment Stupa was constructed in accord with specific instructions transmitted by the realized and compassionate masters Jigme Lingpa and Jamgon Kongtrul. The general elements of its construction, given at the end of this book, may convey some sense of the knowledge compressed in the stupa's form.

While modern stupas cannot begin to equal in power and number the hundreds of thousands of stupas constructed throughout Asia by the Dharma King Aśoka and Buddhist masters of the past, their harmonious and peaceful energy can be felt at work in the world. When built according to ancient principles, these newer stupas unite past and present in a continuum of enlightened energy that brings forth innumerable blessings and opens the way for transmission of the Dharma to the West. A similar opening for Dharma transmission was made in Tibet over two thousand years ago, when Aśoka built the Cagri Odbar (lCag-ri-'od-bar) Chorten in Golog. This stupa, which rises eighty feet high from a base a hundred feet in diameter, is now virtually covered with maṇi-stones and other offerings Buddhists have made there over the centuries.

As long as sentient beings exist and there is suffering in the six realms, compassion will be activated to liberate beings. Although the Buddha no longer exists in physical form, through the power of the stupa, his qualities and compassion still resonate throughout the universe. His teachings are still fresh and alive: In symbol and

written form they shine like a beacon of pure light in our darkened times, penetrating confusion and illuminating the way to enlightenment. For more than twenty-five centuries, masters of the Buddhist traditions have embodied these teachings, activating their living essence and keeping open the door to realization.

The interaction of mind and symbol is not well understood in the West, for the science of mind is still in its infancy here, and our ability to comprehend the inner workings of relics and stupas is limited. Yet such knowledge is a priceless resource. We have some inkling of the power of codes imprinted on computer chips; how much greater may be the capacity of mind for promoting peace and happiness, for healing imbalances, and for living wisely in a world of continual change. The scriptures and symbols of the esoteric traditions have preserved keys to this knowledge. It is hoped that future generations will find ways to use these keys, not simply for understanding the past, but for activating blessings in the present and opening even greater possibilities for the future.

Stupas are a powerful catalyst for this knowledge. Where heart and mind are open to their significance, they continue to support all that benefits living beings.

Sarvam Mangalam

Tarthang Tulku
Odiyan
April, 1997

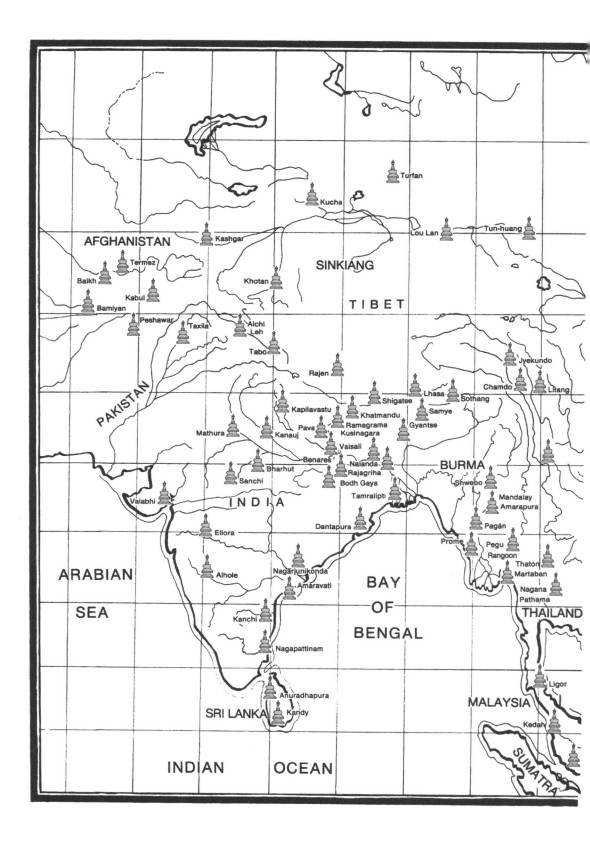

Sacred Symbol of
Enlightenment

The stupa has long been a potent Buddhist symbol, a pure manifestation of enlightenment. Constructed in accord with universal principles and empowered with the knowledge conveyed through the Buddhist lineages, stupas promote harmony and balance in the world. Magnified many times over by the relics sealed within, their ability to defuse the forces of chaos and negativity can ease the ills of body and mind, heighten awareness, and avert natural disasters. For those attuned to their significance, stupas can directly transmit the power of enlightenment.

Consecrated by the blessings of the enlightened lineages, the stupa transforms offerings into merit that opens the spiritual path and awakens the aspiration for realization. Providing no place for the ego to take hold, the stupa is a pure receptacle for devotion and prayer directed to peace and harmony among living beings. It promotes order in nature and in the wider cosmos, protecting from disasters and healing the disquiets of the human heart. Within its range of blessings, suffering dissolves, and compassion begins to emerge. From compassion arises Bodhicitta, the heart of enlightenment.

Embodiment of Dharmadhātu

> *I bow down to the Dharmadhātu.*
> *The Glorious Dharmadhātu, the mainstay of hosts of gods,*
> *defines and demonstrates the holy Dharma:*
> *Able to free beings from the terrifying ocean of samsara,*
> *the Dharmadhātu, always aware, protects as the protector.*
> *To lessen all wickedness, to achieve all that is desired,*
> *the actual Dharmadhātu here arose.*
> —Svayambhūpurāṇa

The Svayambhūpurāṇa describes the arising of the primeval cosmic stupa and its appearance throughout the aeons in Buddhafield after Buddhafield, from the time of the Buddha Vipaśyin to the time of the Buddha Śākyamuni. Although the Svayambhū of our time is located in Nepal, the text clearly refers to the stupa as Dharmadhātu, beyond all concepts of time and space. Emphasizing the stupa's primeval nature, it locates the site of the stupa's arising in the three times (past, present, and future), during which it bears four names: the Mountain of Lotuses; Mount Gośriṅga, the Bull-Horn Mountain (a place associated also with Khotan); the Vajra Range; and the Bull's Tail.

The Dharmadhātu, which literally means field of Dharma, is cosmic in scope; having no beginning or end, it encompasses all pure enlightened qualities. Transcending all modes of dualistic thought, Dharmadhātu accommodates the appearance of all Buddhas, who manifest out of compassion to demonstrate the way to enlightenment. The Dharmadhātu has no substance or form; ineffable and unchanging, it shines through the forms of Buddhas and Bodhisattvas, embodiments of enlightenment. As the Svayambhūpurāṇa relates, in aeons past the pure Dharmadhātu arose from a thousand-petalled lotus, and out of compassion for living beings, became visible in the form of a stupa.

Having described how the stupa manifested spontaneously at the time of previous Buddhas, Śākyamuni related at length the benefits of honoring the stupa of the Dharmadhātu. As he spoke,

4

"through the purity of intention, the sacred Svayambhū issued self arisen from the seed that had been planted in the field of unexcelled merit, being the fruit of liberation, the desire for true benefit, and the manifestation of the Noble Dharma for the specific welfare of all sentient beings."(Svayambhūpurāṇa, chapter 1) A more detailed account of the Svayambhū stupa is given in chapter nine.

Stupa, Caitya, Dhātugarbha

The Buddhist traditions hold that the basic form of the stupa, which conveys enlightened qualities, could have been revealed only by the Enlightened Ones themselves. As the unique bequest of the Buddhas, the stupa is at once the heart of a sacred space and the seed of all sacred buildings. From the stupa came the caitya, temple, and gaṇdola, known by different terms in the languages of Buddhist cultures.

The word stupa, Sanskrit for "pile" or "heap," originally referred to the heaped-up mound of brick and earth that constituted the earliest stupas' hemispherical domes. When additional elements came into use, such as gateways, circumambulation paths, square or round bases and thrones, and shrines built into the domes in four or eight directions, the term caitya was often used to refer to the entire monument, while stupa continued to indicate its central form: the base and three steps, the rounded dome, and the surmounting parasol. While the two terms are often used interchangeably, caitya takes on specific dimensions of meaning in the tradition made known by Nāgārjuna and followed in Tibet. This subject merits careful research, as the caitya has its roots in an exacting spiritual science unknown in the West, and texts conveying this knowledge are largely unavailable or untranslated.

In Pāli, the language used by the Theravādins of Sri Lanka and Southeast Asia, thūpa is used for stupa and cetiya for caitya. The Pāli cetiya passes into Burmese and Thai as zedi and chedi. In Tibetan, the word for stupa is 'bum-pa, meaning vase, referring to the distinctive dome curved in the shape of a human heart. Chorten, like caitya, refers to the whole structure, from the base to the top.

5

A third designation is dāgaba, derived from the Pali dhātu-gabbha (Skt. dhātugarbha), or womb of relics. Originally, the term dāgaba appears to have been applied to the harmikā, the square relic-box mounted on the hemispherical domes of Aśokan stupas. Later, the term was also applied to the hemispherical cupola. (PSBS 81–82) In the Mahāvamsa, dhātugabbha is used to indicate the chamber inside the stupa where the relic-casket is placed, as in the Ruvanveli Dāgaba. At some point dāgaba evolved into the word pagoda, the term generally used in Southeast Asia.

The word pagoda is associated with the multi-storied structures that developed from the stupa's spire and parasols in China, Korea, and Japan. The Chinese word for this tower-shaped monument is t'a (Korean t'ap, Japanese tō), which derives from the ideogram for the Sanskrit dhā of dhātugarbha. From t'ap comes the term tope commonly used by archaeologists. Here the Chinese tradition, basing its authority on the Mahāsamghika-vinaya, makes a distinction between dhātugarbha and caitya: Monuments containing relics are called t'a; those that enshrine images or commemorate significant places are known as che-t'i (caitya).

Relics of the Enlightened Ones

Corporeal relics of the Buddha convey the enlightened qualities of Dharmadhātu, brought into tangible form as the body of the Enlightened Ones. Relics convey the power and blessings of Dharmadhātu, which can be palpably sensed but not seen. As described in the Sūtras, people of all levels of spiritual attainment found the Buddha's presence compelling and irresistible. The Lalitavistara Sūtra relates that the Buddha's former companions in ascetic practices, knowing he had abandoned the path of austerities, determined to pay him no heed. Yet upon his approach, "wanting to arise, they were like caged birds singed by a fire beneath the cage; agitated on their seats, they broke their agreement, and each arose to honor him." (VB 618) Later, as the Buddha was teaching, the messengers sent by his father to invite him to Kapilavastu became Arhats upon seeing him and were no longer concerned with the

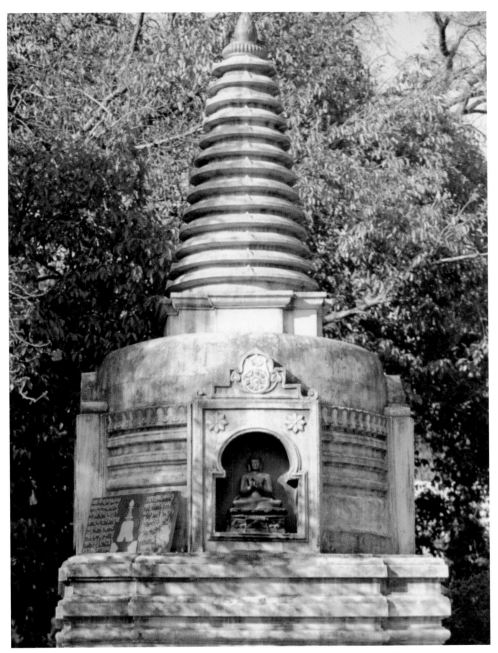

This relic stupa stands in the courtyard of the Mahābodhi Temple at Bodh Gayā, site of the Buddha's enlightenment. Statues of the Buddha face outward from niches set into the stupa at the four directions.

purpose of their journey. Even the royal elephant Nālagiri, maddened at the instigation of Devadatta, ceased its rampage upon nearing the Buddha and knelt down at his feet. In a similar manner, relics of the Buddha are said to have the power to gentle the minds of living beings and establish them in the enlightened view.

The quantity of corporeal relics left behind by each Buddha varies in proportion to the needs and conditions of his time. So important are relics in keeping open the doors to the Dharma that the Bhadrakalpika Sūtra lists the quantity of relics as one of the twelve characteristics to be noted for each of the thousand Buddhas of our aeon: land of birth, family lineage, father and mother, son, principal attendant, the disciple foremost in greatness and foremost in goodness, their monastic assemblies, the extent of their lifespan, the duration of their Dharma in the world, and the extent of their relics. (FA 517)

The meaning of relic can be extended to statues and paintings that represent the body of the Buddha; to the sacred books that represent the Buddha's speech; and to stupas and temples that represent the Buddha's heart. Traditionally, stupas have been receptacles for these representations as well, often in the form of tsa-tsas, small votive seals imprinted with sacred images, dhāraṇīs, and the forms of stupas, either separately or in combination.

Śākyamuni, the Buddha of our time, was the fourth Buddha of our aeon to leave relics as a support for enlightenment. The Karuṇāpuṇḍarīka relates that the first was Krakucchanda, born in Bhadra, who lived when the lifespan of human beings was forty thousand years. The second was Kanakamuni, born in Pañcanagara, who lived when the lifespan was thirty thousand years. The third was Kāśyapa, born in Chetana, who lived when the lifespan was twenty thousand years. (Bu 98) These three Tathāgatas, known together with Śākyamuni as the Buddhas of the Past, all left a single relic: their entire body, radiant and whole.

Traditional accounts relate that stupas were built to enshrine the relics of Kāśyapa, the Buddha before Śākyamuni, and some

sources mention stupas built for Krakucchanda and Kanakamuni as well. Thus it was that Prince Gautama, intent on breaking the bonds of samsara, cut his hair before a stupa to Kāśyapa, although all manifestations of Kāśyapa had long passed from the perception of ordinary beings. Performed in the presence of the stupa, this gesture activated the full power of Bodhicitta and set the stage for the prince's demonstration of complete, perfect enlightenment.

The Buddha Śākyamuni was born when the lifespan was one hundred years. As the Bhadrakalpika relates, his relics were extensive. (FA 519–21) The Thūpavaṁsa, a Pāli text that describes the construction of the great stupa of Ruvanveli, cites the Buddha as saying, "I am not to live for long [not nearly so long as the previous Buddhas of our aeon], but am to pass away entirely. As my teaching has not yet been spread everywhere, when I pass away entirely, let the multitude take my relics, even those the size of a mustard seed, and make a shrine each in his own dwelling place." (after LT 25)

Stupas Built during the Lifetime of Śākyamuni Buddha

The Lalitavistara Sūtra mentions stupas built during the Buddha's lifetime to commemorate his actions before and after enlightenment. Since these stupas became part of the pilgrim's path, their locations have been described by travelers in ancient times and sought out and identified by archaeologists.

The stupas mentioned in the Lalitavistara honor events related to the Buddha's home-departure. Leaving his father's palace, the Bodhisattva rode through the night on the road to Vaiśālī, accompanied by his charioteer Chandaka. After crossing the Rapti River near the town of Maneya in the district of Anumaineya, the Bodhisattva dismounted and sent Chandaka back with his horse. The Lalitavistara states that the stupa known as Chandaka-nivarttana, Chandaka's Return, was built on this place. Following the descriptions and distances given by Fa-hsien and Hsüan-tsang, Alexander Cunningham, the British archaeologist who located numerous Buddhist sites,

9

associated this pilgrimage place with the village of Chandaoli on the eastern bank of the Aumi River, ten miles south of Gorakhpur.

At a second location, the Bodhisattva cut off his long hair, emblem of royalty, and cast it away. The locks of hair were taken up by the devas, who built a stupa on this spot called Cūḍapatigraha, Heap of Hairlocks. After cutting his hair, the Bodhisattva exchanged his princely garments of Kāśī cloth for the rough clothing of a wood-cutter. On this place the people erected a stupa named Kāśayagra-han, Garments Removed. Noting the distances and cognate local names, Cunningham identifies the Heap of Hairlocks Stupa with the village of Chureya, three miles north of Chandaoli; three and a half miles southwest of Chandaoli is the village of Kaseyar, which he associates with the Kāśayagrahan Stupa. (AGI 360–61)

Shortly after his enlightenment, the Buddha gave hair and clip-pings of his nails to Trapuṣa and Bhallika, two merchants who offered him honey and cakes, and asked that they be placed within a stupa. The Buddha then demonstrated the stupa's form by folding his robe four times for the base, inverting his almsbowl and placing it upon the robe for the dome, and placing his staff upon the bowl for the pinnacle. When the merchants returned to their homeland, they built stupas to enshrine the hair and nail relics they had received. Claimed by several Buddhist traditions, these stupas, the first associated with the relics of the Buddha Śākyamuni, have been variously located in Afghanistan, Sri Lanka, and Burma. The Dulwa (Vinaya) records that at least one stupa was built during the Buddha's lifetime for the relics of a disciple. When Śāriputra passed away, the patron Anāthapiṇḍada obtained the Buddha's permission to build a stupa over Śāriputra's ashes in consideration of his long-standing friendship with the great disciple. (R 111)

During his forty-five years of teaching the Dharma, the Buddha traveled far beyond the Madhyadeśa, the Middle Country, the part of northern India where he spent most of his life. Chronicles of the Buddha's life describe his visits to wild or lake-covered lands in the south and north to prepare them for human habitation and plant the seeds of the Dharma. In this way a Buddha expands the fields of

enlightenment, transforming mundane earth into the ground of realization. Stupas figure prominently in these accounts, which have deep symbolic significance.

The Eight Great Relic Stupas

After the Buddha's parinirvāṇa, his relics were gathered from the cremation pyre and divided into eight portions, which were distributed among the leaders of tribes that venerated the Enlightened One and claimed a share of his remains: King Ajātaśatru of Magadha, the Licchavis of Vaiśālī, the Śākyas of Kapilavastu, the Bulayas of Allakakappa, the Brahmin of Veṭhadvīpa, the Koliyas of Rāmagrāma, and the Mallas of Pāvā and Kuśinagara. The Mahāparinirvāṇa Sūtra relates that each carried a portion of the relics to his city and enshrined them in a stupa. The stupas that held these remains are known as the eight great relic stupas.

Accounts of the parinirvāṇa agree on the eight great relic stupas but describe additional elements in different ways. The Mūlasarvāstivādin Vinaya mentions two additional relics: the Moriyas of Pippalavana received the embers from the cremation fire and Droṇa, the Brahmin who divided the relics, was given the urn that had held the Buddha's ashes. (R 147) Another Sūtra preserved in Tibetan describes three additional relics: the urn received by Droṇa, the ashes of the cloth that had formed the inner wrappings of the Buddha's body, and the unburned remnants of the outer wrappings. Hsüan-tsang relates that Droṇa divided the relics into three major portions, "one for the devas, one for the nāgas, and one for the eight kingdoms among men." (HT II:41) The portion allotted to humanity was then divided eight ways.

The Sūtra known as the Li-yul Lung-bstan-pa (Prophecy of the Li Country) names the location of the eight relic stupas as Rāmagrāmaka; Pāvā, the land of the Mallas; Vaiśālī; Cañcākalpa; Viṣṇudvīpa; Kapila; and Rājagṛiha. (TTK 7). Although many of these relic stupas are described in the Chinese pilgrims' accounts, the actual location of some of these stupas is today a matter of speculation. The

11

following sites have been proposed as possibilities: a mound twenty-eight feet high east of Lumbinī may have enshrined the relics given the Koliyas of Rāmagrama; a stupa excavated at Piprahwa may have held the relics given to the Śākyas; a stupa foundation near Vaiśālī may have once held the relics given the Licchavis; and the ruins of an ancient city named Sahankat may have been the site of the stupa built over the embers of the cremation fire. (AGI 362)

The Parinirvāṇa Stupa is thought to have once enshrined the relics given to the Mallas of Kuśinagara, and the city of Pāvā has been identified as the village of Padaraona twelve miles northeast of Kasia (Kuśinagara), where statues of the Buddha have been found inside a large mound covered with broken bricks. (AGI 366) Hsüan-tsang describes the stupa that enshrined the pot or urn received by the Brahman Droṇa as located about twenty-five miles southwest of Vaiśālī. The village named Deghwāra, meaning a vessel, has been proposed as a possible site for the Kumbhān (measuring vessel) or Droṇa Stupa. (AGI 372–73) Allakakappa, the city of the Bulayas, may have some association with the site of Navandgarh near the modern village of Lauriya, where rows of earthen tumuli are marked with a lion-topped stone pillar bearing Aśokan inscriptions. (AGI 378–79) This identification remains tentative, as does the nature of this ancient site.

According to the Thūpavaṃsa, a Pāli treatise on the building of the Mahāthūpa in Anurādhapura, there were seven additional relics that were not distributed in the manner described above: four teeth, the two collarbones, and the parietal bones of the cranium, a large relic described by Hsüan-tsang. These and other important relics such as the Buddha's almsbowl, robe, and shadow figure prominently in accounts of famous stupas erected in Sri Lanka and the lands northwest of India.

The precious relics were redistributed by Aśoka in the third century B.C.E. In a tradition related in the Thūpavaṃsa, after the Buddha's relics had been divided and enshrined in the eight relic stupas, Ajātaśatru, king of Magadha, secretly collected the relics, as the Arhats had instructed him, and placed them in an underground

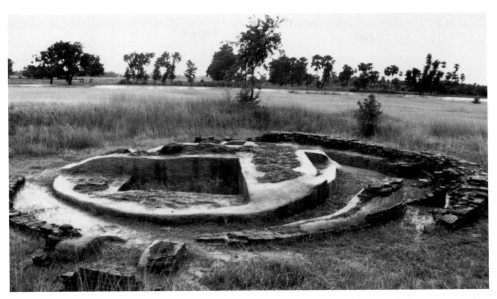

Ruins of an ancient stupa at Vaiśālī, considered one of the eight great relic stupas. The rings reveal the original diameter and two successive enlargements, the first made by Aśoka and the second during the Kuṣāṇa period (50 B.C.E.–150 C.E.).

vault he built at Rājagṛiha. Here the relics were preserved intact for the Dharma king Aśoka, who would distribute them more widely.

The Aśokāvadāna relates that King Aśoka conceived the intention to build eighty-four thousand stupas—a number variously said to represent the eighty-four thousand teachings of the Buddha and the number of atoms in a human body. In collecting the relics, the king pulled down seven of the eight relic stupas, beginning with the stupa at Rājagṛiha. But when he came to the stupa at Rāmagrāma, he found it protected and worshipped by a nāga, and left it untouched.

According to the Mahāvaṁsa, the stupa at Rāmagrāma was washed away by the Ganges, and the relic casket was carried down the river to the ocean, where it was discovered by the nāgas and eventually given to King Duṭṭhagāmini, who placed the relics in the Mahāthūpa (Ruvanveli) erected at Anuradhapura. But Hsüan-tsang observed in the mid-seventh century that the stupa of Rāmagrāma was in place and undisturbed.

King Aśoka had cases made for each of the portions of relics and gave them to the yakṣas (nature spirits), commanding them to erect stupas at all places on earth and even over the great seas. A tradition mentioned in Kṣemendra's Bodhisattvāvadānakalpalatā and followed in Tibet emphasizes the cosmic significance of Aśoka's action: It holds that the king's command resulted in the creation of a million stupas within a single day, all consecrated by the great Arhat Upagupta.

Enshrined within innumerable stupas, the relics of the Buddha radiated the blessings of enlightenment throughout the world, penetrating the veil of samsara and turning the minds of beings toward the great joy of awakening. Fa-hsien relates that the first stupa erected by Aśoka was a short distance south of his capital at Pāṭaliputra. Here, next to a footprint of a Buddha, Aśoka also built the Aśokārāma, the royal monastery. He then began a 256-day pilgrimage to the holy places, accompanied by his mentor Upagupta. The great Arhat showed the king the sites of the Buddha's acts described in the Sūtras and demonstrated the proper way to show respect and devotion for these sacred places. This instruction and Aśoka's enactment popularized the practice of pilgrimage that the Buddha had recommended to his disciples before the parinirvāṇa.

Tradition holds that Aśoka built stupas in Nepal and Tibet as well as in India, both directly and through his command to the yakṣas. After his time, stupas containing the Buddha's relics became the central focus of the pilgrim's devotion. Stupas built to enshrine the relics of the Arhats, great masters, and siddhas also became objects of veneration, as did stupas built to commemorate places empowered by the acts of Śākyamuni in this or in previous lifetimes. This practice follows the Buddha's instruction given in his final teaching, when he named the four types of beings worthy of stupas: the Tathāgatas, Pratyekabuddhas, disciples (Arhats), and cakravartin kings. Wherever monks traveled to disseminate the Buddha's teachings, they built stupas to mark the pilgrim's route and consecrate sacred spaces for practice and realization. Stupas became the spiritual focus of every monastic center.

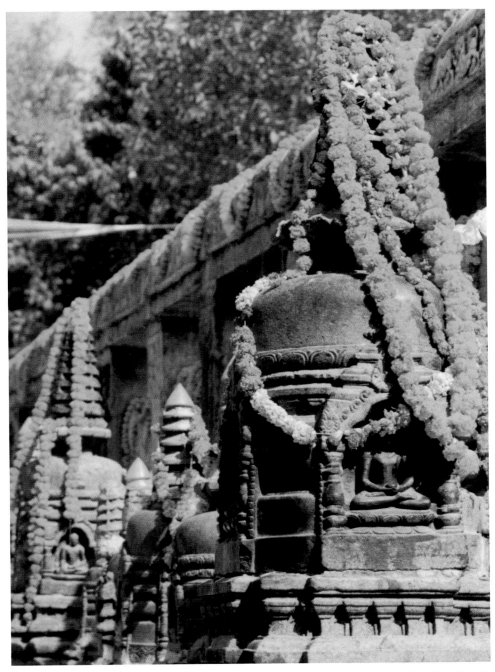

*Ancient relic stupas commemorating the great Arhats at Bodh Gayā,
arrayed with traditional flower garland offerings.*

15

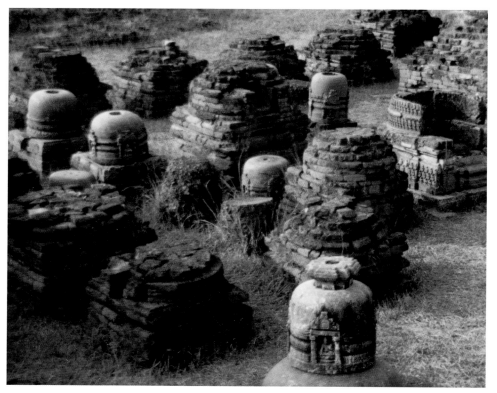

Clusters of votive stupas indicate places of special sanctity. Above: votive stupas at the great caitya of Nālandā.

Types of Stupas

Four major types of stupas have been known since ancient times: śarīraka, stupas that enshrine corporeal relics; paribhojika, stupas that enshrine objects used by or closely associated with the Buddha, such as his almsbowl, staff, or the pot that received his relics; uddeśika, stupas commemorating events in the Buddha's life; and votive, small stupas offered by pilgrims at holy sites. All four types were constructed in India, Sri Lanka, and the northwestern lands strongly influenced by Indian culture. In South India, which appears to have had no tradition of associations with the Buddha's past lives, only śarīraka and votive stupas have been found.

EIGHT PLACES
OF PILGRIMAGE

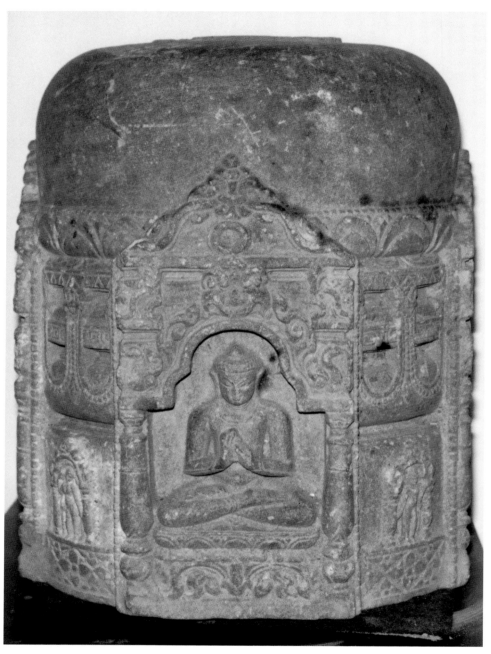

This ancient votive stupa depicts the Buddha's four major actions: birth at Lumbinī, enlightenment at Bodh Gayā, turning the wheel of the Dharma at Sārnāth, and parinirvāṇa at Kuśinagara.

Eight Places of Pilgrimage

While the actions of the Enlightened Ones are innumerable and as vast and profound as their verbal teachings, the Buddhist traditions focus on twelve acts performed by all Buddhas as having special significance: reflections on his final birth while in the Tuṣita Heaven, descent from Tuṣita into his mother's womb, birth in the garden of Lumbinī, education in the arts and sciences and skill in sports, life of pleasure at Kapilavastu, departure from home, practice of austerities, defeat of Māra, enlightenment at Bodh Gayā, setting the wheel of the Dharma in motion at Sārnāth, teaching his mother in the Trāyastriṁśa Heaven, and entering parinirvāṇa at Kusināgara. The Buddha himself named four sites as primary places of pilgrimage: Lumbinī, the place of his birth; Bodh Gayā, site of the great enlightenment; Sārnāth, where he gave his first teaching, and Kuśinagara, where he entered parinirvāṇa.

The Vinaya records that the Buddha requested that a stupa be erected at each of these sites to gladden the hearts of those who would walk in the footsteps of the Enlightened Ones. After the Buddha passed away, these four holy places became central places of pilgrimage and devotion. In time, four more sites were added:

Rājagṛiha, where the Buddha pacified a maddened elephant; Śrāvastī, the site of the great miracle; Vaiśālī, where monkeys offered the Buddha a gift of honey; and Saṁkāśya, where the Buddha descended to earth after teaching his mother in the Trāyastriṁśa Heaven. The first three are also renowned as places where the Buddha taught the Dharma extensively and developed the Sangha, the community that followed the Buddha's teachings. These eight holy places are traditionally identified with the Eight Mahācaityas, whose shapes reflect qualities associated with each site. (p.213ff)

Lumbinī and Kapilavastu

Located in modern Rummindei, Nepal, near the foothills of the Himalayas, the Lumbinī of the Buddha's day was an elegant garden named for Lumbinī, the mother of Queen Māyā. Here Queen Māyā stopped to rest on her way to her mother's house; reaching out, she grasped a branch of a plakṣa tree with her right hand, and the Bodhisattva, the future Buddha, emerged from her right side. The newborn child took seven steps in each of the four directions, and lotus blossoms arose beneath his feet. Shining radiantly, he proclaimed the fulfillment of his ancient vow: "Thus have I come for the well-being of the world. This is my final birth."

Queen Māyā died seven days after the prince's birth and was reborn in the Trāyastriṁśa Heaven, the realm of the Thirty-three Gods. The child was taken to his father's palace in Kapilavastu, where he was raised by his aunt and stepmother, Mahāprajāpatī. The sage Asita, noting that the child bore the thirty-two signs of a great being, predicted that if he followed a worldly path, he would be a cakravartin king, a just and benevolent ruler of a great empire. If he left home for the wanderer's life, he would turn the wheel of the Dharma, opening the way to liberation for countless beings.

Hearing Asita's prophecy, King Śuddhodana was torn between joy and anxiety. To assure that his son would take his place among the greatest of kings, he decreed that the prince be exposed only to youth, beauty, and pleasure. There must be no sorrow to awaken

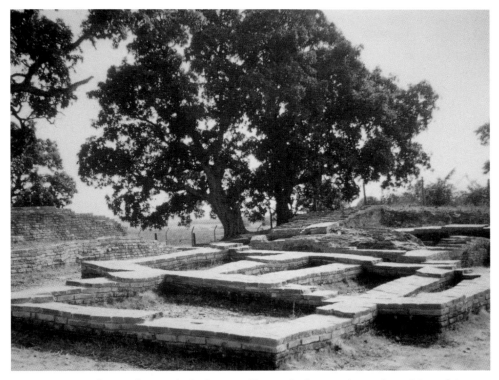

Remains of temples and shrines still mark the ancient site of Lumbinī.

thoughts of renunciation. When the prince became a man, his father urged him to marry, hoping in this way to bind him firmly to his royal destiny.

The unfolding of events set in motion in ages past could not be so easily prevented. Eventually the prince's chariot passed through the palace gates; on the road to the royal gardens, the prince perceived three sights that revealed the truth and horror of old age, sickness, and death. As the reality concealed from him so long penetrated his mind, he saw a mendicant monk, whose clarity and calm suggested the possibility that such suffering could be overcome. Soon after, in the dark of night, the prince summoned his charioteer, mounted his horse, and left Kapilavastu through the eastern gate, vowing not to return until he had found the way to free all beings from the sufferings inherent in human existence.

After his enlightenment, the Buddha returned to Kapilavastu to teach the Dharma to his kinsfolk, the Śākyas. Five hundred Śākyas became his disciples, including his cousin Ānanda and his son Rāhula. King Śuddhodana, his father, became a lay disciple along with all of his subjects. After the king's death, Mahāprajāpatī and Gopā, the Buddha's stepmother and former wife, were ordained along with five hundred Śākyan women. With this act, the Buddha established the order of nuns.

So thoroughly did the Śākyans follow the Buddha's teachings of compassion and non-harming that when Virūḍhaka, the vengeful king of Kosala, attacked Kapilavastu, the Śākyans, renowned for their skills as warriors, offered no resistance. Soon after Virūḍhaka destroyed Kapilavastu and annihilated most of the Śākyas, he also met his end, and Ajātaśatru, king of Magadha, annexed both Kosala and the land of the Śākyas into his expanding empire. There is no mention in the Buddhist records that Kapilavastu was ever rebuilt.

When Aśoka visited Lumbinī, he erected a pillar to mark the birthplace of the Buddha and possibly a stupa also, as indicated by recent excavations. The Chinese pilgrims Fa-hsien and Hsüan-tsang, writing of their visits here in the fifth and seventh centuries respectively, mention numerous smaller stupas but no central large ones. At Kapilavastu, Fa-hsien describes a virtual city of stupas, each commemorating places significant to the Buddha's life: the place Asita stood when he saw the marks of a great being on the young prince's body and predicted that he would become a world ruler or a fully enlightened being; the place where the future Buddha encountered the reality of old age, sickness, and death; and the place near the eastern gate where the prince departed from Kapilavastu. Stupas stood where the Buddha as a youth had cast the body of an elephant beyond the city walls and where his arrow had landed during the Śākyan contest of skill in sports.

The largest stupa stood where King Śuddhodana had welcomed the Buddha on his return to Kapilavastu, a famous meeting described in the Pitāputrasamāgamana Sūtra. Hsüan-tsang adds that there were hundreds, perhaps thousands of small stupas in a

field to the northwest, commemorating the destruction of the Śākyas at the hands of Virūḍhaka. Near this field he identifies stupas marking the birthplaces of the Buddhas Krakucchanda and Kanakamuni. Some miles southeast of Kapilavastu were two stupas built by Aśoka commemorating the Buddha's home-departure. One stupa stood where Prince Gautama removed his ornaments and sent his charioteer back without him, and the other marked the place where he cut his hair, renouncing worldly life for the path of liberation.

Today, two sites claim to be ancient Kapilavastu: Tilaurakot in Nepal and Piprahwa in India. Important finds have been made at both sites that connect them with the Śākyas, the Buddha's family, although precise identification is elusive. Since monasteries were built at each site, both may have traditionally been venerated as holy places.

Excavations at Tilaurakot have revealed extensive remains of ancient stupas, monasteries, and shrines. Seals discovered there indicate that the remains of two stupas were known in Gupta times as the stupas of Śuddhodana and Māyā, the Buddha's father and mother. At Piprahwa, a little over fifteen miles south of Tilaurakot, excavations have unearthed a stupa that could be one of the original relic stupas. In the 1970s, this stupa was discovered to have a lower layer which enshrined stupa-shaped soapstone caskets containing bone relics. The diameter of this stupa, considered the earliest excavated to date, is nearly 114 feet; the height of its low dome is estimated to have been less than twenty-five feet.

Bodh Gayā

For all Buddhists, Bodh Gayā, the site of the Buddha's enactment of enlightenment, is the holiest of sacred sites. Here under the Bodhi Tree is the Vajrāsana, the adamantine, unshakable seat where the Buddha overcame the wiles and power of Māra, lord of illusion, and opened the way for enlightened knowledge to flow into the consciousness of living beings. The early focus of the pilgrim's devotion was the Bodhi Tree itself, around which Aśoka built a small shrine

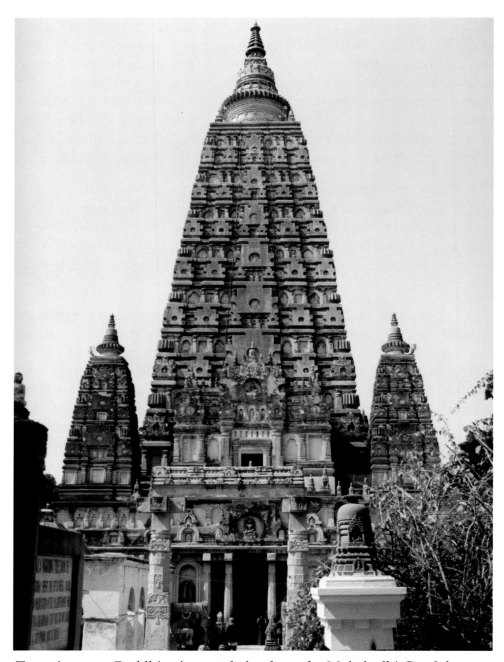

Towering over Buddhism's most holy place, the Mahābodhi Gaṇḍola combines the blessings of both stupa and temple. The relic stupa crowning the Mahābodhi is attributed to Nāgārjuna.

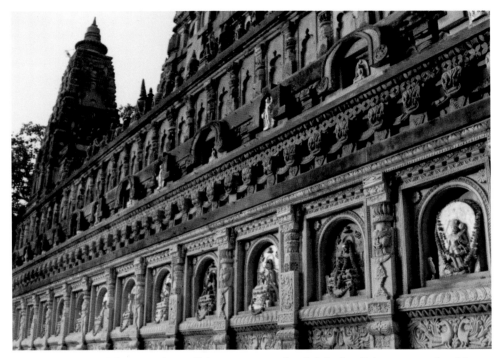

Images of Buddhas and Bodhisattvas on the Mahābodhi convey the blessings of enlightenment to practitioners circumambulating below.

open at the top. A bas-relief on a gate at the great stupa of Bhārhut, thought to represent this early sacred structure, shows devotees worshipping at such a shrine. At some point this early shrine was replaced by the Mahābodhi, which became the central monument for the entire Buddhist world. Although some seek its origins at the time of Kaniṣka, archaeologists generally date the Mahābodhi's construction between the fifth and seventh centuries C.E.

Hsüan-tsang, arriving at Bodh Gayā in the seventh century, described the Mahābodhi as it appears today, a magnificent building standing 160 or 170 feet high immediately east of the spreading Bodhi Tree. Its walls, constructed of blue bricks covered with lime, have rows of niches that frame golden statues of the Buddha and Bodhisattvas. Tibetan tradition ascribes its vase-shaped top to the great master Nāgārjuna, who is said to have placed inside it precious relics of the Buddha. By this action the Mahābodhi was

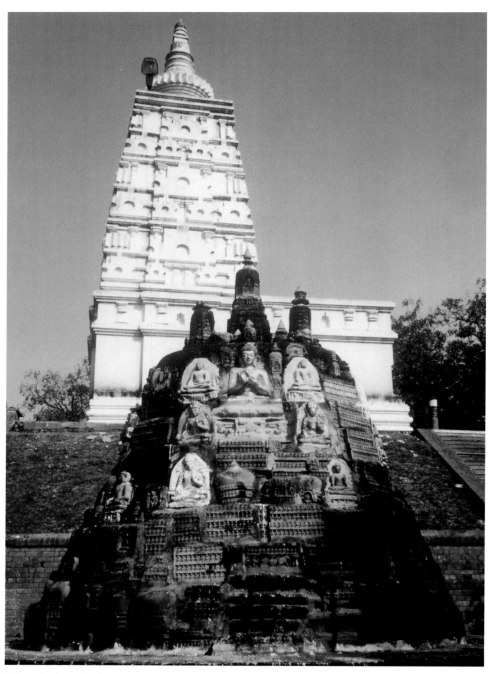

The Animeścalocana Stupa rises behind a monument formed of images and symbols recovered during excavation of the Mahābodhi compound.

transformed into a gaṇḍola, a sacred structure merging temple and stupa into a magnificent tower of enlightenment.

Numerous stupas fill the Mahābodhi compound, the largest being the Animeścalocana Stupa, which the Tantras describe as having been erected on the hill formed of the ashes of trees that were cleared to reveal to the Buddha the Bodhi Tree that marked the Vajrāsana, the seat of enlightenment. Smaller stupas dedicated to the great Arhats, encircled with votive stupas and shrines, stand in a row north of the Mahābodhi. To the south are the bases of other stupas, probably the ones described by the Chinese pilgrims as marking sites of specific actions associated with the Buddha's walk to the Bodhi Tree. Most of the thousands of seals and votive stupas offered by pilgrims through the centuries have long since disappeared. Many were lost during the restoration in the nineteenth century, which uncovered layer after layer of artifacts in the silt built up throughout the compound. The remnants of some images and seals can be seen today mounted on a stupa-shaped mound near the Mahābodhi Temple.

Today, after centuries of neglect and near ruin, the Mahābodhi is once again an active center of devotion, meditation, and ceremonies that carry its blessings far beyond the borders of India. Restored in the late nineteenth century, the great gaṇḍola is now administered by the Temple Management Committee established by the Government of India. Renovation has continued under its auspices: Gilded images have been restored to the Mahābodhi's niches, and four images of standing Buddhas placed on its corners. Inner and outer circumambulation paths have been constructed and the lotus pool renovated. Adherents of all Buddhist traditions have built temples and monasteries on the land outside its grounds and continue to beautify this sacred site. Construction of an eighty-foot-high stupa on the grounds of Shechen Monastery in Bodh Gayā is planned for 1997.

In recent years, Tibetans have gathered at Bodh Gayā in great numbers to pray for their homeland, for their families left behind in Tibet, and for peace in a world where aggression and greed still

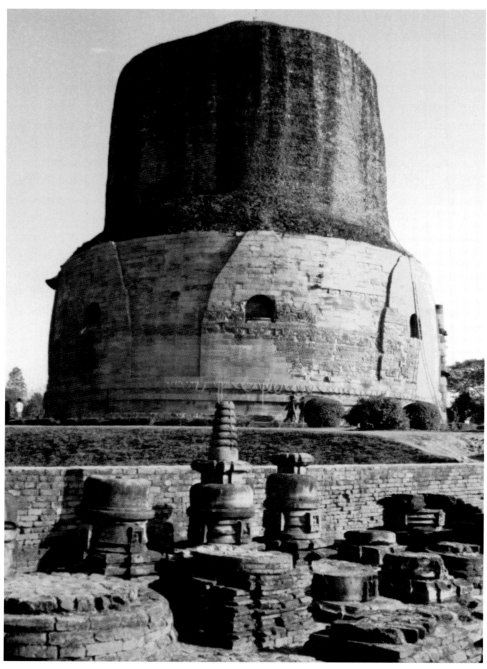

The Dhamekh Stupa, thought to have been built around the first century C.E., is once again a focal point for pilgrimage and ceremonies.

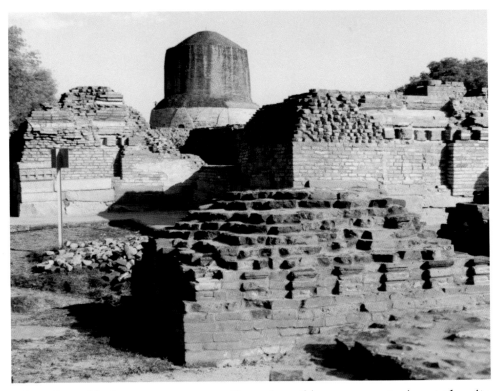

The Dhamekh Stupa towers over the ruins of large monasteries at the site of the Buddha's first teaching.

inflict unbearable misery on countless thousands of people. Their devotion and meditation, joined to that of a continual flow of pilgrims from all Buddhist lands, have gone far toward revitalizing this holy place as a potent symbol of spiritual transformation and a beacon of hope for world peace.

Sārnāth

At the time of the Buddha, Sārnāth had long been revered as a holy gathering place for sages. The Jātakas describe Sārnāth as the site of numerous acts of self-sacrifice and compassion. Here the Bodhisattva as a king of deer offered his life to save that of a pregnant doe. Greatly impressed, the king of Banares created a park as a refuge for

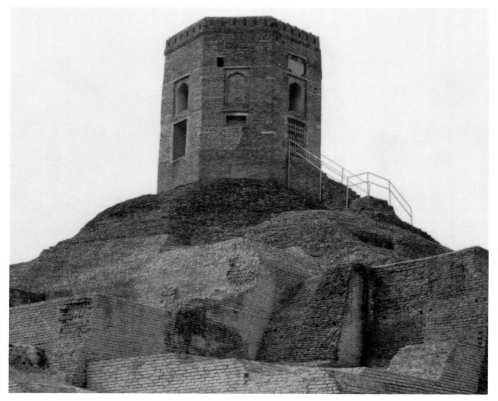

The remains of an ancient stupa in the Chaukhandi Mound may mark the site where the Buddha met his first disciples.

the deer, a place where all acts of violence were prohibited. It was in this most beautiful wood that ninety-one koṭis of Buddhas formerly turned the Wheel of the Doctrine; here the Buddha met his five former companions in ascetic practices and revealed to them the Four Noble Truths, the Eightfold Path, and the twelve links of interdependent cooperation. (VB 608, 628–32) All five became Arhats upon hearing this teaching, and their realization made fully manifest the Three Jewels of enlightenment: Buddha, Dharma, and Sangha.

Honored by Aśoka and venerated by a continuous stream of pilgrims, Sārnāth became an important Buddhist center. By the seventh century C.E. the site of the Buddha's first teaching had thirty active monasteries, three large stupas, and several hundred shrines

and smaller stupas. (HT II:44–46) Sārnāth prospered until the end of the twelfth century, when both Sārnāth and Banaras were devastated by the Ghūrid Turks who invaded India from the northwest. Abandoned for centuries, Sārnāth was reinstated as a Buddhist holy place in the nineteenth century, when archaeologists discovered statues of the Buddha preserved intact in a room hidden deep inside the ruins of one of its monasteries.

Today the grounds of the Deer Park are protected from further destruction, and pilgrims once again circumambulate the Dhamekh Stupa, Sārnāth's only intact sacred monument. In this place, which still retains a palpable sense of peace and blessing, the Mahābodhi Society has built the Navagandhakuṭi, a new temple with a shrine empowered by relics recovered from an ancient ruined stupa. Here as in Bodh Gayā there are new temples and monasteries recently built by various Buddhist traditions.

Dhamekh Stupa The Dhamekh Stupa, a solid round tower, rises to a height of 128 feet. Its foundation, ninety-three feet in diameter, extends ten feet below the ground. For years the top of this stupa was covered with grass and surrounded by a pile of rubble eighteen feet deep. In recent times this rubble was cleared away, revealing the stupa's octagonal base faced with several sections of the elegantly carved stone that once covered the stupa's entire lower section. Niches in each of its eight sides once framed life-sized statues. Although much of its stone facing has been removed, some original parts of it remain, and the Dhamekh still presides majestically over the place of the Buddha's first teaching. Archaeologists generally date this stupa to the sixth century C.E.

Chaukhandi Mound Hsüan-tsang described a lofty stupa about a half-mile southwest of the main vihāras, said to have been placed where the Buddha met his five former companions in ascetic practice. "The foundations are broad and the building high, and adorned with all sorts of carved work and precious substances. There are no successive stages with niches" (HT II:51) This description appears to apply to the Chaukhandi Mound of Sārnāth, now topped by an octagonal tower built by Govardhan, son of Todarmal, to

commemorate the Emperor Humayun's overnight stay at this site. The outer bricks were removed long ago, leaving only the inner mound and a complex of walls that could indeed have supported the structure Hsüan-tsang describes.

Dharmarājika Stupa According to archaeologists, the Dharma-rājika Stupa, usually attributed to Aśoka, may actually predate the great Dharma king. Railing pillars found in the ruins indicate that this stupa, like the great stupa of Sāñcī, may have been encircled by carved railings. Hsüan-tsang described this monument as the stupa marking the place where the Buddha gave his first teaching, noting the "pillar bright as jade" that stood nearby. Its foundation lies next to the broken shaft of the Aśokan pillar that can still be seen amongst the ruins. After surviving centuries of invasion, destruc-tion, and neglect, the Dharmarājika Stupa was demolished in 1794 to obtain materials for building the Jagatganj marketplace. Inside was found a stone casket holding a green marble box containing relics, pearls, rubies, and silver and gold earrings. The stone casket, replaced in the ruins, was later rediscovered, but the marble box and its contents appear to have been lost. Only the foundation of the Dharmarājika Stupa remains today.

Stupas nearby marked the places where five hundred Pratyeka-buddhas entered nirvana upon hearing of the impending birth of the Buddha; where the five former disciples had come to practice, leaving the Bodhisattva at the Nairañjanā River; where the Buddha predicted that Maitreya would become a Buddha, and where Śākya-muni's attainment of Buddhahood, predicted in ages past, was reaf-firmed by the Buddha Kāśyapa. Within the sacred precincts were "many sacred vestiges, with vihāras and stupas several hundred in number. We have named only two or three of these, as it would be difficult to enter into details." (HT II:49)

Kuśinagara

As described in the Mahāparinirvāṇa Sūtra, the Buddha became ill while traveling to Kuśinagara, the capital of the Mallas, neighbors of

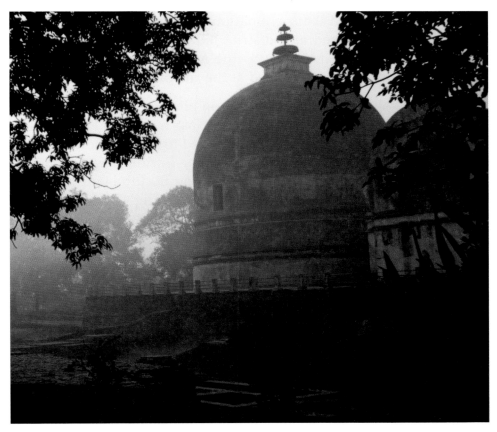

The restored Parinirvāṇa Stupa at Kuśinagara shares its foundation plinth with the Parinirvāṇa Temple, also recently restored.

the Śākyas, the Buddha's countrymen. Stopping in a grove of sala trees, he asked his faithful attendant Ānanda to prepare the place for his passing away, and lay down on his right side, his right hand cushioning his head. To the disciples who gathered around him, the Buddha summarized his teachings, then asked if questions remained in the minds of anyone present. When all fell silent, the Buddha gave his final teaching: "Bhikṣus, never forget: All compounded things are impermanent." With these words, the breath left his body, and the Buddha entered parinirvāṇa. Upon his passing the earth shook, stars shot from the heavens, the sky broke into flames in the ten directions, and the air resounded with celestial music. As the Buddha had requested, his body was given to the

Mallas, who prepared it for cremation. When this was completed, the relics were collected and distributed as described on page 11. One portion of the relics went to the Mallas of Kuśinagara, who enshrined them in a stupa erected at the site of the parinirvāṇa.

When Aśoka came to Kuśinagara on pilgrimage, he built stupas and erected pillars commemorating the last words and acts of the Buddha. Stupas and monasteries continued to be built here through the fifth century. After Fa-hsien's visit, the Parinirvāṇa Stupa was renovated and a large statue of the reclining Buddha was placed in the temple next to it. By the time of Hsüan-tsang's visit, the stupa was in ruins, but the vihāra still held its treasure.

"There is here a great brick vihāra, in which is a figure of the nirvana of the Tathāgata. He is lying with his head to the north as if asleep. By the side of this vihāra is a stupa built by King Aśoka; although in a ruinous state, yet it is some two hundred feet in height." (HT II:32–33) Fa-hsien and Hsüan-tsang both describe four additional stupas (among many others) that marked places where the Buddha ordained Subhadra, his last disciple; where the disciples made offerings to the Buddha for seven days; where Vajrapāṇi the yakṣa laid aside his golden club; and where the Buddha's relics were divided. The two Chinese pilgrims also visited the stupa erected by the Moriyas of Pippalavana over the embers of the funeral pyre.

After the thirteenth century, the site of the Buddha's parinirvāṇa continued to be honored in the Buddhist traditions but was effectively lost to the world. Nothing more is known of this stupa or its temple until recent times. In 1861 Hsüan-tsang's description led Cunningham to identify the site of Kuśinagara. In 1876, the excavation of a large mound of bricks revealed the large plinth where the stupa and vihāra had once stood. Within the mound, excavators found the great nirvana image Hsüan-tsang had described. When the vihāra was rebuilt, this image, over eighteen feet in length, was restored to its original place. Donations from Burma supported the restoration of the Parinirvāṇa Stupa in 1927 and again in 1972.

The Rāmābhār Tīla, a large brick mound about a mile northwest of the Parinirvāṇa Stupa, marks the site of the Buddha's cre-

mation. Pilgrims entering the mound can still see the charred earth at its base. Numerous votive mounds around the Rāmābhār mound indicate that this monument, nearly twice as large as the Parinirvāṇa Stupa, has long been venerated as a place for offerings and devotion.

Rājagṛiha

Rājagṛiha, Bimbisāra's royal city, was the site of the Bamboo Grove, the first home of the Sangha and the locus of many of the Buddha's teachings. Rising above the city to the east is the Vulture Peak, where the Buddha taught the Prajñāpāramitā, the Saddharma-puṇḍarīka, and numerous other Sutras. To the north is the village of Nālandā, home of Śāriputra and Maudgalyāyana, two of the Buddha's principal disciples.

In Rājagṛiha, Devadatta's jealousy led to attempts to kill the Buddha by rolling a great stone down a mountainside and by releasing a maddened elephant in his path. The rock injured only the Buddha's toe, and the raging elephant grew calm and knelt at his feet. The act of taming the elephant became known as one of the eight great wonders that shaped the pilgrim's path.

For the Sangha, however, another event was of greater significance. It was in Rājagṛiha that Devadatta convinced some monks to leave the Buddha's Sangha and form a new community under his direction. This attempt to split the Sangha (named in the Vinaya as one of the most serious offenses) was thwarted at the Buddha's request by Maudgalyāyana and Śāriputra, who clarified the monks' confusion and accepted them back into the Sangha. This act associated Rājagṛiha with the qualities of healing and resolution of differences that have traditionally characterized Buddhist communities.

After the Buddha's parinirvāṇa, Ajātaśatru enshrined his portion of the relics in a stupa near Rājagṛiha. About forty years later, he built a second stupa to enshrine half of the relics of the great disciple Ānanda. Both stupas were noted by the Chinese pilgrims, but neither stands today. When kings who ruled after Ajātaśatru moved

their capital north to Pāṭaliputra (modern Patna), Rājagṛiha declined, and by the fifth century C.E., the ancient city was abandoned, possibly as the result of a plague. The modern village of Rajgir lies north of the bowl-shaped valley of old Rājagṛiha.

With the discovery of Nālandā to the north and the modern resurgence of pilgrimage among the world's Buddhists, Rājagṛiha has once again become a focus of devotion, as evidenced by the Viśvaśānti Stupa that now stands on the crest of Chaṭha Hill and the new vihāra in the Bamboo Grove, both sponsored by Japanese Buddhists. Modeled on the Aśokan-style stupa, the Viśvaśānti is built on an octagonal plinth associated with the eight types of Sangha, with Buddha images looking out over the four directions. Its name points to the wish for peace among all peoples of the world.

About three miles to the northeast, near the village of Giryek, a tower-shaped stupa rises at the end of the ridge of hills extending from Rājagṛiha. According to Hsüan-tsang, this stupa stood next to a monastery where monks had been won over to the Mahāyāna by the self-sacrifice of a goose. In Hsüan-tsang's time, the monument was known as the Haṁsa, or Goose Stupa. This stupa is known today as Jarāsandha's Tower. Archaeological research here in the nineteenth century unearthed a pedestal with a figure of a large goose, confirming the stupa as the one described by Hsüan-tsang.

Śrāvastī

Śrāvastī, King Prasenajit's capital city, was the prosperous center of Kosala, the largest kingdom of the Buddha's time. In Śrāvastī, the merchant Anāthapiṇḍada secured Jeta's Grove as a home for the Sangha. During the Buddha's lifetime, Śrāvastī became the site of several important vihāras, including the Purvārāma, the Eastern Monastery, and the vihāra of Mahāprajāpatī, head of the order of nuns. Here, according to traditional accounts, the Buddha spent the rainy season retreats of the last twenty-five years of his life. Here and elsewhere he shaped the Sangha into a unique spiritual com-

munity based on sound moral principles and guidelines that fostered harmony while allowing unlimited scope for realization.

The locus of numerous teachings, Śrāvastī is renowned as the place where the Buddha defeated six teachers in debate and performed two great miracles demonstrating his mastery of the elements and ability to reveal the true nature of his Buddhafield. The second miracle, in which he seated himself on a lotus and manifested replicas of Buddhas throughout the heavens, is often depicted in sculptures. For this demonstration of spiritual power that resolves doubt and opens the doors of the Dharma, Śrāvastī is revered as one of the eight great wonders.

Commemorating this holy place, Aśoka erected a tall pillar on each side of the eastern entrance to Jeta's Grove, where there once stood a seven-storied monastery. Stupas were built on the site of Anāthapiṇḍada's house, the vihāra of Mahāprajāpatī, and the cremation place of Aṅgulimāliya, a ritual murderer who became an Arhat after his conversion to the Dharma. Southeast of Śrāvastī was the site of a stupa where the Buddha met the vengeful king Virūḍhaka on his way to destroy Kapilavastu. The king turned back, but, as the Buddha had foreseen, he eventually returned and carried out his purpose.

When Fa-hsien visited Śrāvastī in the fifth century, only two hundred families were living in the city, but these stupas were still standing. By Hsüan-tsang's time (c. 632), Śrāvastī was deserted and in ruins. Like most other Buddhist sites, Śrāvastī was forgotten until the nineteenth century, when excavation revealed the remains of Jeta's Grove and close by, the ancient city of Śrāvastī.

Although the site has been only partially excavated, extensive remains of large Buddhist buildings appear to surround the ruins of the walled city of Śrāvastī itself. Mounds indicate the location of many of the stupas described by the Chinese pilgrims. Further research could well uncover numerous other reminders of events and teachings preserved in the Sūtras. In recent years, Sri Lankan,

Burmese, Thai, and Chinese monks have built temples at Śrāvastī. A modern stupa now stands on the grounds of the Sri Lankan temple.

Saṁkāśya

After the Buddha had resided for a time in the Trāyastriṁśa Heaven, three flights of stairs took form for his return to earth. The Blessed One descended on the middle flight, made of the seven precious substances. On his right, on a silver staircase, descended Brahmā, lord of the highest heaven, and on the left, on steps of gold, Śakra, lord of the Trāyastriṁśa devas.[1] When the Buddha stepped upon the earth, the three stairways descended into the ground until only seven steps were visible.

In later years, King Aśoka sent his men to dig to the bottom of the stairs, but they reached water before they could find the end. Aśoka built a vihāra over the site, and placed an image of the Buddha at the head of the middle staircase. Behind the vihāra he erected an elephant-topped pillar. Fa-hsien found stupas marking the place where the nun Utpalavarṇā, transformed by the Buddha's compassion into a cakravartin king, greeted the Buddha upon his return; the place where he cut his hair and nails; and the place where all four Buddhas of our aeon sat and walked in meditation. Stupas also stood where Brahmā and Śakra followed the Buddha in stepping onto the ground.

Associated with miracles and a direct link to the heaven realms, Saṁkāśya became a popular place of pilgrimage. In the fifth century about one thousand monks and nuns lived at the vihara built by Aśoka, and another monastery housed about seven hundred more. In the seventh century, Hsüan-tsang described the temple built over the ladders as "wonderfully magnificent." By that time, the ladders had sunk into the earth and disappeared, but had been replaced with new ladders nearly seventy feet in length.

1. Sources vary as to the substances that formed the three staircases. Lapis lazuli is often mentioned for the central staircase.

Today only a large mound surrounded by an earthen rampart over three miles in circumference suggests the former size of this ancient city and its religious importance. The temple of the stairs, surmounted by a Śaivite shrine, cannot be excavated. The elephant capital that once crowned the pillar erected by Aśoka is the sole physical reminder of Saṁkāśya's association with the life of the Buddha. Remote from centers of Buddhist activity, Saṁkāśya is the least likely of the eight holy places to be developed. Still, immortalized in the teachings of all Buddhist traditions and symbolized in the "heaven-descending" stupas, Saṁkāśya remains a potent reminder of the universality of the Buddha's teaching.

Vaiśālī

The capital of the Licchavis, Vaiśālī was the largest city of the Vṛijian confederacy. Before the time of the Buddha, the Licchavis, the Mallas, the Videhas, and other tribes had formed this confederacy for mutual protection against their powerful neighbors, Kosala on their western border and Magadha to the south. As the scriptures record, the city of Vaiśālī itself was a place of great beauty, inhabited by people respected throughout northern India for their love of freedom, their harmonious interactions, and their prosperity.

On the Buddha's first visit to Vaiśālī after his enlightenment, he ended a great plague that was devastating the city and won the respect and love of the people. Another time when the Buddha visited Vaiśālī, a group of monkeys dug a pool for the Buddha's use and offered him honey for refreshment. The Sūtras record that a number of teachings were given beside this pool as well as in the Mahāvana (the Great Forest north of the city) and the Mango Grove of the patroness Āmrapālī. It was in the Mango Grove that the Buddha told his disciples that he would soon enter parinirvāṇa.

In the fifth century, Fa-hsien described numerous reminders of the Buddha's sojourns in Vaiśālī: the chapel and stupa of the Mahā-vana, the ruins of a stupa built by Āmrapālī, and a stupa that marked the site of the great council at Vaiśālī, when seven hundred

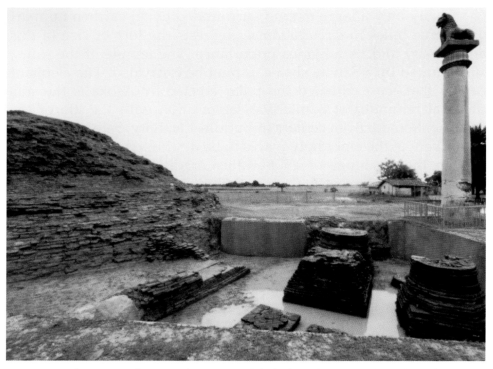

For more than two thousand years, Aśoka's lion has gazed at the solid brick stupa of Vaiśālī, built by Aśoka next to the pool that monkeys prepared for the Buddha.

Arhats convened to reaffirm the Buddha's teachings a hundred years after the parinirvāṇa. To the south was the stupa the Licchavis had built over the relics of Ānanda, the Buddha's faithful attendant. Two centuries later, Hsüan-tsang found Vaiśālī in ruins, but the ancient monuments could still be discerned: Three stupas commemorated the layman Vimalakīrti and the place where he spoke of the Dharma to Mañjuśrī. Three more marked the sites where the Buddha stopped on the way to Kuśinagara, where he gazed for the last time on the beloved city of Vaiśālī, and where he announced that he would soon enter parinirvāṇa. For this act, Vaiśālī became associated with the Buddha's ability to control his lifespan.

A little over thirty miles to the north, Hsüan-tsang located an ancient city where the Buddha had reigned in a previous existence

India

The earliest stupas of our historical era were built in India according to the instructions the Buddha gave to Trapuṣa and Bhallika: Upon a broad base of three steps resembling a folded robe rests a hemispherical dome shaped like an inverted almsbowl. From the top of the dome rises an umbrella-like structure reminiscent of the Buddha's staff.

A heaped-up and compacted mound of earth, stones, and broken bricks generally formed the stupa's central core; around it was laid an outer sheathing of bricks or stone, forming a low hemisphere with a flattened top with a diameter as much as five times its height. This form of dome, aṇḍa in Sanskrit, resembled its essential meaning, "egg." The dome rose over the relic chamber, which was placed in the center of the base. The ruins of the stupa at Piprahwa and the earliest stupas in Andhra, some of which may predate King Aśoka, exemplify this style of construction.

The details of construction of India's stupas are known through archaeological research that began near the end of the eighteenth century and gained momentum during the nineteenth. The loss of

two major stupas—the Dharmarājika of Sārnāth and Amārāvatī in Andhra—stimulated archaeologists to identify Buddhist sites and carefully research the monuments that remained. As a result, major discoveries have been made and relics recovered from sites abandoned long ago. Now that archaeologists are aware of the value of relics to the Buddhist traditions, relics recovered are generally given to appropriate authorities for empowering new temples and stupas.

Excavations have revealed that the relics themselves were often contained in two layers of caskets, the inner one of a precious substance and the outer of soapstone or similar material. In at least one instance, at the ancient stupa of Piprahwa, two sets of relics have been found in the same stupa, one in an upper chamber of a later date, and the original relic deposit in a smaller chamber concealed below. (BRK 35–37)

From early times, the base of the stupa has been carefully aligned with the four directions. While the doctrines of the different schools appear to have influenced specific features discovered in the foundations of early stupas, respect for the larger significance of the monument appears to have guided the stupa's placement and orientation. At some point, knowledge of geomancy, the science of subtle energy fields of earth, water, fire, air, and ether, was joined to mandalic principles. As the stupa's architecture became more precise, its cosmic significance became more apparent.

The Mahāvastu and Thūpavaṃsa discuss the importance of constructing the base and the relic-chamber of a stupa and describe the elaborate consecration ritual to which King Duṭṭhagāmani invited monks from centers in all parts of the Buddhist world. To this day, in all Buddhist traditions, the foundations of stupas and temples are established and consecrated with the greatest care.

The harmikā, a square stone box surrounded by a fence-like enclosure of railings on the stupa's top, also contains relics. The harmikā reflects precisely the directional orientation of the stupa's base; relics are deposited in a box in the harmikā's center, or, as Atīśa describes, in an obelisk that forms the stupa's spire.

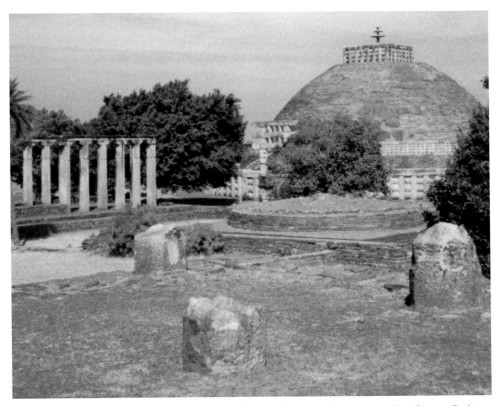

The Great Stupa of Sāñcī, seen here from the southeast, was built on Caitya (Temple) Hill by the Dharma king Aśoka and enlarged during the Śuṅga dynasty (2nd century B.C.E.).

The spire itself may extend deep into the earthen mound that forms the core of the dome or it may pass completely through the mound into the earth below. A third type, in which the spire is affixed to the top of the dome, was described by the Chinese pilgrims in their accounts of raising the spire of the Kaniṣka stupa.

The Kṣudrakavastu, one of the seven Vinaya texts of the Mūlasarvāstivādin tradition, explains that the parasols on the spire indicate the degree of spiritual attainment: A stupa of the Buddha is to be complete in every detail, with a rain-cover and thirteen parasols; a stupa of a Pratyekabuddha has seven parasols, but no rain cover; and a stupa of an Arhat has four parasols. For the stages

leading up to the Arhat: A stupa for the non-returner has three parasols, for the once-returner, two parasols, and for the stream-enterer, one. In time, parasols were also represented as rings or wheels. Tibetan chortens empowered by dhāraṇīs and mantras are generally considered Buddha stupas and have thirteen rings. Symbols mounted at the top of the spire vary among traditions and cultures; for example, a jewel appears at the top of Sri Lankan stupas and the twin symbol of sun and moon topped by a flame crowns the Tibetan chorten.

Indications of the four directions began to appear externally as niches on the sides of stupas, as markers of auspicious places to offer prayers, as staircases, as vertical pillars, and as gates. Entering at the east and moving clockwise, practitioners could symbolically follow the great acts of the Buddha associated with the four directions: east (birth), south (enlightenment), west (teaching) and north (parinirvāṇa). (PCBS 8) In time images of the Buddha were placed in niches positioned in one or in all four directions.

The beautifully-preserved stupas of Sāñcī and numerous ruins excavated throughout India verify that Aśoka and others of his time followed the simple yet elegant form of the rounded hemisphere. While Sāñcī's great stupa was enlarged and resurfaced, a smaller stupa at Sāñcī (pictured on page 44) may be the purest example remaining of the relatively unaugmented Aśokan style. From its slightly flattened top rises a single parasol surrounded by a harmikā, a square box enclosed in a fence of stone uprights and railings.

For the Chinese pilgrims of the fifth to seventh centuries, the rounded form of the Aśokan stupa with its flattened top was a familiar sight: Hsüan-tsang alone noted a large number of Aśokan stupas in his travels in Central Asia, Afghanistan, and India. A height of a hundred feet was not uncommon, with some rising to two or even three hundred feet.

In South India, in the river valleys of Andhra, great stupas attributed to Aśoka may actually have predated the Mauryan emperor. Buddhist tradition relates the story of Bavari, a South Indian who became a disciple of the Buddha, opening the possibility that

Buddhism was practiced in the south at an early date. Excavation of the great stupa of Amāravatī reveals pottery of a type associated with the fourth and fifth centuries B.C.E. The stupas at Dhānya-kāṭaka, Vaddamanu, and Bhaṭṭiprolu may be nearly as ancient.

Stupas built after Aśoka's time tended to be higher in proportion to their base and more perfectly hemispherical in shape. This was made possible by technological advances in compacting the core, constructing inner support walls, and shaping a stronger structure. As Buddhism expanded beyond Magadha and entered new lands, the hemisphere continued to became taller and the base smaller. In the tradition of Sri Lanka, where the first stupas were built during Aśoka's lifetime, the egg, water-bubble, and conical "paddy-heap" shapes evolved as variations on the Aśokan style, and the parasols became more stylized as architectural forms. Archaeologists have noted that the shapes of nearly all of Sri Lanka's stupas have been altered through restorations, so their original form is difficult to ascertain.

Sāñcī and Bhārhut

Before Aśoka became king, he ruled the western cities of Ujjain and Vidiśā as regent. In Ujjain, he married Devī, who bore him two children, a son named Mahinda and a daughter, Sanghamittā. When her children entered the monastic Sangha, Devī commemorated their ordination by building the Vidiśagiri Vihāra at Sāñcī, which became a center of the Sthavira school. It was from this vihāra that Mahinda departed to transmit the Dharma to Sri Lanka.

When Aśoka visited Sāñcī as king, he erected a pillar with an inscription and constructed a great stupa. The great stupa was damaged early in the second century B.C.E., probably by Puṣyamitra, the first king of the Śuṅga dynasty, but it was rebuilt by one of his successors. In reconstruction, the stupa was greatly enlarged and sheathed in a durable stone facing, reaching its present dimensions of 120 feet in diameter at the base of the cupola and fifty-four feet in height. Sometime after the cupola was completed, a circular terrace

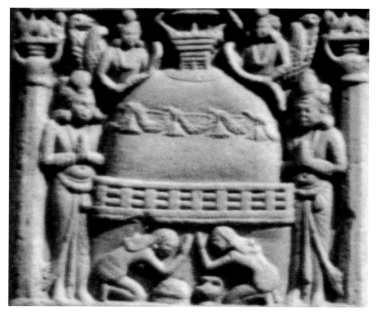

Worship at a stupa, a bas-relief on one of the Sāñcī gates.

fourteen feet high and five and a half feet wide was created around it and surrounded by an ornamental railing. Staircases were placed at the four directions to give access to the terrace, and small structures were built onto the stupa at the four directions to mark the significant places for offering prayers and devotion. The entire hill the stupa stands on was probably paved about this time. The hill itself became known as Caityagiri, Temple Hill.

The country around Sāñcī, anchored by the flourishing trade center of Vidiśā, continued to thrive. During the Śuṅga dynasty (c. 187–75 B.C.E.), Vidiśā became the most prosperous city in central India. Its merchants and travelers generously supported the Buddhist Sanghas by building and ornamenting stupas and temples.

Stupas, the major focus of the laity's devotion, were an obvious place for illustrations of the moral, ethical, and inspirational teachings conveyed orally by the monks and nuns. Stone, a substance which called to mind the enduring quality of the Dharma, became the favored medium of expression. On stone railings and on the

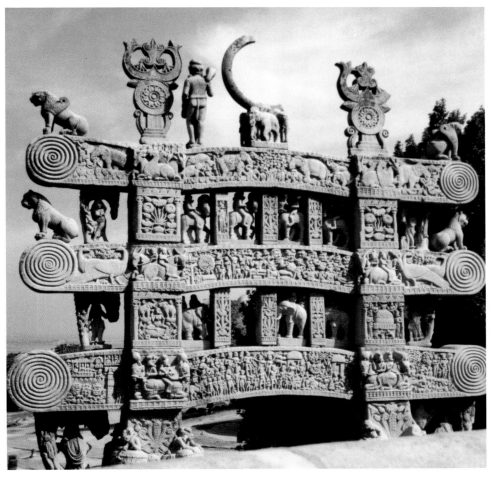

The great gates at Sāñcī are richly carved with symbols, scenes associated with the Buddha's acts, illustrations of his acts in previous lives, and depictions of patrons' devotional offerings.

stone or tiled bases of stupas were carved accounts of the Buddha's previous lives in lively detail. Here also were carved the twelve acts of the Buddha, together with scenes that called to mind familiar acts of devotion and compassion. Sponsoring sacred sculptures was a meritorious action in itself and a valued offering to others. Practitioners circumambulating the stupas could follow the unfolding of visual teachings from the Sūtras, reminders of the view and path to enlightenment.

The exquisitely carved gates and railings at Sāñcī that enclosed the circumambulation path were probably added during the first century B.C.E. The southern gate, associated with enlightenment and the Sangha, was the first gate erected. It was followed by the northern gate, then by the eastern and western gates, which appear to have been erected as a pair. The care, artistic skill, and attention to detail evident in these ornamentations indicate that monasteries here were supported by prosperous lay communities. Inscriptions on the gateways and railings record donors' names, occupations, and their home countries—a detailed record of patronage by people from all walks of life, from ruling families to merchants, monks, nuns, seamstresses, and carpenters, who came here from all parts of northern India and lands beyond the Indus River. Miraculously, the richly sculpted gates and railings of Sāñcī have survived the centuries and still stand today. To this impulse to convey the Buddhist teachings in stone India owes the origins of its reputation as a land of temples and towers.

Sāñcī is the most spectacular and best preserved of the more than sixty stupas that are collectively known as the Bhilsa Topes. A close second is Bhārhut, which also had a great stupa sheathed in stone, encircled by railings, and furnished with lofty carved gateways erected at the four directions. The great stupa at Bhārhut, mined for bricks by local villagers, is now less complete than the main stupa at Sāñcī, but it shows the same type of ornamentation. The intricate stonework of the gates of stupas at Bhārhut and Sāñcī is representative of the carvings that once ornamented the gates, railings, and sides of many of India's great stupas.

About this time, the Dharmarājika Stupa of Sārnāth was similarly enlarged and ornamented, as was the Dharmarājika Stupa of Taxila, located in modern Pakistan. Built by Aśoka, the Dharmarājika Stupa of Taxila had been damaged by earthquakes. Renovation nearly doubled its original mass: Sixteen spoke-like walls were added to radiate out from its central core; the whole hemisphere was filled in, then faced with a sturdy sheathing of polished stone. Carved stone railings were added to form an enclosed pradakṣiṇa or

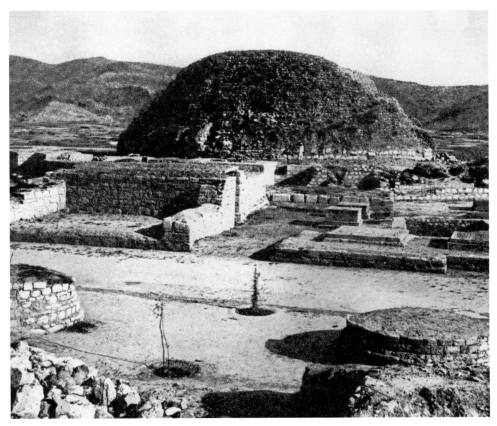

The Dharmarājika Stupa at Taxila, originally built by Aśoka, was later enlarged, faced with stone for stability and beauty, and ornamented by a railing-enclosed circumambulation path.

circumambulation path. A century or so later, the great master Nāgārjuna participated in renovating at least two major shrines: the Mahābodhi gaṇḍola at Bodh Gayā and the magnificent stupa of Amāravatī.

In South India, pillars erected in the four directions took the place of the gates added to northern stupas. The great stupa of Amāravatī was ornamented with five lotus-topped pillars that stood facing the four directions. Although the stupa of Amāravatī no longer stands, models created as bas-reliefs depict its shape and ornamentation (page 59).

Stupas of South India

Tradition holds that the Buddha visited places in Andhra as well as the kingdoms of Coḷa, Drāviḍa, and Malakūṭa, which lay to the south. In all of these places the pilgrim Hsüan-tsang found stupas built by Aśoka commemorating sites where the Buddha had prepared the land to receive the Dharma. Andhra, where the long fertile valleys of the Godavarī and Krisṇā rivers form natural highways connecting the Deccan plateau with the eastern coast, was especially blessed with Buddhist centers that flourished between the third century B.C.E. and the seventh or eighth centuries C.E. To an extent modern scholars are just beginning to realize, monks made their way along the dakṣiṇāpatha, the southern route that led from Vidiśā in central India south and east to Andhra's thriving centers of trade. Aśoka's conquest of Kaliṅga removed a major barrier to travel along India's eastern coast. From Aśoka's time monks and pilgrims could travel this route to the southeastern Buddhist centers, as did Hsüan-tsang in the seventh century.

In recent times, archaeologists have verified that the stupas of Andhra are among the earliest known. Many trace their origins to the time of Aśoka, and several, such as Vaddamanu, Bhaṭṭiprolu, and Dhānyakāṭaka, may actually have been built prior to his reign. The early Andhran stupas, as seen at Vaddamanu and Bhaṭṭiprolu, are low circular brick and plaster mounds with large bases three to five times their estimated height. As archaeologists have noted, in many cases the sophisticated stonework of their foundation reflects a long familiarity with working in stone.

Although some of the early stupas of Andhra are solid brick mounds, the foundation of Vaddamanu was carefully laid out in three concentric circles, each about four feet wide. Other stupa foundations reveal wheel-shaped designs with varying numbers of spokes, some with auspicious symbols worked into their centers. The wheel-shaped stupa bases and intricate sculpture facings appear to be most common to stupas built by Mahāsāṁghika schools, while stupas at Theravādin sites tend to dispense with these inner designs and to have fewer indications of ornamentation. A surpris-

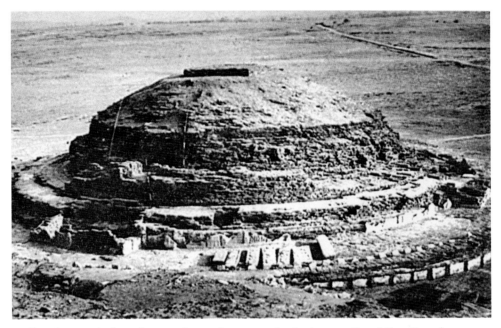

Pillar bases define the ancient circumambulation path of the Candavaram Stupa, Andhra's only surviving stupa. Its two terraces and remnants of its āyakavedikā projections toward the four directions can still be clearly seen.

ing number of relic caskets with relics intact have been recovered from the ruins of Andhra's stupas, possibly because numerous sites were buried by silt and jungle and have only recently been identified and uncovered.

British archaeologists of the nineteenth century tended to focus on the northern sites, where major discoveries were bringing the life of the Buddha out of the realm of legend. The destruction of the great stupa of Amāravatī at the end of the eighteenth century drew attention to this site in 1813. While Bhaṭṭiprolu and several other Buddhist sites were excavated in the late nineteenth century, research on southern sites was generally sporadic until the accidental discovery of Nāgarjunakoṇḍa in 1926. Even then, this important site was not fully investigated until 1954, when the Nāgārjunasagar Dam was under construction and the entire valley was about to become a lake.

Between 1954 and 1960, in a concentrated effort, archaeologists unearthed nearly a hundred sites, thirty of them Buddhist. Research on Buddhist sites continues in South India. Each year new discoveries of inscriptions and ruins contribute a few more details to the still scanty historical record of a thousand years of Buddhist activity.

Candavaram Andhra's only surviving stupa was discovered as recently as 1972 at Candavaram, a village on the Gundalakamma River that was once the juncture of Andhra's main trade routes. All that is missing is the stupa's staff and parasol; the base, dome, and harmikā are intact. Like other stupas of its age, the Candavaram stupa underwent two reconstructions. The original stupa had two terraces, which were retained during enlargement. The first reconstruction enclosed the whole stupa within a wall and filled in the gap with earth, stones, and bricks. The second reconstruction added four projections known as āyakavedikā that opened outward to the four directions. Jithendra Das reports that the casing slabs of the stupa were carved with Buddhist themes and ornamented with winged animals, unusual motifs for Indian Buddhist art. (BAA 44) Rows of pillars indicate the border of the circumambulation path.

Gummadidurru Inscriptions indicate that the main stupa of Gummadidurru dates to the second century C.E., when it was built by a native of South India. From a second inscription dated in the seventh century C.E., it appears that Buddhists were active here from the second to the seventh or eighth centuries. Ornately carved in the style of Amāravatī, the Gummadidurru stupa has a much smaller base, measuring a little over fifty-three feet in diameter. The brick base is wheel-shaped, with spokes radiating outward from a central auspicious symbol, and the āyakavedikā projections at the four directions stretch more than twelve feet out from the stupa. The entire monument, including the walls of the projecting shrines, was covered with intricately ornamented stone slabs, most of which depicted scenes from the Buddha's life. Although the stupa did not survive, a model carved into one of the slabs illustrates a high, richly ornamented dome topped with a harmikā and pillar. A Buddha image in the abhaya mudrā, the gesture of dispelling fear, appears

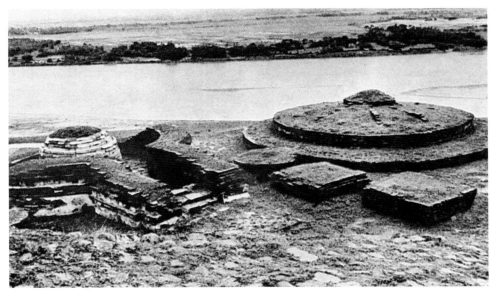

Foundations of the Sālihuṇḍam Stupa and an enclosed shrine (caitya-gṛiha). The round raised platform is the plinth of a small stupa that was the shrine's sacred center.

in a projecting shrine. Lions top the walls of the shrine and guard the five lotus-topped pillars depicted above it. Devotees make offerings and worship at the base of the stupa; above, celestial figures rejoice in the stupa's presence.

Sālihuṇḍam Traveling south along India's eastern coast, Hsüan-tsang passed through the country of Kaliṅga, where he noted a stone stupa about a hundred feet high on top of a mountain precipice. "Here, at the beginning of the kalpa, when the years of men's lives were boundless, a Pratyekabuddha attained nirvana." (HT II:209) The site described by Hsüan-tsang, located on the south bank of the Vaṁśadhārā River, has been tentatively identified as Sālihuṇḍam. Extensive ruins of stupas, statues, and brick vihāras discovered here between 1943 and 1947 include representations of Tārā and Māricī, indicating that this was a site of Vajrayāna practice.

The main stupa was found at the top of the hill, as Hsüan-tsang had described. Beside it were the remains of a small circular shrine

that once housed a stupa. An inscription written in script used in the second century C.E. and bearing the name of King Aśoka was found at the stupa's site. This inscription, supported by stratification analysis, indicates that this stupa could well have been built over an earlier one erected by the great Dharma king. Excavators found three stone caskets arranged in a row across the diameter of the stupa foundation. Each contained a crystal reliquary: One reliquary was rounded like the ancient stupa of Sāñcī; the second was bell-shaped; and the third was more elongated and surrounded with elegantly carved railings. These shapes are thought to mirror the Sālihuṇḍam stupa's appearance when first constructed and after each of two renovations.

Bhaṭṭiprolu Bhaṭṭiprolu, located near Repalle, is considered one of the earliest Buddhist centers in Andhra. Its great stupa, constructed about the same time as the Bhārhut and Sāñcī stupas, was made of solid bricks faced with carved white limestone. The foundation bricks were skillfully laid, with each course of bricks resembling the shape of a lotus. A stone wall or railing once encircled the stupa, but all that remains today is a mound of bricks and a few stone pillars. Excavations in 1891 unearthed three receptacles placed one above the other and a few feet apart. All contained relic caskets with precious substances; bone relics were found in two of them, identified by inscriptions on the caskets as relics of the Buddha. The relics were preserved and given to the Mahābodhi Society, which enshrined them in the Dharmarājika Vihāra at their center in Calcutta. Inscriptions found on the relic caskets date to the third century B.C.E.

Amārāvatī The Amārāvatī stupa is part of the ruins of Dhānya-kāṭaka, a major Buddhist site known today as Dīpaladinne, Hill of Lamps. Historically, Buddhist texts and pilgrims alike have referred to the site as Śrī Dhānyakāṭaka or a variant version of that name. This name may trace its origin to Dhāranīkoṭa, a village located just over a mile to the west. Hsüan-tsang describes two monasteries nearby, Pūrvaśaila, near a hill to the east, and Aparaśaila, next to a hill on the west. Here a king who honored the Buddha had hollowed a valley, made a road, opened the mountain crags, and constructed

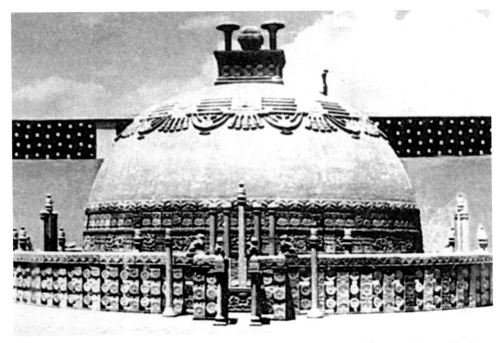

A model of the great stupa of Amāravatī, constructed from a bas-relief on one of the stupa's white granite facing stones.

pavilions and long galleries. The pilgrim relates that this region was a major gathering place for the three-month rainy season retreat.

Archaeological evidence indicates that Dhānyakāṭaka was an active Buddhist center for a thousand years, from about 300 B.C.E. to 700 C.E. The recent find of a fragment of an Aśokan pillar edict near the stupa's foundation confirms that this site was already important to Buddhists by the time of Aśoka's visit, and Aśoka may well have enlarged a stupa already built on this site. Inscriptions on railings found at the site are written in the style associated with Aśoka.

Conditions appear to have favored the growth of a major Buddhist center characterized by numerous exceptionally well-built stupas. The region was rich in stone utilized by the valley's inhabitants since prehistoric times. The Pūrvaśailas and Aparaśailas, whose monasteries Hsüan-tsang described, were branches of the Caityaka school, named for their veneration of caityas and their

construction and beautification of stupas. Their activity corresponded with the regions' burgeoning prosperity as a major trading center. Inscriptions of donors indicate that stupas and monasteries alike benefited from the largesse of all classes of donors and from the skills of artists attracted to the area.

Tibetan tradition records that the master Nāgārjuna, with the patronage of the Sātavāhaṇa king, personally directed the building of the stupa's intricately carved railing, ornamented with sacred symbols and scenes from the Jātakas and the life of the Buddha. Expanded and ornamented during three major dynasties of rulers—the Sātavāhaṇa, Ikṣvāku, and Pallava—the great stupa of Dhānya-kāṭaka was widely renowned for its magnificence. The sculptures on the stupa's facing and the surrounding railing, made of polished white limestone and shaped in a warm, fluid style, were known and emulated by artists in the sea-trading cities along the coast of Southeast Asia.

The Amārāvatī Stupa, one of the most beautiful in the Buddhist world, was preserved intact until the end of the eighteenth century, when the local ruler had the sculptures removed and taken to the Amareśvara Temple. He used much of its elegant white limestone facing for building materials. Most of the stupa was mined for building materials by 1816. Workers found a stone box containing a crystal casket with a pearl and gold leaves, which are now in the Government Museum in Madras.[1] Further excavations revealed sculptured slabs and the remains of railings, sculptures, and a relic casket. Five more relic caskets were found between 1958–59 in the ruins of a shrine on the south side of the stupa, suggesting reconstruction and reconsecration at some earlier time. In 1973–74, archaeological research determined that the stupa was first constructed in the third century B.C.E. (BAA 55)

Through the years scholars have studied the surviving slabs and the foundation in attempts to ascertain the stupa's appearance

1. C. Sivaramamurthy, *Amārāvatī Sculptures*, cited by D. Jithendra Das, *The Buddhist Architecture in Andhra*. New Delhi: Books and Books, 1993, p. 54.

and size. Models have been created based on sculptures of the stupa found at the site. The diameter of the base of the stupa is now generally measured at 150 feet, with the diameter of the dome only slightly smaller. The height is estimated to have been close to one hundred feet.

The circumambulation path around the dome was about thirteen feet wide and paved with slabs of limestone. Four platforms covered with sculptured slabs projected outward from the dome in the four directions, each faced with five pillars. Above the dome was the harmikā, from which rose an octagonal pillar flanked by two smaller pillars fitted with stone parasols. Today only a few sculptured slabs remain to flesh out detailed archaeological reports, none of which can capture the spiritual essence of a monument that once ranked among the wonders of the world.

Nāgārjunakoṇḍa Tāranātha records that Nāgārjuna spent his final years at Śrī Parvata, where his patron King Sātavāhana built a great stupa and a monastery. Śrī Parvata is identified as a plateau near the ancient Sātavāhana capital of Vijayapurī, in a secluded valley along the Kṛṣṇā River. This plateau later became known as Nāgārjuna-koṇḍa, Nāgārjuna's Hill. Seeking to become the great master's disciple, Āryadeva came here from Sri Lanka. Long after Nāgārjuna passed away, Āryadeva continued his master's work, writing commentaries that framed the foundation of the Madhyamaka tradition. At Naṇḍura, near Nāgārjunakoṇḍa, a container was found that is said to hold Āryadeva's relics.

Buddhism flourished during the reigns of the Ikṣvāku kings who succeeded the Sātavāhanas in the mid-third century C.E. Nāgārjunakoṇḍa developed into the largest Buddhist center in South India, with thirty monasteries affiliated with five Buddhist traditions housing monks from Sri Lanka, China, Gandhāra, Bengal, and all parts of South India. Building ceased in the mid-fourth century after the Pallava kings came to power. Lacking support, the monasteries declined and were abandoned. Silt and forest gradually covered the site.

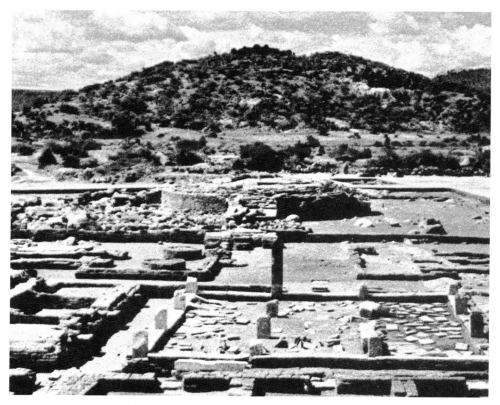

*Massive stonework supported the great stupa that was the spiritual center
of the Aparamahāvinaseliya Monastery at Nāgārjunakoṇḍa.*

While each monastery had at least one stupa, the great stupa of
the Aparamahāvinaseliya Monastery appears to be Nāgārjuna-
koṇḍa's oldest and most central sacred monument. Inscriptions date
the stupa around 246 C.E., but archaeologists note that this may be
the date of renovation and believe the stupa actually dates from the
time of Nāgārjuna.

The base of the stupa is about ninety feet in diameter; built on
three concentric circles of brick connected by crossed spoke-like
walls radiating from a central core, the stupa may have been about
eighty feet high, and it appears to have had a railing. In an outer
chamber, relics were found encased in a gold reliquary that held a
stupa-shaped silver casket, gold flowers, pearls, garnets, and crys-

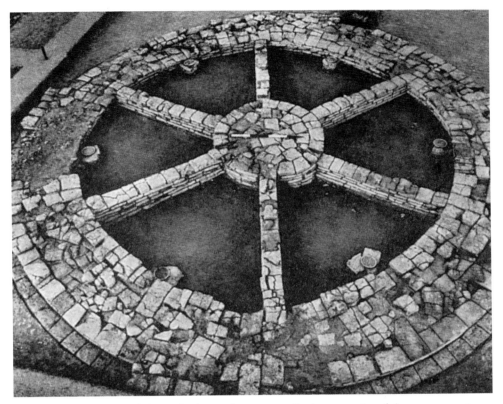

A six-spoked wheel foundation of a stupa that once stood in a monastery compound at Nāgārjunakoṇḍa.

tals. Inside the silver casket was a small bone relic. The foundations of nine more stupas were found near the great stupa. With the opening of the Nāgārjunasagar Dam, the entire valley was flooded. Salvaged remains and models made of the larger sites were placed in a museum built on a hill above the dam.

The stupas described above are only six of the hundreds of stupas unearthed or tentatively identified in Andhra. At most sites, only stone foundations remain, shaped in patterns that suggest the stupas here were built to embody specific qualities of the teachings. The pilgrim visiting these long-abandoned places can only imagine the size and extent of South India's sacred Buddhist centers.

Development of Forms

At the end of the first century B.C.E., most stupas in India appear to have had the same basic form: a three-stepped foundation, an increasingly taller dome, a harmikā, staff, and ring-shaped parasols or wheels rising one above the other. Walls of carved uprights and railings enclosed the circumambulation paths of major stupas, and secondary paths encircling the whole began to take form. As important sites were developed, major stupas were encircled by three or even four circumambulation paths, as can be seen at the Mahābodhi compound in Bodh Gayā. Terraces similar to that on the great stupa of Sāñcī were added. In time, Mahāyāna Sanghas developed these early terraces into additional stages that enabled practitioners to ascend higher, enacting in their circumambulation the path to enlightenment. Among this type of stupa the best known are the Jarungkhashor stupa in Boudhnath, Nepal, the tashi gomang stupas of Tibet, and the great mandala of Barabuḍur in Java.

In time, niches were affixed or built into the sides of stupas, where images of the Buddha could face outward to the four directions. In Gandhāra, along the Indus River, northwest into Afghanistan, and following the Silk Road round the Tarim Basin to the borders of China, stupas were built on a square base with terraces rising to substantial heights and topped by a high rounded dome and soaring pinnacle. More elaborate staircases were sometimes added at the four directions, imparting a cruciform shape to the foundation. In the great monastic universities of Vikramaśīla and Somapurī, built in the eighth century C.E., this cruciform structure became the center of a living mandala that integrated stupa, temple, and monastery.

The shape of the sacred monument found expression in various ways as cultures adopting Buddhism made the stupa their own and imbued it with profound religious significance. The whole stupa might be placed on a lion throne, like the Tibetan chorten; eyes might be painted on large harmikās, as in the stupas of Nepal, and the wheels of their spires fused into square-sided pyramids. Or the dome might disappear, and the harmikā and multi-leveled parasol

transformed into the soaring pagodas of Korea, China, and Japan, with their graceful upturned roofs rising one above the other. Temple and stupa would merge into the great gandolas, like the nine-storied Mahābodhi, or the chetis, wats, and zedis of Southeast Asia.

Theravādin traditions emphasized the physical relics of the Buddha and their power to awaken devotion and intensify meditation. Mahāyāna schools added images of the Great Bodhisattvas and encouraged practitioners to see in the stupa the three bodies of the Buddha and a mirror of their inner nature. Vajrayāna masters brought out the deeper meaning of elements, proportions, and symbols to communicate the most subtle meanings on levels inaccessible through words. While differing in method, forms, and explanations, each yāna, or vehicle to enlightenment, saw in the stupa ways to cleanse obscurations, purify the mind, generate merit, and move ever closer to enlightenment.

Cave Stupas

At the end of the second century B.C.E., Buddhist Sanghas began carving temples and monasteries out of the living rock in the western Indian state of Mahārāṣtra. The earliest vihāra caves were relatively simple rock-hewn caverns, and the caves that served as temples were carved to emulate wooden structures, complete with columns and rafters. As artisans and craftsmen became more comfortable with stone, they developed a distinctive cave architecture, rich in sculpture and ornamentation. To date, about twelve hundred excavated caves have been located in India. Nearly three quarters of these caves were created by Buddhist communities.

Although authoritative texts describe statues of the Buddha built during his lifetime, the earliest cave temples have stupas in a central position as the primary reminder of enlightenment. It is possible that earlier temples made of wood may have established this practice, but this is difficult to confirm. Archaeological research has

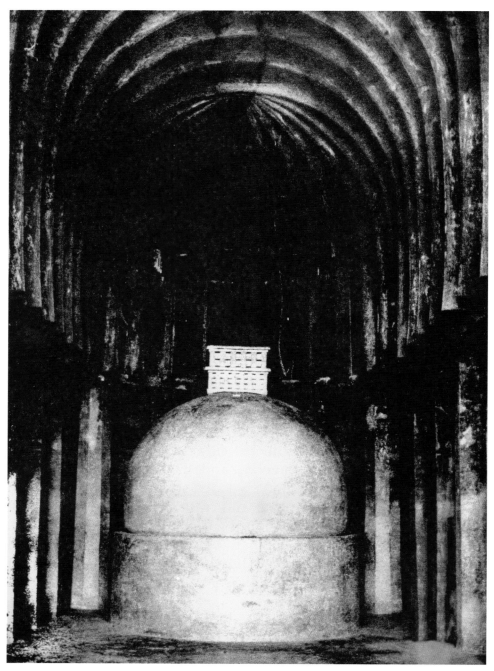

The simply-shaped monolithic stupa in Bhājā's temple cave dates to the second century B.C.E.

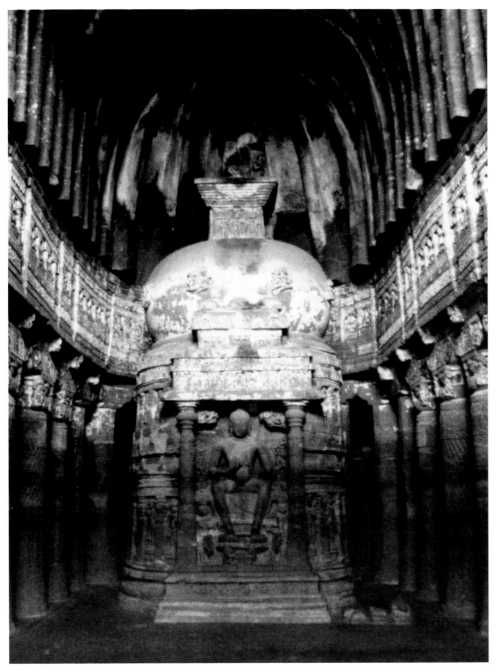

The Buddha appears on the rock-cut stupa in cave twenty-six, a Mahāyāna temple cave at Ajaṇṭā created in the fifth century.

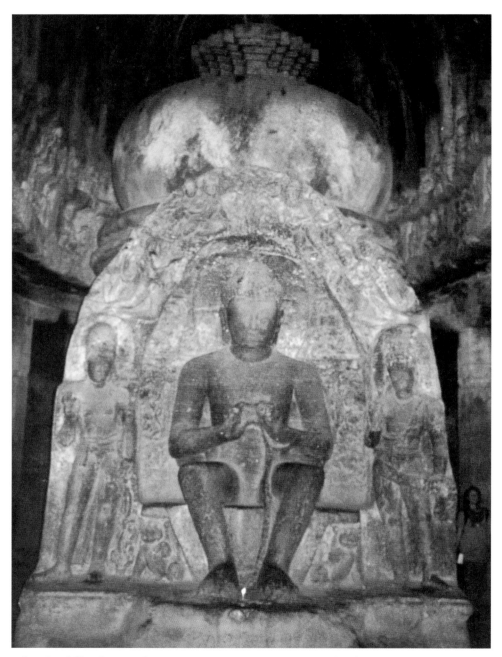

The Buddha-image became more prominent in the later Mahāyāna cave stupas. In the Viśvakarman cave at Ellora, the Buddha is seated with his hands in the Dharmacakra mudrā, the gesture of teaching.

The harmikā of this cave temple stupa at Ajaṇṭā is carved to resemble the fenced harmikās of Aśokan stupas. Remnants of frescoes can be seen on the walls above.

verified that above-ground temples at Sāñcī and Sārnāth both had stupas as the central focus of devotion in the third century B.C.E.

There is no indication that these monolithic stupas carved from solid rock were intended to hold relics, but their form is complete, with base, dome, harmikā, some version of parasol, and spire. The rock-cut stupas are taller in proportion to the base than contemporary stupas erected above ground. In some cases the top was modified, with parasols represented by widening squares surmounted by a parasol. In all cave temples, stupas were positioned at the curved end (nave) of the temple, far enough out from the wall to allow for circumambulation, which appears to have been a monastic as well as lay practice from early times.

Cave stupas dating to the second century B.C.E. have been found in the temple caves of Bhājā, Bedsa, and Kondane; in cave ten at Ajantā; and in cave three at Pitalkhora. The Bhājā cave stupa, with its tall, simple dome and banded center, is similar to the shapes of Amāravatī and Gummadidurru stupas in the southeastern province of Andhra. Although the entire stupa is solid rock, its harmika is carved to resemble open railings and supports as in the Sāñcī, Amāravatī, and Gummadidurru stupas. Near the main stupa are fourteen smaller memorial stupas. Within a hundred years Ajantā's cave nine and caves nine, ten, twelve and thirteen at Pitalkhora were also excavated as stupa temples, known as caityagṛiha, houses for (stupa) shrines.

The building of cave temples continued through the second and third centuries C.E. at Kārli, Nāsik, Junnar, and Ajantā. Nearly all these temples were occupied by the early Buddhist schools or by the Sangha of Ten Directions, as the communities unaffiliated with one of the early schools were known. Beginning in the third century, Mahāyāna sanghas also began to construct caves, especially at Ajantā and Ellora. Cave building continued at Ajantā until the seventh century, when the focus of construction shifted abruptly to Ellora, where it continued through the eighth century. Mahāyāna sanghas are also associated with caves excavated in Andhra at Nāgārjunakonda, Udayagiri, and Brahmagiri between the third and

fifth centuries. Inscriptional evidence links Ajaṇṭā with the Andhran centers of Amarāvatī and Nāgārjunakoṇḍa, and with the monastery caves of Nāsik and Kārli.

The Great Buddhist Universities

In the deep and broad vistas of the Mahāyāna, the stupa is closely associated with mandala, the pattern through which the primordial energy of enlightenment takes on shape and form and enters the range of human perception. The fundamental mandala is the five-fold field of Buddha-attributes: kāya, vāca, citta, guṇa, and karma, the body, speech, heart, qualities, and actions of enlightened being. Each is in turn the center of a mandala, linked to light in its purity of white and the rainbow colors of red, blue, yellow, and green. Citta appears in the center and kāya and vāca to east and west, though citta and kāya may change places. These three form the mandala's basic triad, with guṇa and karma to south and north.

Kāya shapes the mandala of embodiment, portrayed as the deity in his palace, the lord of the cosmos and his environing world. Vāca creates the mandala of communication and transformation, while the citta mandala is the heart, the transparent, centerless center of awareness, the basis of perception, the pure realm of Dharma, radiating light from all directions. The guṇa mandala reveals the qualities of enlightenment. Its power lies in manifesting beauty, merits, blessings, the elements of liberation and untold benefits, likened to the five precious gems—sapphire, diamond, topaz, ruby, and emerald. The karma mandala is the realm of action. The inter-action of the physical senses and the five great elements gives birth to sense experience. Conduct, unfolding in a fivefold patterning, creates the world of circumstances, the ever-changing setting for the five stages of life.

Kāya, vāca, guṇa, and karma, with citta in their center, express the architecture of enlightenment just as the four cosmic continents with Mt. Meru at their center express the underlying structures of the universe. From these the paradises of the five Dhyāni Buddhas

arise, offering fields for attainment and realization. Vairocana, in the center, represents the Buddha family; its color is the deep blue of space which allows the presentation of all forms. Akṣobhyavajra, in the east, represents the Vajra family; its color is white, emblematic of creativity which gives birth to shape and structure. Ratnasambhava, Amitābha, and Amoghasiddhi represent the families of Ratna, Padma, and Karma, associated with the south, west, and north, and with the colors yellow, red, and green. South is the direction of enlightenment; west is the harvest and integration; and north is associated with the action that carries enlightenment forth into the world. Patterned by the mandala, Buddha-nature acts within the world, making liberation possible.

Guided by a deep understanding of Prajñāpāramitā, masters of the Mahāyāna based the structure of their sacred buildings on the mandala and infused them with symbolic elements. From the empowerments and consecrations of the center to the orientation to the four directions, all symbols, colors, and ornamentations of stupas harmonize with mandalic principles. This vision guided not only the creation of individual structures but also influenced the shape of entire monastic complexes.

The stupa, recognized by all Buddhist traditions as the ultimate sacred center, took its natural place at the mandala's core. Around the great stupa at Nālandā, established as a home for the Mahāyāna, temple were erected at each corner. Any earlier stupa that may have marked the birthplace of the great disciple Śāriputra would have been enveloped by the massive structure that became the focal point of Nālandā's monasteries, temples, shrines, and assembly halls.

The fullest expression of the integrated mandalic form appeared in India in the eighth century, with the building of three great monasteries: Vikramaśīla, Odantapurī, and Somapurī. All three must once have been virtual monastic cities. In the center of Vikramaśīla and Somapurī rose a great stupa with prominent staircases at the four directions inviting entrance to the temple inside. Around them were structures that defined the monastery's central courtyard: living quarters for monks, shrines, and smaller stupas.

Similar structures appeared later in Southeast Asia, in the wats and chedis of Thailand and Burma.

For centuries, these monastic universities were dynamic centers of scholarship, meditation, and realization that nurtured the growth of the Mahāyāna traditions throughout Asia and supported the transmission of Vajrayāna lineages. All were destroyed between 1297 and 1304 when a Muslim army under Bhakhtyār Khaljī marched east from Vārāṇasī intent on pillage and destruction. Over the centuries the great monasteries lay buried and forgotten, their sites marked only by shapeless mounds of brush and rubble. To date three have been located and explored through excavation, but the probable site of Odantapurī, the model for Samye, Tibet's first monastery, is topped by a Muslim graveyard and cannot be disturbed.

The founding and growth of India's monastic universities and the great masters associated with them were chronicled by the sixteenth-century Tibetan historian Tāranātha in his *History of Buddhism in India* (Simla, 1970). For Nālandā, the journals of the Chinese scholar/pilgrims provide invaluable eye-witness accounts of life and studies in ancient India's most renowned university. While only a very short summary can be given here, a fuller review of the Mahāyāna universities and their outstanding masters can be found in *Holy Places of the Buddha* (Berkeley, 1994).

Nālandā

Located seven miles north of Rājagṛha, Nālandā has a long association with the Buddha, who often walked the road between Rājagṛha and Nālandā with his disciples. Villages bordering Nālandā were home to the great Arhats Śāriputra and Maudgalyāyana, who passed away in this region during the Buddha's lifetime. Stupas were erected in their honor and their relics enshrined within. When Aśoka visited Nālandā on his pilgrimage tour, he gave offerings and erected a shrine at the stupa of Śāriputra.

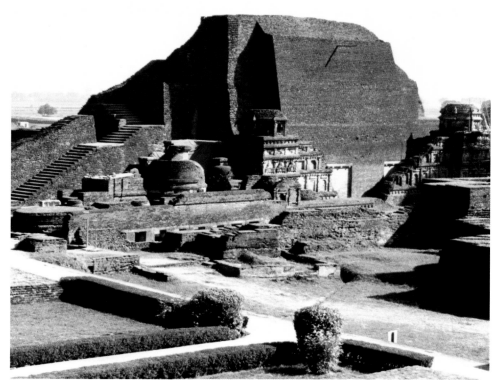

Temples stand at the four corners of the great stupa at Nālandā, positioned at the head of a row of monasteries on one side and temples and shrines on the other.

About four hundred years after the Buddha's parinirvāṇa, Nālandā was chosen to become the home for the study and practice of the Mahāyāna teachings. Five hundred Mahāyāna teachers came to Śāriputra's birthplace, from where it was prophesied that the Mahāyāna would become widely known. On the site where Aśoka had erected a shrine, eight temples were built for the five hundred teachers. Here the master Rāhulabhadra took in the youth Nāgārjuna, who penetrated the profound meanings of the Buddha's teachings of Prajñāpāramitā and became the foremost exponent of the Mahāyāna view and path. His work, continued by his disciple Āryadeva, became the foundation of the Madhyamaka school.

In the fourth century, Asaṅga, renowned as the transcriber of the treatises of Maitreya, lived at Nālandā for twelve years. After his death, his brother Vasubandhu, author of the Abhidharmakoṣa, became Nālandā's principal teacher. Among the many disciples attributed to him are the great logician Dignāga, the philosopher Sthiramati, the Vinaya master Guṇabhadra, and Vimuktasena, master of Prajñāpāramitā. By the early fifth century, Nālandā had become the major center for the lineages of Nāgārjuna and Asaṅga that gave rise to the two great Mahāyāna systems of philosophy and practice: Madhyamaka, developed by the followers of Nāgārjuna, and Yogācāra/Cittamatra, established by the followers of Asaṅga and Vasubandhu.

During the fifth century, the Gupta rulers, impressed by the accomplishments of Nālandā's masters, sponsored the building of monasteries with large lecture halls and supported Nālandā's transformation into a major educational center for all of India. Nālandā's fame was widespread; students came to Nālandā from all parts of the Buddhist world. Among them were Hsüan-tsang and I-tsing, who spent years at Nālandā and described the buildings, its teachers, and its programs in great detail. Hsüan-tsang noted stupas that held relics of the Buddha's hair and nails and marked where the Buddha had taught, as well as the great shrines where kings, ministers, and dignitaries from neighboring states gathered to make offerings on holy days. The most impressive monument was the stupa of Śāriputra, a great brick structure with temples built onto each of its corners, and surrounded by smaller stupas and shrines and masses of votive stupas.

Nālandā enjoyed royal patronage from King Harṣa, who ruled in the seventh century, and from all the kings of the Pāla dynasty who ruled eastern India after the fragmentation of Harṣa's empire. During the reign of the early Pāla kings, Śāntarakṣita, the great abbot of Nālandā, went to Tibet to transmit the Vinaya and śāstra lineages and establish the Tibetan Sangha, while hundreds of Tibetans came to Nālandā to prepare for the work of translation. The interaction of Tibetans with paṇḍitas from Nālandā and Kashmir ensured the successful transmission of the Dharma to Tibet.

Nālandā continued to flourish through the mid-twelfth century. But the Sena kings who succeeded the Pālas in 1144 neither supported nor protected Buddhism, and Nālandā fell prey to the Ghūrid Turks who invaded around 1297. Tāranātha records that the Turks took over Odantapurī and turned it into a fort. Encamped at Odantapurī, they raided Nālandā continuously for years, discouraging reoccupation.

Ravaged and abandoned, India's great Buddhist universities passed into history, their names forgotten in their own land but still venerated in Tibet. In the 1860s, Hsüan-tsang's journal led Cunningham to a group of high conical mounds which was soon identified as Nālandā. The first excavations unearthed the great stupa with its distinctive corner temples.. Further excavations brought to light the monasteries and assembly halls where for centuries the greatest intellects of India tirelessly sought to uncover the deeper meanings of the Buddhadharma.

Today, pilgrims and visitors can climb the stairs that lead to the top of the great stupa and view from this vantage point the extensive ruins of monasteries and shrines stretching over the huge compound. The remains of Nālandā extend far outside these massive walls; excavation continues, but many years may pass before all of Nālandā's monuments are uncovered.

Vikramaśīla and Somapurī

There is no eye-witness account of Vikramaśīla or Somapurī comparable to Hsüan-tsang's description of Nālandā. The best source available today is Tāranātha's *History*. Writing long after both monasteries had been destroyed and abandoned, Tāranātha relates the founding of the two monasteries, both sponsored by King Dharmapāla toward the end of the eighth century, but gives only fragmentary indications of their location and physical appearance.

The discovery and excavation of these monasteries earlier this century revealed an architectural style previously unknown in

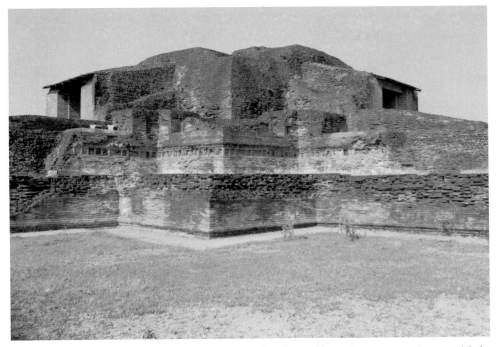

Staircases lead to entrances placed in the four directions on Vikramaśīla's central caitya.

India: outer walls containing living quarters for monks enclosing a large courtyard, in the center of which a lofty stupa rose with temples extending like arms out to the four directions.

While cruciform stupas were known from excavations in the northwest and Khotan, these were the first discovered in the Buddhist heartland of India, and the first Buddhist centers anywhere to integrate stupa, temple, and monastery into a mandalic structure. Their discovery verified a direct link with Samye, Tibet's first monastery, traditionally held to be modeled after Odantapurī.

Vikramaśīla Tāranātha records that Vikramaśīla was located in Magadha, at the top of a hill overlooking the Ganges. Its central monument is said to have been encircled by fifty-three smaller temples dedicated to the Guhya Tantra and fifty-four ordinary temples, forming a complex of 108 temples surrounded by a boundary wall.

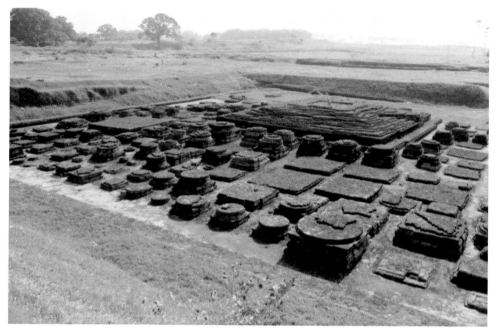

Plinths of votive stupas cluster around a raised shrine at Vikramaśīla; the whole area may have been enclosed at one time.

Upon its completion, King Dharmapāla provided for a staff of 108 paṇḍitas and six administrators. Each paṇḍita was responsible for teaching a special aspect of doctrine, and the head of the monastery was charged with watching over Nālandā as well.

After years of conjecture as to Vikramaśīla's location, excavations at the small village of Antichak, begun in 1960, have unearthed a monastery built around a central cruciform stupa similar to the descriptions of Odantapurī and the ruins of Somapurī. The multi-storied stupa complex is forty-eight feet in height and seventy-six feet wide, surrounded by two layers of circumambulation paths connected by stairs at the four directions. More recent excavations unearthed the monastic cells surrounding the central monument on four sides, revealing the full extent of the walled area as 1,083 feet on each side. This rim structure contained at least 208 cells with large round tower-like projections on the corners and smaller round and rectangular projections on the sides.

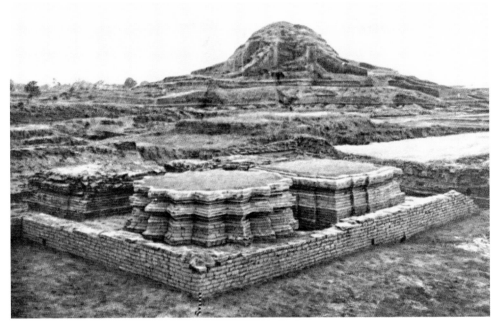

Plinths of smaller stupas stand in the courtyard of Somapurī. In the background is Somapurī's central monument, a stupa with temples.

Somapurī Somapurī, built in a remote region east of Vikramaśīla and distant from trade routes, was obviously intended to be a place of retreat. Its history is the most fragmentary of the four monastic centers that were the jewels of the Pāla dynasty. Abhayadatta, tenth-century chronicler of India's great siddhas, refers to a "great ocean of siddhas" who lived at Somapurī, among them the siddhas Kanhapa and Virūpa, who probably flourished in the eighth century. Here Kanhapa, a Mantrayāna scholar, was initiated into the practice of Hevajra, and the great siddha Virūpa was ordained and attained siddhi.

Somapurī's fortunes were closely linked to those of the Pāla kings, all of whom strongly supported Buddhism. During the reign of Mahīpāla (tenth century), Somapurī's temple was completely renovated and votive stupas built in its shrine to Tārā. In the eleventh century, local disruptions and external invasions weakened the Pāla rulers and possibly damaged Somapurī as well. When the Pālas

79

were supplanted by the Sena dynasty, Somapurī lost all vestiges of support and protection. Like Nālandā and Vikramaśīla, it lay in the path of Muslim armies under Muhammad Bhakhtyār Khaljī and was destroyed around 1304.

In the nineteenth century, a large mound was discovered near Pāhārpur about twenty-nine miles northwest of Mahāsthan, the ancient capital of Puṇḍravardhana, which is now part of Bangladesh. At the time of its discovery, the eighty-foot-high mound was covered with brush and crowned by a great spreading banyan tree. In 1923 excavation began to reveal a cruciform central structure surrounded by a thick wall measuring 919 x 922 feet: the largest single monastery ever built on Indian soil. Further excavation revealed a central structure having three raised terraces with a stupa on its top, elaborately decorated walls with carved brick cornices, and friezes made from terracotta plaques and carved stone reliefs. Temples project outward from this central structure in each of the four directions. The plaques ornamenting the temple walls may have inspired the Burmese style of decorating temples and stupas with scenes from the Buddha's lives carved onto square terracotta panels.

The archaeological report states that this kind of temple construction, using recessed corners and reintrant angles, had never before been seen in India, and notes its similarities to buildings in central Java and Burma. More recent excavations carried out in Bangladesh have brought a number of smaller but similar monasteries to light, bearing witness to the vigor and duration of Buddhism in eastern India.

BEYOND THE INDUS
TO SERINDIA

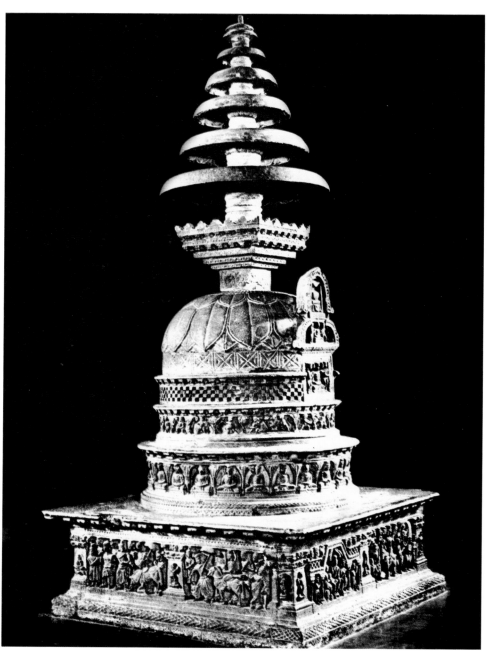

This model of a stupa from Gandhāra, preserved in the Indian Museum, Calcutta, is similar in style and proportion to remains of stupas found in the Indus Valley and lands to the north and west.

Beyond the Indus
to Serindia

The lands north and northwest of India were once home to thriving Buddhist centers that arose along the ancient trade route connecting India with Persia, Central Asia, and China. The Silk Road, the major route across the deserts of Central Asia, linked China to Persia, while another route stretched southeast, through the Khyber Pass, across the Punjab, and into central India. For much of its history, Afghanistan and Pakistan, as well as the ancient cities of Central Asia, were strongly influenced by Indian culture. Thus historians describing ancient times often refer to the region beyond the Indus as Greater India, and to Central Asia as Serindia.

According to the Buddhist traditions, the merchants Trapuṣa and Bhallika brought relics of the Buddha's hair and nails to their home in northeastern Afghanistan and erected two stupas at Balkh. During the reign of Aśoka, Buddhist Sanghas were active at Taxila, a cultural crossroads in northwestern Pakistan. Here Aśoka erected the Dharmarājika Stupa and extended his influence further west at least as far as Kandahār in eastern Afghanistan, where his rock inscriptions have been found.

In the second century B.C.E., with the weakening of Indian rule, Greeks who had settled in northern Afghanistan after the death of Alexander the Great moved south and east into the Punjab, where they came into contact with Buddhist teachings. The Milindapañha, a Buddhist text translated into English as *The Questions of King Milinda*, preserves an example of this meeting in the dialogue between the monk Nāgasena and the Greek king Menander. History records that Buddhism flourished in the lands ruled by the Greeks, whose kingdoms extended from Bactria in northern Afghanistan through Gandhāra, Uḍḍiyana, and Taxila in northern Pakistan and eventually to Sindh in western India.

By the opening of the first century B.C.E., Buddhist schools were well-established in the northwest: Mahāsāṁghika schools were flourishing in Kandahār, Balkh, and Bamiyan, and Sthavira and Sarvāstivādin schools had major centers in Kashmir and Gandhāra. These and more Buddhist traditions continued to flourish through the reigns of the Śaka, Parthian, and Kuṣāṇa kings who, in close succession, followed the Greeks into northwestern India, where they established kingdoms.

The best known of these foreign kings is Kaniṣka, who came to power in the first century C.E. and extended his influence through northern India east to Pāṭaliputra and south to the Narmadā River. To the north, his kingdom opened onto the Silk Road, providing easy access to Central Asia. As the Chinese pilgrims describe, Kaniṣka, who sponsored a great council of the Buddhist Sangha, built a great stupa near his capital. Kings who succeeded him followed his example. Kuṣāṇa rule opened the way for monks to carry the Dharma through Central Asia to China, and Buddhist centers and stupas began to arise in the oasis states along the Silk Road.

The Parthian rulers of the first century B.C.E. brought Greek artisans to Gandhāra, a kingdom in the lower Kābul Valley, along the Kābul River between the Kunar and Indus rivers. While the Indian artists of Mathurā supplied images of the Buddha to the Dharma centers of northern India, the Greek artisans began to apply their skills to carving statues of the Buddha for communities west of

the Indus. The Kuṣāṇa kings and the Buddhist Sanghas of the north-west relied heavily on the Gandhāran artists, whose influence can be seen in Buddhist art and architecture from the northern Punjab through Central Asia. The influence of the Gandhāran style lasted until the early fifth century, when Gandhāra fell to the Huns who destroyed Taxila and devastated the Indian northwest.

In the early centuries C.E., Buddhist centers were expanding rapidly. As Buddhist Sanghas flourished, large stupas were built to mark places where Śākyamuni and Buddhas before him performed acts of great compassion in previous lifetimes. These stupas, widely known throughout the ancient world, attracted pilgrims from distant lands. Fa-hsien, who arrived in the fifth century just before the Hun invasions, followed a trail defined by great stupas. In the seventh century, Hsüan-tsang turned west at the Indus before entering India to visit the places where in earlier lives the Buddha had demonstrated the perfections of virtue and generosity. The journals of these pilgrims contain wondrous accounts heard from local monastics as well as invaluable eye-witness reports of numerous stupas of the northwest.

In the nineteenth and twentieth centuries, these journals inspired European archaeologists to walk the ancient pilgrimage trails in search of the civilizations that once flourished beyond the Indus in Afghanistan and Central Asia. Their efforts were rewarded by the discovery of cave temples, some with libraries of Buddhist manuscripts and beautifully frescoed walls; the remains of ancient cities; and stupas that even in ruin evoked wonder and a sense of spiritual power.

The story of Buddhism in Afghanistan and Central Asia is still to be told. Much work lies ahead before linguists, archaeologists, Buddhist scholars, and art historians can clarify the history of this complex region. Time continues to erode Buddhism's physical remains, and it is likely that much of its history may never be found. Yet this quest is important. In this region, Buddhism was transmitted across the boundaries of a wide array of cultures, languages, and

races peacefully, without resort to force or colonization, and apparently without inviting opposition or persecution.

As Buddhism took hold in the cities circling the Tarim Basin, cultures prospered, languages developed ways of expressing subtle insights, artists created works of great spiritual beauty, and scholarship produced translations that disseminated the Buddhist teachings widely. While Afghanistan and Central Asia played important roles in the transmission of Buddhism to China, only a brief overview can be presented here. A fuller account of Afghanistan can be found in *Holy Places of the Buddha* (Dharma Publishing 1994) and specialized sources for Central Asia are noted in the bibliography.

Aśokan Stupas of the Northwest

Most of the Aśokan stupas in the northwest marked the sites of famous accounts of the Bodhisattva's boundless compassion and generosity. Four stupas in the northwest of modern Pakistan, all attributed to King Aśoka, were known as the Four Great Stupas. One was a stupa north of Taxila known as the Gift of the Head, where the Bodhisattva as King Candraprabha gave his head to a brahmin, and by this act gave the country its name (Taxila is equivalent to Takṣaśilā, cut-off head). An account of this event, given in Kṣemendra's Bodhisattvāvadāna-kalpalatā, relates that the king's last wish was that a stupa capable of liberating all beings would appear at this place.

Following Hsüan-tsang's detailed description, archaeologists have identified the Gift of the Head Stupa as the Bhallar Tope, located on an outcropping north of Taxila. Protected by its stone facing, the distinctive rounded body of the stupa consists of six or seven tiers and rises to an imposing height.

Two stupas located several days travel to the east marked where the Bodhisattva, as King Śībi, had seen and fed a starving tigress. The fifth-century pilgrim Fa-hsien wrote of the starving tigress stupas, "The kings, ministers, and people of the kingdoms

around vie with one another in making offerings to them. The lines of those who come to scatter flowers and light lamps at them never cease." The fourth of the Four Great Stupas, located near Puṣkāravatī, was built where the Bodhisattva, in one thousand past lives as king of this land, had given his eyes for the sake of another. Faced with carved wood and veined stone, this stupa was several hundred feet high.

Also in this region, a stupa marked where the Buddha had converted the demoness Harītī, who in grief for her lost child had been spreading pestilence over the countryside, resulting in the deaths of many children. Awakened to the consequences of her action, Harītī became the protectress of all children. Another stupa stood where the Bodhisattva Śyāma, wounded by a poisoned arrow, was healed by the strength of his faith and medications given by Śakra, lord of the gods. The site of the Harītī Stupa has been identified as Saramakh-ḍherī and the place of Śyāma's healing as Penano-ḍherī.

Three more famous stupas were built by Aśoka at Taxila, a place he once governed as regent. Two are associated with wondrous events: the Treasure of Maitreya Stupa, where Śākyamuni predicted that a treasure of gems would appear spontaneously upon the enlightenment of the future Buddha Maitreya, and the Kuṇāla Stupa, marking the place where Aśoka's son Kuṇāla was blinded at his stepmother's instigation. Foregoing retribution, he wandered for years as a musician, but regained his sight through an act of truth after returning to his father's capital at Pāṭaliputra. The Kuṇāla Stupa, associated with Kuṇāla's compassion and forbearance, gained a reputation for healing blindness and difficulties of sight. Both the Kuṇāla and Treasure of Maitreya stupas were active places of worship for hundreds of years. In recent times, the Kuṇāla Stupa has been located at Taxila on the northern side of Hathial Hill.

The largest stupa at Taxila today is the Dharmarājika. Named after the Dharmarāja (Dharma king) Aśoka, it rises from a plateau above the Tanranala River. The smaller stupas that surrounded the great stupa were damaged around 25 to 30 C.E. when an earthquake devastated Taxila. This disaster may have prompted the great

stupa's reconstruction, which was probably undertaken by King Kaniṣka in the first or second century C.E.

During renovation, the solid core of the original stupa became the hub of a wheel-shaped base with sixteen walls radiating out from the center. A third phase added flights of steps at the four cardinal directions, an unusual feature for the Taxila stupas, which had only one staircase or none at all. Only one other Taxila stupa, found at Bhamala, has four staircases.

The Dharmarājika Stupa was eventually provided with a durable stone facing, which ensured its survival to the present day. Its deep band of ornamental stonework is later in style and was probably added in the fourth or fifth centuries. This stupa, also known as Chir Tope, has had at least four phases of construction; its base is now 150 feet in diameter, and its present height is forty-five feet. Relics found here were given to Sri Lanka to be enshrined at the Temple of the Tooth Relic in Kandy.

Northwest and west of the Dharmarājika Stupa were two major monasteries: Mohra Moradu and Jaulian. Jaulian, which was probably established between the second and fifth centuries C.E., had two large stupas and numerous small ones; its main stupa was enshrined within the Jaulian Temple. Additional stupas have been discovered at major sites south of the Dharmarājika Stupa. Among these sites is Candraśīla, where the monastery and its stupas were built on terraces projecting from a hill.

Gandhāran Stupas

Kaniṣka's Stupa Fa-hsien's journal relates that when the Buddha was traveling in the region of Puruṣapura, modern Peshawar, he told Ānanda, his faithful attendant, that after his parinirvāṇa, a king named Kaniṣka would build a great stupa at this place. In time, as was predicted, Kaniṣka, king of the Kuṣaṇas, a tribe that had moved into this region from Central Asia, extended his reign over this region and much of northern India around the end of the first cen-

tury C.E. One day, as the king was riding on a tour of inspection, Śakra, king of the devas, took the form of a young boy. To inspire the king, he began building a small stupa directly in the king's path. When the king asked him what he was making, he replied, "I am making a stupa for Buddha." Over the boy's stupa, the king erected another, which was more than four hundred chang high (variously calculated as being four hundred or six hundred feet) and adorned with layers of precious substances. When the king's stupa was completed, the little stupa made by the boy was seen projecting out from its southern side to a height of about three feet. Of all the stupas and temples Fa-hsien saw in his journey, there was not one comparable to this in solemn beauty and majestic grandeur. (FH 34)

The pilgrim Sung-yun, who passed through this region a few years later, describes this stupa as made from carved wood, with stairs leading to the top, and covered by a roof carved from many different varieties of wood. Thirteen stories tall, the stupa was capped by a gilded iron pillar thirty feet high, encircled by thirteen copper discs. He writes of the stupa, "At sunrise the gilded discs of the vane are lit up with dazzling glory, whilst the gentle breeze of morning causes the precious bells to tinkle with a pleasing sound. Of all the pagodas of the western world, this one is by far the first (in size and importance)." (HT:cv) Sung-yun measures the foundation as three hundred paces in circumference (nine hundred feet), and the height of the stupa as seven hundred feet. He mentions that this stupa had been three times destroyed by fire and each time rebuilt. Another pilgrim, Tao-yung, states that the iron pillar was eighty-eight feet high with fifteen discs, and that the stupa was 360 paces in circumference and a total of 743 feet high. (HT:civ)

Hsüan-tsang, in the seventh century, cites a tradition that the Buddha predicted that when this stupa had been destroyed seven times by fire, his Dharma would disappear. He too was informed that the stupa had been destroyed three times; at the time of his visit, steps were being taken for its reconstruction, so he was not able to describe it. (HT I:103) He cites a tradition that Kaniṣka had originally erected a five-story stupa 750 feet high, but then, disturbed by a por-

tent that his action was prideful, reduced its size. (The final size of the original stupa is not clear from the translation of his account.)

In modern times archaeologists have located the site of this stupa at Shāh-ji-ki-ḍherī and excavated its base, revealing a cruciform structure with projections fifty feet long reaching out in the four directions. The foundation measured 286 feet in diameter, making it easily the largest stupa of its kind. (HCIP 3:492) A reliquary with a seated statue of the Buddha on its top was found in the stupa's relic chamber. On it was found the name Kani, used in another inscription for King Kaniṣka. This casket is now housed in the Peshāwar Museum.

The Kaniṣka Stupa, which surely impressed others as it did the Chinese travelers, became the model for the cruciform-shaped Rawak Stupa of Khotan. The square multi-staged Gandhāran style with its high cylindrical drum, seen in stupas from Mohenjo Daro on the lower Indus through Central Asia, passed into China, where it underwent transformation into styles uniquely Chinese.

Afghanistan

The Chinese pilgrims describe numerous Aśokan stupas in eastern Afghanistan. In Balkh, Hsüan-tsang noted an Aśokan stupa two hundred feet high, covered with a plaster hard as diamond and ornamented with precious substances. A relic stupa, it at times reflected a divine splendor. Archaeologists have confirmed that a durable stucco or plaster coating was characteristic of numerous stupas built in this region.

Hsüan-tsang reported the local practice of building stupas on the places where Arhats of that region had entered nirvana. More than a hundred stupas stood near a monastery here, their foundations closely touching. To the west was a stupa said to have been built at the time of Kāśyapa Buddha. To the northwest were stupas erected by Trapuṣa and Bhallika, the merchants who offered honey and cakes to the Buddha after his enlightenment and received from him clippings of hair and nails.

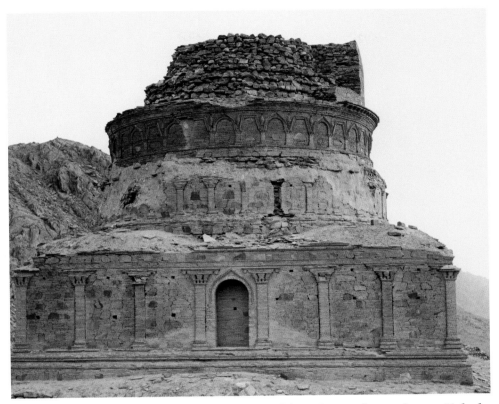

A high rounded dome once topped the Guldara Stupa, located near Kabul.

Balkh and its major monastery, the Navasaṁgārāma, were destroyed by Muslim Turks around 700 C.E. At this site today a monument known locally as the Tapa-i-Rustam (Tower of Rustam) still rises sixty feet above the ruins of a large monastery.

Near Charikar, in the ancient kingdom of Kapiśa, the remains of Tope Darrah tower more than sixty feet above the level of the valley, where ruins of many monasteries have been found. In this region, Hsüan-tsang noted, "The stupas and saṅghārāmas [monasteries] are of an imposing height, and are built on high level spots, from which they may be seen on every side, shining in their purity." (HT I:55)

To the east of Kapiśa was the capital of Nagarahāra, famed as the place where in a previous life as the young ascetic Sumati,

91

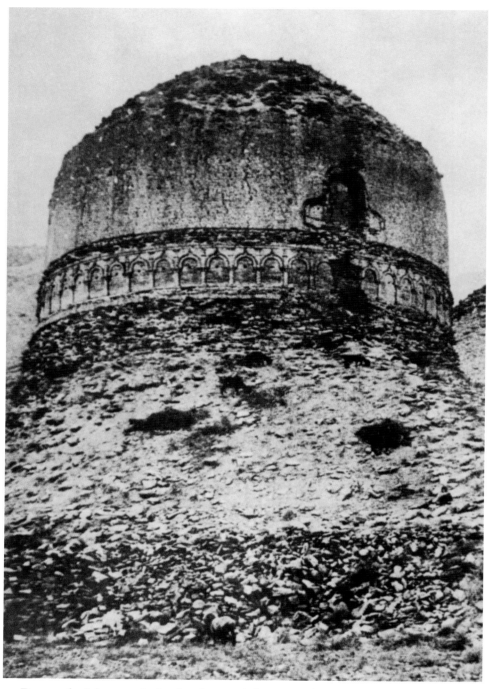

Rows of niches encircle the dome of the Darrah Stupa in Afghanistan.

Śākyamuni had offered flowers to the Buddha Dīpamkara and received his prediction of enlightenment. Here Hsüan-tsang described an Aśokan stupa three hundred feet high, "wonderfully constructed of stone beautifully adorned and carved." Nearby stood another stupa that commemorated buying the flower offerings. Flowers still rained from the sky on holy days in commemoration of this auspicious event, and people responded by making offerings at the stupa. Locating this stupa among the extensive remains of cities, stupas, and monasteries in this region has proven difficult. Some of the ruins around modern Jalalakot, Nagarahāra's most likely location, are very large: A stupa about eighteen hundred feet in circumference has been found at Khwaja Lahoree, and a stupa at Chahar Bāgh measures three hundred feet around.

A great stupa at Mangala, in this same region, stood where the Bodhisattva, as the sage Kṣānti, allowed himself to be dismembered by King Kāli. Outside the city was the Rohitaka (Red) Stupa constructed by Aśoka. More than a hundred feet high, it commemorated the generosity of King Maitrībala, who drew blood from his body to feed five yakṣas. To the northeast was the Abhuta, the Wondrous Stupa made of stone, said to have appeared spontaneously after the Buddha taught the Dharma on this spot.

The locations and names of these stupas invite comparison with the Surkh (Red) Stupa and the Nandara Stupa, also known as Khasta (Wonderful), located in modern times on the plain of Dauranta north of Kābul. Remains of at least eighteen stupas have been identified on the Dauranta plain, including the Guldara Stupa and six more at Chahar Bāgh.

The stupas of Dauranta appear to have been built in the second century C.E. In Hsüan-tsang's time a monastery here had a famous tooth relic that was honored by regular convocations of pilgrims. If the name Dauranta is indeed derived from danta, meaning tooth, it may reflect the region's association with the renowned relic.

At Haḍḍa, about five miles south of Jalalakot, formerly the boundary of the kingdom of Nagarahāra, was the mountain where

The remains of a stupa at Lou-lan, probably built in the third century C.E., rises fifty-one feet above the desert floor. Its cylindrical drum sits on a three-storied square base measuring fifty-one feet on a side.

the Buddha in a previous life jumped off a precipice, giving up his body to repay the kindness of a yakṣa. A monastery here was known to house important relics of the Buddha, including a parietal bone twelve inches in circumference. Hsüan-tsang relates that this bone was stored in a small reliquary stupa made of the seven precious substances. Another stupa contained a piece of a skull bone in the shape of a lotus leaf. There are ruins here of a great stupa known as Tapa Shutur, which appears to have been the main monument of Haḍḍa. It is possible that this was the skull-relic stupa described by the Chinese travelers.

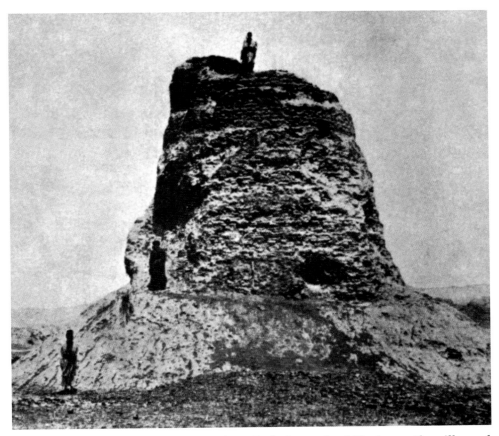

Near this ruined stupa at Khānning-Shahri, north of Kashgar, the silk road walked by merchants and monks divides to circle the Tarim Basin. Like many abandoned stupas, this stupa has been opened by treasure-seekers.

Central Asia

Central Asia is a vast expanse of land surrounded by a great ring of mountains open to the east, where the Gobi desert gives way to the ancient borders of China, marked by the Great Wall. At its center lies the Tarim Basin, watered in ancient times by rivers linked to irrigation systems decayed or destroyed centuries ago. Along these rivers arose the oasis cities populated by people of various races and cultures.

Bordered by China on the east, Tibet and Kashmir on the south, and the Iranian empires on the southwest, Central Asia became a major crossroads for the great civilizations of ancient times. Caravans of merchants traveled the fabled Silk Road, which began in Chang-an, capital of Han dynasty China, and crossed the desert to Tun-huang, where it divided to circle the Tarim Basin. The northern route passed through the cities of Turfan and Kuchā, then west to Kashgar and on to Samarkhand, gateway to Antioch and Tyre. The southern branch skirted the mountains above Tibet, passing through Niya, Khotan, and Yarkhand before turning south to Kābul.

By the second century B.C.E., monasteries were appearing along the Kābul River as far north as Balkh and Bamiyan. With the opening of the Silk Road in 112 B.C.E, monks joined the caravans traveling north and east to the cities of Central Asia. During the reign of King Kaniṣka, whose kingdom extended north into Central Asia, signs of the Dharma began to appear in Kashgar, Kuchā, and Turfan, and in the west throughout Sogdia to the eastern borderlands of Iran. The southern arm of the Silk Road followed the Kunlun mountains east through Kashgar, Khotan, and Mirān. Hsüan-tsang cites traditions that the soaring peaks of these mountains were selected by Arhats as sites for entering nirvana, or as places where they could remain undisturbed in meditation awaiting a future Buddha.

Where the trade routes passed close to the mountains, temple complexes were carved out of the steep cliffs. Massive monastic complexes were erected in more level regions. At Qizil, near Kuchā, more than three hundred temples were established; other temples were built at Sorcuq near Karashar to the east, and at Bezaklin and Qocho near Turfan. In style and beauty, these temples rivaled the famous cave temples of Ajaṇṭā, Ellora, and Kārli.

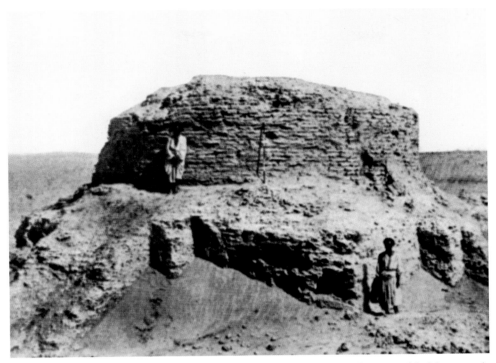

The great stupa of Khotan's Rawak monastery, partially engulfed by sand, still has remnants of staircases projecting outward in the four directions.

Khotan

While Buddhism in most Central Asian cities is known mainly through pilgrims' journals and archaeological reports, Khotan, known as Li-yul in Tibet, has traditional accounts that trace to the time of the Buddha. The Li-yul Lung-bstan-pa, or Prophecy of the Country of Li, relates that shortly before the Buddha entered parinirvāṇa, he predicted the manner in which the Dharma would come to Khotan and named the Bodhisattvas, yakṣas, humans, and nāgas who would protect this land. Here, after his passing away, a great city with five towers would be built. This city would be named U-then (Kusthāna). (R 232–33) In this land kings and donors would build 363 vihāras where monks and nuns would practice the Mahāyāna. Five hundred Bodhisattvas—half of them monks and

97

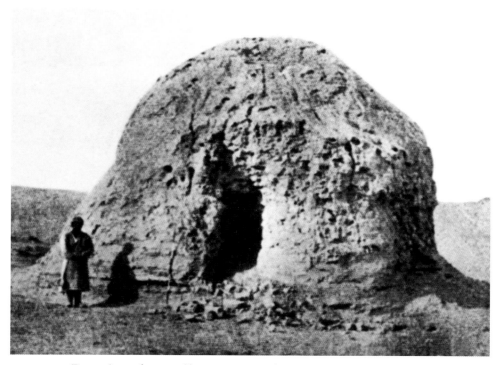

Remains of a small stupa near the ancient site of Mirān.

nuns and the other half laymen—would honor the relics continuously. (TTK 13)

Hsüan-tsang traces the founding of Khotan to Kuṇāla, son of Aśoka, who is said to have gone into exile in this Central Asian kingdom after being blinded in Taxila. Another account, related in the Prophecy of the Country of Li, ascribes the founding of Khotan to Kusthāna, another son of Aśoka, who, abandoned as a child, was raised by the Chinese emperor and came to Khotan at the age of nineteen. This account states that the Dharma was introduced 163 years later, when Vijayasambhava, an incarnation of Maitreya, had been king for five years. At that time the king built the Tsar-ma, Khotan's first monastery, for the great Bodhisattva Mañjuśrī, who had taken birth as the monk Vairocana for the sake of transmitting the Dharma. After the great vihāra was built, the king's ministers and subjects erected smaller vihāras and stupas and enshrined relics

98

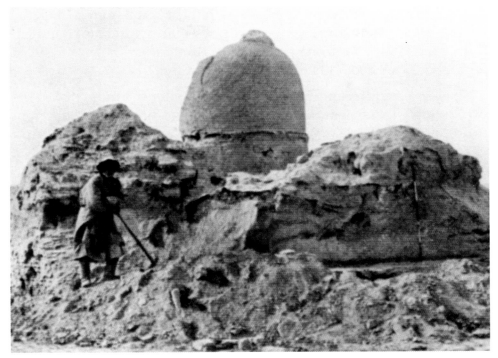

This shrine once completely enclosed this well-preserved stupa at Mirān.

inside them. When this was done, Vairocana asked a nāga king to bring him a stupa containing relics of Śākyamuni and the six Buddhas, which he placed in the Buddha Hall. Both the Prophecy and the account of Hsüan-tsang describe this stupa as emanating a wondrous light. (R 238)

Both versions of Khotan's founding point to an ancient connection between India and Khotan, which merged the customs of China and Central Asia with religious and linguistic influences from India. Fa-hsien, writing in the fifth century, describes Khotan as a prosperous kingdom where each family had a small stupa at least twenty feet high in front of its door. The Gomati Monastery, one of Khotan's four large monasteries, housed three thousand Mahāyāna monks. To the west was the king's new monastery ornamented with carvings and inlay, with a great stupa and a large Buddha-hall. This complex had taken three kings eighty years to complete. Hsüan-

tsang also noted this center, which he refers to as Samajñā, and the hundred-foot-high stupa "which exhibits many miraculous indications." (HT II:316) An unnamed king of Khotan had built this stupa for an Arhat whose body emitted a radiant light.

In the seventh century, Khotan came under the influence of the expanding Tibetan empire, but between the ninth and tenth centuries, Muslim Turks took over Khotan and brought to an abrupt end a Buddhist culture nearly a thousand years old.

Rawak Stupa Northeast of the ruins of Khotan lies the great stupa of the Rawak Monastery. Cruciform in shape, the stupa has a square base with four large projecting staircases in the four directions. Its ground plan is similar to the Kaniṣka Stupa and the Tapa-i-Rustam at Balkh. The stupa is surrounded by a wall 164 x 143 feet. The wall's inner and outer faces are richly decorated with ninety-one colossal stucco images of Buddhas and Bodhisattvas. These sculptures, damaged by erosion and sandstorms, may once have been protected by a wooden roof. Within seven miles of Rawak is Dandan Ullik, a major Mahāyāna Buddhist center, where nineteenth-century archaeologists recovered Prajñāpāramitā Sūtras and other Mahāyāna texts.

Mirān Stupa One of several stupas discovered at Mirān, an ancient city near Lop Nor on the eastern side of Central Asia, this monument strongly reflects the influence of Gandhāran art. It is a tall structure enclosed in a round conical building which served as a protected circumambulation path. The interior walls of the outer building were covered with graceful murals painted in the Gandhāran style. Scholars estimate that the Brahmī script found on the walls dates to the third century C.E.

Fa-hsien wrote of this region that despite its proximity to China, both monastics and laypeople practiced only the religion of India, and all the monks used the Indian books and the Indian language. Fa-hsien was the last pilgrim to write about Mirān and Lou-lan (Shan-shan), its neighbor to the east, which Hsüan-tsang dismisses as "long deserted and wild."

NEPAL

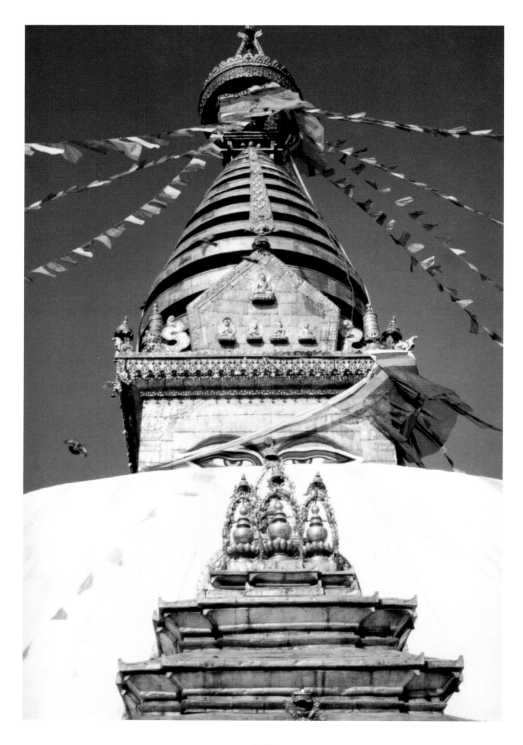

Nepal

Throughout the numerous aeons of this Bhadrakalpa, the Golden Age of One Thousand Buddhas, the Buddha Śākyamuni, in his previous lives as a Bodhisattva, observed the spiritual development of the region now known as Nepal. After Śākyamuni had himself become a fully enlightened Buddha, he visited the mountain range that defined the Kathmandu Valley, and here, on the western face of the mountain, in the area known as the Elephant's Tail, taught a gathering of five hundred monks together with many gods, including Brahmā, Viṣṇu, and Śiva. In response to a series of questions set forth by the future Buddha Maitreya, Śākyamuni Buddha gave the full account of this land and of the Stupa of the Dharmadhātu. This teaching is recorded in the History of the Svayambhū Stupa of Nepal, the Bal-yul-rang-byung-mchod-rten-po-lo-rgyus. The following account of the Svayambhū Stupa is excerpted from this text.

"Many aeons past, during the Kṛitayuga, or Age of Perfection, the mountain range surrounding the Kathmandu Valley was called

Left: Svayambhū, the sacred Stupa of the Dharmadhātu in Kathmandu.

103

the Lotus Range. In the Dvāyayuga, or Second Age, it was called Gośṛṅga (Glang-ru), and in the Tretāyuga, the Third Age, it was called Vajrakūṭāgara (rDo-rje-brtsegs, Vajra Range). In the Kaliyuga, the Buddha relates, it will be called the Glang-mjug, or Elephant's Tail. During the present time it is known by the same name as it bore in the Age of Perfection: the Padma'i-ri, or Lotus Mountains.

"The region itself teems with life, much like a rain forest, with flowering trees, vines, and wild flowers in profusion. The sounds of exotic birds, wild animals, insects, and waterfalls fill the air, indicating the many forms of life in this valley, where hosts of gods, nāgas, yakṣas, gandharvas, asuras, garuḍas, kinnaras, and mahoragas also make their home.

"Here in ages past, enlightenment became manifest as Dharmadhātu—a symbol of enlightenment's pervasive nature—in the form of a stupa known as Rang-byung-mchod-rten, the Uncreated First-Born Stupa, or Svayambhū, the Self-Arisen. Each of the previous Buddhas of the Bhadrakalpa contributed to the cosmic design and mission of this Stupa of the Dharmadhātu.

"The first Buddha of the Bhadrakalpa, Vipaśyin (rNam-gzigs), was instrumental in its genesis. During the lifespan of the Tathāgata Śikhin (gTsug-tor-can), the Stupa of the Dharmadhātu arose in the center of a lotus in the vast lake that then filled the Kathmandu Valley. The next Tathāgata, Viśvabhū (Thams-cad-skyobs), made the stupa accessible to worshippers so that all could become free from defilement and sin. The following Tathāgata influenced the stupa's appearance as the Dharmadhātu-vāgīśvara, the Power of Mañjuśrī's Speech Made Manifest, and the holy places surrounding the stupa came into being. The Tathāgata Kāśyapa ('Od-srungs) was later instrumental in concealing and protecting the stupa in its present form over the ensuing ages. Each Buddha thus manifested knowledge and power, and disseminated innumerable blessings throughout the region.

Right: The Svayambhū's gilt copper harmikā and spire support hundreds of mantra-imprinted prayer flags.

Nepal

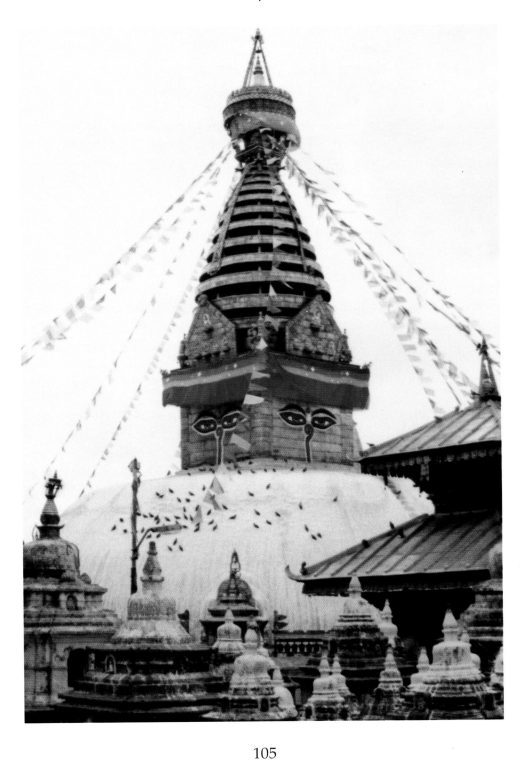

Manifesting the Svayambhū Stupa

"The seed of the Stupa of the Dharmadhātu appeared during the era of the Tathāgata Vipaśyin, when the lifespan was eighty thousand years. This seed appeared in the center of a lake that filled the Kathmandu Valley to a distance of seven miles across and was bounded on all sides by a mountain range. During this era, the present Buddha, Śākyamuni, was a Bodhisattva named Dharmasatya (bDen-pa'i-chos), who served the Tathāgata in the city of Bandhumat (gNyen-ldan).

"In the second period of the Stupa of the Dharmadhātu, during the era of the Tathāgata Śikhin, when the lifespan was seventy thousand years, a lotus appeared in the center of the lake. Blooming, the lotus, the size of a chariot wheel, unfolded a thousand petals to reveal a stem made of precious gems and a calyx formed of a myriad sparkling diamonds, in which ruby filaments surrounded a central crystal about three feet in height, which radiated the pristine quality of enlightenment. This crystal was a manifestation of the Dharmakāya as Dharmadhātu, which by its nature purifies all sin.

"During the Kṛitayuga, when the lifespan was sixty thousand years, the Buddha Viśvabhū appeared. At that time, the Stupa of the Dharmadhātu, being in the center of the lake Place of the Nāgas, was inaccessible. Perceiving this, the Bodhisattva Mañjuśrī manifested in one of his forms and drained the lake so that all beings would have access to the stupa's enlightened wisdom-nature. The waters that remained in the valley formed the lake called Ādhāra (Kun-'dzin), which is now known as Dhanādaha, home of the nāga king Karkota. This lake came up to the base of the Stupa of the Dharmadhātu, and the land surrounding the stupa became known as the Upacchandoha. During this era, the present Buddha, Śākyamuni, was a Bodhisattva named Kūṭakīrtirāja (Ri-bo-grags-pa'i-rgyal-po), who served the Tathāgata Viśvabhū in the city of Anupama (dPe-med).

"The Tathāgata Krakucchanda ('Khor-ba-'jig) appeared when the lifespan was forty thousand years. Through Krakucchanda's influence, villages and cities arose in this land, which developed

Mandalic arrays of the Five Dhyāni Buddhas mounted on the base of the Svayambhū stupa's rings face the four directions.

into a kingdom ruled by the Dharma king Dharmākara (Chos-kyi-'byung-gnas). On Conch Mountain (gDung-gi-ri, Śaṅkhaparvata), the Tathāgata Krakucchanda gave teachings to five hundred of the nobility and five hundred brahmins, and all the princes and brahmins became ordained. From the special teachings of this Tathāgata arose a stream of merit known as the Bhāgamatī (sKra-can-ma, modern Bhāgmatī) River. The Bhāgamatī then divided to create a second river, named Keśapatī (sKra-can-ma) after the shorn hair of the newly ordained princes and brahmins. From the strength of the

merit accumulated by those ordained here, many stupas appeared in the eight areas of the Upacchandoha:

1. Maṇikūṭa (Nor-bu-brtsegs, Jewel-Topknot), a peak named after the prince whose topknot produced jewels. The river that flows down from this mountain is called the Maṇilokinī (Nor-bu-dmar-ldan), because its red color recalls the blood that flowed from the severed topknot.
2. Gokarṇa (Ba-lang-rna, Elephant's Ear)
3. Caru Mountain (mDzes-pa'i-ri)
4. Kumbatīrthala (Bum-pa'i-gnas, Place of the Sacred Vessel)
5. Phaṇiparvata (gDengs-ka'i-ri, Hood of the Cobra Mountain)
6. the forested area called Garttaka (Dong)
7. Gandhāpatī (Dri-ldan-ri, Aromatic Mountain)
8. Vikrama Plain, where the monks were ordained

"The Bhāgamatī, the stream of merit, had divided in two to create the Keśapatī. On these two rivers and their tributaries appeared twelve power places, each with special powers and the home of a particular nāga. Praying and performing special ceremonies in these places still brings many blessings. Four of the places are on the Bhāgamatī itself, four on the Keśapatī, and four more on streams connected to the Bhāgamatī. Bathing and praying at these twelve places brings inconceivable merit because of the great power of their connection with the Stupa of the Dharmadhātu and its vicinity. During this era, the present Buddha, Śākyamuni, was a Bodhisattva named Prabhapāla ('Od-skyong), who served the Tathāgata Krakucchanda in the city of Kṣantivatī (bZod-ldan).

"Next appeared the Tathāgata Kanakamuni (gSer-thub), when the lifespan was thirty thousand years. During this period the area became known as Dharmadhātu-vāgīśvara (Chos-dbyings-gsung-gi-dbang-phyug), the Powerful Communication of the Dharma-dhātu. Again, Mañjudeva, incarnation of Mañjuśrī, appeared to teach the essential meaning of the twelve vowels, the symbolic and secret essence of the Mañjuśrīnāmasaṁgīti, to a monk from Vimala. These twelve vowels contain the speech and wisdom of the

Buddha's teachings: Within the twelve sounds are all the knowledge of the esoteric teachings.

"Sound, carrying the meaning, allowed all to manifest and enter into enlightened knowledge. Mañjuśrī himself appeared as the lotus of the Dharmadhātu to manifest enlightenment in form. During this era, the present Buddha, Śākyamuni, was a Bodhisattva named Sudharmarāja (Chos-legs-rgyal-po), who served the Tathāgata Kanakamuni in the city called Śohā (mDzes-ldan).

"The next Tathāgata, Kāśyapa ('Od-srungs), appeared when the lifespan was twenty thousand years. During this time, the Stupa of the Dharmadhātu was hidden by a holy monk named Śāntaśrī (Zhi-ba'i-dpal). In order to protect it, he covered it over with stone. When a drought afflicted the land, this monk guided Guṇakarma (Yon-tan-'dod-pa'i-lha) in coercing the nāga king Karkoṭa to cause the rain to fall always in a timely manner. Thus the land of Nepal became not only a place of great power, but also one that is pleasant and ruled according to the Dharma. During this era, the present Buddha, Śākyamuni, was the Bodhisattva Prabhārāja ('Od-kyi-rgyal-po), who served the Tathāgata Kāśyapa in the city of Vārāṇasī.

"Thus has the Svayambhū Stupa endured through the aeons as a symbol of enlightenment and become the very heart of Nepal."

The Kathmandu Valley

Geologists agree that the valley of Kathmandu, stretching along the Bhāgmatī River in a flat oval twenty miles long and fifteen miles wide, was once a lake. High terraced mountains rise on each side like a staircase to the heavens; beyond are the high Himalayas, perpetually covered with snow. The folds of mountains shielding valley and river, born from an ancient union of continents, form a unique land configuration that people from ancient times have regarded as places of great natural power. The earthquakes common in the valley heighten awareness of the forces of nature.

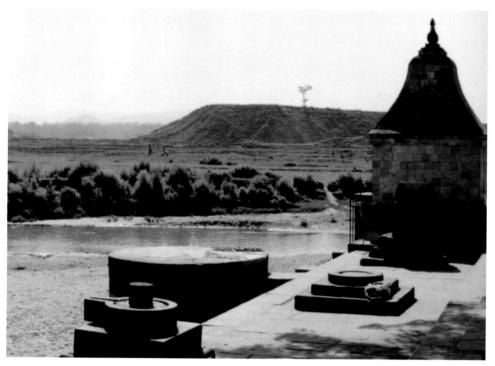

A bell-shaped stupa marks a place of power at Guhesvarā, the root of the Svayambhū lotus.

The place where Mañjuśrī opened the mountain range with his sword is known today as Kotvar or Chobar. Above it, the modern Bhāgmatī River flows past Guheśvarā, the place where the ancient lotus took root in the great lake, today the site of the temple dedicated to Phagmo Nalchu. At this place the sacred waters of the Bhāgmatī purify all kleśas and karmic obscurations.

Nearby, on the highest point of the twin-peaked hill rising at the center of the Kathmandu Valley, stands the Svayambhū Stupa. Pilgrims intent upon merit climb the long row of steps on the hill's eastern side, which begins gently but increases sharply in height as one nears the top.

Mounting the last section of stairs, the pilgrim faces the great stupa at a dramatic angle that conveys a palpable sense of sacred

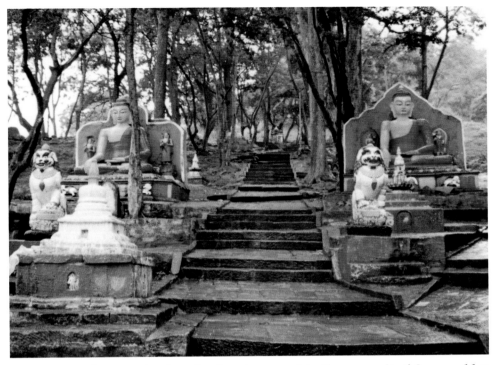

Buddhas and stupas invite pilgrims to ascend to the summit of Svayambhū Hill, one of Kathmandu's most sacred sites.

presence. Near this stupa, on a lower rise of the hill, a shrine has been erected where Mañjuśrī stood to empty the lake and left his footprints on sacred ground. These monuments mark the birthplace of the Kathmandu Valley that developed into the land of Nepal.

Numerous places in the Kathmandu Valley are revered by Hindus and Buddhists alike for their associations with the enlightened actions of the Buddhas of past times and the long lineage of great masters, siddhas, and scholars who maintained the Dharma of the Buddha Śākyamuni. For centuries, pilgrims and travelers have come to the Kathmandu Valley to pray at the great stupas of Svayambhū and Boudha, where the energies of earth and sky lend themselves naturally to realization. The Dharma King Aśoka is said to have visited the Kathmandu Valley in the third century B.C.E. and built stupas to mark the center and directional boundaries of the

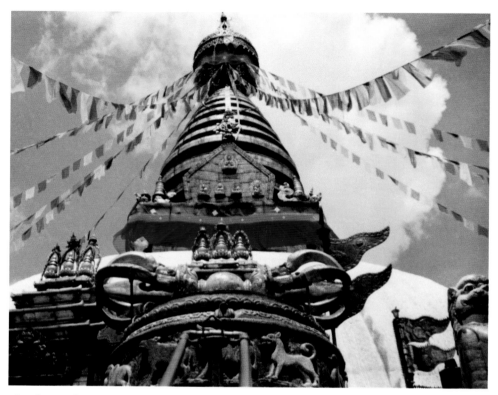

An imposing view of the bronze-topped Svayambhū Stupa rises before pilgrims ascending the eastern walkway. Right, votive stupas of Svayambhū.

future city of Pātān, Kathmandu's earliest center of culture. His daughter Cārumatī is said to have married a local prince and settled here. The Cārumatī Vihāra at Chābāhil still bears her name.

The Buddha was born in Lumbinī, on the terai, a tropical strip of the Ganges plain that lies within the borders of modern Nepal. Since Lumbinī was then part of the Śākya kingdom (and later, part of Kosala, modern Uttar Pradesh), the Buddha's birthplace is historically associated with India. Although Lumbinī was a central place of pilgrimage, travel to this sacred site declined between the fifth and seventh centuries. When the Malla kings annexed the Terai in the thirteenth century, Kathmandu was already established as Nepal's religious and cultural center. Remembered only by name, the Buddha's birthplace lay deserted until modern times.

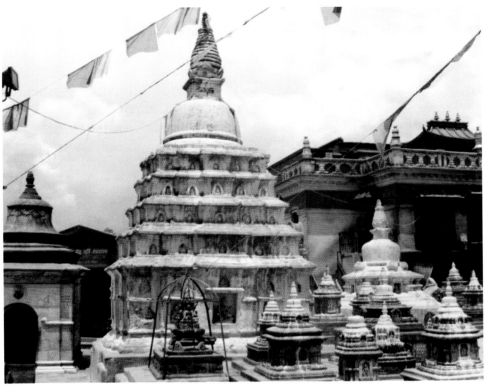

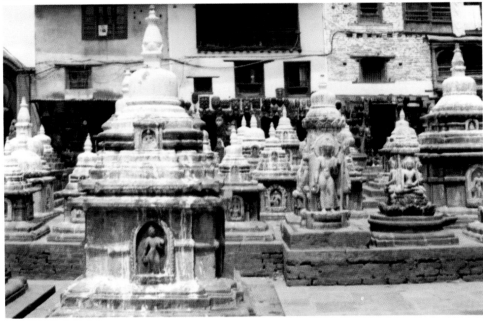

Historical Background

The history of Nepal is largely derived from Buddhist and Hindu accounts that have multidimensional significance. Against this backdrop, dynastic records trace the kings of the Kathmandu Valley to the Kiratis, who emigrated from the eastern part of Nepal around the time of the Buddha. The original inhabitants of the valley were the Newars, thought to derive from the Mongoloid tribes of the north and the Aryans from the south and west.

While Buddhism may have been practiced here since the time of Aśoka and his daughter, Buddhists arriving from India in the third to fourth centuries C.E. established Nepal as a land of the Dharma. Hindu kings came to power around 400 C.E., when the Kirati kings were displaced by the Licchavis of northeastern India, the same tribe described in the Sūtras as residing in Vaiśālī. In 602 C.E. Aṁśuvarman (r. 576–615) inherited the throne from his father-in-law and founded the Thakuri dynasty. Aṁśuvarman, a contemporary of King Harṣavardhana of India, is well-known in Tibet as the father of Bṛikuṭī, who married the Tibetan king Srongsen Gampo and was instrumental in bringing the Dharma to Tibet.

Associated with a long line of Buddhist masters and siddhas, the Kathmandu Valley figures prominently in the transmission of Buddhism to Tibet. Among the masters who lived here are the Oḍḍiyana Guru Padmasambhava, revered in the Nyingma tradition as a second Buddha; the great teachers and siddhas Nāgārjuna, Tilopa, Nāropa, Vāgīśvarakīrti, Śāvari, and Jālandhari-pa. It was here that Vasubandhu, brother of Asaṅga and master of Vijñāna-vāda philosophy, spent his last years. A beautiful white stupa located between the Svayambhū Stupa and the Mañjughoṣa shrine marks the place of his passing from life.

When the Muslims invaded northern India in the late twelfth and early thirteenth centuries, Indian princes sought refuge in Nepal. Their descendants founded the Malla dynasty that ruled until the eighteenth century. Although these kings were staunch Hindus who considered themselves incarnations of Viṣṇu, most of

A stupa dedicated to the great Tibetan scholar and terton Jigme Lingpa (1729–98), located at Pharping.

them were tolerant of Buddhism, which continued to flourish in Nepal as it declined in India. During the time of the Malla kings, numerous Buddhist Sanskrit manuscripts were hand-copied and preserved in the royal archives as well as in monastic libraries.

The artisans of Kathmandu, especially renowned for their metal-working skills, became famous in Buddhist lands to the north and stimulated the artistic traditions of Tibet and China. The Newari artist Aniko erected a golden stupa in Tibet in the thirteenth century and in 1246 was summoned to work in China by Kublai Khan. There he established metal, clay, and architectural traditions that endured for centuries after his death.

In the eighteenth century, the Gurkhas, descended from the Rajput princes of western India, unified the Kathmandu Valley and extended the territory of Nepal, ending generations of rivalries and political fragmentation. Numerous Buddhist manuscripts were destroyed in the late nineteenth century and the Dharma traditions weakened. But in this century, Nepal has opened its doors to the Buddhist traditions of Tibet as well as to the nations of the West. Since 1959, Tibetans have settled in Kathmandu in increasing numbers, and all schools of Tibetan Buddhism are now represented, especially in Boudha, site of the great Boudhnāth Stupa. As in ancient times, pilgrims from Tibet, now joined by Western students as well as streams of tourists, come to the ancient shrines to retrace inwardly as well as physically the timeless path to enlightenment.

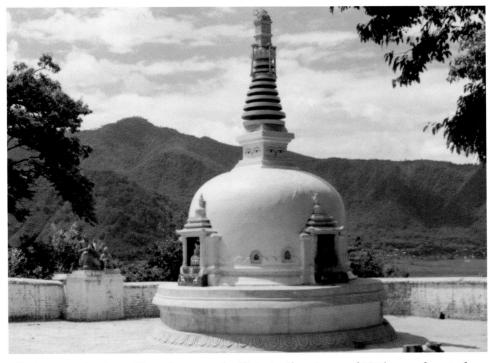

Shrines at the four directions are built into the stupa of Kāśyapa, located on Mañjuśrī Hill, Kathmandu.

or as Jana Bahā Deva, considered by some accounts to be the fourth brother. Folk tradition holds that the image was stolen in times past; discovered in a well in Jamal in the mid-fifteenth century, it was enshrined at Jana Bāhāl, its present location. The temple, two stories in height, is one of Nepal's most elaborate shrines, sacred to Hindus and Buddhists alike. Above its doors, mounted in long wooden frames, are glass-covered paintings about twelve inches high of 108 forms of Avalokiteśvara. This rare iconographical collection forms an artistic border around three sides of the temple.

Stupa at Itum Bāhāl Itum Bāhāl, located in Kathmandu north of the old palace, is one of the oldest vihāras in Kathmandu. Enshrined here is an image of White Tārā (Sitatārā). Known as the Talking Tārā, this statue is said to have flown here from Tibet and to actually speak to the devout pilgrim. The courtyard of the vihāra has a stone

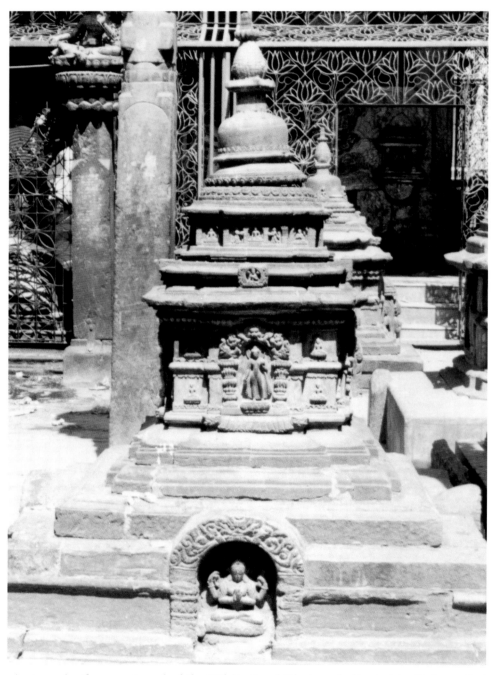

A stupa in the courtyard of the White Lord Shrine, dedicated to Padmapāṇi Lokeśvara, emanation of compassion.

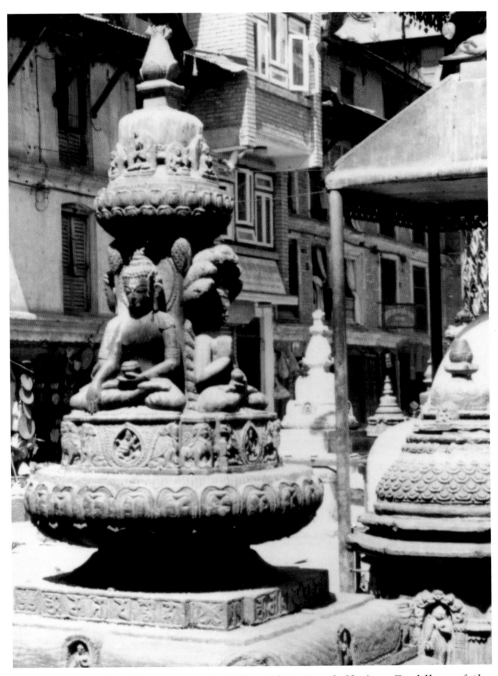

From a stupa in the courtyard of the White Lord Shrine, Buddhas of the Past send blessings in the four directions.

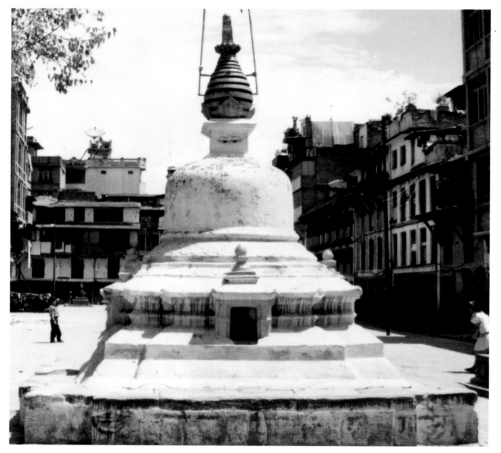

The stupa at Itum Bāhāl, one of the oldest vihāras in Kathmandu, stands in a courtyard near the old palace.

stupa and a lotus-based monument with statues of the Buddhas of the Past facing the four directions.

Major Stupas of Pātān

Five Aśokan Stupas The five stupas marking the center of Pātān and its ancient north, east, south, and west boundaries are attributed to the Dharma king Aśoka. All are shaped in the early hemispherical form, topped by harmikās with eyes looking out to the four directions. The shrines built into their sides were added at a later time.

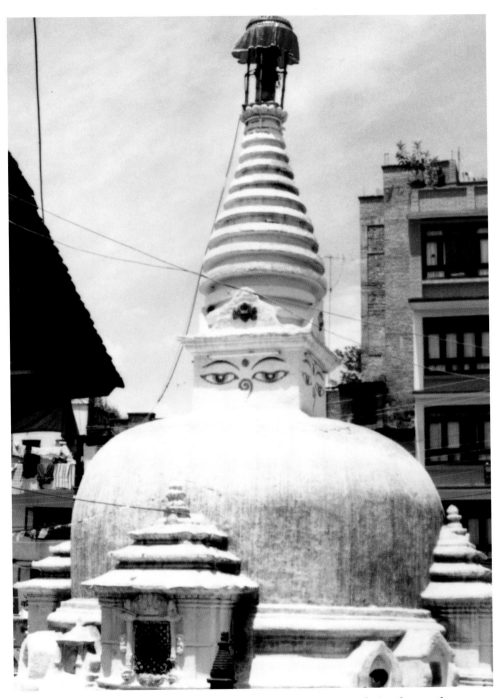

The ancient white stupa stands near Bir Hospital, Kathmandu.

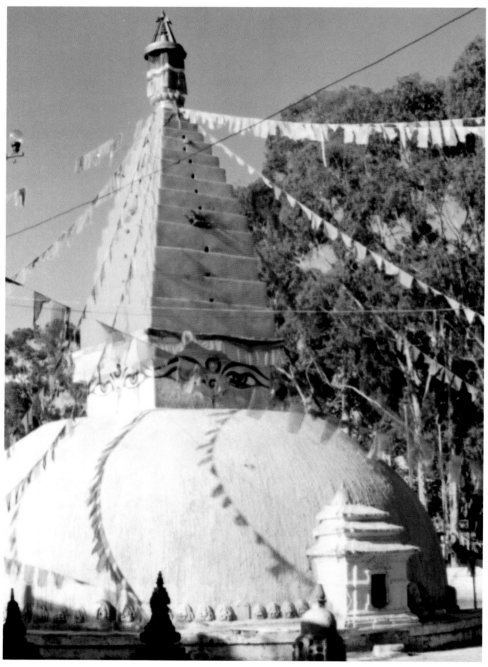

Licchavi inscriptions verify the antiquity of the Chābāhil Stupa, tradition-ally ascribed to Aśoka's daughter Cārumatī.

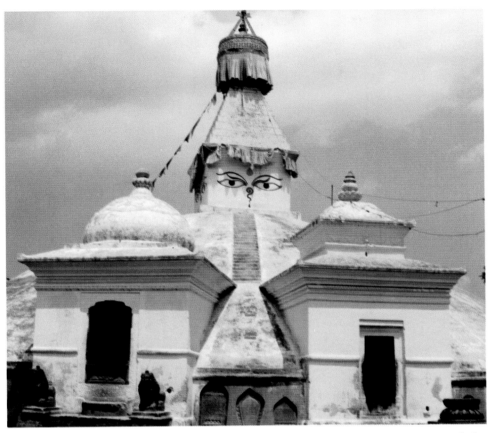

The shrines of the central Aśokan Stupa house ancient stone statues of the Buddha. Over: The stupas of the four directions.

Chābāhil Stupa Tradition attributes the building of this stupa to Aśoka's daughter Cārumatī, who came to the Kathmandu Valley with her father and remained to marry the prince Devapāla. Devapāla founded Deopātan, which has since developed into the city of Pātān. The stupa is located in Bhagavān Thān, Place of the Blessed One, perhaps named for the image of Dīpaṁkāra Buddha enshrined in the nearby Cārumatī Vihāra. The Chābāhil Vihāra is known for its ancient images; stupas in the courtyard enshrine statues of the Buddha and a beautiful image of Padmapāṇi.

Mahābauddha The Mahābauddha (Mahābodhi), a soaring monument in Pātān commemorating the Buddha's enlightenment, was

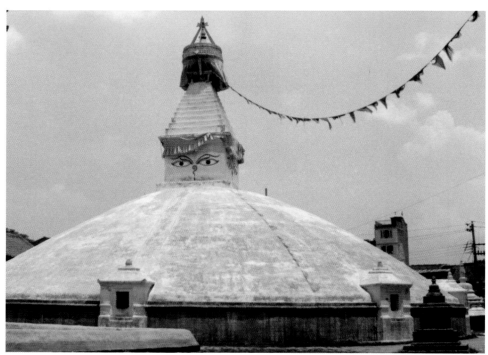

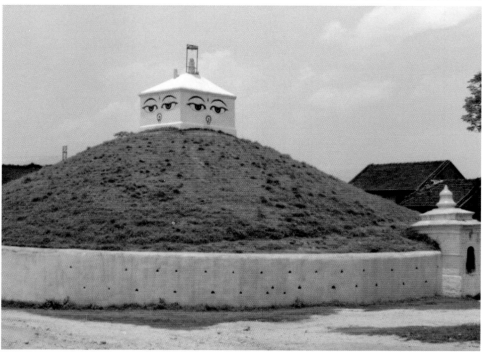

Heritage of a pilgrim's devotion: Buddha-images fill hundreds of niches in the Mahābauddha's facade.

built by Jīvarāja, a Buddhist pilgrim, during the reign of King Mahendra Malla, sometime before 1585. Born in Bodh Gayā, Jīvarāja resided most of his life in Kathmandu. After a pilgrimage to Bodh Gayā, he returned to Kathmandu, where as an act of devotion he built a smaller version of the Mahābodhi temple. He is said to have brought from Bodh Gayā a stone image of the Buddha in the earth-touching gesture. An alternate tradition holds that the actual construction was carried out in the early seventeenth century by a pandit named Abhayarāja and his descendants, who belonged to the Śākya caste.

Like the Mahābodhi, the Mahābauddha is actually a gaṇḍola, a tower-like stupa built over a central temple. Images of the Buddha in every niche and inscribed on every brick inspired the stupa's

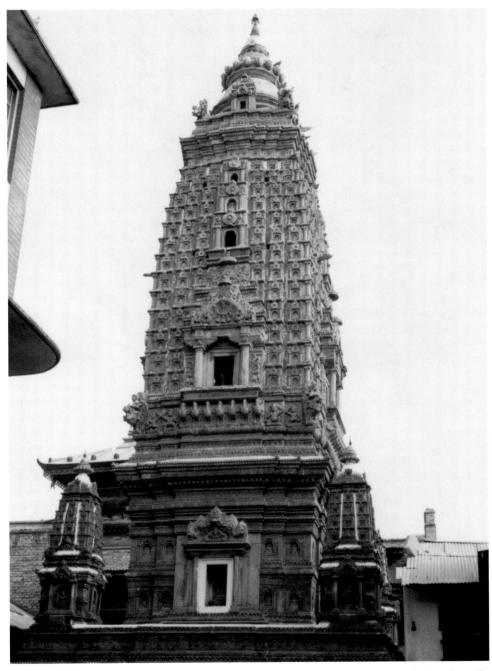

The Mahābauddha, Temple of Ten Thousand Buddhas, was built by the pilgrim Jīvarāja as an act of devotion.

The stupa in the courtyard of the Hiraṇyavarṇa Mahāvihāra, the Golden Temple of Pātān. The vihāra houses an image of the Buddha Śākyamuni arrayed in the jeweled ornaments of Sambhogakāya manifestations.

A complex of Aśokan-style stupas still stands at Kīrtipur, an historic city southwest of Kathmandu.

popular name, the Temple of One Thousand Buddhas, and the entire structure is ornamented with scenes from the Buddha's life. Purely Indian in style, this kind of monument is rare in Nepal.

The Mahābauddha was badly damaged by a great earthquake in 1934 and had to be completely rebuilt. At that time a temple dedicated to Māyādevī, the Buddha's mother, was built from bricks left over from the reconstruction.

The Great Stupa of Boudha

The ancient stupa of Boudhnāth is Boudha's greatest treasure. One of the oldest stupas, worshipped continually since its construction, Boudhnāth stands on a place revered as a center of natural mandalas.

Geomanticists calculate that the stupa is located at the Kathmandu Valley's strongest convergence of power.

The Boudhnāth Stupa rises from a huge four-tiered base. Each of its levels provides large numbers of pilgrims ample space for circumambulation and meditation. From each side of the square harmikā that crowns the stupa, pairs of eyes look out on the four directions. Between the eyes is the numeral one, a reminder of the non-duality that underlies all appearances. Rising from the harmika is a four-sided pyramid symbolic of Mount Meru, the great mountain that forms the center of our world system. In place of rings or wheels, thirteen square layers rise from the harmika, calling to mind thirteen stages on the path to enlightenment: the ten stages of the Bodhisattva path and three additional levels variously named. An unusually large parasol surmounts the pyramid, culminating in the stupa's spire. From its central mandala to the top of its pinnacle, the great stupa is rich in cosmic symbology.

As related in *Legend of the Great Stupa* (Dharma Publishing, 1973), a Terma teaching by the Great Guru Padmasambhava, the construction of the Jarungkhashor Stupa is directly related to the transmission of the Dharma to Tibet. Its origin traces to two tears shed by the compassionate Bodhisattva Avalokiteśvara upon viewing the suffering of living beings. The Compassionate One prayed that these tears might assist beings in overcoming their pain. The tears took form in the Trāyastrimśa Heaven as Indra's daughters. One daughter stole some flowers, and as a result of this transgression was reborn in the time of the Buddha Kāśyapa as the poultry-woman Shamvara.

Having prospered in her business, Shamvara conceived the wish to build a great stupa to enshrine the relics of the Tathāgatas. Receiving the king's permission and a grant of land, Shamvara and her four sons set about the task, using a donkey to haul earth and stones for construction. Several times townspeople sought to obstruct their efforts, but each time the king praised Shamvara's purpose and admired her dedication. Since the king upheld his word and her detractors were unsuccessful, the stupa became

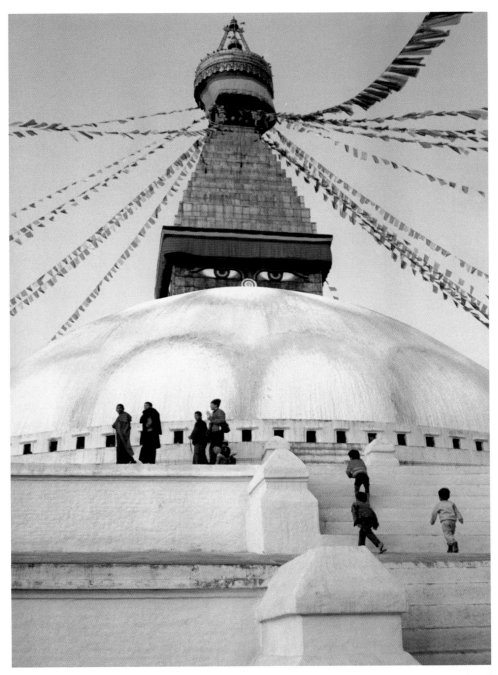

Pilgrims circumambulate the upper stage of the Boudhnāth (Lord of Enlightenment) Stupa.

known as Jarungkhashor, meaning that once permission has been granted, any obstacle can be overcome.

Shamvara died while work was in progress, and her four sons completed the stupa seven years after it was begun. Inside its relic chamber were enshrined the indestructible remains of the Buddha Kāśyapa; cymbals sounded and the earth shook three times. At this auspicious time, a great assembly of Buddhas and Bodhisattvas appeared. The boundless light of divine wisdom shining from them eclipsed the sun and illumined the night for five consecutive days.

The Enlightened Ones revealed that through the merit of building this stupa, any wish made by the stupa's creators would be fully granted. The four sons made vows of aspiration, asking that they be reborn at a time when they could help establish the Dharma in Tibet. The eldest son, who wished to protect the Dharma and establish it in the Land of Snows, became Trisong Detsen, king of Tibet. The second son, who wished to be reborn as a monk capable of ordaining the Sangha, became the Bodhisattva Abbot Śāntarakṣita. The third son prayed for rebirth as a tantric yogin to guard the Dharma and was reborn as the Great Guru Padmasambhava. The youngest son sought to be the minister who would coordinate their activities. Their prayers evoked the aspiration of others around them, who in turn offered themselves to serve this great purpose. "Let us be reborn . . . offering everything under the sky and the sky itself."

In relating this history to his disciples in eighth-century Tibet, Guru Padmasambhava described the stupa as a wish-fulfilling gem: "After the Buddhas and Bodhisattvas of the past, present, and future were absorbed in their reality into the receptacle of Pure Mind forever, this Great Stupa could grant any supplication and fulfill every aspiration immediately and effortlessly, for it became as the Wish Fulfilling Gem, the Yeshe Norbu. The benefits and favors received by any being who with a pure heart prostrates before the Great Stupa, circumambulates it, and adores it are inconceivable and incalculable beyond the expression of the Buddhas of the past, present, and future, for these stones were laid in order to bring inconceivable joy to humanity. As this Great Stupa is the supreme

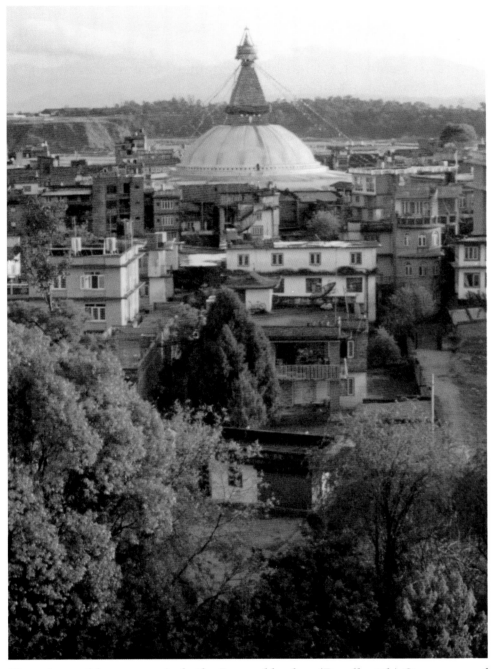

Temples and houses encircle the Jarungkhashor (Boudhnāth) Stupa, one of the Kathmandu Valley's most ancient and revered pilgrimage sites.

receptacle of the Mind of the Buddhas of the past, present, and future, so it is the plane of adoration of both mundane and supramundane beings; whatever supplication is made and whatever prayer is offered, all wishes will be granted. One may even obtain supreme realization and spiritual power."

The Great Guru enumerated the countless blessings of honoring the stupa of Jarungkhashor, which grants all manner of happiness: "Whoever visits the Great Stupa and gazes upon it has the three doors of the lower realms of hungry ghosts, animals, and hellish spirits closed against him when his spirit wanders in the Bardo after death. Whoever hears the vibration of the Great Stupa with his ears has the seed of supreme illumination planted within him. Whoever visualizes the nature of the Great Stupa is freed from megalomania, paranoia, and lethargy and is reborn into the stream of concentration. Whoever folds his hands in reverence follows the Path of Reality.

"Any leader who makes a sacrifice to the Great Stupa becomes a monarch of the universe. Whoever circumambulates the Great Stupa attains the seven qualities of divine happiness: noble birth, fine form, great pleasure, virtue and understanding, power and prosperity, freedom from disease and extreme longevity. Whoever offers prayers finds immediate fulfillment of his wishes for both himself and others. Whoever offers flowers to the Great Stupa obtains ease and contentment, prosperity and health. Whoever offers incense achieves pure action; whoever offers lamps has the darkness of unknowing illuminated; whoever offers perfume is freed from anxiety and suffering; whoever offers sacrificial food lives a life of concentration free from hunger.

"Whoever offers music to the Great Stupa spreads the Vibration of Dharma throughout the ten directions; whoever offers the sound of cymbals obtains deep and strong understanding and prosperity. Whoever offers the sound of tinkling bells obtains a gentle and sweet voice—the sacred tones of Brahmā. Whoever offers a mandala to the Great Stupa attains perfect virtue and understanding as fruit of social interaction and meditation practice. Whoever offers a

Stupa in the courtyard of Thamel Vihāra, also known as Vikramaśīla. Founded by Atīśa in 1041, the vihāra is said to preserve the original text of the Hundred Thousand Line Prajñāpāramitā brought by Nāgārjuna from the realm of the nāgas.

maṇḍala of the five precious stones—gold, silver, turquoise, coral, and pearl—is freed from poverty and misfortune and becomes master of the inexhaustible ethereal treasury. Whoever offers a maṇḍala of the seven precious things enjoys the riches of the kingdom in his temporal existence and acquires the Divine Body with the seven limbs of adoration in the realm of sublimity.

"Whoever offers a mandala of the seven spices of life is freed from diseases of body, emotion, impulse, and consciousness, from fatal diseases and all sickness. Whoever offers a mandala of the five essentials of existence is released from the manifold sufferings of

pride, envy, hatred, lust, and lethargy and attains the Buddha Body of the Five Transmuted Lineages of Amitābha, Amoghasiddhi, Vajrasattva, Ratnasambhava, and Vairocana. Whoever offers a mandala of the five grains reaps a rich harvest from the seeds shown.

"Whoever offers the five kinds of incense to the Great Stupa becomes attractive and loved by all; whoever offers the five kinds of perfume obtains a clean house untroubled by unpleasant odors. Whoever offers the five divine gifts accumulates merit, and his power, glory, pleasure, and worldly goods increase. Whoever offers the celestial parasol and victory banner has the tension of passion alleviated and becomes worthy of honor and reverence.

"Whoever offers embroidered hangings or a divine ensign obtains happiness, wealth, and abundance, and is freed from fear of fire, water, lions, elephants, retribution, snakes, temptresses, and thieves. Whoever offers a rosary or crown attains the ecstasy of men and gods and is bejeweled with the seven precious things; whoever offers a lamp experiences, in a vision, the reality of all the Buddhas and Bodhisattvas of the ten directions. Whoever offers mustard oil is freed from the veil of lethargy; whoever offers a butter lamp irradiates the ten directions with the light of Dharma. . . .

"Whoever restores the Great Stupa accomplishes the four forms of Buddha Activity, attains every aim conceived and receives the highest understanding. Whoever makes bricks becomes Monarch of the Universe, Lord of every speck of dust. Whoever carries earth and stones has the dangers to life eliminated and obstacles in living removed—receiving lifelong health and beauty; whoever strives to purify body, speech, and mind, the three doors of illumination, is blessed by all the Buddha's Trikāya. Whoever makes virtuous friends follows the Dharma Path of the ten virtues, and never being without kindly exemplars, he receives whatever power is required in every situation. Whoever supervises the work of restoration is reborn a leader of the Bodhisattvas of the ten directions performing only Buddha Service. Whoever perseveres at his craft will master medicine, dialectics, music, and metaphysics in all future existences. Whoever makes the seven ritual paces toward the Great Stupa when

Sri Lanka

T he Mahāvaṁsa, the Great Chronicle of the Theravādin tradi-
tion, relates that the Buddha, master of boundless wisdom,
looking to the salvation of Laṅkā in time to come, visited Sri
Lanka three times. The first time was nine months after the enlight-
enment, when the island was home only to yakṣas and nāgas. The
Buddha arrived during a great gathering of yakṣas and caused a
fierce storm to arise. In return for quelling the storm, the terrified
yakṣas agreed to leave Sri Lanka, and the Buddha enabled them to
move to another island. As the local devas came to praise the
Buddha for expelling the yakṣas, he turned the Wheel of the
Dharma in this new land, which became known as the Jewel Island
for its abundance of precious gems.

When the deva leader Mahāsumana asked for relics to honor
after the Buddha's return to India, he received some hairs from the
head of the Enlightened One. Mahāsumana erected a stupa at Mahi-
yaṅgaṇa, where the Buddha had taught, and enshrined the hair-
relics within it. A stupa still stands at this place, now known as
Alutnuvara, where the Mahāvālī River descends from the moun-
tains. (ASC 5) The Pūgāvalī, a thirteenth-century text, attributes a

145

second ancient stupa at Tiriyāya, on Sri Lanka's eastern coast, to the merchants Tapassu and Bhalluka (Trapuṣa and Bhallika), who also received hair-relics from the Buddha. (ASC 5)

Five years after the enlightenment, the Buddha again came to Sri Lanka, this time to bring peace to the warring nāgas. Arriving in the region of Nāgadīpa, he converted the nāgas to the Dharma and planted a rājāyatana tree to commemorate this event. When another three years had passed, the nāga king Maṇiakkhika invited the Buddha and the Sangha to Sri Lanka, an indication that the land was now pacified and receptive to the teachings. The Tathāgata came to Sri Lanka accompanied by five hundred disciples. This time he left his footprints and consecrated sites where shrines, stupas, and monasteries would eventually arise.

Early History of Sri Lanka

The Mahāvaṁsa relates that the city of Anurādhapura was settled by exiles from South India at the time of the Buddha's parinirvāṇa. Archaeologists generally date the earliest sites in the city to five hundred B.C.E. Here in the fourth century, under the constellation Anurādha, King Pandukabhaya established his capital, which takes its name from this auspicious juncture. Envisioning the city to come, the king laid out a plan for construction and built a large reservoir to the west.

A century later, when Aśoka ruled in India, Devānaṁpiyatissa was king of Sri Lanka. During his reign, Aśoka's son, the Thera Mahinda, left his monastery near Vidiṣā in India and came to Sri Lanka accompanied by five disciples, his nephew Sumana, and the lay disciple Bhaṇḍuka. The monks met the king on Mt. Mihintaḷe, eight miles east of Anurādhapura, as he pursued a deer through the jungle. The king's initial fear changed to devout respect when he realized that the visitors were not yakṣas, but monks of extraordinary powers. He took refuge in the Dharma and invited the monks to teach his people.

Within a few days, eight thousand Sri Lankans attained the first stage of liberation. Then the king guided a golden plough around the boundaries of the Mahāmegha, the Great Cloud Garden, and donated it to the Sangha. In this garden the king built the Mahāvihāra, the Great Monastery, which became the first home of the Sri Lankan Sangha. His successors Uttiya and his younger brothers Mahāsiva and Sūratissa, each of whom reigned for ten years, continued to support the Sangha, but this dynasty was interrupted by the Tamils who conquered Anurādhapura in 155 B.C.E. and ruled for twenty-two years. Sinhalese rule was restored in 133 B.C.E., but lasted only ten years; the Tamils under Eḷāra regained power in 145 B.C.E. and held it for forty-four years more. Tamil rule ended the vigorous period of construction initiated by Devānampiyatissa. With the exception of the Thūpārāma and the Ambasthala, the names and locations of stupas built during the reigns of the four early Sinhalese Buddhist kings have long been forgotten.

Sinhalese princes established centers of power in Kalaṇiya in the southwest and in Tissamahārāma in the southeast. While Tamils ruled in the north, the Sinhalese Buddhists continued to build stupas in the south. The stupa built in Kalaṇiya to mark the place where the Buddha met with the nāga king on his third visit to Sri Lanka is still highly venerated today. Stupas at Mahāgāma and a large stupa at Seruvavila may also date to this time. (ASC 6)

The Early Stupas

Thūpārāma Of all the relic stupas built by King Devānampiyatissa and the three kings who succeeded him, two are primary places venerated by Buddhists to this day: the Thūpārāma in Anurādhapura, and the Ambasthala Thupa on Mt. Mihintaḷe. The Thūpārāma was erected by Devānampiyatissa near his palace in Anurādhapura, on a place consecrated in aeons past by shrines dedicated to previous Buddhas.

The Thūpavaṁsa, an account of the building of the Thūpārāma, relates that Mahinda instructed the king concerning the value

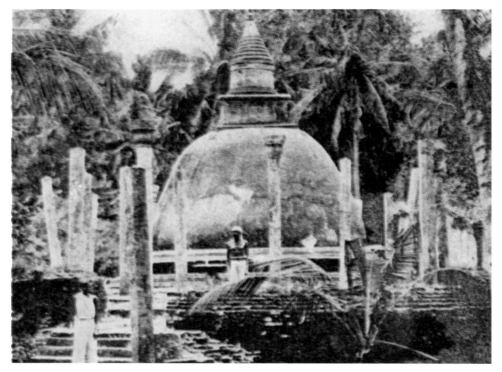

The Ambasthala Thūpa enshrines the relics of Mahinda, the Arhat who introduced Buddhism to Sri Lanka in the third century B.C.E.

of relics and the merit that would come from erecting a stupa. When the king inquired where such relics might be found, Mahinda sent Sumana to request relics from Śakra, lord of the Trāyastriṁśa Heaven, from the nāga kings, and from his father Aśoka.

From Śakra, Sumana obtained the Buddha's right tooth and right collarbone, and from Aśoka he received the Buddha's alms-bowl filled with relics, which he brought to Mt. Mihintale. After enshrining the collarbone relic and sealing the Thūpārāma, the king, his brothers, and his queens built additional stupas, delighting the devas, nāgas, and yakṣas. Then, retrieving the bowl of relics from Mt. Mihintale, Devānaṁpiyatissa encircled his capital with stupas, each placed at a day's journey from the palace, and had the relics enshrined within them. The Buddha's almsbowl was preserved in the royal palace, where it was greatly venerated.

148

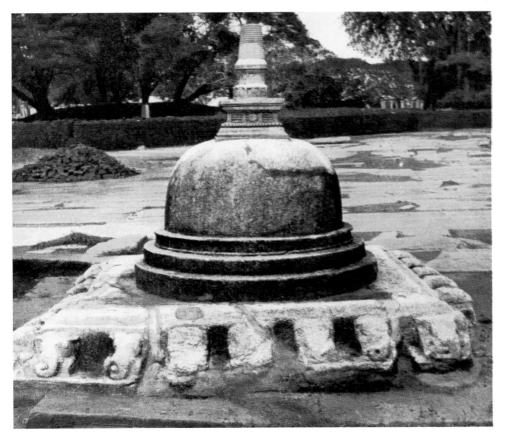

A base of kneeling elephants supports a votive stupa in the Ruvanveli compound, recalling the elephant that held the relics for the great stupa.

made for the stupa, and directed artists to paint the stupa's finishing details on it. Filled with joy, the king asked Saddhātissa to complete the stupa in just this way and to continue all the ceremonies the king had introduced in honor of the Buddha. Saddhātissa carried out the king's dying request and completed the great stupa soon after his death. (MV XXXII:61–62) The kings that followed him also honored the great stupa and continued to develop it.

The Ruvanveli Dāgaba is widely respected as Sri Lanka's holiest shrine. Its original height is said to have been three hundred feet, making it the largest stupa of its time. Today the great stupa rises 290 feet and has a base diameter of 298 feet, very close to its original

dimensions. Its magnificence inspired a later king, Mahādāṭhika Mahānāga (r. 67–79 C.E.) to erect a similar stupa on the summit of Mt. Mihintaḷe. Mahānāga's monument, still known as the Mahāthūpa, rises from a base 136 feet in diameter.

The Ruvanveli Dāgaba stands next to the Mahāvihāra, the monastery that was home to the Mahāvihārins, the oldest of the three major Buddhist traditions in Sri Lanka. It is reached by passing through the gatehouse and crossing a sand courtyard to the elephant wall, which faces the platform of the dāgaba. In the entryway to a temple on its side stand large statues of the three Buddhas of the past and the Buddha of the present, with a modern sculpture of Maitreya to their left. The stupa's spire is topped by a rock crystal two feet in diameter. This crystal was donated by the Burmese Sangha to replace the original jewel, a ruby said to have been the size of a man's fist, which was lost to thieves at some point in the past. The Ruvanveli is encircled by rings of columns that probably once supported a roof.

Abhayagiri (now called the Jetavana) The massive Abhayagiri Stupa, one of Sri Lanka's eight major shrines, was built by King Vaṭṭagāmaṇi Abhaya (r. 44–17 B.C.E.). The Mahāvaṁsa records, "When two hundred and seventeen years ten months and ten days had passed since the founding of the Mahāvihāra, the king, filled with pious zeal, built the Abhayagiri Vihāra." (MV XXXIII:81–82) This stupa is thought to mark the site where the Buddha sat in meditation on one of his visits to Sri Lanka. Gajabāhu I (r. 173–95 C.E.) enlarged the stupa and ornamented its four gates with edifices called ādi-mukha. The Abhayagiri Dāgaba, 355 feet in diameter, once rose to a height of 350 feet; neglected in recent times, it has crumbled to a height of 245 feet.

According to Fa-hsien, who visited Sri Lanka in the early fifth century, "When Buddha came to this country, wishing to transform the wicked nāgas, by his supernatural powers he planted one foot at the north of the royal city and the other on the top of a mountain [identified as Adam's Peak], the two being fifteen days' journey apart. Over the footprint at the north of the city the king built a large

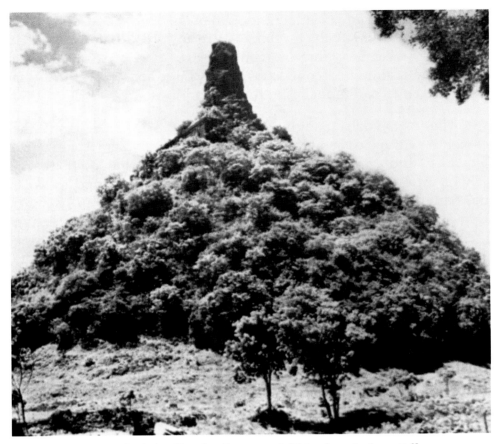

The Abhayagiri (originally the Jetavana) Dāgaba at Anurādhapura was built by King Mahāsena between 362–89 C.E.

tope, four hundred feet high, grandly adorned with gold and silver and finished with a combination of all the precious substances. By the side of the tope he built a monastery, called the Abhayagiri, where there are five thousand monks." (RBC 102)

King Vaṭṭagāmaṇi gave the Abhayagiri Monastery to the Thera Mahātissa in gratitute for his help in restoring him to power. This abbot was subsequently charged with a breach of discipline and expelled from the Mahāvihāra order together with his disciple Tissa. Soon afterwards, the Indian monk Dharmaruci became the leader of the Abhayagiri Sangha. Although the monastery was always con-

sidered a Theravādin center, the Abhayagiri monks also studied Mahāyana and Vajrayāna teachings. A major presence in Sri Lanka, Abhayagiri became a thriving center for art and philosophy. The monastery maintained connections with Buddhist centers in India and China and had branches in Burma and Java.

The Abhayagiri Sangha flourished in Sri Lanka until the eleventh century, when all three Sri Lankan Sanghas (Abhayagiri, Jetavana, and Mahāvihāra) were merged into the Mahāvihārin school. After the Abhayagiri and Jetavana schools ceased to exist, the names of their former centers were confused: the Abhayagiri Dāgaba became known as the Jetavana Dāgaba, while the stupa at the Jetavana became known as the Abhayagiri. As a result, the Jetavana can now be found near the Abhayagiri Vihāra, and the Abhayagiri Dāgaba rises from the former site of the Jetavana Vihāra.

Vaṭṭagāmani is also known as the builder of the Śīlasobbaka-kandaka Cettiya, which is part of the Laṅkārāma, one of the eight sacred sites of Sri Lankan Buddhists. This stupa was erected shortly after the king recovered the throne to mark the place where he concealed himself after his defeat by the Tamils. During Vaṭṭagāmani's reign, his general Uttiya built the Dakkhiṇa Thūpa, now known as Eḷāra's Tomb, over an earlier stupa housing the ashes of King Duṭṭhagāmani. These relics are now in the Sri Lankan Archaeological Museum.

Jetavana (now called Abhayagiri) The stupa now known as the Abhayagiri Dāgaba, built by King Mahāsena between 362 and 389, is associated with the Sagaliya school founded by the monk Kohontissa in the third century C.E. Tradition holds that this stupa was built on the place where Mahinda first taught the Dharma to the people of Sri Lanka. It is said to be solid brick, rising from a brick foundation twenty-six feet deep to a height of four hundred feet. Although its spire is broken and its exterior has deteriorated, with a base diameter of 370 feet and a modern height of 231 feet, it is still the most massive stupa in Sri Lanka. Efforts are now being made to preserve this monument and restore the vāhalkaḍas built at the stupa's four directions.

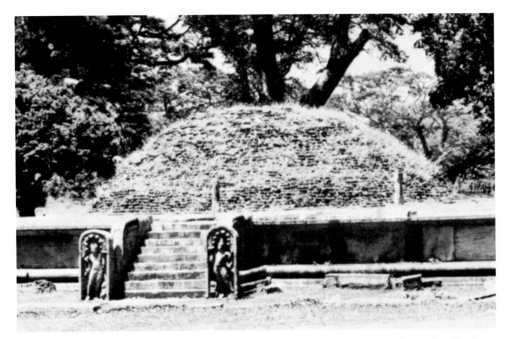

Ruins of two ancient stupas in Anurādhapura. Above, the Khujjatissa Cetiya; below, the Nakā Vihāra.

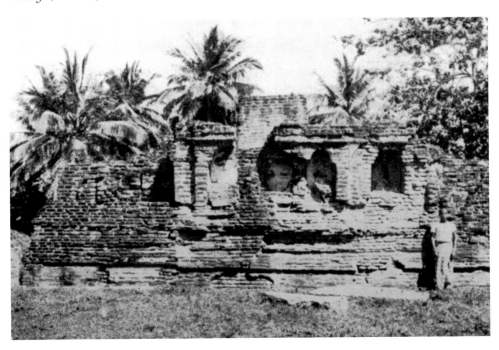

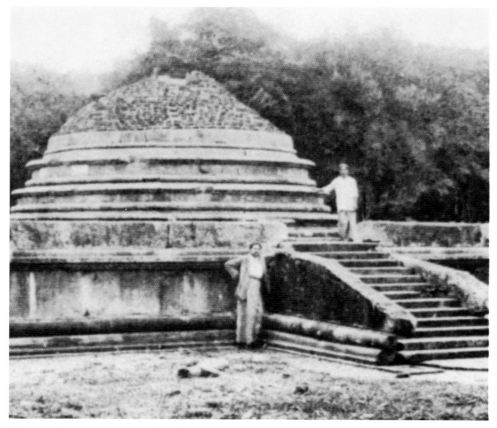

The Indikaṭusāya on Mt. Mihintale, associated with the Mahāyana teachings, was probably built in the eighth century C.E.

Parākramabāhu (1153–86) brought stability and initiated a major period of reconstruction. He repaired older stupas and erected two large stupas near his capital at Polonnaruva, but these monuments were forgotten and have not been identified in recent years. Using captured Tamil workers, he initiated construction of the Unagalā Vihāra, designed to be the largest stupa in Sri Lanka. This stupa was never completed.

Kirivehera Dāgaba The well-preserved Kirivehera Dāgaba, with a base diameter of eighty-eight feet, is thought to have been built in the twelfth century by Bhaddavatī, one of King Parākramabāhu's

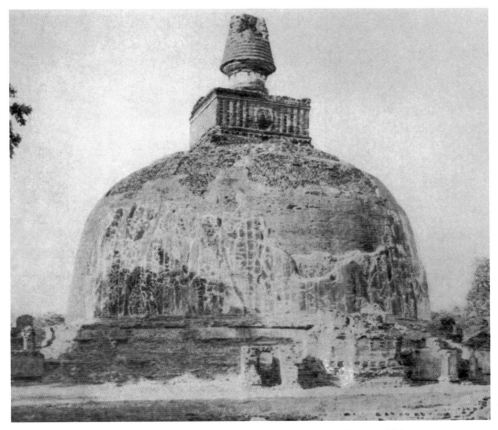

The Kirivehera Dāgaba, Poḷonnaruva, was built in the twelfth century C.E. during the reign of King Parākramabāhu.

wives. Its higher cupola presages the bell-shape which has come to characterize modern Sri Lankan stupas. The three steps at its base are taller than on earlier stupas. Shrines placed at the four directions mark the important places for offering prayer and devotion.

Rankot Vihāra Niśśaṁka Malla (r. 1187–96), who succeeded King Parākramabāhu, built a massive stupa in Poḷonnaruva modeled after and named for the Ruvanveli Dāgaba in Anurādhapura. Now known as the Rankot Vihāra, this stupa has a base diameter of 186 feet.

Vaṭadāge The Vaṭadāge at Poḷonnaruva is one of several stupas bearing this name, which refers to a circular receptacle for relics.

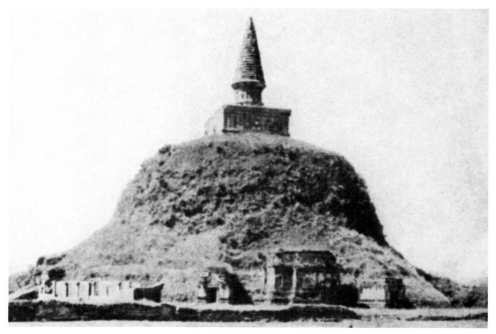

Above, the Rankot Vihāra, Poḷonnaruva, a bell-shaped stupa built by Niśśaṁka Mala. Below, the Vaṭadāge in Poḷonnaruva.

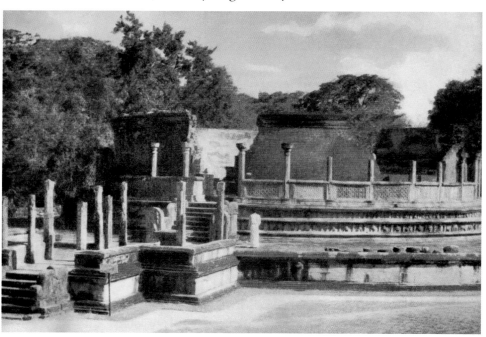

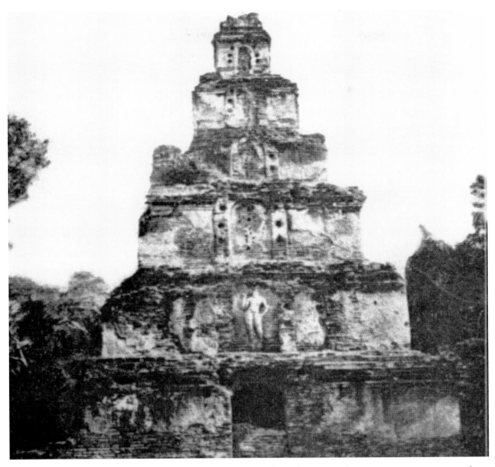

The Satmahāl Prāsāda, the Seven-Storied Palace, Poḷonnaruva, was probably built during the twelfth century.

Three concentric circles of stone pillars surround a small central stupa twenty-seven feet in diameter. The stupa rises from a paved circular plinth accessed by stairs positioned at the four cardinal directions. Its retaining wall and stairs are richly ornamented.

Satmahāl Prāsāda The Satmahāl Prāsāda, the Seven-Storied Palace, is formed of seven square layers progressively smaller toward the top. It rises like a pyramid to a height of fifty-three feet from a square base thirty-nine feet on a side. It was once taller than it is today; the top level is gone, but remains of a standing figure can be

seen in the center of each level on each of the four sides. Although its origin is unknown, it is very similar in style to the stupa built at Wat Kukut in Lamphun, Thailand, in the eighth century. Thai monks were studying in Sri Lanka during the last half of the twelfth century, and contact with Thailand is thought to have influenced the adoption of this style, which is said to represent the seven mountain ranges surrounding Mt. Meru.

Decline and Occupation

The Sinhalese kingdom centered in Poḷonnaruva declined after Niśśaṁka Malla's reign and came to an end in the thirteenth century. Beseiged by forays of invaders from South India, the Sinhalese rulers abandoned both Anurādhapura and Poḷonnaruva and moved further south. Anurādhapura, city of 113 kings, lay buried deep in the jungle for hundreds of years, but the Bodhi Tree planted at the time of Mahinda lived on, cared for by the few monks who remained in this area. Jungles, warfare, and malaria discouraged the Sinhalese from resettling their former capitals. Few stupas were built during this period, and all are small and deteriorated.

Sri Lanka's Buddhist culture was disrupted further during more than three centuries of European occupation, from the sixteenth century until modern times. The Portuguese who controlled Sri Lanka from the sixteenth through seventeenth centuries were succeeded by the British in 1815. Abandoned for almost seven centuries and ravaged by treasure seekers, many ancient stupas deteriorated into unidentifiable piles of debris.

In the nineteenth century, the weakened Sinhalese lineages were restored by Theravadin Buddhists from Thailand, and a period of reconstruction began. This restoration appears to be a mixed benefit, as archaeologists have expressed great concern that restoration is destroying the original art and architecture of Sri Lanka's ancient monuments. Yet preservation is necessary to prevent outright loss, and efforts to preserve Sri Lanka's great stupas continue today.

CHINA

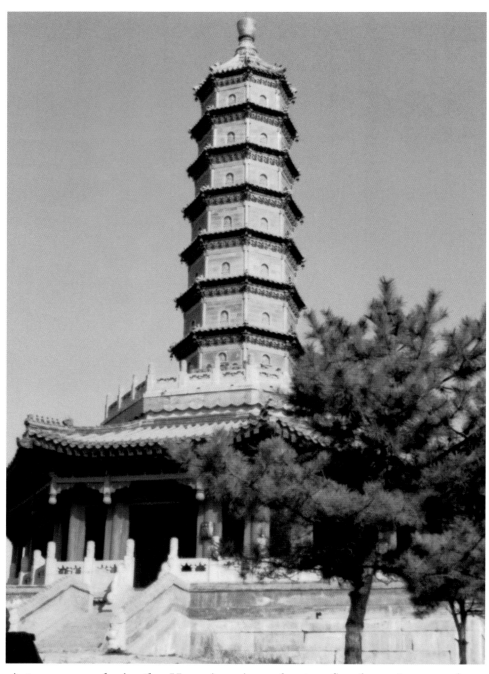

A tower pagoda in the Hu-pei region, about a five hour journey from Beijing, was built at the time of the Fifth Dalai Lama (17th century).

166

China

The Buddhist traditions of China, Korea, and Japan are closely related, as are the forms of their sacred monuments. Yet each culture developed its own way of manifesting the truth of the Buddha's teachings, and each gave the world a distinctive architecture in which to express the universal qualities of enlightenment.

The origin of Buddhism in China traces to the Emperor Hsia-ming of the Han dynasty, who dreamed of a golden figure flying above the imperial palace. When the emperor asked his ministers who this radiant being might be, the minister Fu-yi told him of the Buddha, the Enlightened One from the holy land of India, who was golden in color and was known to appear in distant lands. Desiring to understand the meaning of this vision, Hsia-ming sent envoys to India to learn of the Buddha and his teachings. Upon their return to the imperial court at Lo-yang, the envoys brought with them the monks Kāśyapa Mataṅga and Dharmarakṣa, some scriptures, and images of the Buddha. When Kāśyapa Mataṅga translated the first Buddhist teaching, the Sūtra in Forty-two Sections, into the Chinese language in 67 C.E., he described the emperor's dream in the preface, providing the earliest account of the Dharma in China.

Monks from Central Asia and lands northwest of the Indus supported the growth of Buddhism in China for several centuries thereafter. Dharmarakṣa, known as the Bodhisattva of Tun-huang, was descended from a Central Asian tribe west of the Great Wall. An Shih-kao and An Hsüan were Parthians from northern Afghanistan, and the great translator Kumārajīva was born in Kashgar of Indian and Khotanese parents. The Sūtras translated by An Shih-kao became the basis of the dhyāna (meditation) tradition. Translations of the Sukhāvatīvyūha, a Sūtra describing the paradise of Amitābha, and the Perfection of Wisdom Sūtras in Eight and Twenty-five Thousand Lines introduced the Mahāyāna and supported practices combining devotion and Bodhisattva compassion.

In the early fourth century, soon after Kumārajīva began translating in China, the Chinese pilgrim Fa-hsien returned from India with a large collection of Vinaya texts which gave China access to the Vinaya of several Buddhist traditions. Among Kumārajīva's translations were three important works by the great master Nāgārjuna that formed the basis of the San-lun, or Three Treatises school established by Kumārajīva's disciples.

In the fifth and sixth centuries, Chinese masters took a more prominent role in translation and established schools based on the Sūtras and śāstras. The Amitābha Sūtras became the basis for the Ching-t'u, or Pure Land School; the Avataṁsaka Sūtra inspired the Hua-yen School, and the Saddharmapuṇḍarīka (Lotus of the True Law) gave rise to the T'ien-t'ai tradition. Ch'an Buddhism, an outgrowth of the earlier dhyāna, or meditation systems, took the Laṅkāvatāra Sūtra as its philosophical basis.

In the seventh century, Paramārtha's translation of Vasubandhu's texts inspired Hsüan-tsang to search for more śāstras in India. His efforts brought to China a massive infusion of Buddhist teachings and the journal he kept provided a detailed record of Buddhism as it then existed in Central Asia and India. The Abhidharma texts obtained by Hsüan-tsang became the basis of an Abhidharma (A-p'i-ta-mo) school, and the teachings of Maitreya, Asaṅga, and their commentators inspired the Yogācāra (Fa-hsiang)

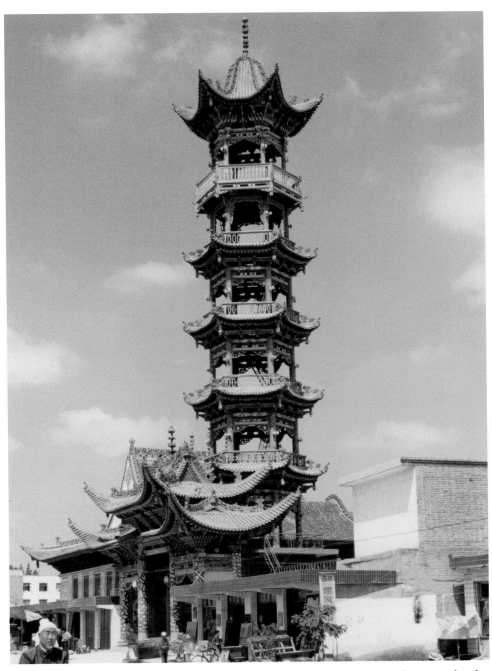

The tower of this seven-storied pagoda near Lan-chou clearly reveals the essential openness of the Chinese pagoda and the absence of a central pillar.

school. The translations and teachings of the Indian Vajrayāna masters Vajrabodhi and Amoghavajra gave rise to the Chen-yen school. Chen-yen, like other schools directly based on Indian models (San-lun, A-p'i-ta-mo, and Fa-hsiang), declined in the eighth century, while the Ch'an, T'ien-t'ai, Ching-t'u, and Hua-yen schools continued to flourish.

All Chinese Buddhist traditions were disrupted in 845 when the emperor called for the destruction of major Buddhist temples, confiscated their lands, and ordered monks and nuns to return to lay life. Although the persecution ended with the death of the emperor a year later, the philosophical schools were seriously weakened. Only Ch'an and Pure Land, the two schools least dependent on imperial support, succeeded in recovering their former strength.

The Pagoda

The pagodas (Chinese t'a, Korean t'ap, Japanese tō) seen throughout far eastern lands trace their distinctive form through China, where the tower style was preferred and highly developed. Korean monks took their inspiration from Chinese models and developed their own distinctly Korean representations. The Japanese pagoda benefited from the forms developed in China and Korea, while Japanese architects refined them, guided by the Japanese genius for integrating nature and the human spirit through shapes of subtle yet profound spiritual significance.

From China, the heritage of the pagoda traces through Central Asia to northwestern India. Aśokan stupas were well-known to the early masters who came to China from India and the mountainous lands of the northwest, but the Aśokan-style stupa did not become widespread in China. During the early centuries of transmission to China, Buddhism was regarded as a foreign religion. Native Chinese were discouraged from becoming monks, and the Vinaya texts were virtually unknown until the time of Fa-hsien and Kumārajīva, in the early fifth century C.E. There is no evidence that stupas were built in China prior to that time.

The imposing towers built in northwestern India during the early centuries C.E. appear to have inspired the multistoried pagodas of China. The earliest Chinese stupas are represented in the cave temples of Yun-kang near Ta-t'ong and Lung-men near Lo-yang. The relief of the pagoda in the Yun-kang cave temple, carved around 530 C.E., shows a five-storied square structure with five niches carved into each side of each level, each bearing images of the Buddha. Similar Buddha images are carved into the niches that cover the walls and ceilings of the temple. This tower-like pagoda resembles the remains of the niched bases of the tall multistoried Gandhāran stupas found in Afghanistan and the ruins of Mohenjo Daro in modern Pakistan. It also echoes the great watchtowers erected throughout Chinese-occupied lands. As Chinese masters developed the Buddhist schools and established temples and monasteries throughout China, relic-bearing pagodas were central to the sacred space, the focus of ritual and devotion.

Although at first glance a pagoda may bear little resemblance to the stupa, dāgaba, or chorten, it serves the same purpose as a receptacle for relics and a focus for spiritual practice. The externals of the stupa have vanished; in most pagodas, the hemispherical dome has also disappeared. The foundation, a mandalic structure built around a central core, is oriented horizontally toward the four directions; the harmikā, now internal to the structure and close to the foundation, holds the empowering relics, images, and special substances. A central pillar extends the mandala vertically and carries the blessings upward and outward on the horizontal lines of multiple roofs, culminating in the finial at the top.

The rhythms of pillar and multiple roofs emphasize the interplay of horizontal and vertical planes, the energy of enlightenment supporting all levels of the spiritual path, and other teachings of integration and harmony so richly conveyed through the Buddhist traditions. Around the empowered core are images of the Buddha facing the four directions. Although the Japanese pagodas are usually sealed, and their images and sacred objects hidden from view, most of the Chinese pagodas allow entrance to the first story and

sometimes higher; there is usually a space where devotees can circumambulate the central shrine. Often this circumambulation hall is ornamented with images of Buddhas and Bodhisattvas.

Chinese Pagodas

Chinese pagodas are generally constructed of glazed bricks, stone, wood, or bronze. Although their styles vary considerably, in general the roofs stay close to the outer walls, drawing attention to the vertical rise and mass of the building itself. Chinese pagodas have compact pillars with an interior space for a central Buddha-image and a circumambulation path. Outside of the circumambulation area, there is little open space inside the pagoda; on each floor small narrow walkways extend to the four directions and open into windows at the walls, carrying the energy of enlightenment from the pagoda's core out into the world. The outer walls are often ornamented with images of the thousand Buddhas of our aeon, and wind-bells ring from their roofs.[1] Bells were used on stupas admired by the Chinese pilgrims also, as seen in their descriptions of the Kaniṣka Stupa.

On the basis of form, Glauche distinguishes six main pagoda architectural styles:

1. The step pagoda (chi-t'a), which rises in a series of square shapes with each floor smaller than the one before, is exemplified by the Wild Goose Pagoda. In this pagoda, an inner staircase gives access to the top of the building. Built of wood and bricks in 625, the Wild Goose Pagoda was rebuilt in 705. Later in that century it became the receptacle for the manuscripts Hsüan-tsang brought to China.

2. The T'ien-ning pagoda, named for the pagoda that stands at the T'ien-ning monastery near Beijing, is a tall and slender multistoried tower-like building.

1. Johannes W. Glauche, *Der Stupa: Kultbau des Buddhismus*, 32–33.

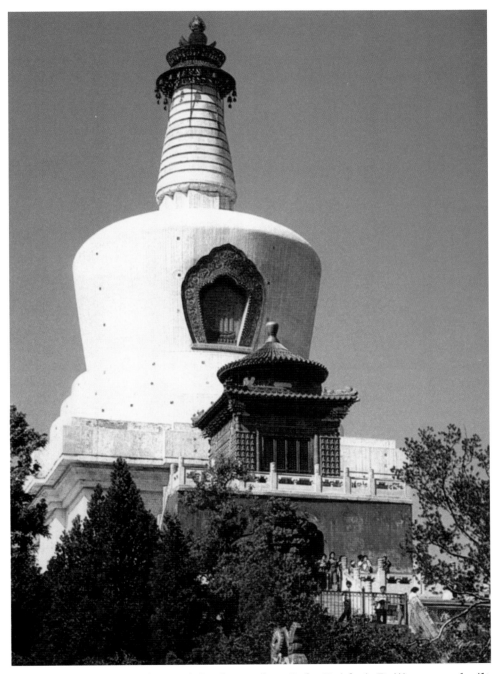

The Pei-t'a (White Chorten) in the park at Lake Pei-hai, Beijing, was built in the seventeenth century for the visit of the Fifth Dalai Lama.

3. The ring pagoda (ti-seng t'a) has multiple floors that rise like rings around the center, as in the Fei-hung t'a (Flying Rainbow Pagoda) at the Kuang-sheng Temple. The Fei-hung t'a is a highly ornamented broad-based octagonal building with Buddhas looking out to eight directions from openings on each of its thirteen stories.

4. The floor pagoda (seng-t'a) has floors of nearly equal height and diameter that shape a less pronounced pyramidical structure, as in the Iron Pagoda at Kai-feng, named for its brown iron-colored ceramic brick walls. The eight-sided Iron Pagoda has thirteen stories and rises to a height of 178 feet.

5. The gallery pagoda (wai-lang seng-t'a), a variation of the floor pagoda, has balconies that encircle each floor, as in the five-storied Śākyamuni Pagoda at the Fo-kung Temple. Made of wood, the eight-sided Śākyamuni Pagoda is wide in relation to its height.

6. The relic pagoda (she-li t'a, from the Sanskrit śarīra) contains relics of the Buddhist saints. These pagodas are smaller in size and are often clustered in the forested cemetery areas near monasteries known as pagoda-woods. Some types of relic pagodas are known as grave pagodas (mu-t'a). China's earliest surviving pagoda, the Ssu-men t'a, a grave pagoda at the Shen-tung monastery built in 544, resembles a small square house with doors at the four directions. Images of the Buddha are placed around the central pillar, and devotees can enter for circumambulation. The roof is topped by a small Aśokan stupa (a-yu-wang t'a), which serves as the reliquary.[2]

China, like Thailand, Burma, and Nepal, has massive temple-pagodas inspired by the Mahābodhi in Bodh Gayā: the Vajra Stupa in the Five-Pagoda Temple in Beijing, and the Diamond Throne Pagoda in the Temple of Azure Clouds west of the capital. China also has hybrid pagodas that combine the distinctive vase of the Tibetan chorten with the multi-storied octagonal pagoda, as in the Pei-t'a (White Pagoda) of Lan-chou.

2. Op cit., pp. 33–36.

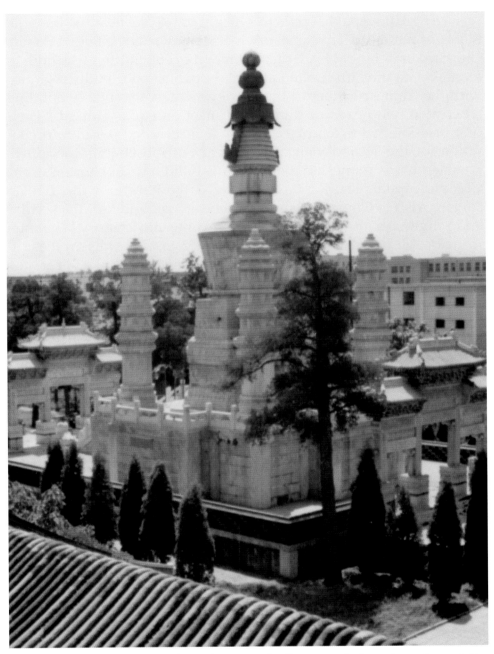

The Namgyal Chorten of Beijing was built to enshrine the ashes of the Sixth Panchen Lama. Four smaller towers rise at the corners of the central chorten.

The great stupa that rises to a height of 162 feet near the Imperial Palace is actually a Tibetan chorten also known as the Pei-t'a (White Chorten) of Beijing. This large and magnificent chorten was built at a time when the Fifth Dalai Lama had established friendly relations with the Chinese Emperor, but there was then no suitable building where the two heads of state could meet on equal ground. (Their first meeting had taken place quietly in a secluded park.) In preparation for the second visit of the Great Fifth to Beijing, the fourth Panchen Lama requested that Tibetans build a great chorten in the Chinese capital. The Pei-t'a symbolized the nature of the Tibetan leader's visit to China and stands today as a reminder of the secular and religious stature of Tibet in the seventeenth century. The interior can still be accessed through a high gate; the walls are beautifully painted and a finely-drawn mandala of Yamāntaka covers the broad ceiling of the vase.

The ornamentation of the seven-storied tower pagoda in the Hu-pei region (p.166) is defined in shades of green, gold, and orange. Paintings of the Buddha line the circumambulation path of this eight-sided pagoda built in the seventeenth century to commemorate the Fifth Dalai Lama's visit here.

The central stupa of the Namgyal Chorten (p. 175) enshrines the ashes of the Sixth Panchen Lama, who passed away at this very place. The chorten's exterior walls have exquisite carvings of the thousand Buddhas of our aeon, complemented by carvings on the gates placed at the north and south. Four smaller stupas erected at the four corners emphasize the mandalic structure of this chorten, which is the sacred center of the Huang-ssu, the Yellow Monastery of the Gelug school. This chorten is built in the park where the Fifth Dalai Lama met the Chinese emperor on his first visit to China; Tibetans have held this site as holy since that time. In 1986, the Panchen Lama built a school for higher education here that has now developed into China's largest Buddhist university.

The white chorten of Wu-t'ai-shan, the famous 'five-peaked mountain," incorporates the heart-shaped vase of the Tibetan chorten into the round tower of the Chinese t'a. Wu-t'ai-shan was once an

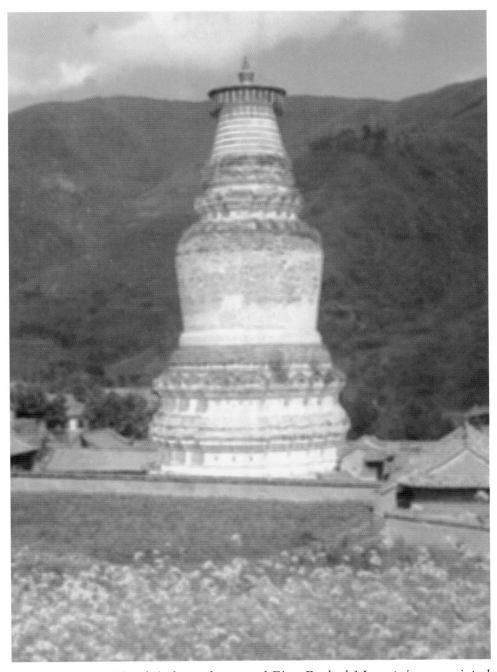

The chorten at Wu-t'ai-shan, the sacred Five-Peaked Mountain, associated with the Great Bodhisattva Mañjuśrī.

unbelievably magnificent Buddhist center. More than one hundred temples rose from its hillside, overlooking canyons and vast forest tracts. Many outstanding masters were associated with this holy place, the home of the Great Bodhisattva Mañjuśrī. Among them was Vimalamitra, siddha and translator of many profound Tantras. An important Vidyādhara of the Atiyoga and Mahāyoga lineages, Vimalamitra lived at Wu-t'ai-shan during the eighth to ninth centuries after working to further Dharma transmission in Tibet.

While there are few practitioners now in residence at this holy place, lamas who have recently visited Wu-t'ai-shan report that the environment is still permeated with the blessings of the Dharma. Some of the temples still remain. The interior walls of a large temple dedicated to Mañjuśrī are lined with Sūtras cast on bronze plaques several inches thick, indicating the dedication to knowledge that made Wu-t'ai-shan a revered focus of practice and pilgrimage for Buddhists of many Asian lands.

KOREA

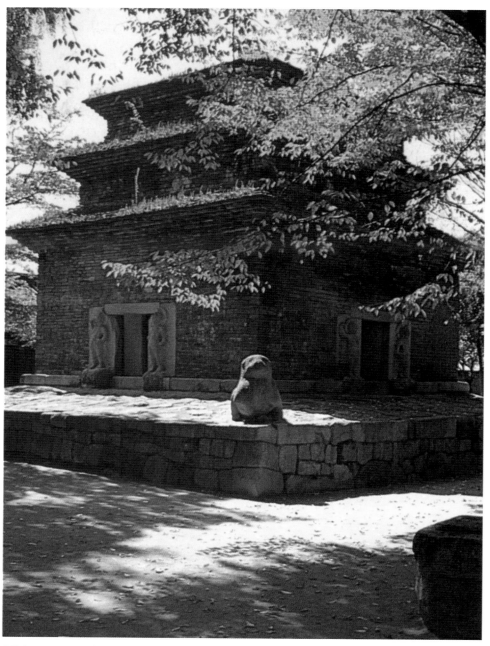

This square, three-storied brick pagoda at Punhwangsa in Kyonngju, built during the United Shilla Period (668–935), is one of Korea's earliest Buddhist stupas existing today.

Korea

The transmission of Buddhism to China led naturally to its transmission to Korea. Korea, governed by China until the early fourth century, continued to value Chinese culture long after Chinese rule ended and readily accepted the view and practices of Mahāyāna Buddhism.

In the early fourth century, when Buddhist monks may have begun to enter Korea, Korea was actually three independent kingdoms: Koguryŏ in the north, Shilla in the southwestern part of the peninsula, and Paekche in the southeastern side. A fourth kingdom known as Kaya briefly carved out an enclave between Shilla and Paekche, but was taken over by Shilla in the sixth century.

Traditional accounts relate that the Chinese monk Shun-tao introduced the Dharma to Kogyuryŏ in 372 C.E., while the Central Asian monk Mālānanda arrived in Paekche in 384. Buddhism was well received in both Kogyuryŏ and Paekche, and Korean monks were soon traveling to China to study at the major centers. The Korean kingdom of Shilla officially accepted the Dharma in 528. The Shillan king Pŏphung eventually became a monk and established Shilla's first monastery, while his wife became a nun.

Buddhism appears to have entered Korea without arousing opposition from the indigenous shamanistic tradition. Places sacred to the spirits of earth and sky were natural sites for Buddhist centers. Shrines honoring these spirits were built at the monasteries and the Korean people continued to venerate them while adopting the tenets of the new religion. A strong respect for the power of nature and the potency of shamanistic practices shaped the unique character of Korean Buddhism.

With the help of the T'ang emperor of China, the kingdom of Shilla took over Koguryŏ and Paekche in the seventh century and unified Korea into a single kingdom. Unification strengthened the Korean Sangha; in turn, Buddhism gave Korean a cultural cohesiveness that bonded the former Three Kingdoms into a nation. Aware of their value, Korean rulers supported the growth of the Sangha and the building of Buddhist centers. Buddhism also gave Korea a common bond with T'ang China, facilitating a free flow of cultural and religious interactions.

Korea now entered a golden age of art and architecture. Skilled artisans, inspired and guided by the Buddhist lineages, were generously supported by the ruling class. The Sangha prospered, and many monasteries and pagodas were built. Among them was Hwangnyongsa, which became the center of Korean Buddhism and produced a steady stream of great masters and scholars.

Close contact with China encouraged the rise of five principal schools based on the Chinese systems: the Vinaya school, the Nirvana school based on the Mahāparinirvāṇa Sūtra, the Dharmatā, Hua-yen, and Fa-hsiang. The Pure Land practice, disseminated by Wŏnhyo, founder of the Dharmatā school, became the most popular with the general public. The Avataṁsaka Sūtra, which emphasizes the teaching of the interdependence of all phenomena, became the major focus of scholarly activities.

Of teachings brought from China in the seventh century (Ch'an, Tantra, and Abhidharmakoṣa), only Ch'an developed a strong following. Ch'an (Korean Sŏn) developed nine lineages and became

known as the Nine Mountain School. Scholarly and meditative traditions merged in the twelfth century, through the work of the Sŏn master Chi-nul, who built on the efforts of an earlier master Ui-chon. Chi-nul founded a temple, Songgwangsa, on Mt. Chogye, which was the center of the Sŏn school for three hundred years. By the fourteenth century, all streams of the Sŏn tradition had merged into the Chogye school.

After the Koryŏ dynasty supplanted the Shillas in 935, Buddhism continued to play a prominent role in Korean culture. The king affirmed that the well-being of the country depended on the protective power of the Buddhas, and succeeding kings generously supported the Dharma. Monasteries were built and supported by the ruling family; examinations instituted by the king promoted scholarly study, and a complete edition of the Chinese Tripiṭaka, compiled from texts collected by Ui-chon in China, was carved onto woodblocks and printed. When these blocks were destroyed by invading Mongols, the king sponsored the creation of a new, more comprehensive edition.

Although the Sangha continued to flourish through the period of Mongol suzerainty, it met with severe restrictions when the Yi dynasty came to power at the end of the fourteenth century. With few remissions, restrictions continued to this century, relegating the practice of Buddhism to the remote mountain regions where the early temples had been founded. Restrictions on the celibate monastic Sangha continued under Japanese occupation (1910–45). After 1945, the monastic Sangha established new temples and schools. Today there are eighteen Buddhist schools in South Korea, all of which adhere to the Mahāyāna. Chogye, encompassing celibates and laity alike, remains the largest of the Korean traditions.

Korean Pagodas

Although Korea has a few brick pagodas modeled after the Chinese, and a few pagodas made of wood can be found, the great majority of Korean pagodas are made of stone and have three, five, or seven

floors. These stone pagodas have proved as enduring as their materials. While most of Korea's ancient temples have disappeared, more than two hundred stone pagodas still stand as reminders of the long history of Buddhism in Korea.

Three Kingdoms Period Few examples of Buddhist art and architecture of the Three Kingdoms period have survived, although paintings on the walls of royal tombs indicate that the early Korean artists possessed a high level of artistic skill. C. Kim describes a rock-cut group of three large images of the Buddha with Maitreya, the future Buddha, on his left and a standing Bodhisattva on his right. Amazingly, this carving, made in Paekche and considered the oldest preserved in Korea, was not discovered until 1959, in a valley near Sŏsan. (BKT 76) Paekche is also the site of the two earliest known Korean pagodas. Both were built of stone, meant to stand through the ages in monasteries and temples in Paekche that have long since vanished, and both were erected prior to the mid-seventh century.

The stone pagoda at Iksan, all that remains of the Mirūksa (Maitreya Temple), is thought to be the earliest pagoda standing in Korea because its stone is shaped to closely replicate the appearance of wooden pagodas. The large square pagoda has six roofs diminishing in size toward the top, but it may actually have been a seven-storied pagoda. It has been partially destroyed, with only one side remaining, but it still stands forty-six feet high.

The five-storied Chŏngnimsa Pagoda rises from central Puyŏ, the last Paekche capital, to a height of twenty-seven feet. It is more slender and lighter-appearing than the Mirūksa Pagoda, and its roofs have a more graceful upward turn. The artisans who produced it appear to have moved beyond the wooden form to a simpler style and a more confident utilization of stone.

A third early pagoda, at Punhwangsa, a temple near Kyŏngju, was considered one of the three treasures of the Shilla kingdom. It is said to have had nine stories before the Tokugawas of Japan destroyed half of it in the course of an invasion. Later, a monk

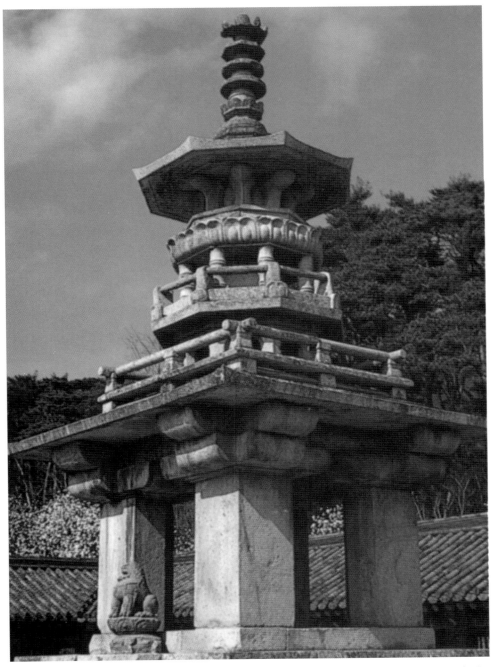

The Prabhūtaratna Stupa (Tabo-t'ap, Stupa of Many Treasures) stands in the courtyard of the Pulguksa, Temple of the Buddha-Land.

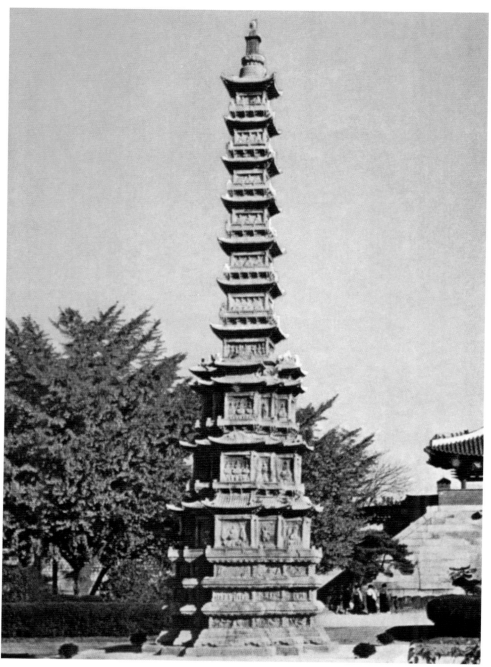

The ornately-carved stone Kyŏngch'ŏnsa Pagoda, now in Seoul, was created in 1348 during the Koryŏ dynasty.

attempting to rebuild it destroyed the other half. The present structure has three stories.

United Shilla Pagodas The United Shilla period was the golden age of images and art in Korea. A monastery and cave temple created during the reign of King Kyŏngdŏk rank high among Korea's architectural treasures. The monastery of Pulguksa, Temple of the Buddha-Land, is one of the earliest Korean temples still in existence. Although its wooden parts have been more recently replaced, the original stonework of foundation, gates, and bridges is intact.

Before the main hall stand two stone pagodas, the Śākyamuni Stupa (Sŏkka-t'ap) and the Prabhūtaratna Stupa (Tabo-t'ap). The three-storied Śākyamuni Stupa rises to a height of twenty-four feet. The unadorned triple-roofed tower, which probably holds relics, stands on two broad platforms, the second smaller than the first. The base is surrounded by a rock and gravel garden defined by a square curb with round rocks carved with lotuses marking the eight directions. The Prabhūtaratna Stupa is an eight-sided stone stupa that stands on a wide platform supported on four massive stone columns. Its staircases at the four directions, flanked on either side by stone stele, recall those on Sri Lankan stupas. Its seven-ringed spire rises above the body of the stupa, which is enclosed in a square railing. Both of these stupas are officially recognized as national treasures.

A short distance from this monastery is the cave temple of Sŏkkuram, which enshrines as its central figure a twelve-foot-high granite image of Śākyamuni Buddha in the earth-touching gesture associated with enlightenment. The Buddha is surrounded by relief sculptures of thirty-seven Bodhisattvas, Arhats, devas, and world-protectors. Also represented is the layman Vimalakīrti, renowned for his dialogue with the great Bodhisattva Mañjuśrī.

Koryŏ Pagodas Among the pagodas built during the Koryŏ dynasty, the Kyŏngch'ŏnsa Pagoda is an unusual and elegant creation. Built of stone, the Kyŏngch'ŏnsa Pagoda was created in 1348 in honor of the ruling family of the Yüan dynasty. Originally erected

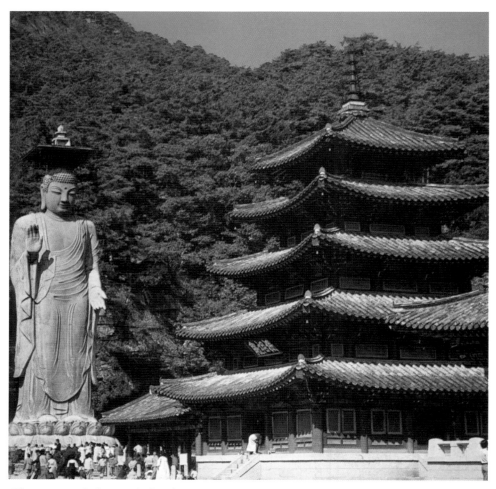

The ground floor of the five-storied pagoda of the Popju Temple, built in 1624, is a Buddha Hall lined with murals depicting the story of the Buddha's life. This pagoda is a registered national treasure.

near Kaesŏng, it now stands forty-four feet high in the garden of the Kyŏngbok Palace in Seoul. Each of its ten floors is carved with representations of the Buddha and ornamented with animal and flower motifs. There are also other distinctively-shaped stone pagodas: The Woljong Temple Pagoda near Pyongyang has nine octagonal stories that reach to a height of fifty feet, and the pagoda at Kuzang Temple, seven feet tall, has thirteen six-sided stories.

The oldest wood pagodas are the five-storied pagoda at the Popju Temple, which dates to 1605 and rises to a height of seventy-four feet, and the three-storied pagoda of Sangbong Temple, which is about thirty-two feet high. The design of the Sangbong Temple, with its long overhanging roofs, is similar in appearance to the Japanese pagoda.

Sacred Forms in New Lands

In the twentieth century, Korean Buddhism has increasingly expanded beyond its traditional regions, carried to Western lands by expatriate Korean communities. In the United States, Western students interested in the practice of Zen have gathered around Chinese, Korean, and Japanese masters to form communities dedicated to study and practice. As these communities develop, they have tended to recreate the special environments conducive to quiet reflection, study, and practice. While the first priority for new communities is generally the Buddha Hall where zazen takes place, the need for pagodas and stupas soon finds expression, first in small replications on altars in temples, and more recently in larger structures outside. As in the past, the emergence of these sacred forms in new lands happens simultaneously, almost miraculously, with the activation of serious Dharma study and practice. The pagoda of the Providence Zen Center (overleaf), recently built in the United States, exemplifies the emergence of traditional pagodas in a new land.

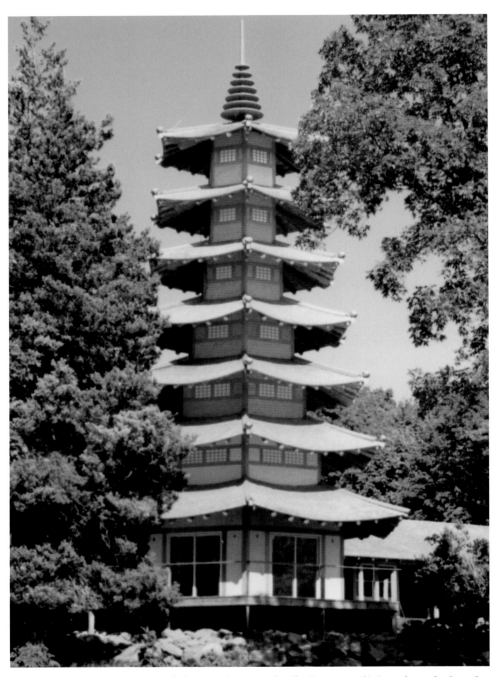

This six-sided seven-roofed pagoda was built in a traditional style by the members of the Providence Zen Center in Rhode Island, U.S.A.

JAPAN

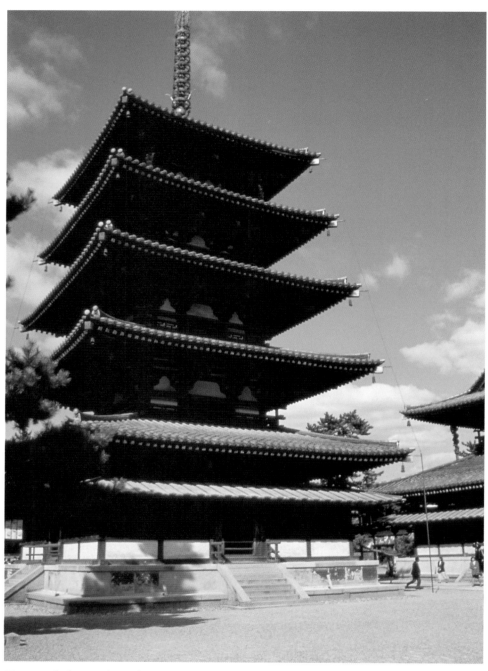

Rescued from demolition in the late 1800s, the pagoda of Hōryūji is a national treasure, a symbol of the beginning of Buddhism in Japan.

Japan

Japan received Buddhist teachings from Korean and Chinese monks between the sixth and seventh centuries. The first recorded presence of Buddhism in Japan traces to Korean envoys sent by King Song of Paekche, who arrived in Japan in the sixth century bearing a gilded bronze image of the Buddha and scrolls of Buddhist texts. Later that century, King Widok of Paekche sent more texts and relics accompanied by Buddhist teachers, a sculptor, and a temple architect, who designed Asukadera, Japan's first temple. Before the century ended, monks from Koguryŏ had also arrived in Japan.

At the close of the sixth century, the Empress Suiko took the vows of a Buddhist nun, and Prince Shōtoku became regent of Japan. A student of the Koguryŏ monk Eji, Shōtoku was attracted to Buddhism's emphasis on harmony and peace and became a strong supporter and patron of the Dharma. He declared Buddhism the national religion and sent the first of many embassies to Ch'ang-an, capital of T'ang China, to study the teachings. In 588 C.E., he built a temple, the Shitennōji, in Ōsaka, and in 607 he sponsored construction of Hōryūji, Japan's first monastery, near his capital at Nara. Upon his death, Hōryūji became a shrine to the benevolent prince

honored in Japan as a Bodhisattva. Endowed with study and teaching facilities, the temple developed into an important center for transmitting the new religion.

By 624, fifty temples had been built and about eight hundred monks and five hundred nuns ordained. Philosophical schools were forming, based on texts and teachings brought from China. Treatises of the San-lun school inspired the Japanese Sanron tradition, and Japanese monks returned from China to introduce Abhidharma and the Fa-hsiang school. The Abhidharmakoṣa became the basis for the academic Kusha school, while Fa-hsiang teachings gave rise to the Hossō school, to which belonged such prestigious temples as Hōryūji, Yakushiji, and Kofukoji in Nara and Kiyomizu in Kyoto.

While imperial patronage supported the construction of pagodas and monasteries throughout the provinces, Nara became the central location for ordination. In the mid-eighth century, Indian, Chinese, and Korean masters introduced Hua-yen to Japan, where it became known as the Kegon school. Nara remained the major center of Japanese Buddhism until struggles for power prompted Emperor Kammu to relocate his capital first to Nagaoka, then to Kyoto in 794.

While Nara retained its significance as a Buddhist center for some time thereafter, other cities also grew in importance as new schools arose. Kyoto in particular became what it is today: the heart of Japanese art and culture, home to all Japanese Buddhist traditions, and a vital spiritual center visited annually by hundreds of thousands of Japanese pilgrims. Here are found major temples of all Japanese Buddhist traditions: Tōji, the first temple of the Shingon school, Japan's only Vajrayāna tradition; Kiyomizu, a temple of the Hossō school; Myōshinji, center of Eisai's Rinzai school of Zen Buddhism; Chion-in, central temple of Jōdoshū (Pure Land School); and Nishi (Western) and Higashi (Eastern) Hongwanji, headquarters of the two orders of Jōdoshinshu (True Pure Land School). To the north and south of Kyoto, on Mt. Hiei and Mt. Kōya, arose Japan's greatest monastic complexes: Enryakuji, center of the Tendai (T'ien-t'ai) tradition, and the great Shingon center of Kōyasan.

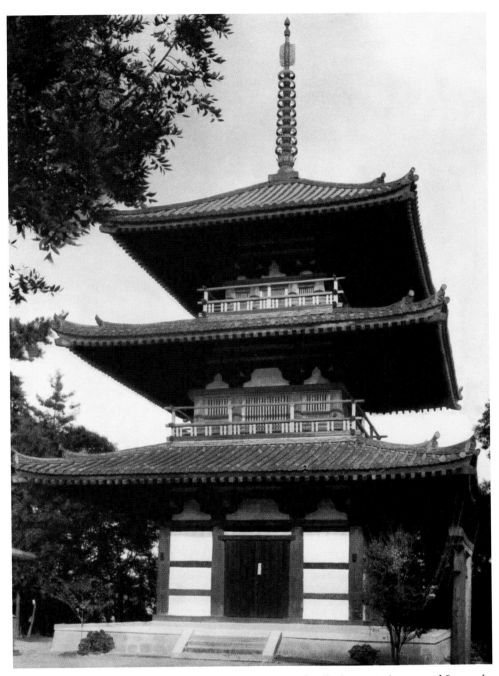

The three-storied pagoda of Hokkiji in Nara, built in 706, is one of Japan's oldest surviving pagodas.

Zen, based on the Ch'an traditions of China, became a major influence on Japanese culture between 1184–1333, when Kamakura was the administrative center of the Japanese Shogunate. With this shift of power northward, religious and artistic traditions began to locate in Kamakura, which became a center of Buddhism as well as a focus of Japanese culture.. Near Kamakura, Dōgen, founder of Sōtō Zen, established his center, Eiheiji, in Echizen province in the thirteenth century.

Political disorder brought the Kamakura period to an end. Several Buddhist schools were drawn into the upheavals and numerous temples were destroyed. When the Tokugawa Shōgunate restored peace in the seventeenth century, it imposed restrictions on all schools. In some parts of Japan Buddhism continued relatively free of regulations, with Zen in particular supporting a strong tradition of integrating spiritual practice with everyday activities.

Japanese Pagodas

Through centuries of political turmoil, Japan has preserved the texts, art, and sculpture of its early period of Dharma transmission. The ancient capital of Nara is a living museum: Here are found the Hōryūji Pagoda, one of the world's oldest wooden structures, and equally ancient wooden statues of great spiritual beauty. The city of Kyoto has nearly eighteen hundred temples and shrines, many of major historical and artistic importance.

In this land of frequent, sometimes devastating earthquakes, multitiered wooden pagodas seem to have a magical power to withstand the forces of nature. Rising three, five, or seven stories on a relatively slender square base, their distinctive form and the dignified elegance of their upcurving roofs are inspiring reminders of the harmonious and enduring quality of the Dharma.

Of all the Chinese styles, Japanese Buddhists selected the square pagodas with overhanging roofs and developed this single style to a high level of perfection. This style was introduced to Japan by

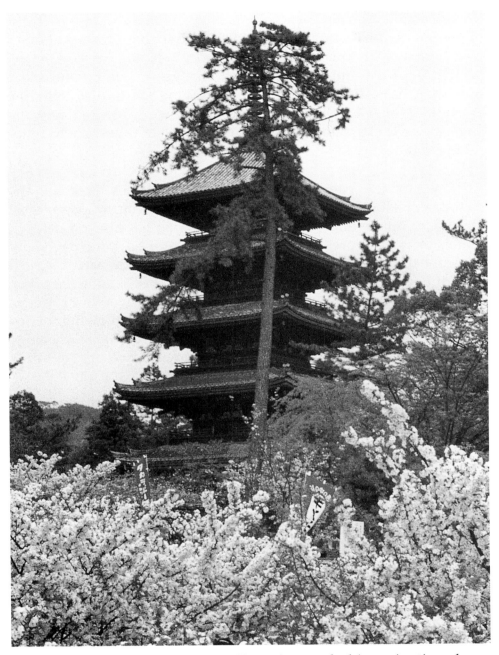

The pagoda of Ninnaji in western Kyoto is wreathed in springtime cherry blossoms, poignant reminders that the vigor of youth will fade and that precious opportunities for enlightenment must not be wasted.

Korean architects from Paekche, who built Asukadera, Japan's earliest temple, and its central pagoda in the late sixth century. Although stone stupas with much shorter roofs exist in Japan, wood, a material that expands and contracts with changes in temperature and humidity, has a living, breathing quality that admirably suits the symbolism of the pagoda. These features were worked into the yagirobe style characteristic of Japan's elegant and durable five-storied pagodas.

The Japanese pagoda generally has three stories, as seen in the pagodas of Hokkiji and Tōji, or five stories, as in the pagodas of Hōryūji, Ninnaji, and Murōji. Some pagodas have seven or even more stories, as represented in the thirteen-storied stone pagoda at Uji or the thirteen-storied thatched-roof pagoda at Tanzan. A special type of pagoda known as Tahoto, favored by the Shingon tradition, characteristically has two roofs. The roofs of the wooden pagodas are characterized by a long overhang on the eaves, allowing them a graceful curving line supported by parallel rafters placed below. The three, five, seven, or even more roofs are stacked one on top of the other, each smaller than the one below.

The lowest roof of the earliest Japanese pagodas was broader than the upper roofs and relatively close to the ground, but the Japanese soon developed ways to heighten their pagodas without the need for this broad stabilizing base. This change can be seen by comparing Hōryūji, built in the seventh century, with more recent pagodas. The roofs of more recent pagodas have a more uniform overhang, and the bracketing of the roof supports provides a much more complex and stronger layering system. This bracketing system, which created aesthetically pleasing patterns, became the hallmark of Japanese Buddhist architecture.

The architecture of Japanese pagodas has enabled them to survive centuries of earthquakes that would have seriously weakened or destroyed most tall and slender wooden buildings. No nails are used in their construction; the pagoda is designed to shake and move with earth or with wind. As a consequence, Japan's pagodas

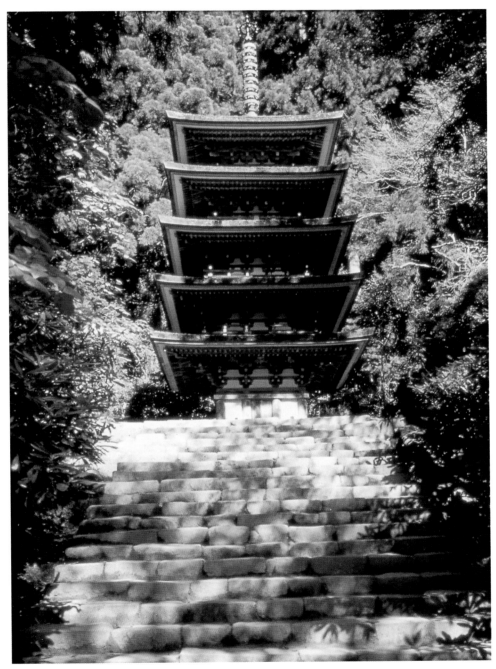

The pagoda of Murōji, an eighth-century mountain temple near Nara, is positioned high on a stone platform in a verdant setting.

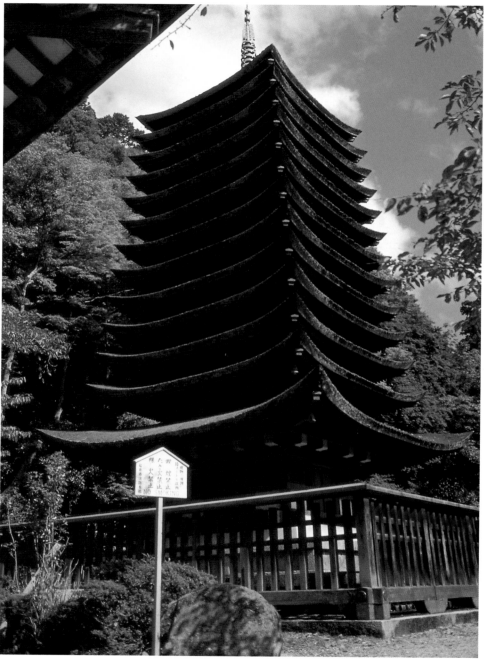

The thirteen-roofed pagoda of the Tanzan Shrine in Nara, built in 1451, is ranked as one of Japan's important cultural properties.

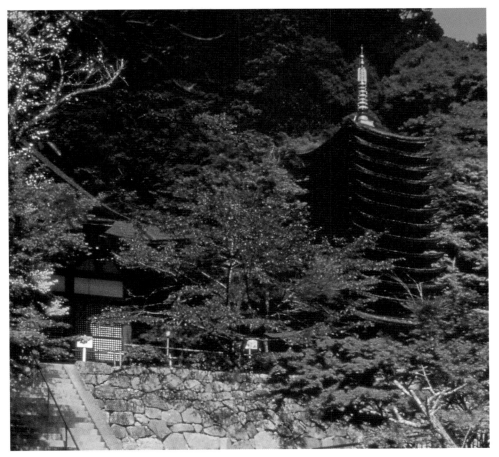

The pagoda rises dramatically above the Tanzan shrine in a setting distinguished by natural beauty.

are among the oldest wooden structures in the world. Of all the elements, fire is their major nemesis.

Among the special features of the Japanese pagoda is the shinbusha, the heart-wood, the great pillar shaped from a tall straight tree that runs the full length of the pagoda and extends into the ground; in the Hōryūji pagoda, its depth is nearly ten feet. Although the shinbusha appears to be a central weight-bearing element, in actuality it serves no structural purpose except possibly to maintain the essential alignment of the stacked floors during an earthquake.

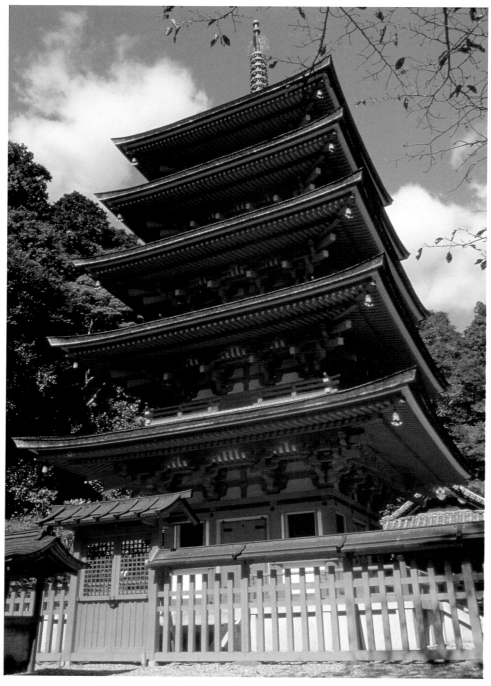

The pagoda of Hasedera Temple, Kamakura.

In fact, it was recently discovered that the central pillar of Hōryūji's ancient pagoda had rotted away at the ground level and no longer made contact with the ground, yet the building continues to stand.[1]

The relics of Japanese pagodas are usually enshrined in a chamber built into the center of the foundation and ceremonially consecrated before the rest of the building is constructed. The heart-wood pillar is placed at the center and surrounded by four smaller pillars, the shitembashira, and twelve outer posts, the gawabashira. Neither the shitembashira nor the gawabashira extend beyond a single story. Each story is supported by its own pillars and rafters in an ingenious interdependent arrangement. The spire at the top, generally made of iron, has nine rings topped by a finial.

Like Chinese and Korean pagodas, the Japanese pagoda is constructed to allow access for circumambulation, but has no access to the upper stories, which are not used. The walls may be painted with images of the Ādibuddha, Buddhas, and Bodhisattvas, reflecting the pagoda's mandalic orientation.

Hōryūji It is said that Prince Shōtoku built Hōryūji to fulfill the wish of his deceased father, Emperor Yōmei. Since that time, Hōryūji has been cherished as a grand reminder of filial piety. Completed in 607, Hōryūji became the major center of Buddhism, which rapidly expanded in the early seventh century. In honor of its prominent position, it became known as Hōryū-Gakumonji, or the Temple of the Way and Learning. Archaeological research indicates that the Hōryūji pagoda burned to the ground, presumably in 670, but was soon rebuilt and repositioned to align with the north star. (EBA 72) It now stands next to Hōryūji's Golden Hall. Buildings on the twenty-five acres of land surrounding the temple house priceless cultural and spiritual treasures, including Hōryūji's three famous statues, the Kudara Kannon (Avalokiteśvara), Yumechigai Kannon, and Amitābha.

1. Atsushi Ueda, "The Long-Standing Mystery of Japan's Imperturbable Pagodas," *Look Japan* 42:485 (August 1996), pp. 22–24.

The iron ornament from the top of a pagoda at Yakushiji, as preserved in the Nara Museum.

Yakushiji Yakushiji is one of Nara's seven largest temples. During the eighth century, as the headquarters of the Hossō (Vijñānavāda) School, it was one of the most important temples in Japan. It was built in Asuka, on the southern side of Nara, around 680 C.E., then moved to its present location in Nishinokyo, a short distance west of Nara, in 720. Two pagodas once stood like giant sentinels before Yakushiji's main hall, but only the eastern pagoda survived the fire that destroyed Yakushiji in 1528. Recent reconstruction efforts are recreating the ancient temple complex. The western pagoda, the Buddha Hall, and the Picture Hall have been rebuilt, and work continues to restore Yakushiji to its original appearance. Yakushiji's bronze statues rank among Japan's national treasures, as does its ancient eastern pagoda.

Although six roofs extend from their centers, the Yakushiji pagodas actually have only three primary roofs. The smaller intermediary roofs are an architectural device that permits a larger ground plan. However, this design appears to have served as a transitional style; no copies of it are known to exist.

Tōdaiji Tōdaiji, located in Nara, is the headquarters of the Kegon school. Here the largest wooden building in the world enshrines a massive 167-foot-high bronze statue of Vairocana Buddha. Begun in

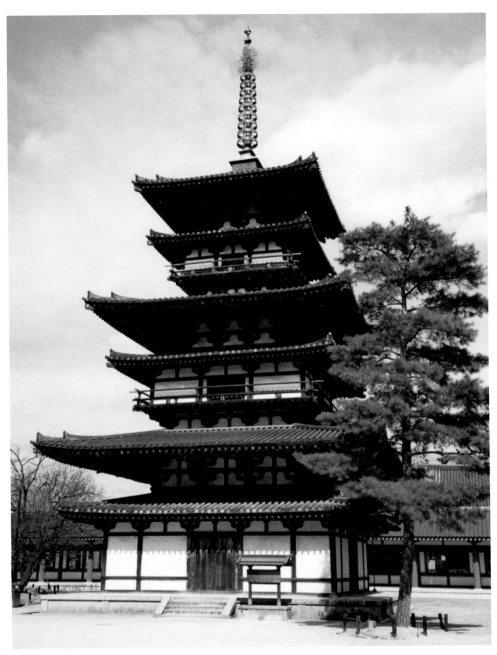

The eastern pagoda of Yakushiji, erected in Nara around 718, is a rare example of a three-roofed pagoda with smaller intermediate roofs. The pagoda is about 110 feet high; its iron spire (sōrin) is thirty-seven feet.

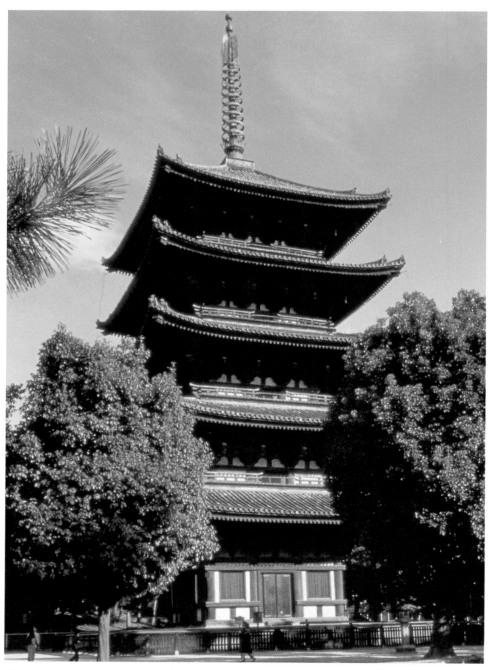

The five-story eastern pagoda of Kofukoji, a temple of the Hossō school and one of the main temples in the central park of Nara.

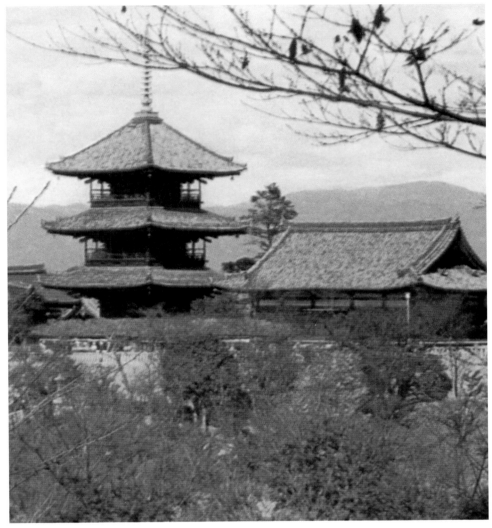

The pagoda of Kiyomizu, a temple of the Hossō tradition overlooking Kyoto, founded in the Heian Period and most recently rebuilt in 1633.

745, Tōdaiji was completed in 752, when it was consecrated by a great assembly of monks from Japan, India, and China. Until 1180, two seven-roofed pagodas, the tallest ever built in Japan, stood in front of the Buddha Hall. These pagodas, like numerous other buildings and works of art in Nara, were destroyed in the struggles between the Taira and Minamoto clans that erupted in the twelfth

207

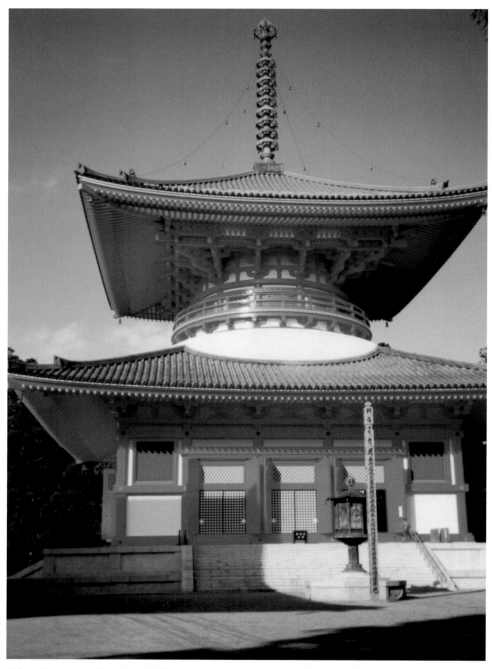

The Kompon Daitō of Kōyasan Monastery, initiated by Kukai, founder of the Shingon school, exemplifies the Tahoto style.

century. Although the great Buddha Hall has been rebuilt twice since that time, the pagodas have never been restored.

Tōji Tōji, East Temple, was the first temple built in the new capital of Kyoto. As the most important surviving temple of the Heian (Kyoto) Period of Japanese history, it is one of the city's great treasures. The Tōji Pagoda, the highest in Japan, rises east of the Main Hall. The temple houses fine statues of the Buddha Dainichi surrounded by four Buddhas of the Diamond World, accompanied by the five peaceful and five wrathful Bodhisattvas.

Kompon Daitō, Kōyasan Construction of the Kompon Daitō, the great stupa of Kōyasan monastery, was initiated by Kukai, founder of the Shingon tradition, and completed in 835, shortly after his death. The two-roofed pagoda exemplifies the Tahoto style, the Japanese form of Prabhūtaratna, the Stupa of Many Treasures. This form of pagoda most closely reflects the elements of the Indian stupa. Between its two roofs is nestled a stupa-shaped hemisphere, its central reliquary. On the ground floor is a Shingon shrine constructed as a mandala of the five Dhyāni Buddhas, with Vairocana as the central image. (SKB 44)

The Kompon Daitō, like all pagodas of this type, has an intricate symbology that reflects the world view of the Shingon tradition. Its measurements, proportions, and methods of construction are a carefully guarded part of the Shingon esoteric transmission. The extensive Kōyasan complex has two other important Tahoto pagodas: the Kongo Sammai and the pagoda of the Ryohōin, where four smaller towers surround the central stupa. (SKB 44)

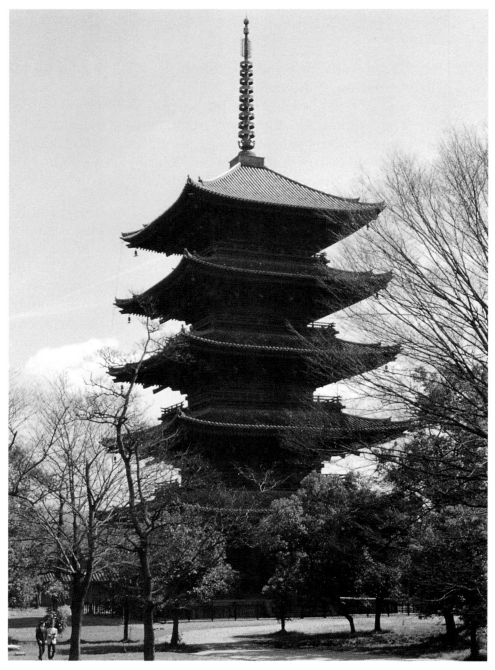

The soaring five-roofed pagoda of Tōji in Kyoto exemplifies the harmony and interdependence of the spiritual and natural realms.

210

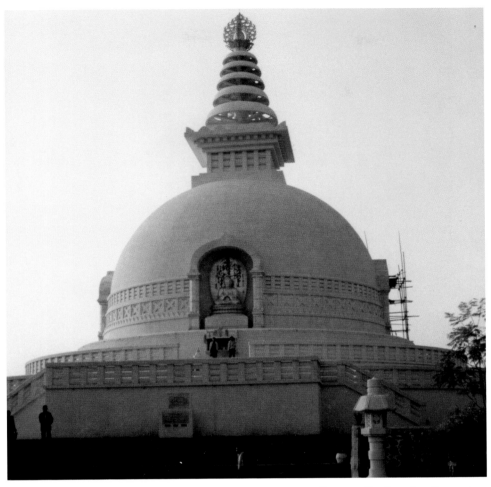

The Viśvaśānti Stupa, recently built in Rājagṛiha, India by the Japanese Sangha, mirrors the Nihonzan Myōhōji, recently built near Mount Fuji.

Nihonzan Myōhōji In recent years, Japanese Buddhists have supported the building of temples and stupas in the holy places of India. The large white stupa of Nihonzan Myōhōji, Japan's only large stupa built in the traditional Aśokan style, symbolizes this sense of connection with the homeland of the Buddha. Located near Mount Fuji, this stupa became the model for the Viśvaśānti Peace Stupa erected in India on Chaṭha Hill overlooking Rājagṛiha and the Vulture Peak.

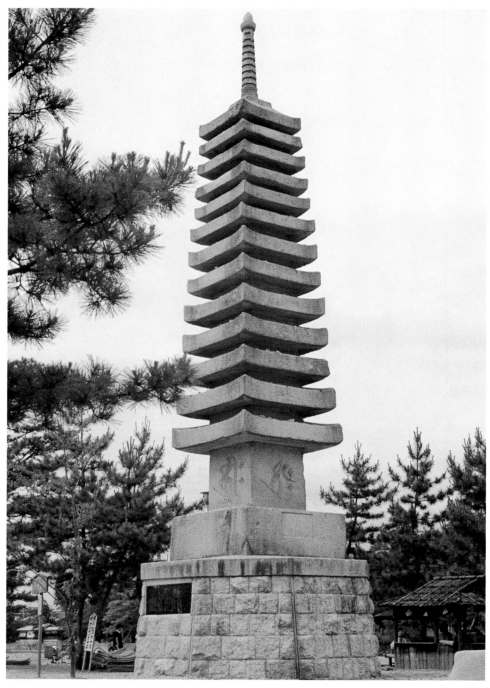

The thirteen-level stone pagoda at Uji, Japan.

THE EIGHT
MAHĀCAITYAS

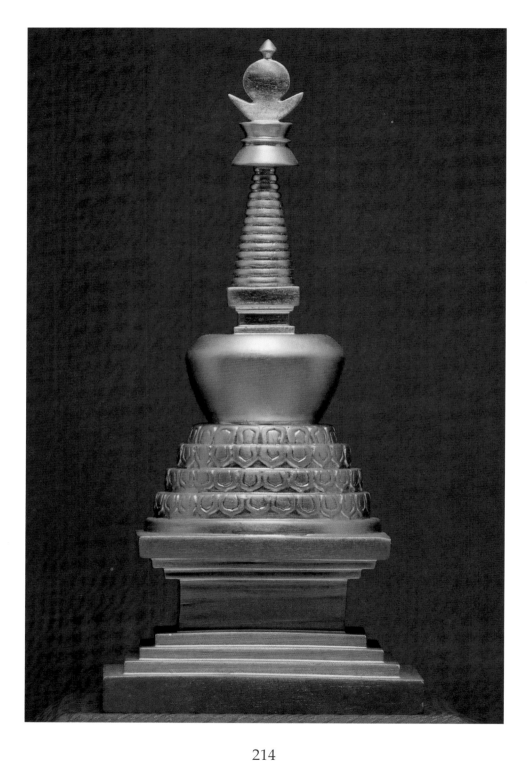

214

The Eight Mahācaityas

In his Aṣṭamahāsthanacaitya-stotras (NE 1133–1134), the great master Nāgārjuna associates the Eight Mahācaityas with specific actions and places that correspond with the four primary places of pilgrimage and the four wondrous actions: birth in Kapilavastu, enlightenment on the banks of the Nairañjanā River (Bodh Gayā), turning the wheel of the Dharma at Vārāṇasī, overcoming the six philosophers and opening the doors of the Dharma at Śrāvastī, descent from the Trāyastriṁsa heaven at Saṁkāśya, reconciling dissension and unifying the Sangha at Rājagṛiha, demonstrating supernormal control over lifespan at Vaiśālī, and parinirvāṇa in the śāla grove near Kuśinagara.

More than 2,500 years ago, the Buddha gave guidelines for the construction of stupas and described the value of devotional practices directed to them. It is clear from these teachings that the purpose of creating, caring for, and honoring a stupa is not to honor

1. The Stupa Arrayed with Lotuses (sKu-bltams mchod-rten) calls to mind the Buddha's birth at Kapilavastu. The steps in the middle are round and encircled with lotus petals.

215

what is dead and gone, but to attune oneself and others to the undying heart of reality, the source of all happiness and enduring joy. Eloquent shrines to life, stupas embody the view and actions that fully and fearlessly embrace the reality of human existence, finding within the transience that defines the rise and decline of all phenomena the timeless current of becoming. It is this realization, that we participate simultaneously in the singular and universal, that heals loneliness and separation, gives meaning to life, and confers the power to appreciate whatever arises.

The forms of the Eight Mahācaityas point the way to this realization. In awakening us to the nature of our being and moving us toward integration, these stupas are truly banners of victory over illusion and reminders of Dharmakāya, the living heart of the Buddha. In respecting the stupa we respect our own potential for enlightenment. In bowing down in its presence, we invite the awakening of Bodhicitta; in circumambulating it we move through the mandala that radiates from its center, attuning our being to a fundamental harmony and order. The stupa, born from the generosity and compassion of the Enlightened Ones, receives our offerings, cleanses from them the most subtle residues of self-interest, and projects them purely back into the world.

The Sūtras explain the benefits of circumambulating stupas, maintaining them, and beautifying them with offerings of gold, flowers, incense, and devotion. In so doing, one honors the precious seed of enlightenment inherent in self and others and enriches the soil in which it can grow. The verses that follow are a translation of the Caitya-pradaksina-gāthā, preserved in the bKa'-'gyur, the section of the Tibetan Canon devoted to the direct teachings of the Buddha. (NE 321)

2. The Stupa of the Great Enlightenment (Byang-chub-chen-po'i mchod-rten) has four steps that are regular and unembellished. This stupa honors the Buddha as an embodiment of enlightenment demonstrated at Bodh Gayā.

216

217

Verses for Circumambulating a Stupa

Homage to the Three Jewels

After the Buddha, the One of Great Wisdom, had turned
the Dharma Wheel in the world, the wise one Śāriputra
humbly asked,

"What are the results that come from circumambulating
a stupa? May the Guide of the supreme universe
of this great kalpa please advise me."

The perfect Buddha, supreme among two-legged beings,
the Enlightened One, granted this reply: "I will indicate
a few of the qualities gained from circumambulating stupas.

"When you circumambulate a stupa you will be honored
by gods, nāgas, yakṣas, gandharvas, and asuras, by garuḍas,
kinnaras, and mahoragas.

"Once you gain the leisure, so very rare, and circumambulate
a stupa for even a very short time, the eight adverse states
will be no more.

"Circumambulating a stupa will have this result:
mindfulness and clear perception; a radiant appearance
and intelligence; and you will be honored everywhere.

"Circumambulating a stupa will have this result:
a very long life—a lifetime more like that of a god—
in which you will obtain great renown.

*3. The Stupa of Auspicious Manifold Doorways (bKra-shis sgo-mangs
chos-kyi 'khor-lo'i mchod-rten) indicates the opening of the doors of the
Dharma in Vārāṇasī. Four, eight, twelve, or sixteen doors in each of the
four directions symbolize the Four Truths, eight deliverances, twelve links
of Pratītyasamutpāda, or sixteen śūnyatās.*

"Circumambulating a stupa will have this result:
rebirth in Jambuling in a family of worthy line
and virtuous mind.

"Circumambulating a stupa will have this result:
You will be pure as the snow; you will be good,
radiant, and wise, and you will lead a happy life.

"Circumambulating a stupa will have this result:
wealth of every kind; freedom from greed;
generosity and joy in giving.

"Circumambulating a stupa will have this result:
You will be a true delight, beautiful to behold, radiant,
a joy to see, and endowed with vast enjoyment of life.

"Circumambulating a stupa will have this result:
You will see the whole process of perception as empty,
and, bewilderment about the Dharma ended,
you will quickly obtain the state of bliss.

"Circumambulating a stupa will have this result:
You will be reborn in an imperial line of kings with
a circle of female attendants, and you will have
great strength and perseverance.

"Circumambulating a stupa will have this result:
You will be reborn in the great Brahmā's lofty realm,
where you will possess self-discipline, profound
understanding, and knowledge of healing rituals.

"Circumambulating a stupa will have this result:
You will be reborn in Gṛihapati's lofty realm,

4. The Stupa of Displaying the Great Miracle (Cho-'phrul mchod-rten) commemorates the Buddha's defeat of the tīrthika philosopher-magicians in the shade of a mango tree in Śrāvastī and the wondrous displays that attended it. This stupa has projections in each of the four directions on each of the four steps.

provided with all sorts of riches
and a wealth of grain and jewels.

"Circumambulating a stupa will have this result:
You will be reborn as a lord of Jambuling,
with a domain extending to the ends of the earth,
and you will be a Dharma king.

"Circumambulating a stupa will have this result:
You will be reborn as a cakravartin king, possessing
the seven most precious supports for a king;
accordingly, you will turn the Dharma wheel.

"Circumambulating a stupa will have this result:
After death you will pass to the higher realms;
rejoicing in the Buddha's doctrine, you will be
a yogin and a miracle-worker.

"Circumambulating a stupa will have this result:
You will pass from the realm of the gods to be reborn
in the human realm, and will enter the womb
with clear intent.

"Circumambulating a stupa will have this result:
You will never be harmed by the contaminants
that come from the conditions of the womb—
you will be like the purest of gems.

"Circumambulating a stupa will have this result:
You will dwell happily in the womb, you will be born
easily, and joyfully you will drink at the breast.

5. The Descending from Heaven Stupa (lHa-babs mchod-rten) has stair-cases built into each of its four sides. It commemorates the Buddha's descent from the Trāyastriṁśa heaven at Saṁkāśya after teaching the Abhidharma to his mother, and it symbolizes the coming of the Tathāgatas for the sake of sentient beings.

"Circumambulating a stupa will have this result:
You will have a father who will ensure you
the finest care by many attendants
and a nursemaid who is always attentive.

"Circumambulating a stupa will have this result:
Your relatives will adore you, loving you even more
than your parents do. And as you grow,
your pleasure will steadily increase.

"Circumambulating a stupa will have this result:
Flesh-eaters and other demonic beings will not harm you,
and you will live a life of flawless enjoyment.

"Circumambulating a stupa will have this result:
For one hundred kalpas your body will be perfect;
you will never be crippled or blind.

"Circumambulating a stupa will have this result:
Your eyes will become totally pure: oblong, sapphire-
hued, and beautiful like the eyes of the gods.

"Circumambulating a stupa will have this result:
Both body and mind will be well-balanced,
your determination unswerving, and your shoulders
broad and dependable.

"Circumambulating a stupa will have this result:
Your body will be powerful and perfectly shaped,
completely and beautifully adorned
with wondrous characteristics.

6. *The Stupa of Reconciling Dissension Among the Sangha (dGe-'dun-gyi-dbyen-'dum-pa mchod-rten) is known as the stupa of true compassion in Rājagriha. The steps of this stupa are octagonal; each has eight corners and eight sides. This stupa calls to mind the infinite qualities through which the Buddha manifests for the sake of sentient beings.*

"Circumambulating a stupa will have this result:
You will become Indra, Lord of the Thirty-three—
the one with miraculous abilities, the great Lord of Gods.

"Circumambulating a stupa will have this result:
You will become the king of the gods of the heaven
called Yāma or Tuṣita or of the heaven Nirmāṇarati
or Parinirmita-vaśavartin.

"Circumambulating a stupa will have this result:
You will gain the power of Brahmā himself in the
world of Brahmā, and you will be worshipped
by many tens of millions of gods.

"Circumambulating a stupa will have this result:
For one thousand times ten million kalpas—
and one hundred times one hundred billion more—
you will be endowed with wisdom and always honored.

"Circumambulating a stupa will have this result:
For one thousand times ten million kalpas your body
will be pure and your attire pristine as you practice
the immaculate Dharma.

"Circumambulating a stupa will have this result:
You will gain strength and perfect vitality,
and setting laziness aside, you will obtain
the supreme accomplishments.

"Circumambulating a stupa will have this result:
You will become steadfast and dynamic:
through immense ability, unstoppable,
quickly achieving the highest aims.

7. *The Stupa of Longevity (sKu-tshe byin-gyis brlabs-pa'i mchod-rten)*
commemorates a Tathāgata's ability to control the extent of his life, a teach-
ing given at Vaiśālī, when the Buddha announced he would soon enter
parinirvāṇa. This stupa has three round steps that call to mind the three
doors of deliverance.

"Circumambulating a stupa will have this result:
You will obtain a melodious voice with a pleasing pitch
and a dulcet tone. You will never be harmed
and you will be free from disease.

"Circumambulating a stupa will have this result:
You will quickly reach the stage of Enlightened Teacher
such as I myself, and you will obtain rebirth as a great sage.

"Circumambulating a stupa will have this result:
You will soon obtain the four foundations of mindfulness,
the Four Immeasurables of Mind, and the powers
of the Bases of Miraculous Ability.

"Circumambulating a stupa will have this result:
You will achieve the Four Noble Truths,
the powers and the strengths, and the fruit
of the limbs of enlightenment.

"Circumambulating a stupa will have this result:
You will obtain the six superknowledges, unstained,
having cast off all the emotional fetters,
and you will become a wonder-working Arhat.

"Circumambulating a stupa will have this result:
Having cast off desire and hatred and having given up
all your attendants, you will gain the enlightenment
of a Pratyekabuddha.

"Circumambulating a stupa will have this result:
You will be ornamented with the marks of the Tathāgatas
manifest in the world, and you will obtain a body of golden hue.

8. The Parinirvāṇa Stupa (Myang-'das mchod-rten) recalls the Buddha's last great act at Kuśinagara. The base of the vase of the Parinirvāṇa Stupa rests directly on the throne with no steps in between. This form of stupa indicates the calming and purification of mind.

"Circumambulation is a physical act; circumambulation
is an act of speech as well; circumambulation is an act
of the mind; circumambulation instills the aspiration
for enlightenment. By circumambulation, you achieve
your aims in all the stages of bliss so hard to traverse.

"What then are the benefits of circumambulating the stupa
of the Lord of the World? Although words are far too limited
to express them well, out of mercy for sentient beings,
and as requested by Śāriputra, the Lord of the World
will indicate the benefits of honoring the stupa.

"The value of one hundred horses, one hundred measures
of gold, one hundred chariots drawn by mules, one hundred
chariots drawn by mares and filled with precious jewels
could not even begin to equal one sixteenth part
of one step of one circumambulation.

"One hundred maidens of Kamboja wearing jeweled
earrings, with circlets of gold upon their arms and
adorned with rings and necklaces of the finest gold;
one hundred elephants, snowy white, robust and broad-backed,
adorned with gold and jewels, carrying their great trunks curved
over their heads like plowshares, could not even begin to equal one
sixteenth part of the value of one step of one circumambulation.

"O wise one, the benefit of those who joyfully take one step around
the Buddha's stupa is unmatched by the benefit of gaining one
hundred thousand measures of gold from the gold river of Jambu.

"O wise one, the benefit of those who joyfully offer
a clay bowl to the Buddha's stupa is unmatched by the benefit
of those with one hundred thousand palaces made of gold
from the gold river of Jambu.

"O wise one, the benefit of those who joyfully heap flowers
before the Buddha's stupa is unmatched by the benefit
of having one hundred thousand vessels made of gold
from the gold river of Jambu.

"O wise one, the benefit of those who joyfully bear flower garlands
for the Buddha's stupa is unmatched by the benefit
of having twenty million bales.

"O wise one, the benefit of those who joyfully sprinkle
perfumed water upon the Buddha's stupa is unmatched
by the benefit of having one thousand hillocks of gold
made from the gold river of Jambu.

"O wise one, the benefit of those who joyfully offer butter lamps
to the Buddha's stupa is unmatched by the benefits
of having one hundred thousand times ten million measures
of gold from the gold river of Jambu.

"O wise one, the benefit of those who joyfully offer
victory banners, pennants, and parasols to the Buddha's stupa
is unmatched by the benefit of those who possess
one hundred thousand great mountains of gold.

"These are the teachings on the benefits of making offerings
to the immeasurable Tathāgata, to the perfect Buddha
who is like the ocean, who is the consummate leader of beings.

"There is no difference between the merit of those
who make offerings while I am here and those
who make offerings after my nirvana,
if their virtuous intentions are the same.

"Such is the inconceivable Buddha;
so also the inconceivable Buddhadharma;
for those with faith in the inconceivable,
inconceivable are the results."

This completes the verse on circumambulating a stupa,
known in Sanskrit as the Caitya-pradakṣiṇa-gāthā
and in Tibetan as mChod-rten bskor-ba'i tshigs-su bcad-pa.

Elements of the Mahācaitya

The stupa's form represents the structure of the path to enlightenment, the interplay of the five elements, and many further aspects of the knowledge that has been so abundantly developed in the Buddhist traditions. Tibetan masters analyzing the stupa's forms base their works on the teachings of Nāgārjuna, who identified the essential shapes of three major receptacles of Dharmakāya: inverted almsbowl, small house-type edifice, and victory banner.

Drakpa Gyaltsan (1147–1216) explains that each shape has specific symbolic significance. The inverted almsbowl, placed on a lotus and a lunar disk, symbolizes the pristine nature of Dharmakāya unadorned with any attribute whatsoever. The small house, square and beautiful, single or multi-storied, conveys the perfect completion of Dharmakāya qualities. The victory banner, represented by the chorten (Sanskrit caitya), symbolizes the actions that overcome illusion, evoke the aspiration for enlightenment, and support its fulfillment. The eight specific forms of the chorten are known as the eight Mahācaityas.[1]

House Stupa

The inverted almsbowl form, exemplified by the Aśokan stupa, is a hemisphere rising from a three-stepped base, topped by a harmikā and a staff-like pinnacle. The simple "small house" style (chorten kangtse) requires no specialized knowledge and can be built by laypeople. It was among the first style to be used in China, but it is now rarely built even in Tibet. The diagram below illustrates the ten parts of the house style as known in Tibet.

1. From Drakpa Gyaltsan's A-gya'i cho-ga dang rab-tu gnas-pa don gsal-ba, as romanized by Yael Bentor in "In Praise of Stupas." *Indo-Iranian Journal* 38:1 (Jan. 1995):33

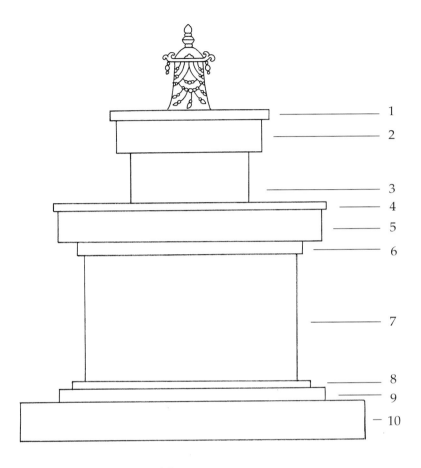

1. kha-gyan
2. bre
3. bre-gdan
4. kha-rgyun
5. bad-chen
6. bad-chung
7. dmangs
8. them-skas
9. ge-sar
10. sa-gdan-dam-stengs-bu

The Twenty-Four Elements of the Chorten

1.	sa-'dzin	foundation
2.	them-skas	stairs
3.	gdong-chen	face
4.	gsung-sne	edging or hem
5.	bad-chung	small lotuses (small border)
6.	bad-gam	large lotuses (balcony)
7.	dge-bcu	the ten virtues
8.	bang-rim	steps
9.	'bum-gdan	seat of the vase
10.	sgo-khyim	door of the vase
11.	'bum-pa	vase
12.	bre-rman	foundation of the harmikā
13.	bre-rten	support of the harmikā
14.	bre	harmikā
15	gdugs-'degs-padma	lotus parasol
16.	chos-'khor-bcu-gsum	thirteen dharmacakras
17.	mo-'khor	mother cakra (space in between)
18.	pho-'khor	father cakra
19.	zar-tshag	canopy
20.	thugs-rje-mdo-gzungs	symbol of compassion
21.	char-khebs	rain cover
22.	zla-ba	moon
23.	nyi-ma	sun
24.	tog	top

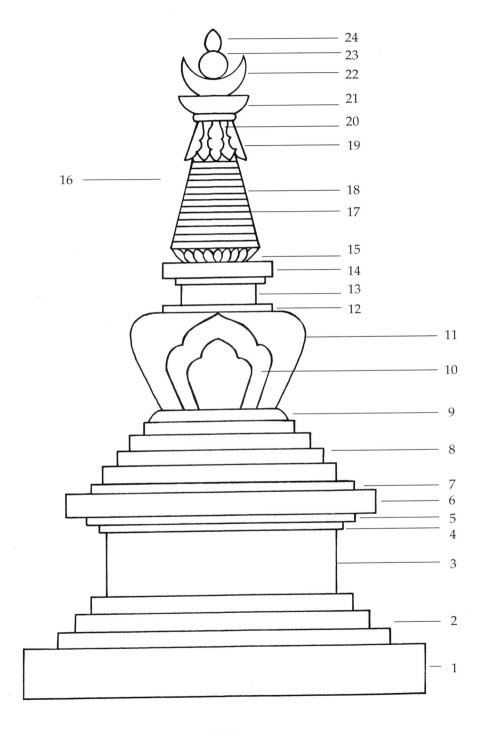

Symbolism of the Chorten

While all three forms of stupa are known in Tibet, the chorten, modeled on the banner of victory, is the style usually built. Tibetans further distinguish two types of chorten, the dudul chorten, created to pacify chaotic natural forces, and the namgyal chorten, which enshrines relics of the Buddha or highly realized lamas.

As traditionally described, all eight forms of chorten have twenty-four parts that are constructed according to precise proportions. These parts may be enumerated somewhat differently; often parts 2–6 are grouped together in a single unit, the lion throne, in which case each of the four terraces is listed separately. While some masters describe the thirteen rings as the ten stages of the Bodhisattva path and the three foundations of mindfulness specific to a Buddha, others relate the first ten rings to the ten powers of the Buddha. A close analysis of available texts may reveal additional variations, but the purpose remains the same: The chorten, like a victory banner, points the way to liberation. The naming and consecration of its parts transforms them into the body of the teachings: They become empowered symbols of the path and its realization.

In consecration instructions from the Kāyavākcitta-supratiṣṭhā-nāma (NE 2496) the great paṇḍita Atīśa says,

"Blessings! For the chortens' foundation, the Dharmadhātu is the base the lion throne as the four fearlessnesses rests upon. The terrace steps proceed in stages from the ten virtues: The first, the four foundations of mindfulness; the second, the four genuine restraints; the third, the four bases of supernormal powers; and the fourth, the five spiritual faculties. The base of the vase are the five strengths; the vase is the seven limbs of enlightenment; and the foundation and support of the harmikā are the eightfold noble path. All these relate to the cause of realization. The remainder relate to the result: The heart-wood is the ten knowledges; the harmikā is the four enlightened wisdoms and the four deliverances; the thirteen wheels are the ten stages of the Bodhisattva path and the three

applications of mindfulness. The parasol (raincover) is the protection of compassion, and the top is the pristine Dharmadhātu."

The foundation as Dharmadhātu: the realm of Dharma, at once the foundation and the context of the whole.

The lion throne as the four fearlessnesses (catur-vaiśāradya): The four fearlessnesses are the empowering throne or vehicle for the transmission of enlightenment. As a result of possessing the four fearlessnesses, Buddhas have the power to help others know all that is knowable, to enable others to abandon what must be abandoned, to teach what ought to be taught, and to help others attain the most pure and supreme enlightenment. The four fearlessnesses arise as the result of four knowledges:

1. knowledge that all factors of existence are understood

2. knowledge that the obstacles are correctly known and the way to stop them can be taught to others

3. knowledge that the path of renunciation, through which all the virtuous qualities are obtained, has in fact been accomplished

4. knowledge that all corruption has been brought to an end.

The base as the ten righteous actions (daśakuśala) which generate the merit and virtue necessary to successfully follow the path. The first three apply to body, the next four apply to speech, and the last three apply to mind.

1. refraining from destroying life
2. refraining from taking what has not been given
3. refraining from improper sexual practices
4. refraining from telling falsehoods
5. refraining from using abusive language
6. refraining from slandering others
7. refraining from indulging in irrelevant talk
8. refraining from covetousness
9. refraining from malice
10. refraining from holding destructive views

237

The first terrace as the four foundations of mindfulness (catvāri smṛityupasthāna):

1. mindfulness of body
2. mindfulness of feeling
3. mindfulness of mind
4. mindfulness of mental events

The second terrace as the four genuine restraints (catvāri-samyak-prahāṇa):

1. not to initiate nonvirtuous actions not yet generated
2. to give up nonvirtuous actions already generated
3. to bring about virtuous actions not yet generated
4. not to allow virtuous actions already arisen to degenerate

The third terrace as the four bases of supernormal powers (catvāri-ṛiddhipāda):

1. meditative experience based on willingness
2. meditative experience based on mind
3. meditative experience based on effort
4. meditative experience based on analysis

The fourth terrace as the five spiritual faculties (pañcendriya):

1. faith
2. effort
3. mindfulness
4. meditative concentration
5. wisdom

The base of the vase as the five spiritual strengths (pañcabala), the same as the five spiritual faculties, integrated and activated as strengths.

The vase as the seven limbs of enlightenment (sapta-bodyaṅga):

1. mindfulness
2. investigation of meanings and values
3. sustained effort
4. joy
5. refinement and serenity

6. meditative concentration
7. equanimity

The foundation and support of the harmikā as the eightfold path (aṣṭāṅgamārga):

1. genuinely pure view
2. genuinely pure conceptualization
3. genuinely pure speech
4. genuinely pure conduct
5. genuinely pure livelihood
6. genuinely pure effort
7. genuinely pure meditation
8. genuinely pure concentration

The ten righteous actions generate merit and virtue, the basis for the spiritual path. The four foundations of mindfulness, four genuine restraints, four bases of supernormal powers, five faculties, five strengths, seven limbs of enlightenment, and the eightfold path are collectively known as the thirty-seven wings of enlightenment. Together with the ten righteous actions they form the cause of realization. The following are the result: the wisdoms and deliverances specific to a Bodhisattva and the ten Bodhisattva stages culminating in omniscience. With this attainment arise qualities specific to the supremely enlightened Buddhas: the three mindfulnesses, great compassion, and nondifferentiated Dharmadhātu.

The wood of life as the ten knowledges (daśajñāna):

1. knowledge of dharma
2. knowledge of the thoughts of others
3. knowledge of relations
4. empirical knowledge
5. knowledge of suffering
6. knowledge of the cause of suffering
7. knowledge of the cessation of suffering
8. knowledge of the way to the cessation of suffering
9. knowledge of things that lead to despair
10. knowledge of the nonproduction of things

The harmikā as the four enlightened wisdoms which enable Buddhas to activate the four deliverances: to help others know all that is knowable and abandon what must be abandoned; to teach what needs to be taught; and to help others attain the supreme enlightenment of a Buddha.

The thirteen wheels as the ten bodhisattva stages (daśabhūmi):
1. the joyous
2. the immaculate
3. the illuminating
4. the radiant
5. the difficult to conquer
6. the manifest
7. the far-reaching
8. the immovable
9. the excellent intelligence
10. the cloud of Dharma

and the three applications of mindfulness (tri-smṛtyupasthāna). These relate to profound equanimity in the three possible circumstances of teaching the Dharma:

11. All disciples may hear, accept, and practice the teachings.
12. None may hear, accept, and practice the teachings.
13. Some disciples may hear, accept, and practice the teachings, while others do not.

The parasol (raincover) as the protection of compassion: The great compassion of a Buddha arises from omniscience. Free from all vestige of self-interest, it applies itself evenly, turning its warmth upon all beings equally. (AK VII:33)

The top as the pristine Dharmadhātu, comprehended by the omniscience of the fully enlightened Buddhas, described as self-arisen primordial wisdom, nondual suchness, complete direct understanding of all aspects of reality.

The whole as the three aspects of enlightened being: Nirmāṇakāya, Sambhogakāya, and Dharmakāya.

TIBET

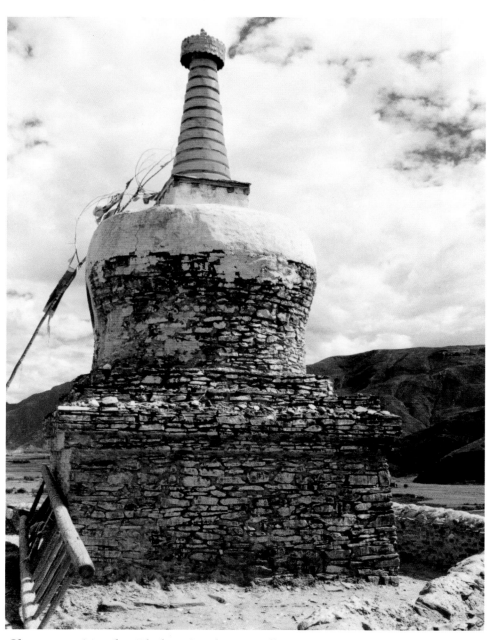

Chorten at Yumbu Lhakar, Yarlung Valley. Ancient residence of Tibet's kings, the Yumbu Lhakar is associated with Lhatotori, who was living here when Buddhist texts and objects fell from heaven onto the palace roof. It is the oldest building in Tibet and the site of Lhatotori's tomb.

Tibet

As recorded in the Sūtras, the Buddha predicted that when the snows melted in the north and the great lakes became rivers, vegetation would cover the land of Tibet. At that time the Dharma would extend into the Land of Snows. The first glimmerings of the light of the Dharma reached Tibet in the fourth century, when Lhatotori, the twenty-eighth in the lineage of Tibetan kings and an incarnation of the Bodhisattva Samantabhadra, ruled the Yarlung Valley, the central provinces of modern Tibet. A casket holding two Sūtras, the six-syllable mantra, a seal engraved with the Cintāmaṇi Dhāraṇī, and a golden stupa appeared at the royal palace and was brought to the king. Although no one could read the texts and the stupa was then unknown in Tibet, the king recognized their spiritual power and had them preserved so that their meaning might be revealed in time. Before his death he received a prediction that this would come to pass in five generations.

In the middle of the sixth century, the Tibetan kingdom entered a period of rapid expansion under king Namri Srongtsen. Namri's son was Srongtsen Gampo, an incarnation of Avalokiteśvara and the first Dharma king of Tibet. Establishing his capital at Lhasa,

Srongtsen Gampo expanded Tibetan influence north to Kokonor and south into India as far as Magadha.

Then, out of compassion for his people, the king laid the foundation for Dharma transmission. To create a written language suitable for translating sacred texts, he sent his minister of state Tonmi Sambhota to India (or Kashmir) to study Sanskrit and the sophisticated science of language that would enable Tibetan to communicate the most subtle meanings. Upon Tonmi's return the king enacted a new constitution based on sound moral principles, implemented the new language, and personally translated twenty-one texts, including teachings related to the great Bodhisattva Avalokiteśvara. He invited experts in all fields of knowledge from lands bordering Tibet and personally trained eighty Tibetans in Avalokiteśvara practices.

Srongtsen Gampo composed the first written Tibetan work, the Mani Kabum, in which he instructed his people in right conduct and chronicled Tibetan culture and history. A great teacher in his own right, he propagated teachings related to Avalokiteśvara, embodiment of enlightened compassion. He married two princesses from Buddhist lands, Brikuṭī, daughter of King Aṁśuvarman of Nepal, and Wen-ch'eng, daughter of the T'ang emperor of China. Both queens brought to Tibet venerated statues of the Buddha: the Jobo Śākyamuni, said to have been carved in Bodh Gayā during the Buddha's lifetime, and the Jobo Ramoche, also known as the Mikyod Dorje (Akṣobhyavajra). The king built temples in Lhasa for enshrining the statues. Among the more than one hundred temples erected upon the king's request, twelve were the land-taming temples built in Tibet's wild borderlands, symbolically restraining the great demoness who represented forces hostile to the Dharma.

In the eighth century, King Trisong Detsen, known for his wisdom as an emanation of the Bodhisattva Mañjuśrī, systematically expanded upon this foundation to ensure a complete Dharma transmission. Fulfilling an ancient prophecy, he invited to Tibet India's foremost scholar Śāntarakṣita, abbot of Nālandā University, and began building the great monastery of Samye. When construction

244

dzong, Yamalung, Nyemo Jemadrak, Uru, Yeru Shangidrak, Changi Namshodo, Onphu, and Tidro. Trisong Detsen himself became one of the Great Guru's twenty-five principal disciples and attained a high level of realization. Before leaving Tibet, the Great Guru prophesied that the king and his sons, as well as his other disciples, would be reborn in Tibet in future generations to recover teachings concealed at Padmasambhava's direction.

As recounted in *The Life and Liberation of Padmasambhava*, the king selected 108 young Tibetans to study Sanskrit and train as translators in India. Among them was Vairotsana, who visited many lands and brought important lineages to Tibet. More than one hundred panditas, invited by the king, accompanied the Tibetans on their return to Tibet. Samye then became the center of a systematic translation effort unparalleled in history. Through the close collaboration of panditas and Tibetan lotsābas, the entire Vinaya was translated within a single generation, together with nearly 750 Sūtras, Dhāranīs, and śāstras, including all the major Prajñāpāramitā Sūtras and the extensive Ratnakūṭa and Avataṁsaka Sūtras.

Simultaneously, a great body of tantric texts was being translated under the direction of Padmasambhava and the great Vidyādhara Vimalamitra. From his hermitage on Mt. Kailāśa, a third master, Buddhaguhya, contributed to this effort. Among the disciples of Guru Padmasambhava and other lineaged masters were Lochen Vairotsana, Ma Rinchen Chog, and Nyak Jñānakumāra. The texts translated at this time included the Mahā, Anu, and Atiyoga Tantras, known in the Nyingma tradition as the Inner Tantras. These Mantrayāna teachings were continued through two lines of transmission: the Kama, or continual transmission from master to disciple, and the Terma, teachings concealed by Padmasambhava and his disciples for recovery at a later time. At the time of concealment, Padmasambhava prophesied the time and place of their recovery and named the masters who would recover them. These masters, the tertons, would be reincarnations of his disciples.

In the ninth century, Ralpacan, Tibet's third great Dharma king, initiated a period of consolidation. The king established a council to

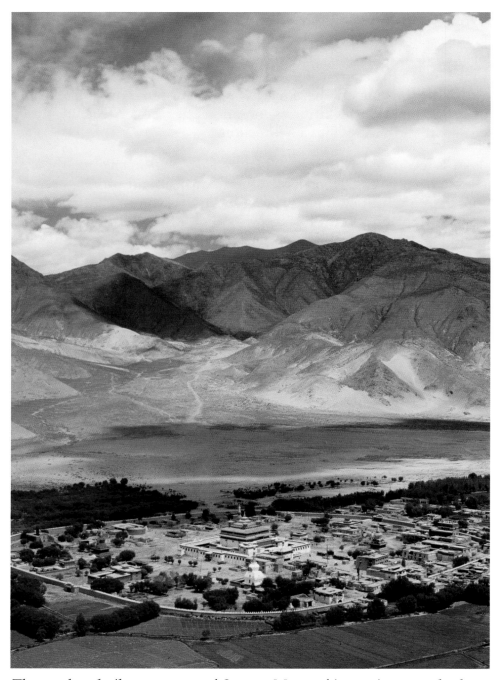

The newly rebuilt monastery of Samye. Many of its ancient temples have disappeared or remain in ruins.

This recently-built chorten rises from Mt. Hepori, overlooking the valley of Samye and the great monastery.

review and standardize translation terminology and apply this standard to the body of translated texts. Among this council's accomplishments was the production of the Mahāvyutpatti, a lexicon of translation terms that is still invaluable for translators today.

In the ninth century, with the death of Ralpacan, his brother Langdarma came to power. Langdarma was hostile to the new religion and persecuted Buddhists, endangering the survival of the Dharma in central Tibet. Three Vinaya masters preserved the texts and the lineage in eastern Tibet, while the Mantrayana masters quietly continued their lineages in remote areas. Further disruptions followed the death of Langdarma, but when peace was restored to the central provinces, monks brought the Vinaya lineage back to Samye and the Mantrayāna was again practiced openly.

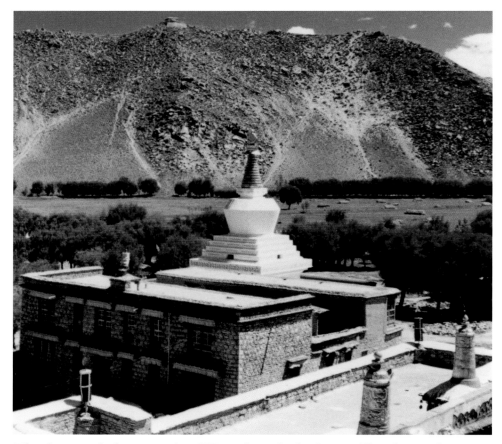

The three peaked mountain of Hepori overlooks Samye like a benevolent pro-tector. The mountain reminds Tibetans of the king, abbot, and guru who built Tibet's first monastery and ensured a home for the Dharma.

Beginning late in the tenth century, Tibetans again braved the hazards of travel to obtain Dharma texts and lineages for their homeland. Among them were Rinchen Zangpo (958–1055) and Lodan Sherab (1059–1109), who spent years in Kashmir; Drokmi Shakya Yeshe (993–1050) and Khyungpo Naljor (978–1079) who studied under great siddhas and scholars in India and Nepal; and Marpa the translator (1012–1097), disciple of the great siddha Nāropa. In the 13th century, the siddha Orgyenpa made a pilgrimage to the land of Oḍḍiyāna, where he obtained rare and precious teachings.

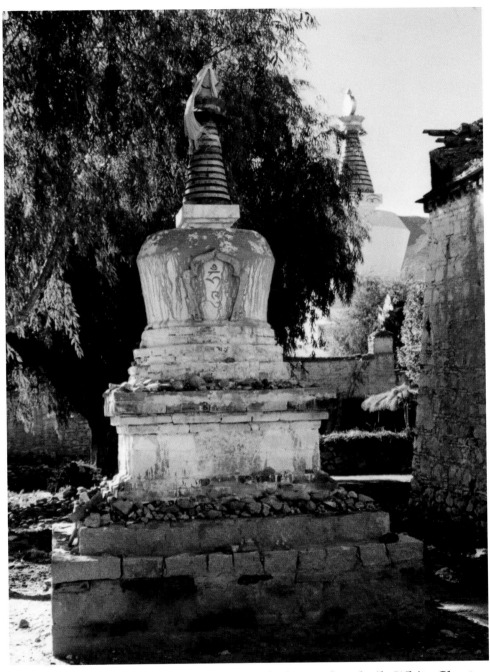

Small chorten at Samye Monastery, with the newly rebuilt White Chorten in the background

251

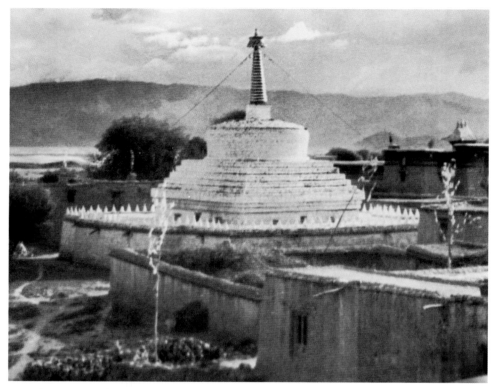

The great white chorten of Samye before its destruction in the 1960s.

During the eleventh and twelfth centuries, scholars from India, troubled by the decline of the Dharma in India and impressed by their Tibetan disciples' accomplishments and devotion, came to Tibet to transmit their lineages and translate texts they brought with them. Among the earliest masters to arrive were the enlightened scholar Śrī Smṛitijñāna (10th–11th centuries) great pandita from Nālandā, who transmitted the Abhidharma; Atīśa (982–1054), Vikramaśīla's foremost scholar, and the great siddha Dampa Sangye (11th century). Such masters worked closely with Tibetan disciples, inspiring a second period of translation and transmission.

The texts and lineages brought to Tibet after the tenth century became known as Sarma, or new traditions. In time, the Sarma lineages gave rise to distinct schools: the Kadam, established in the eleventh century; the Kagyu and Sakya schools, founded in the

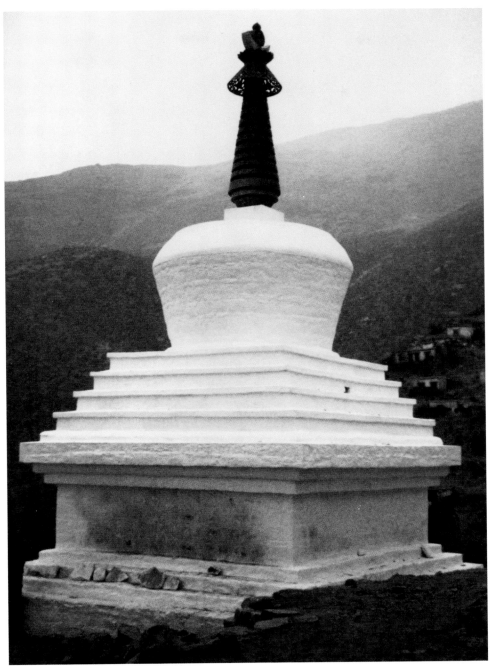

A dudul (subjugation of chaotic forces) chorten in central Tibet. Subjugation stupas protect the land from earthquakes and natural disasters.

253

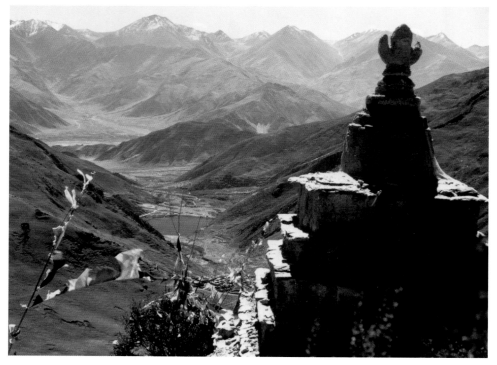

An ancient chorten marks the sacred precinct of Drak Yerpa, about fifteen miles northeast of Lhasa, site of meditation caves used by Srongsen Gampo, Padmasambhava, and disciples of the Great Guru. The stupa overlooks the Kyichu Valley.

twelfth century; and the Gelug, which took form in the fourteenth century. Those who continued to follow the teachings transmitted earlier became known as the Nyingma, the ancient ones. With the exception of the Kadam school, whose lineages merged into other schools, all these traditions continue today.

The vitality of the Dharma in Tibet won the admiration of the Mongols, who received the Dharma in two major stages: the first in the thirteenth century, when the teachings were introduced to the Mongol court, and the second in the sixteenth and seventeenth centuries, when Buddhism was widely accepted throughout the Mongolian empire and the entire Buddhist Canon was translated into Mongolian. The influence of Tibetan Buddhism was felt in

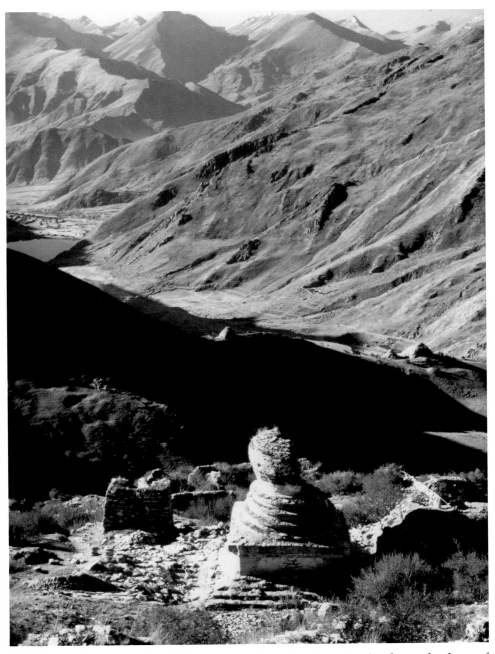

A ruined chorten at Drak Yerpa, a major retreat center in the early days of the Dharma in Tibet. The monastery was completely destroyed in the cultural revolution.

China, nourished through contacts with prominent masters, among them the fifth Dalai Lama, for whom the Pei-t'a (White Chorten) was built in the heart of Beijing.

The Tibetan Chorten

The chorten, as receptacle or repository, usually refers to the entire structure from the base to the tip of its flaming jewel. The bumpa, the rounded vase that is the heart of the chorten, technically corresponds to the rounded hemisphere of the Aśokan stupa. In practice, these terms are generally interchangable. More than a symbol, a chorten *is* Dharmakāya, transformed by empowerment and consecration by masters of the enlightened lineages from an ordinary structure into a sacred form that emanates great spiritual power. Any act of devotion to a stupa is an act of devotion performed in the presence of the Buddha. Magnified by the chorten's field of energy, the merit of offerings returns thousandfold to the practitioner and the environing world.

Because chortens contain relics associated with the Buddhas and the enlightened lineage, their power is intensified by images of spiritual manifestations that are enshrined inside the vase. The chorten generally has a door or window in the vase that allows for inserting sacred objects. Some chortens are large enough to serve as temples or shrines and as special places of meditation or retreat. The great terton and engineer Tangton Gyalpo integrated a chorten into the supports spanning one of his bridges, a blessing for the travelers passing on the bridge below. Another famous chorten stands like a great gate over the pilgrimage trail near Mount Kailāśa (p. 291).

Chortens may enshrine large images facing outward from the center of the vase, where a window opens to one of the four directions. Tsatsas, small clay seals imprinted with mantras, dhāranīs, and sacred images, are often placed in the stupa's base or affixed to its inner walls. As in India, these seals were often stamped with the Ye Dharma mantra, which contains all the Buddha's teachings compressed into a few lines, symbol of the Dharma transmitted through

The Chortens of Samye

The chortens of Samye are among the earliest built in Tibet and the earliest that have contemporary descriptions associated with their founding and construction. Samye, designed as a cosmic mandala, incorporates chortens into a comprehensive expression of the architecture of enlightenment. A description of Samye, its chortens, its completion and consecration is given in an eighth-century Terma text translated in *Legend of the Great Stupa.*

As Padmasambhava relates in Legend of the Great Stupa, "Samye Ling, the Inconceivable Monastery, was modeled upon the universe The great central temple with its three stories was designed like Mount Meru, and the Upper and Lower Yakṣa temples in the east and west flanked the central temple, just as the sun and moon flank Meru. Four large temples in the four directions and eight smaller temples in the intermediate directions, representing the four continents and the eight island continents, adorned the area of the ocean within the circular wall, representing the ring of mountains containing the cosmos. One hundred and eight stupas, each enshrining a vajra, magically materialized by the Protector Vajra-sādhu, surmounted the wall, and four female lions cast in copper rested upon four stone pillars guarding the four gates. (LGS 86ff)

Just as the palace of the gods crowns Mount Meru, so the great central temple with three stories roofed in the three distinct styles of India, China, and Tibet formed the center of Samye. In the temple's highest chamber was the image of the Ādibuddha Samantabhadra; in the middle of the mandala were manifestations of the Buddha Vairocana, surrounded by emanations of the Vajradhātu mandala. In the ground floor chamber rested Mahābodhi, surrounded by the Buddha's disciples and all the Bodhisattvas of the ten directions."

At the consecration of the monastery, flowers were strewn throughout. The gods appeared in the sky, suffusing lights blazed, cymbals sounded spontaneously in the hands of goddesses of libation, and, while the gods rained down flowers and the nāgas presented offerings of jewels, the whole world was filled with

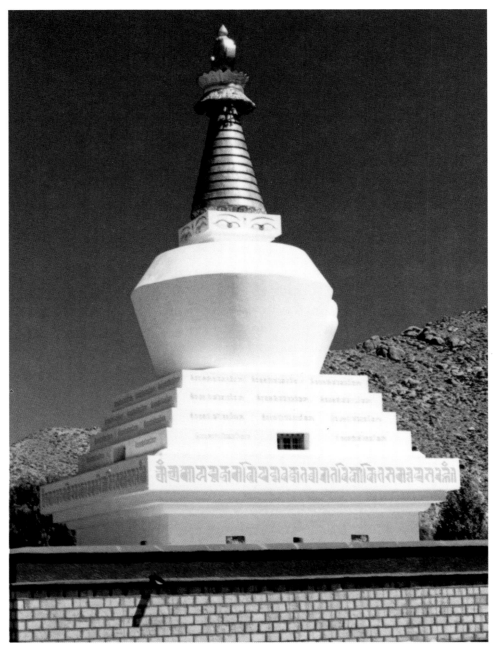

The Chorten Karpo, the White Stupa of Samye Monastery, was originally erected by the nobleman Pelseng, Lion of Glory. Padma Lingpa recovered many treasures concealed in the original chorten.

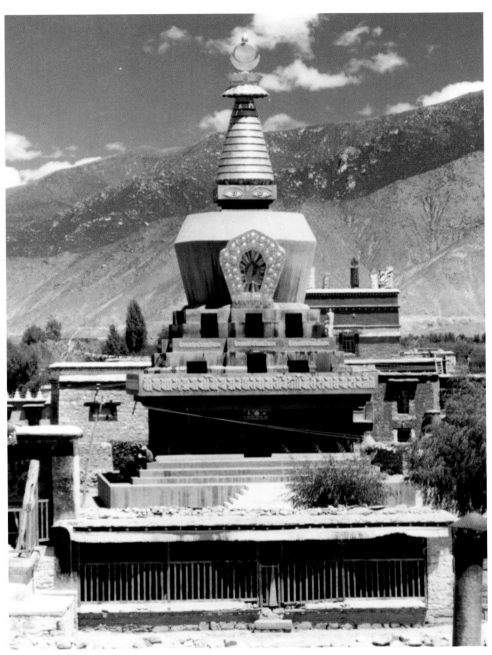

The Green Chorten, originally built by Dorje Trechung, marks the north-west corner of Samye. Each of its sixteen altars held a flask of the waters of life given by the nagas.

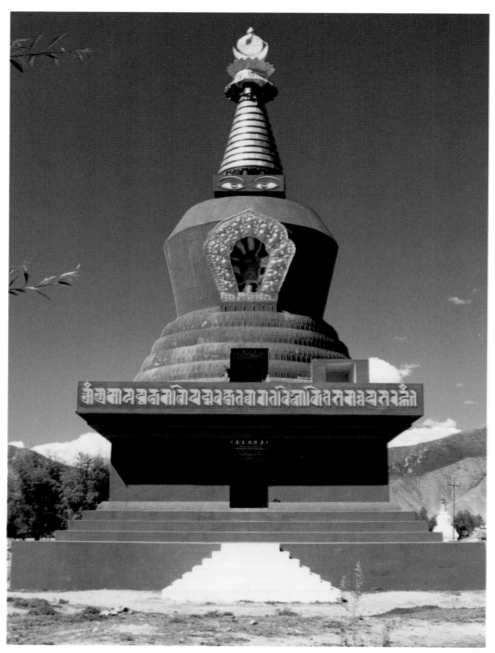

The Red Chorten, originally erected by Gyaltsa Lhaynay, marks the south-west corner of Samye. Modeled after the stupa of longevity, it is said to purify obscurations due to lust.

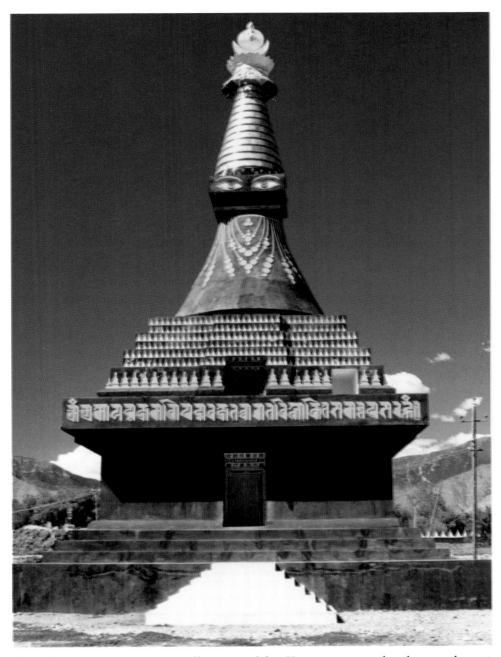

The Black Chorten, originally erected by Tāranāga, marks the northwest corner of Samye. Between the thirteenth and nineteenth centuries, three great Terma masters recovered treasures concealed in this chorten.

auspicious portents and rejoicing. Wrathful ḍākinīs and dharma-pālas honored the celebration. The four stone pillars blazed with fire and the four lions roared. All-healing nectar fell from the sky three times, to bring virtue and happiness to the land of Tibet, and to give continual joy to both men and gods."

The *Life and Liberation of Padmasambhava* (Padma Katang) mentions the four great chortens of Vajrakīla erected around the Samye's central temples at the four directions:

"The nobleman Pelseng, Lion of Glory, raised a white chorten which he adorned with four lions. Gyaltsa Lhaynay of royal blood erected a red chorten which he decorated with a thousand lotuses. And Tāranāga the Distinguished erected a black chorten which he decorated with relics. Dorje Trechung erected a blue chorten which he decorated with sixteen altars. The subdued nāgas hid a flask of life philtre in each one. The wall was black with four doors and four cells. In front of the four doors were four great stone colums, on the wall, a thousand and eight stupas. On the stone columns were four copper female lions." (LL 389–90)

Here, as in Samye's central temple, the Great Guru Padmasambhava concealed important treasure texts that were recovered in later centuries. The White Chorten was the source of termas discovered in the fourteenth and fifteenth centuries by the tertons Drodul Letro Lingpa and Padma Lingpa. Padma Lingpa, an incarnation of Vairotsana, is known to have taken numerous treasures from this chorten.

From the Red Chorten of Samye, the terton Yolmoba Ngag-chang Shakya Zangpo (late 14th-mid 15th century) took out the treasure text on the Jarungkhashor Stupa at Boudha in Nepal. This text, in which Padmasambhava describes the history, ruin, and restoration of the great stupa, had been discovered earlier and reconcealed here by Latsun Ngonmo.

Three masters are associated with termas recovered from the Black Chorten: Nyalpa Josay (12th century), who became known as

the black master of Nyal; Latod Marpo (12th–13th centuries), and Chögyal Dorje (1789–1859), an incarnation of King Trisong Detsen's son, Hlase Mutri Tsanpo.

The white, green, red, and black chortens at Samye were among the earliest chortens built in Tibet. All four were completely destroyed during the Cultural Revolution in the 1960s, but have recently been reconstructed.

Forms of Tibetan Chortens

Since the creation of Samye, Tibetans have erected chortens continuously for more than a thousand years. Numerous masters of all Tibetan traditions have continued to unfold the dimensions of significance encoded in the stupa's elemental form. For the chorten's shape and proportions, Tibetans were guided by Nāgārjuna's description of the eight mahācaityas, which as a special blessing they constructed in sets of eight. Rows of 108 chortens are found in western Tibet (TH 120), and the Padma Katang mentions that 1008 stupas were on the wall of Samye (LL 390). Apart from these formal iconographic groups, Tibetan chortens were most frequently modeled on three of the eight forms: lhabab, the heaven-descending caitya; changchub chenpo, the great enlightenment caitya; and the tashi gomang, the caitya of many doors, a form that Tibetans developed into large multiterraced structures with beautifully painted chapels.

In Tibet, the building and refurbishing of chortens has always been a purely religious act. No secular king imposed his will on these sacred monuments or ordered a stupa built to commemorate his worldly ambition. Geomancy, the science of earth energies, figures strongly in a stupa's location. Since they are most effective when positioned on places of power, they are often seen on high places overlooking vast valleys, where they invite and integrate natural forces. Chortens were an essential part of the mandala formed by the great monastic complexes, where the temple was seen as kāya, the Buddha's body, the Dharma texts as vāca, the Buddha's

speech, and the chorten as citta, the heart of enlightenment. Smaller chortens enshrined relics of great masters or marked the outer boundaries of sacred precincts.

Many of Tibet's chortens, like the four great chortens of Samye, were destroyed in the Cultural Revolution of the 1960s. While some have been restored, monuments of such importance are not so easily replaced. Often the loss of a chorten and knowledge of its history precede the even greater loss of the special sites selected by enlightened masters as conducive to realization. All too little is known about some of Tibet's most holy places, and bringing forth this knowledge remains an important work for the future. Named or pictured below are only a few of the innumerable chortens that once filled the sacred sites of Tibet.

The Three Great Chortens of Yarlung

In the Yarlung Valley, the cradle of Tibetan civilization, are the chortens described in Khyentse's *Guide to the Holy Places of Central Tibet* as the Three Great Chortens: the Takchan, Gungtang, and Tsechu bumpas. All are located south of the Tsangpo River, and all are favored destinations for pilgrims making the rounds of the holy places of Tibet.

Takchan Bumpa According to Khyentse's *Guide*, the Takchan Bumpa enshrines the left eye of Sadaprarudita, teacher of Asaṅga, whose works became the basis of the Yogācārā/Cittamātra tradition. Sadaprarudita's name means Ever Weeping; it derives from the tears he shed when, in practicing the Prajñāpāramitā, he became overwhelmed by its profound truth and beauty. The Takchan Bumpa was built during the twelfth century by order of Geshe

Top right: Shrine marking the boundary of Gangri Tokar, where Longchenpa composed many of his works. Lower right: Chortens at Shugseb Ani Gompa, near Gangri Tokar. This Nyingma nunnery, built at the head of a valley on a place of great natural power, is associated with the twentieth-century woman master Jetsun Lochen Rinpoche.

A chorten on the grounds of Tidro Monastery, also known as Terdrom, in the Drigung region about a mile from Drigung Til.

This stupa at Tidro, a place of practice for Padmasambhava's disciple Yeshe Tsogyal, rests on a six-pointed star-shaped base.

Korchen as part of a Kadampa monastery, now long abandoned. Damaged during the Cultural Revolution, this venerated chorten has been completely restored.

Gungtang Bumpa The Gungtang Bumpa overlooks the Chongye Valley. Carvings of siddhas and paṇḍitas ornament its southern and eastern sides, but the chorten is in a ruinous condition. Its present height is twenty-four feet. Not far from the Gungtang Bumpa are the remains of two smaller stupas, the Śrī Chobumpa, or Kondum, and the Netso stupa, both mentioned in Khyentse's *Guide*. (KBG 51)

Tsechu Bumpa The Tsechu Bumpa, the Water of Longevity Chorten, is located at the entrance of the valley leading to Shedrak, site of the Crystal Cave of the Great Guru Padmasambhava, one of the five most sacred power-places of the Nyingma tradition. This chorten, a favorite site for devotion and circumambulation, rises to a height of about thirty-seven feet from a broad base originally over 150 feet square. Also known as the Chogro Tsechu Bumpa, it is said to have been built in the eighth century to enshrine a rock-crystal image from India given to King Trisong Detsen by the renowned translator Chogroli Gyaltsen. Twice Chogroli Gyaltsen served as the king's trusted messenger: he delivered the king's invitations to both Padmasambhava and the great master Vimalamitra. He later became one of Tibet's four finest translators. Khyentse mentions that life-giving water flows from the stupa on the fifteenth of the lunar month (full moon holy days). (KBG 51)

Chortens of Central Tibet

On the north bank of the Tsangpo River, the valley of the Samye River stretches north from the monastery of Samye. In the region bisected by this valley are numerous meditation sites related to Guru Rinpoche and the first transmission of the Dharma to Tibet. Among them are Zurkar, Drakmar Keutsang, Yamalung, Bairo Puk (Vairotsana's Cave), and Chimphu.

Rignga Chorten Zurkar is known for the Rignga Chorten, caityas of the five Buddha Families, small, dome-shaped white chortens

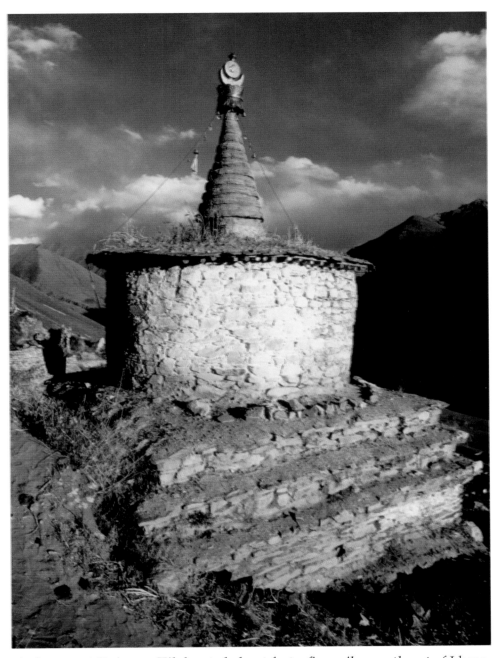

A chorten at Drigung Til, located about forty-five miles northeast of Lhasa. Founded in the twelfth century by Minyak Gomring, Drigung became the center of the Drigung Kagyu order.

The stupa of the great Nyingma master Longchenpa stands near Chimphu, one of Padmasambhava's five special places for realization.

carved out of solid rock. According to Khyentse's *Guide*, these chortens have "the most wonderful images of the five Mystical Families (Dhyāni Buddhas)." (KBG 46) High above the valley overlooking a vast vista, these chortens mark the place where in 762 Trisong Detsen, then twenty years old, first met Padmasambhava. They were carved at the king's order as a meritorious action to balance the karma occasioned by his initial refusal to bow down to the Great Guru, as described in the Padma Tanyig. Here in the fourteenth century, Yarje Orgyen Lingpa recovered two important termas related to the Bodhisattva Avalokiteśvara. The tertons Padma Shewang Gyalpo (15th century), Zhigpo Lingpa (16th century), and Drimed Lingpa (18th century) are also associated with this site, as is Machig

Labdronma, the famous eleventh-century woman siddha who was a disciple of Dampa Sangye.

Chorten of Longchenpa The chorten of the great Nyingma master Longchenpa is located at Chimphu, the meditation retreat of Guru Padmasambhava, one of the Great Guru's five places of realization and the site of numerous terma discoveries. Chimphu is traditionally associated with Padmasambhava's sacred speech. In his *Guide,* Khyentse describes Chimphu as filled with blessing-bestowing symbols of the three planes (Dharmakāya, Sambhoga-kāya, and Nirmānakāya. (KBG 45) The chorten rises from a hill at the apex of a long valley about twenty miles north of Samye. Khyentse also mentions the Tashi Odbar Chorten, a blessing-bestowing chorten in the valley behind Chimphu.

Mindroling Mindroling, a major Nyingma monastery founded in 1676 by Orgyan Terdag Lingpa, was renowned for its beautiful temples, a three-story-high statue of Padmasambhava, and a large stupa that enshrined Terdag Lingpa's relics. Mindroling is located in the valley of Grashi across the river from Dorje Drak. One major temple remains standing today, but its interior is completely ruined.

Dorje Drak Located north of Mindroling across the Tsangpo River, Dorje Drak, one of the six major Nyingma monasteries, was also well known for its temples and stupas, all of which were destroyed in the 1960s.

Tseringjong A chorten at Tseringjong, residence of Kunkhyen Jigme Lingpa, enshrines relics of the great eighteenth-century Nyingma master and terton. (KBG 53)

Netang Netang, located about nine miles southwest of Lhasa at the end of the Kyichu Valley, is associated with Atīśa, the great paṇḍita of Vikramaśīla who came to Tibet in 1042 at the request of Yeshe Od, lama-king of Guge. Atīśa spent three years in Western Tibet, where he worked with Rinchen Zangpo at Toling Monastery. At the urging of Dromton Gyalwe Jungne, a native of the central province of U and a former student of Smṛitiśrījñāna, Atīśa did not

return to India as he had planned, but visited the monasteries of Central Tibet. At Netang, Samye, Yerpa, Lanpa Trilbu, and other Buddhist centers, Atīśa gave teachings, wrote treatises, and attracted numerous disciples. He spent his last years at Netang, where he passed away in 1054. His teachings and lineages were continued within the Kadam school formed by Dromton and other disciples. Bronze relic chortens in the chapels of the Drolma Lhakhang, the temple at Netang Monastery, once enshrined relics of Nāropa, Atīśa, and Atīśa's teacher Serlingpa, as well as other distinguished Kadampa masters. Chortens outside the Drolma Lhakhang enshrine the robes of Atīśa and an outer garment of his disciple Dromton.

Chorten of Marpa Lotsawa Khyentse locates the chorten containing the relics of Marpa Lotsawa, teacher of the saint Milarepa, on the grounds of the Zhung Trezing, the residence of Ngok Chuku Dorje. This site is described as south of the Tsangpo River and upstream from the chortens described above.

Radreng Khyentse describes Radreng, established in the province of Uru in U by the Kadampa master Dromton in 1056, as "resembling the heavenly garden with its great divine trees." (KB 38) Radreng, located about forty-five miles north of Lhasa, became the center of the Kadam school established by Dromton and other disciples of the great master Atīśa. Here are located the reliquaries of Atīśa's teacher Lama Serlingpa, the master Atīśa himself, and his principal disciple Dromton. The entire area around Radreng has sites of central importance to the Kadam lineages.

Shara Bumpa Khyentse describes Shara Bumpa, located north of Lhasa near Pal Nalendra, as having numerous blessing-bestowing stupas. Shara Bumpa was built by Sharapa Yontan Drak (1170–41), a Kadampa master renowned for his knowledge.

Tongdrol Chenmo A Tongdrol Chenmo Chorten (Great Liberation on Sight Caitya) was built at Zhalu Monastery as a funeral offering for the mother of the thirteenth-century master Buston, a major editor and compiler of the Tibetan Canon. (KBG 60)

This bronze Kadampa Chorten at Netang Drolma Lhakhang is associated with the lineages of the great master Atīśa.

Chortens at Tashilunpo Monastery near Shigatse. Founded in 1447 by Gedun Drub, disciple and nephew of Je Tsongkhapa, Tashilunpo became the seat of the Panchen Lamas.

278

Two chortens overlook the broad plain north of the Tsangpo River, where Srongsen Gampo established Lhasa, his capital city. The Potala (not shown), the Dalai Lama's former palace, is on the far side of the valley.

A Karmapa relic chorten in a chapel of Tshurphu Monastery, located about twenty-three miles west of Lhasa.

*Edifice and bell-shaped chortens at Padma Khyung Dzong, part of the
Tshurphu Monastery in the Tolung Valley, the seat of the Karmapa Lamas.
Padma Khyung Dzong was the retreat place of Karma Pakshi, the Second
Karmapa (1204-83) and Rangjung Dorje, the Third Karmapa (1284-1339).*

Tshurphu The chapels of Tshurphu,. center of the Karma school of
the Kagyu tradition, preserve chortens enshrining the relics of
Dusum Khyenpa (1110–93), founder of the Karmapa subschool, and
his descendants (KBG 169, notes). Established by Dusum Khyenpa in
1189, Tshurphu Monastery was completely destroyed in the Chinese
Cultural Revolution.

Tashi Gomang of Central Tibet

Modeled after the Caitya of Many Doors, Tashi Gomang have multiple stories filled with numerous chapels dedicated to specific manifestations of enlightenment. Each chapel houses an image whose significance is deepened by murals that line its walls, offering the pilgrim a symbolic path to enlightenment.

Palkor Chöde The chorten of Palkor Chöde, widely known as the Kumbum, Temple of a Hundred Thousand Images, was built in 1427 by Rabten Kunzang, a chief who established the city of Gyantse as the center of a small kingdom. The Kumbum was built on the site where the Sakya master Sonam Gyaltsen performed a land subjugation ceremony. Miraculously, it has survived several periods of disruption. The eighty chapels of the Kumbum, painted in elegant murals, are dedicated to specific aspects of Buddhas, Bodhisattvas, Arhats, and yidams, and each has its specific form of devotion and meditation practice. Meditation in each chapel prepares the devotee for the next. The first chapel to meet the eyes is dedicated to the Buddha in his teaching aspect, attended by his disciples Śāriputra and Maudgalyayāna. At the culmination of the path, at the highest point, is the chapel dedicated to the Ādibuddha Vajradhara, accompanied by the Bodhisattvas Avalokiteśvara and Mañjuśrī.

Chung Riwoche Chung Riwoche, located at the base of Pal Riwoche hill, was founded north of Dingri in the mid-fifteenth century by the Nyingma terton and engineer, Tangton Gyalpo. Like the Palkhor Chöde, Chung Riwoche belongs to the Sakya tradition. It is noted for its paintings of mandalas that are said to have covered the chapel walls from near the floor to the ceilings. The harmikā of Chung Riwoche has eyes looking out to the four directions. Counting the base, the Kumbum has nine stories. Four of its lower five stories have five chapels per side, a total of eighty chapels on the lower levels. The vase has two levels that once held life-sized statues; the floor at the top of the bell has four chapels facing the four directions, and the whole is surmounted by an open terrace. (THPG 453) Chung Riwoche was a major artistic center. The Kumbum

282

The nine stories of the Palkhor Chöde, Gyantse's Temple of the Hundred Thousand Images, has eighty separate chapels illuminated by murals of Buddhas, Bodhisattvas, Arhats, and yidams.

survived the Cultural Revolution relatively intact and still houses some of its original paintings.

Jonang The kumbum of Jonang, known as Tongdrol Chenpo, the Great Liberation on Sight, was the spiritual center of the Jonangpa school, founded by Dolpopa Sherab Gyaltsen (1292-1360). Nearly as large as the Gyantse Kumbum, the Jonang Kumbum was seven stories in height and octagonal in shape, with chapels arranged circularly on each level. Its distinctive art style developed from that of the Nepali Newars, who were in turn influenced by the Chinese style. Its murals, many of which survive today, date to the fourteenth and fifteenth centuries. This chorten was restored by Tāranātha in 1621, but the Jonangpas were suppressed by the Gelugpas, who took over their monastery after Dolpopa's death. The chorten was extensively restored in the 1990s. (THPG 464-465)

Gyang Bumoche Now in ruins, Gyang Bumoche was built in the early fiftheenth century by Sakya Sonam Tashi (1352-1417) assisted by Tangton Gyalpo. Built on the model of the Gyantse Kumbum, Gyang Bumoche is located on the side of a steep rise near Lhartse, west of Shigatse, very close to Drampa Gyang, one of the land-taming temples built by King Srongtsen Gampo. Its chapels had murals painted by local artists influenced by the painting of China and Nepal. Both the chorten and the monastery of Gyang later passed into the hands of the Gelug school. (KBG 66)

Jampaling The monastery of Jampaling, located at the entrance to the Dranang Valley, was founded in 1472 by Jampa Lingpa Lhundrup Tashi, a descendant of Tonmi Sambhoṭa. Its thirteen-storied chorten was the largest in Tibet before its destruction during the Cultural Revolution. The vase of this chorten was extraordinarily large and cylindrical, with a flattened top; an ornamental band divided the vase into upper and lower levels, each of which had windows facing the four directions. Each of the four steps had five windows opening to the four directions, or twenty windows per level for a total of eighty windows. The walls of its chapels were ornamented with murals painted by Khyentse Chenpo, founder of the Khyenri school of painting.

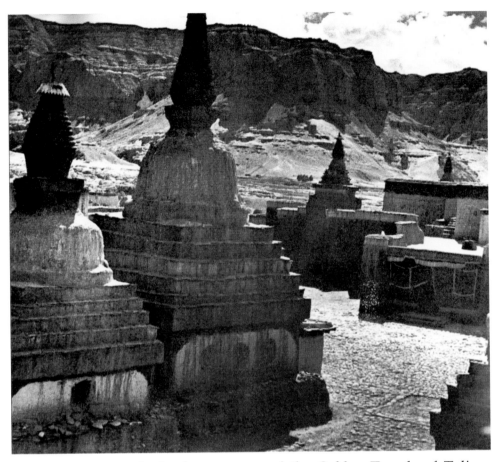

Four chortens mark the four corners of the Golden Temple of Toling, Western Tibet, where Rinchen Zangpo met the great paṇḍita Atīśa.

Western Tibet

Toling The great chorten of Toling Monastery, located in Guge, western Tibet, is said to enshrine the relics of the renowned editor and translator Rinchen Zangpo. Sent to Kashmir to study and learn the eart of translation, Rinchen Zangpo returned to Tibet accompanied by a large entourage of artisans. He founded the monastery of Toling, which developed into a major artistic center and the most important monastery of western Tibet. Here Atīśa, the foremost

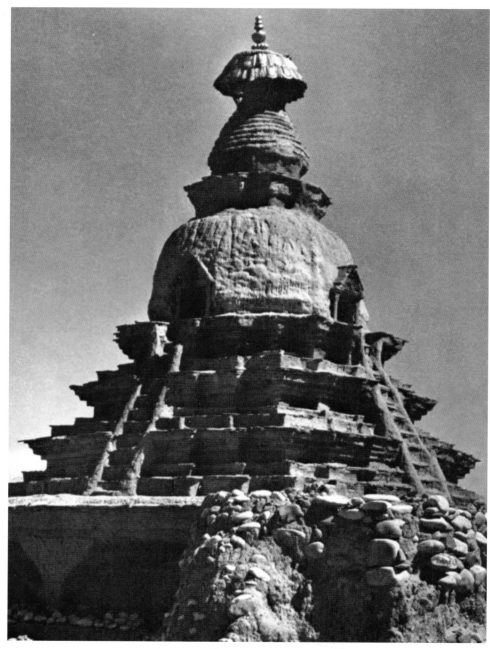

The Lhabab (Descending from Heaven) Chorten of Toling, Western Tibet, is said to enshrine the relics of the great Sarma editor and translator, Rinchen Zangpo.

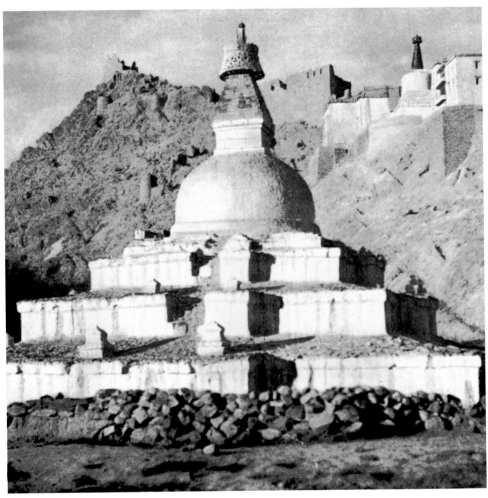

This Nepalese-style stupa, located in Ladakh, Western Tibet, is built in the Descent from Heaven style. A modern Tibetan chorten flanked by buildings rises from the hill above.

paṇḍita of Vikramaśīla University, came at the invitation of Lhalama Yeshe Od to reestablish the monastic Sangha.

Toling's great chorten, built in the lhabab or "heaven-descended" style, has ladders facing the four directions that recall the Buddha's descent from the Trāyastrimśa Heaven after teaching the Abhidharma to his mother, who had died shortly after his birth.

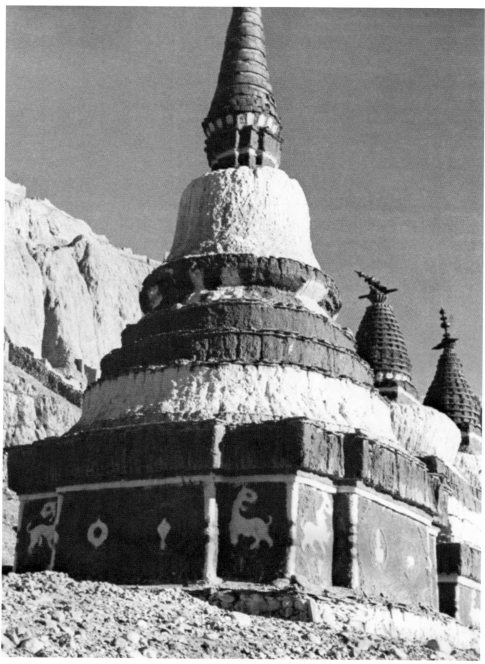

A parinirvāṇa chorten stands at the end of a row of the eight great mahā-caityas in western Tibet.

288

A small chorten kangtse, or "house"-style chorten, inscribed with the mantra Om Maṇi Padme Hum, western Tibet.

289

Chortens mark the outer precincts of the Kardze Monastery, a Gelugpa center in Khams.

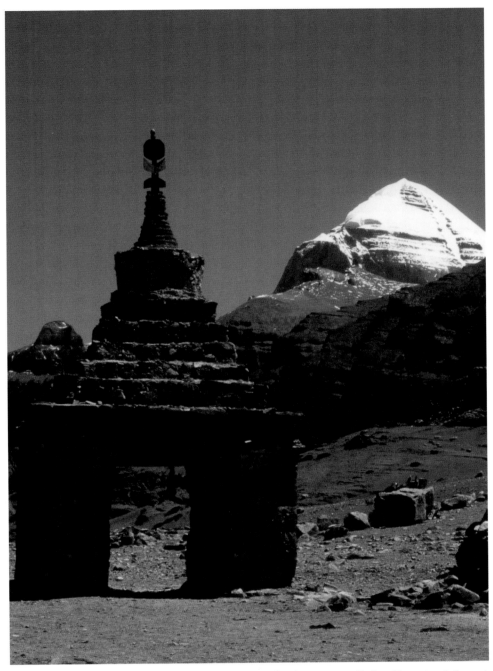

This gateway stupa is built over the pilgrimage trail leading to Mount Kailaśa. Passing below it lightens the burden of karma.

Eastern Tibet

A grassy hill in the region of Golog, identified as the remains of a stupa built by the great Dharma king Aśoka, may mark the site of the earliest Buddhist symbol in Tibet (p. 295). It is now a revered shrine, as is the place where in the seventh century the Chinese princess Kong-jo crossed the border from China into Tibet carrying a famous sandalwood statue of the Buddha (p. 295). A third well-known ancient monument was the Chorten Karpo, the White Stupa that served as a boundary marker defining the outer limits of the "district of horses" (TPS 14), at the far northeastern corner of Tibet on the Sino-Tibetan border (BA 381).

From north to south, the three major provinces of eastern Tibet are Amdo, Golok, and Kham; each is home to major monasteries which were devastated during the cultural revolution. Some have been recently rebuilt, including Kumbum and Labrang in Amdo and Tarthang Monastery in Golok, the largest of Palyul Monastery's numerous branches. Tarthang and Palyul belong to the Nyingma tradition. Kumbum and Labrang, both in Amdo, are major Gelugpa monasteries. Kumbum was built at Tsongkhapa's birthplace with the support of Sonam Gyatso, the first Dalai Lama. Kham is home to numerous Sakya monasteries, including Dzongsar Tashi Lartse. Lhundrup Teng, renowned for its printing house, is a major Sakya monastery in Derge.

Katog, Dzogchen, Zhechen, and Palyul—four of the six major Nyingma monasteries—are located in Khams. Katog was the home of four famous eight-foot-high Kadam-style stupas brought from China by Phagpa (1234–80), nephew of Sakya Paṇḍita, after his visit to the Mongol court. A matching set of four stupas was also taken to Sakya Monastery in central Tibet, Phagpa's official seat. Dzogchen and Zhechen monasteries are located north of Katog. Zhechen was founded in the eighteenth century by Gyurmed Kunzang Namgyal. Dzogchen, founded by Padma Rigzin in 1685 with the encouragement of the Fifth Dalai Lama, was the largest of the Nyingma monasteries.

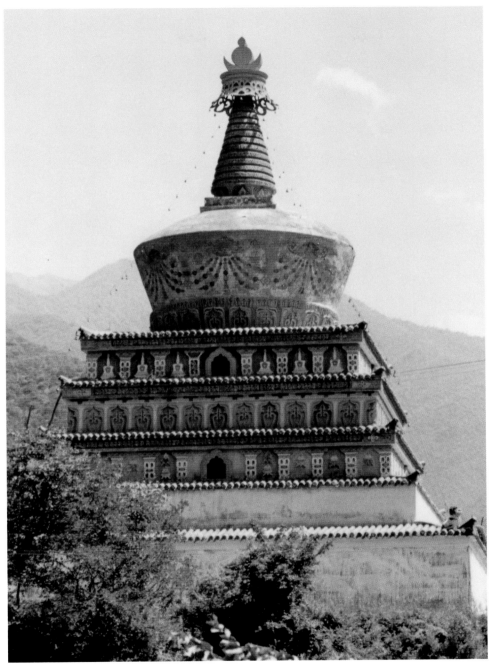

A recently-built five-terraced chorten on the road leading west from Lan-chou, near the ancient border between China and Tibet.

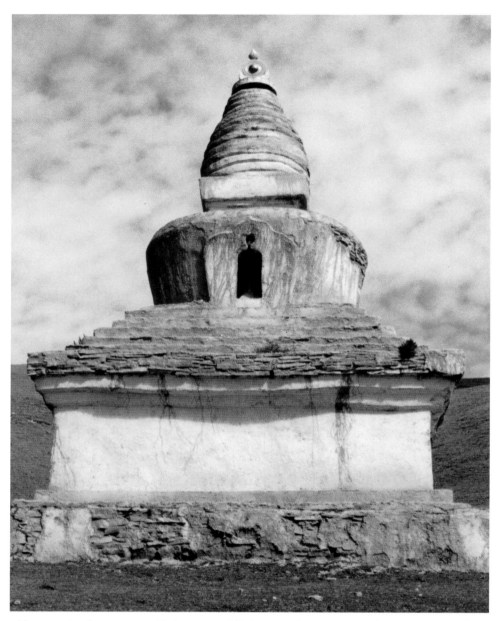

Above, A chorten at Talung, a Nyingma Monastery in Eastern Tibet. Opposite, upper: The pavillion of the Chinese princess Kong-jo on the ancient border of China and Tibet. Opposite, lower: Four groups of the Eight Mahācaityas surround the grassy mound of the Aśokan stupa of Golok, a venerated pilgrimage site. The stupa's mound rises on the right.

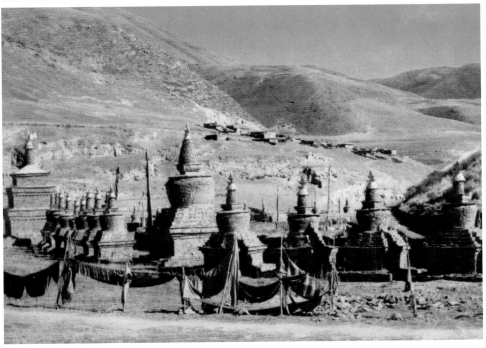

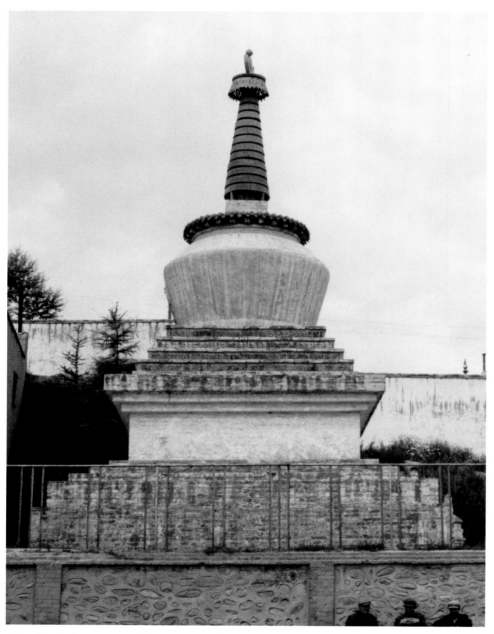

*The Enlightenment Stupa at Kubum Monastery in Amdo, eastern Tibet.
Kubum is one of the six great monasteries of the Gelug tradition. It was
built in 1588 by Odzer Gyatso to honor the birthplace of the great master
Tsongkhapa. Upper right (p. 297): Kubum's Eight Great Chortens.*

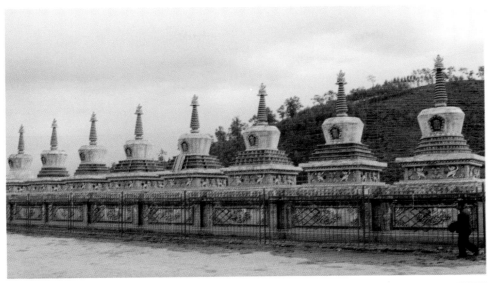

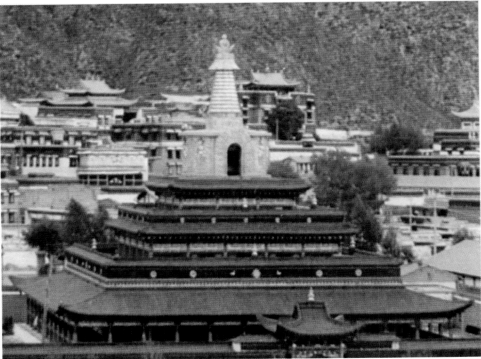

Above: The Liberation on Sight Chorten of Labrang was originally built by Gungtang Tanpe Dronme. Destroyed by the Chinese, it was rebuilt in 1993 by his successor, the second Gungtang Rinpoche. Amdo, eastern Tibet.

The chorten at Tintha Gon Dechen Choling, a monastery of the Palyul school established in 1882, rises from the banks of the Marchu River in Golok, eastern Tibet.

298

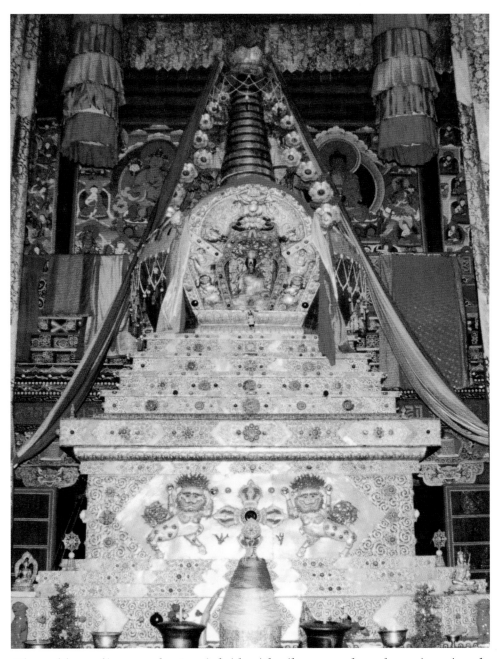

The golden reliquary chorten inlaid with silver, coral, and precious jewels was built in the 1980s by Tarthang Rinpoche in honor of his teacher, Tarthang Chogtrul Rinpoche. Tarthang Monastery, Golok, eastern Tibet.

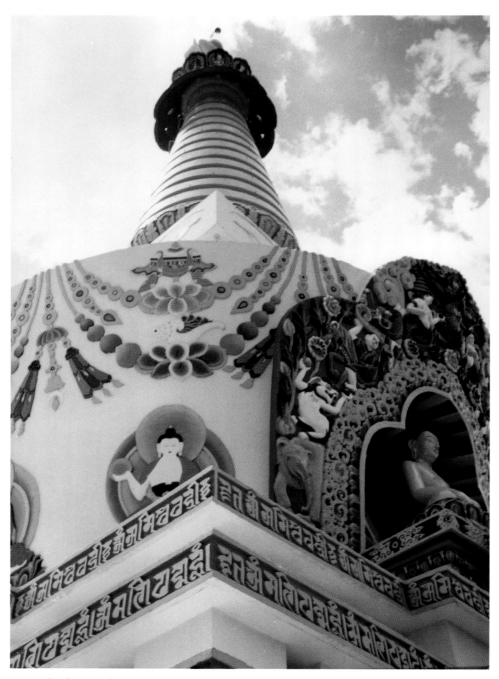

Detail of a modern Tibetan chorten in North Kanara District, Karnataka (South India).

BHUTAN

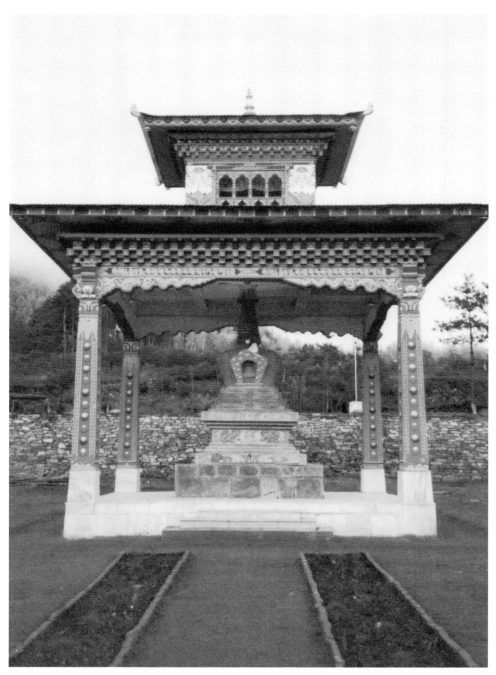

In Bhutan, the smaller Tibetan-style chortens are often covered with beautifully carved and ornamented square-sided structures.

Bhutan

The earliest evidence of Buddhist activity in Bhutan traces to the seventh century, when Srongsen Gampo, king of Tibet, built two border-subjugating temples here, Kyichu in the Paro Valley in western Bhutan and Jampa in the central region of Bumthang. A century later, during the reign of Trisong Detsen in Tibet, the Great Guru Padmasambhava came to Bhutan and meditated in various locations to activate the Mantrayāna practices in this land. Here as in Tibet he concealed treasure texts for later recovery. Bhutanese terma locations named in Padmasambhava's biography include Paro and Paro Taksang in western Bhutan and Bumthang and Membartsho in the central region.

As Buddhism became established in Bhutan, monasteries were built at places blessed by the presence of the Great Guru which are revered as holy to this day. Taksang Monastery clings to a mountain ledge in Paro at the site of one of Padmasambhava's meditation caves, and the temples of Gom Kora near Tashigang and Kuje in Bumthang stand at other sites empowered by the actions of the Great Guru. Devotion to Padmasambhava, venerated as a second Buddha and spiritual son of the Buddha Amitābha, is reflected

A closer view of the Tibetan-style chorten, showing the image of Buddha enshrined in its gold-leafed window.

throughout Bhutan in accounts of the oral tradition and in statues and paintings of the Great Guru's eight major manifestations. A number of monasteries are dedicated to Padmasambhava, including the three temples at Taksang and the Taksang Zangdo Palri, named after the Great Guru's Copper Mountain paradise.

Little is known of the development of Buddhism in Bhutan during the centuries following Padmasambhava's activities. The ninth century in Tibet was a chaotic time marked by the assassination of the Buddhist king Ralpacan and the reign of his brother Langdarma, who disrupted the growth of Buddhism. It is likely that Buddhists from central Tibet sought refuge in Bhutan's quiet valleys during Langdarma's troubled reign and the anarchy that followed his death.

With the revival of Buddhism in the eleventh century, monasteries were built throughout Tibet and distinct schools of Buddhism began to take form. Between the twelfth and fourteenth centuries, masters of these schools began to carry their lineages to Bhutan, where they founded monastic centers.

The earliest traditions established in Bhutan were the Nyingma and Kagyu schools, which are still the most influential. Gyalwa Lhanangpa in the late twelfth century, founder of the Lhapa Kagyu, built his center in the Paro Valley of western Bhutan, and Phajo Drugom Shigpo in the thirteenth century established the Drukpa Kagyud in the Thimphu region, also in western Bhutan. In the fourteenth century, the renowned Nyingma master Longchenpa founded Tharpaling, Samtenling, Shinkar, and Orgyen Chöling monasteries in Bumthang, where he wrote some of his works. (BHU 56) In all, Longchenpa is associated with eight Dharma centers in Bhutan, six of which are known today.

The Nyingma tradition in Bhutan was strengthened by the work of the great tertons, reincarnations of Guru Padmasambhava and his disciples, who recovered texts concealed by the Great Guru at the time of Trisong Detsen. Among the greatest of these tertons were Dorje Lingpa (1346–1405) and Padma Lingpa (1450–1521), both of whom are associated with Bhutan.

305

Dorje Lingpa, an emanation of the eighth-century master Vairotsana, was active in both Tibet and Bhutan, where he established his center at Glingmoka and guided the monastery of Padro. His lineage continues to the present day at Orgyen Chöling.

Padma Lingpa, reincarnation of both Padma Sal, daughter of Trisong Detsen, and the great master Longchenpa, was born in Bumthang. He discovered the hidden temple of Lhokyerchu in Bhutan, one of about fifty locations from which he recovered more than seven hundred concealed teachings. The terma he discovered were propagated by outstanding masters in Bhutan and Tibet, and his lineage is still vital today. In Bumthang, Padma Lingpa established the Petsheling, Tamshing, and Kunzangdrak monasteries (BHU 57); from here, his lineage extended into eastern Bhutan, where it strengthened the influence of the Nyingma tradition. The Bhutanese royal family traces its lineage to this great master.

The Drukpa Kagyu tradition continued to flourish, playing a major role in Bhutan's unification in the seventeenth century and giving rise to the early rulers of Bhutan. Among the many prominent masters of this tradition, the most popular throughout Bhutan is Drukpa Kunley (1455–1529), a great siddha and tantric master whose accounts have a prominent place in Bhutan's folk literature. Another fifteenth-century Tibetan siddha, Tangton Gyalpo (1385–1464), was also a skilled engineer, renowned as the builder of iron bridges, eight of which he built in Bhutan.

Famous Stupas of Bhutan

As in other Buddhist lands, the stupas of Bhutan have been erected to enshrine relics, commemorate the memory of outstanding masters, balance the forces of nature, and protect against natural disasters. In this mountainous land, stupas are found along the major pilgrimage trail that leads east and west, connecting the major centers of Paro and Thimphu with the holy places of Bumthang and Tashigang.

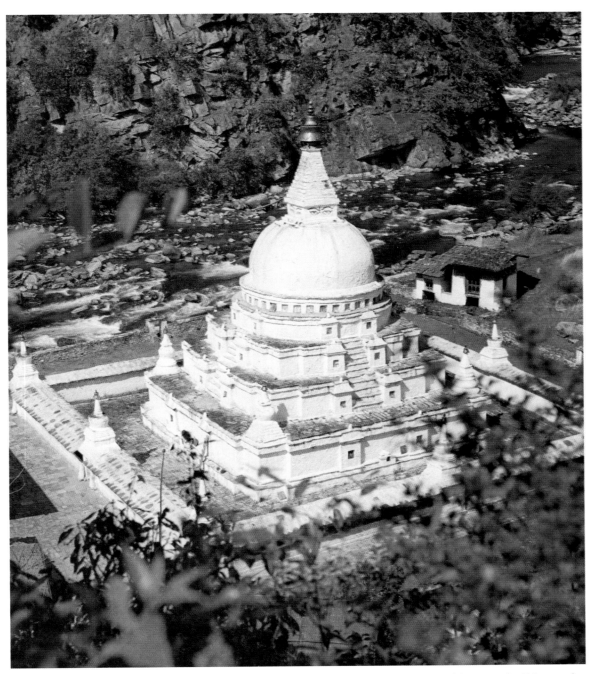

The Chorten Kora, located in the Tashiyantse region north of Tashigang, is Bhutan's largest chorten and a major devotional site on the pilgrim's path.

Bhutanese stupas are modeled on three major forms: Nepalese, Tibetan, and square house-style stupas. The Nepalese Aśokan-style stupa has a large hemisphere rising from a broad stepped base. Eyes are usually painted on the harmikā, from which rises a pinnacle of thirteen rings surmounted by sun, moon, and flame, similar to the Boudhnāth Stupa in the Kathmandu Valley. The Tibetan-style chorten is readily distinguished by its high throne, stepped base and heart-shaped vase. Like the Nepalese-style stupa, the chorten is surmounted by a pinnacle topped by sun, moon, and flame.

Chendebji Chorten Chendebji and Chorten Kora, both Nepalese-style stupas, are among the largest in Bhutan. The Chendebji Chorten rises from a square three-stepped base near the village of Chendebji, in a valley between the Pele-la Pass and Tongsa in central Bhutan. Also known as the White Stupa, Chendebji is said to have been built by the monk Shida in the early eighteenth century as a demon-subduing stupa to protect against chaotic natural forces. The sides of its base are oriented toward the four directions, with figures sculpted on the base of its dome in each direction: the Buddha Śākyamuni on the east; Maitreya, the future Buddha, on the south; the Bodhisattva Avalokiteśvara on the west; and Vajrapāṇi on the north. An account of the chorten's founding is inscribed on the long maṇi wall that extends out from its side.

Chorten Kora Chorten Kora, located in eastern Bhutan north of Yangtse Dzong in the Tashigang region, is Bhutan's largest stupa. Its origin traces to a prediction made by Padmasambhava in Bumdeling Valley that a great stupa would be built at its southern end. Accordingly, the chorten is dedicated to the Great Guru and enshrines his image. Although the date of its construction is uncertain, tradition holds that Chorten Kora was built in 1782 at the direction of Yonten Thaye, the thirteenth head abbot of Bhutan. Continually freshened with whitewash, Chorten Kora was restored in this century by Jigme Wangchuk, the second king of Bhutan. Each year a major festival is held at this sacred site. (BHU 238)

Dungtse Lhakhang Located on the edge of a hill in the Paro Valley, in western Bhutan, the Dungtse Lhakhang was built in 1421

A maṇi wall extends out from the White Chorten of Chendebji, one of Bhutan's largest Nepalese-style stupas.

by the siddha Tangton Gyalpo (1385–1464) and restored in 1841 by Sherab Gyaltsen, the twenty-fifth head abbot of Bhutan. Essentially a dudul chorten, it was erected to subdue a powerful local demoness. Combining the features of stupa and temple, the Dungtse Lhakhang allows entrance to its three-storied chapel. The Lhakhang is laid out as a mandala; the walls of its chapel are lined with paintings arranged according to the unfolding of the mandala, leading from the Dhyāni Buddhas on the ground level through images associated with the major cycles of Tantras practiced within the Drukpa tradition, to which this chorten-temple belongs. Among the images are the eight manifestations of Guru Rinpoche, depictions of the eighty-four great siddhas, and the founders of the Kagyu tradition. (BHU 132)

Memorial Chorten One of Bhutan's most recent chortens, the Memorial Chorten of Thimphu was built in 1974 in honor of His Majesty Jigme Dorje Wangchuk, third king of Bhutan, an outstanding patron of Buddhism who died in 1972. The design for the Memorial Chorten, envisioned by Dungtse Rinpoche, follows the Nyingma tradition. Like the Dungtse Lhakhang, the Memorial Chorten incorporates a temple. Porches, their ceilings painted with mandalas, open on the chorten's four sides, leading to the temple inside. The three-storied temple itself is a repository of images arranged according to the cycles of major treasure texts practiced within the Nyingma tradition.

In recent years, following visions related to preserving the peace in Bhutan and ensuring the vitality of the Dharma, H. H. Dilgo Khyentse Rinpoche had large stupas built at Paro, Chudzom, Chandebji, and in eastern Bhutan. A hundred thousand tsa-tsas empowered with mantras were placed in each stupa. These stupas were built in the traditional manner by fully ordained monks who strictly observed the purification practices, offerings, and ceremonies of their tradition.

The Memorial Chorten in Thimphu was built in 1974 in honor of His Majesty Jigme Dorje Wangchuk, third king of Bhutan.

MYANMAR

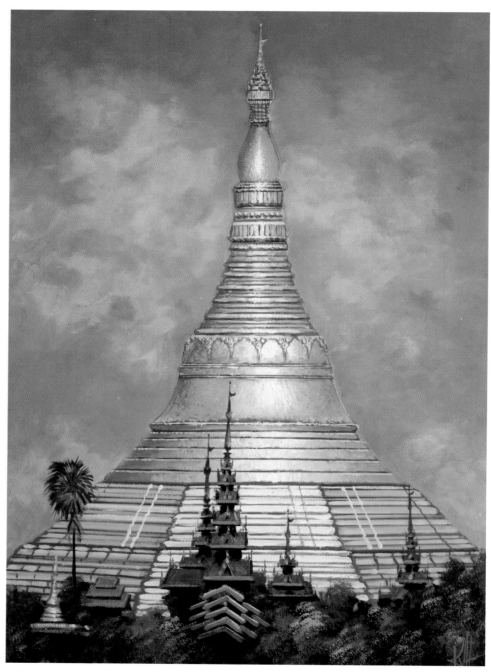

The golden Shwedagon Pagoda, Rangoon, 344 feet high and 1,476 feet in circumference at its base, is modern Myanmar's spiritual center.

Myanmar

Burma, now known as Myanmar, has been home to a number of different cultures and peoples: the Arakans of the northwestern coast; the Mon tribes of southern Myanmar and central Thailand; the Pyu, a Tibeto-Burmese people who moved into south central Myanmar in the third century C.E.; and the Mranmā, who entered central Myanmar later from Yunnan in the north and settled along the Irrawaddy River, the country's central highway.

Myanmar traditionally traces its Buddhist origins to missions sent by King Aśoka or the Arhat Mogalliputta Tissa throughout Aśoka's kingdom and beyond. The Mahāvaṁsa relates that at the time of Aśoka, Mogalliputta Tissa, "looking to the future, beheld the founding of the religion in adjacent countries." Of the nine missions dispatched to propagate the Dharma, Sona and Uttara went to Suvaṇṇabhūmi, associated with lower Myanmar and especially the city of Thaton. (Nagara Paṭhāma, west of Bangkok, has also been mentioned as the site of Sona and Uttara's landing.) The emissaries are said to have converted sixty thousand people by reciting the Brahmajāla Sutta and to have ordained five thousand monks.

At the time of Aśoka, in the third century B.C.E., Indian merchants were prospering from the sea trade with inhabitants of the

towns along the coasts and rivers of Suvaṇṇabhūmi, the "Golden Land." By the first century C.E., the volume of trade had expanded, bringing India and Myanmar into closer contact. Remains of an early Buddhist monastery similar in style to monasteries in south India have been found in Beikthano, a site dated from the second century B.C.E. to the seventh century C.E.

Thaton, located near the Salween River in the southeastern corner of modern Myanmar, and Pegu, to the northwest, were major centers of Mon civilization. Strongly influenced by Indian culture, the Mons dominated the region known as Ramaññadesa that extended southeast to Nagara Paṭhāma. Inscriptions in Sanskrit dating to 500 C.E. connect the early kings of Thaton to Indian merchants and princes, and point to the presence of the Sarvāstivādins, a Hīnayāna tradition strong in northern India and Kashmir from the time of Aśoka until the fourteenth century.

Archaeologists and art historians generally consider that Thaton received artistic styles from Amārāvatī and Nāgārjuna-koṇḍa, thriving Buddhist centers near the coast of southeastern India, and that monks from Nāgārjunakoṇḍa or Kāñcī in South India founded Theravādin monasteries in Thaton. Nourished by Thaton's growing prosperity, these monasteries became artistic and educational centers that supported the rapid development of Mon culture. Among the earliest Buddhist monuments in the Thaton area is the Htsitaung Pagoda in Zokhethok, which appears to date to the early centuries C.E.

The Pyu kingdom that flourished between the third and eighth centuries was also strongly influenced by Indian culture and architectural styles. The ancient name for the Pyus was Ussa, or Orissa, indicating that Orissans may have colonized the area and established their capital at Śrī Kṣetra (modern Prome). The cone-shaped 160-foot-high Payagyi Pagoda at Hmawza dates to this period.

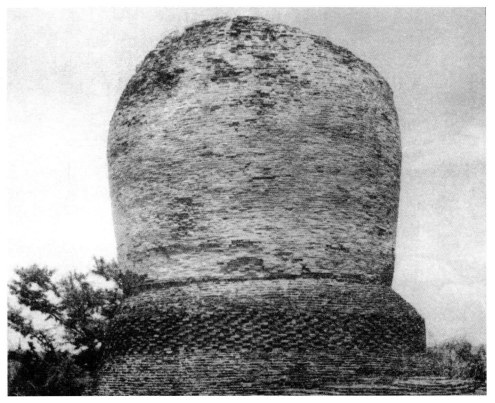

The bulb-shaped dome of the Ngakywenadaung Pagoda, attributed to King Taungthugyi (tenth century), rises to a height of forty-five feet.

Pagan (849–1287)

The Burmese chronicles trace the lineage of the kings of Pagan to 107 C.E., when a displaced Indian ruler settled in the Irrawaddy Valley and began a dynasty that extended through the reign of fifty-five kings. (PGP:g-h) Pyinbya, the thirty-fourth king, is said to have built the walled city of Pagan and made it his capital in 874 C.E.

Five of the pagodas near Pagan pictured below date to the ninth and tenth centuries, when Mahāyāna and Vajrayāna traditions introduced by masters from eastern India were practiced in central Myanmar. (According to the Tibetan historian Tāranātha, the Mahāyāna tradition was introduced to central Myanmar by disciples of

Vasubandhu, a prominent late fourth or fifth-century Indian master.) The vase-shaped cupolas of the Bupaya and Ngakyawena-daung pagodas bear a resemblance to Tibetan chortens.

Bupaya Pagoda The graceful Bupaya Pagoda, poised on three broad terraces, rises high above the Irrawaddy River. Tradition ascribes its construction to King Pyusawhti, leader of the Myanmā in the third century C.E., but historians tend to date it in the eleventh century.

Ngakywenadaung Pagoda Tradition holds that the Ngakywena-daung Pagoda (p. 317), located in Nyaung U, upriver and northeast of the walled city of Pagan, was erected in the tenth century by King Taungthugyi. Lacking a harmikā or spire, its bulb-shaped body rises forty-three feet in height from a circular foundation. It was once covered by green glazed tiles, many of which still remain.

Pawdawmu Pagoda The Pawdawmu Pagoda (p. 325), long thought to be of later date, has recently been freed from its outer shell. The outer coating protected this intricate bell-shaped monument from the ruination suffered by most other pagodas of this time. The dome of the pagoda rises from three triple terraces. A large obelisk crowns the dome, supporting a lotus-shaped capital and a conical finial.

Petleik Pagodas The east and west pagodas of Petleik (p. 320–21), built in the tenth or eleventh centuries, have also been recently cleaned and repaired. Both bell-shaped pagodas rise from a broad lower stage sheathed in terracotta plaques depicting scenes from the Jātakas. These illustrations of events of the Buddha's previous lives, placed where they can be readily seen by circumambulating devotees, serve as reminders of karma, the relationship between cause and effect, a central insight of the Buddha's enlightenment.

Pagan: The Golden Years

Mahāyāna and Vajrayāna traditions were flourishing in Pagan and in the Nan-chao kingdom of Yunnan, Myanmar's northern neighbor, when King Anawrahta came to power and launched Pagan into the days of its greatest splendor. Events leading to the transformation

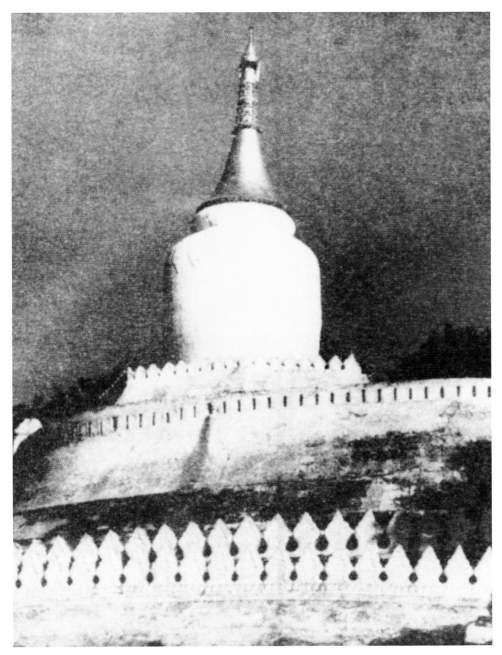

The Bupaya Pagoda, built within the walls of Pagan overlooking the Irrawaddy River, is traditionally attributed to King Pyusawhti (third century), but is generally traced to the eleventh century.

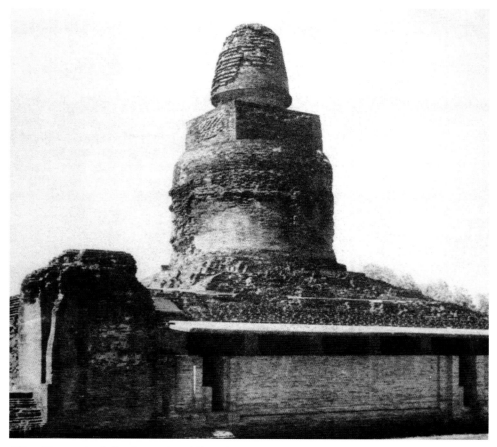

The East Petleik Pagoda, like the West Petleik (right) is located near Thiyipyitsaya, downriver from Pagan.

of Pagan were set in motion when the Theravādin monk Shin Arahan left Thaton and made his way to Pagan. Here he met King Anawrahta and converted him to the Theravādin school. An enthusiastic patron, Anawrahta sought to obtain a copy of the Pāli Tipiṭaka from Thaton, but the king of Thaton rejected his request.

Taking this opportunity to invade Thaton, Anawrahta conquered the Mon capital in 1057 and, in a dramatic gesture, brought its king, architects, scriptures, monks, artists, and craftsmen to Pagan. King Anawrahta is said to have brought thirty elephant-loads of scriptures to Pagan, and to have built the Piṭakataik, the

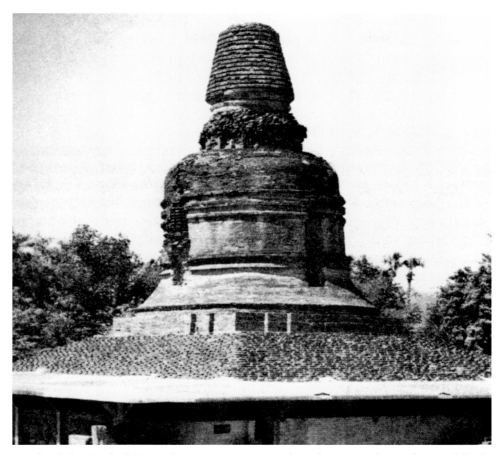

Both of the Petleik Pagodas are ornamented with scenes from the Buddha's previous lives sculpted on terracotta tiles.

Piṭaka Library, to house them. Having effectively transported Thaton's entire culture and religion to his own capital, he extended his rule throughout Myanmar and set the Mon artisans to work at creating splendid monuments for his glory and the benefit of the Sangha. Under King Anawrahta, Myanmar became the strongest center of Theravādin Buddhism of that time.

Eleventh-century Pagan was in contact with Buddhist centers in both Sri Lanka and Bodh Gayā in India, site of the Buddha's enlightenment. Inscriptions at Bodh Gayā dated 1035 and 1086 indicate several Myanmaran efforts to repair the Mahābodhi monu-

321

ment. The 1086 description summarizes the temple's history, noting that King Sado-Meng of Myanmar restored it. Inscriptions at Prome record efforts by Anawrahta's brother Kyanzittha (r. 1084–1113) and his son Alaungsitthi (r. 1113–67) that led to two missions to rebuild the Mahābodhi. In the thirteenth century, King Nantaungma (r. 1211–34 C.E.) symbolically brought the Mahābodhi to Pagan by erecting the Mahābodhi Pagoda in its image.

Monuments constructed in Pagan before Anawrahta conquered Thaton show the influence of Indian, Mon, Pyu, and Arakanese styles. From 1047 to 1060, artisans from Thaton emphasized Mon architectural styles, which gave way to a more distinctive Myanmaran style between 1130 and 1287, when Pagan fell to the Mongols. As the soaring golden Shwedagon (p. 314) clearly demonstrates, the bell shape characteristic of Anawrahta's large pagodas influenced the evolution of the classical Myanmaran style. The paddy-heap and bubble-shaped stupas of Sri Lanka are relatively unknown among the pagodas of Myanmar, where the bell shape is most often seen. The zedi (Pāli cetiya, Sanskrit caitya), a synthesis of temple and stupa, marks the high point of the Myanmaran style. The shapes may vary somewhat but the five basic parts of the zedi consist of a base of three or five terraces, with a cupola, usually bell-shaped, topped by a relic chamber (dhātugarbha), which supports the base of the spire and the spire itself.

While zedis housed relics or commemorated sacred places, Myanmar's great temples are meant to enshrine images of the Buddha and to allow entrance. Square in shape, Myanmar's temples are generally built around a lofty stupa or are topped by prominent prangs (blocky curved domes) or the bell-shape of a stupa.

Myinkaba Pagoda The Myinkaba Pagoda, located on the banks of the Myinkaba River, is said to have been constructed by Anawrahta to atone for killing his brother Sokkada in a battle for succession. Its cylindrical shape, round terraces, and bulb-shaped dome predate the importation of Thaton's Theravādin styles to Pagan.

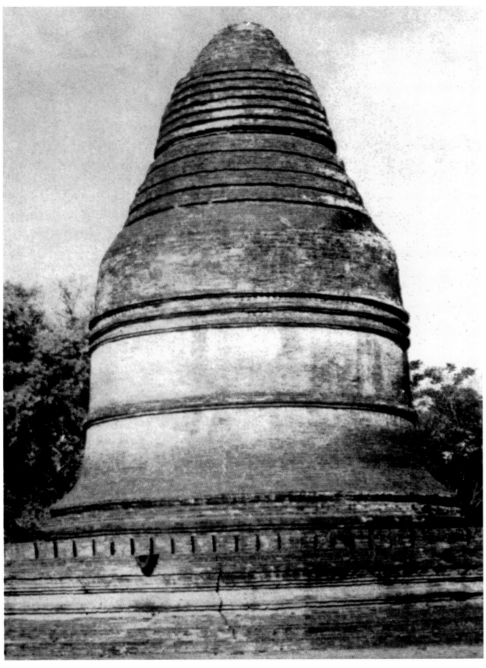

The Myinkaba Pagoda was built in the eleventh century by King Anawrahta to honor his brother Sokkada, the former king of Pagan.

Shwesandaw Pagoda The graceful Shwesandaw Pagoda (p. 327), rising from a high five-stepped base, was the first monument built by Anawrahta after consolidating his kingdom. In this pagoda the king is said to have enshrined hair relics of the Buddha given him by the monks of Pegu. Its size and shape invite comparison with the "cosmic mountain" of Barabuḍur. The dome is more cylindrical than bell-shaped, and smaller in proportion to the massive terraced base than the Shwezigon, begun later in Anawrahta's reign. Staircases are built into all four sides of the base, enabling circumambulation on all five levels of the monument.

Sapada Pagoda Anawrahta is said to have also obtained relics from Vijayabāhu, king of Sri Lanka around 1065, in exchange for sending Myanmaran monks to Sri Lanka to revitalize the ordination lineage, which had been seriously weakened under Coḷa rule. Anawrahta also sent copies of the Pāli Tipiṭaka to replace those lost from Sri Lanka's libraries. This connection with Sri Lanka was strengthened in the late twelfth century, when the monk Sapada studied in Sri Lanka. Returning to Myanmar, he established the Theravādin lineage of the Mahāvihāra tradition and in 1190 built in Pagan the Sri Lankan-style pagoda which still bears his name. The Sapada Pagoda (p. 328) is distinctly Sri Lankan in style. Its bell-shaped body, accessed through a gateway at the top of a flight of stairs, is surmounted by a square harmikā, or relic-chamber, topped by a parasol of concentric rings.

Lokananda Pagoda Anawrahta erected the elegant bell-shaped Lokananda Pagoda (p. 329) on the bank of the Irrawaddy River. Here he is said to have enshrined a replica made by Sri Lankan monks of the Buddha's tooth relic preserved in Sri Lanka. This relic is still greatly venerated today.

Shwezigon Pagoda The Glass Palace Chronicles relate that this magnificent monument (p. 331) was built to enshrine three major relics: a collarbone, parietal bone, and a tooth of the Buddha collected by Anawrahta from stupas built earlier. Begun by Anawrahta in 1059, the Shwezigon was completed by King Kyanzittha, who ruled between 1084 and 1112.

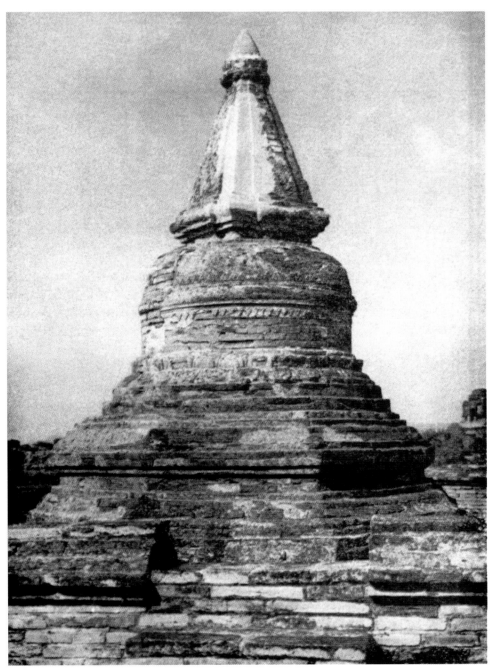

The bell-shaped Pawdawmu Pagoda was built in Myinkaba, south of the walls of Pagan, probably in the eleventh century.

The Shwezigon overlooks the Irrawaddy upriver from Pagan and just west of Nyaung U. Modeled after the Lokananda but with a less pronounced cylindrical rise, the Shwezigon has a distinctive band around the lower portion of the bell. A temple is built into each of its four sides. Its three terraces rise from a square base; staircases built into the terraces at the four directions allow access to the three circumambulation levels, ornamented with scenes from the Buddha's previous lives. Scholars attribute cosmic significance to this stupa's construction, equating the central rise of the great pagoda with Mt. Meru, and the circumambulation path with the pilgrim's passage to ever more refined states of awareness. Greatly admired, it set the example for the Myanmaran zedi, a synthesis of temple and stupa.

Seinnyet Nyima Pagoda The intricately ornamented Seinnyet Nyima Pagoda (p. 332) stands within the walls of the Seinnyet Ama Temple. The pagoda, traditionally dated to the eleventh century, is a solid structure. Its bell-shaped dome rises from a terraced three-stepped base; smaller stupas stand at the four corners of each stage, with lions guarding the stupas on the middle stage. Images of the Buddha are seated in niches set into the middle of the dome facing the four directions. The dome is crowned by a flattened relic chamber (harmikā) surmounted by large concentric rings with a bell-shaped top.

Dhammayazika Pagoda Built by King Narapatisithu in 1196 C.E. to honor the Buddha as king of the Dharma (Dharmarāja), the Dhammayazika Pagoda (p. 334) is a solid bell-shaped pagoda modeled after the Shwezigon. Illustrations of the Buddha's previous lives are sculpted into the terracotta tiles that line its three lower terraces. The terraced base is five-sided; a small temple enshrining a statue of the Buddha is built into eachof its sides. The whole monument is enclosed within a massive fifteen-sided wall with five gates.

Mingala Zedi The Mingala Zedi (p. 335), the Reminder of Blessings pagoda, is considered to represent the highest development of Pagan architecture. Built in 1284 by King Narathihapati, it predates the Mongol invasion by only three years and was among the last of Pagan's great monuments. Its bell-shaped dome, capped by a

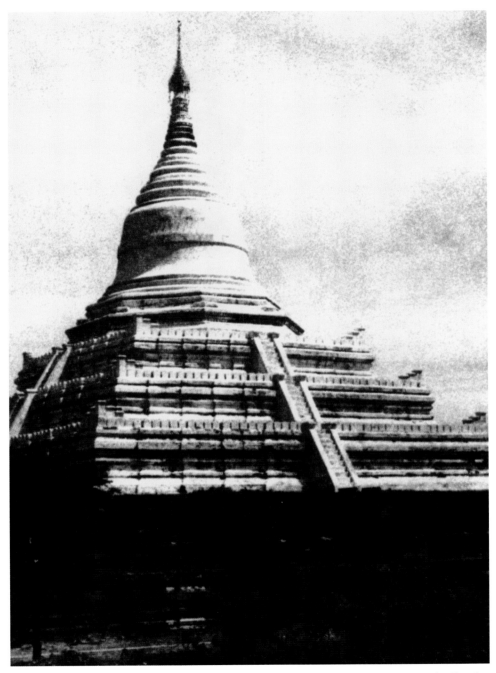

The five-terraced Shwesandaw Pagoda, the first monument built by Anawrahta after conquering Thaton, enshrines hair relics of the Buddha.

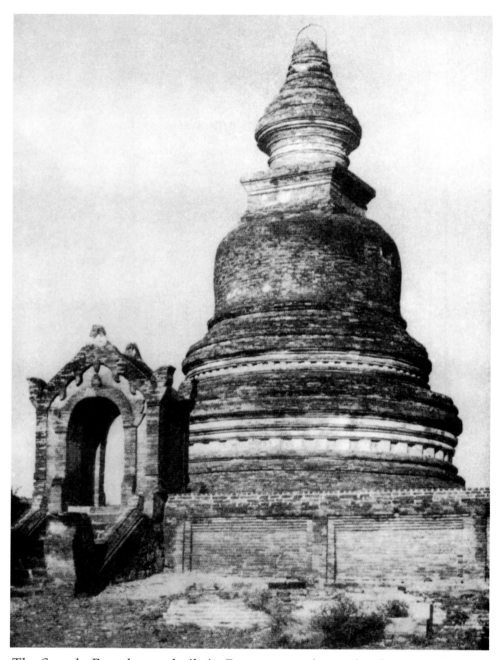

The Sapada Pagoda was built in Pagan around 1190 by the monk Sapada, who studied in Sri Lanka and introduced the Sri Lankan Theravādin tradition to Myanmar.

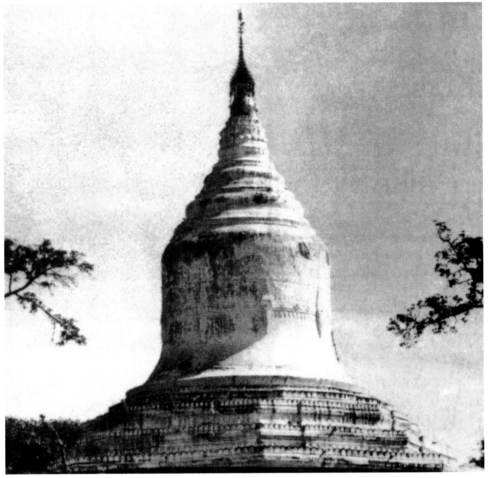

Erected by Anawrahta in the eleventh century, the Lokananda Pagoda enshrines a copy of the tooth relic of Sri Lanka.

graceful spire, rises from a three-stepped base set on a large square foundation. The smaller stupas on the four corners of the top terrace represent the conical pot-style, one of the six major shapes of dome favored by Theravādin Buddhists. Staircases rise up on all four sides of the terraces in the manner of the Descent from Heaven stupas known in the Tibetan tradition. The terracotta tiles lining the terraces are sculpted with scenes from the Buddha's life, which may have contributed to the pagoda's name.

329

Mahābodhi Pagoda The Mahābodhi Pagoda (p. 336) was built by King Nantaungma (r. 1211–34 C.E.). Its shape, modeled on the Mahābodhi of Bodh Gayā, site of the Buddha's enlightenment, is unique in Myanmar. In the niches on each of its seven stories are images of the Buddha seated in the earth-touching gesture associated with the Buddha's defeat of Māra at Bodh Gayā. Larger images are sculpted in the center of each row.

Destruction of Pagan

At its height, Pagan was a virtual city of Buddhist monuments that filled an area of sixteen square miles. Its magnificence faded after 1287, when the invasion of the Mongols ended the dynasty of Burmese kings. Thousands of pagodas and temples were ravaged and left to ruin during the anarchy that prevailed for many years thereafter. This deterioration continues today, accelerated by a growing international market for ancient Buddhist art. Of the two thousand or so stupas, temples, and monasteries that can still be traced in the region of Pagan, only about a hundred are maintained to any extent. (PGP-f)

Following the Mongol invasion, a people known as the Shan occupied much of northern Myanmar. Although the Shan soon converted to Theravādin Buddhism, the political situation remained unstable. The Mahāyāna Sangha continued for a time, but never recovered its former strength. The Theravādin school survived the disruption, but questions concerning the validity of the ordination lineage and aspects of Vinaya observance divided the Sangha into four factions. This division was healed in the late fifteenth century by King Dhammaceti, a former monk, who reformed the Myanmaran Sangha and established a single Vinaya lineage based on the Mahāvihāra tradition of Sri Lanka. Pegu, Dhammaceti's capital city, became the center of this unified tradition. From that time to the present, Theravāda has been the form of Buddhism studied and practiced throughout Myanmar.

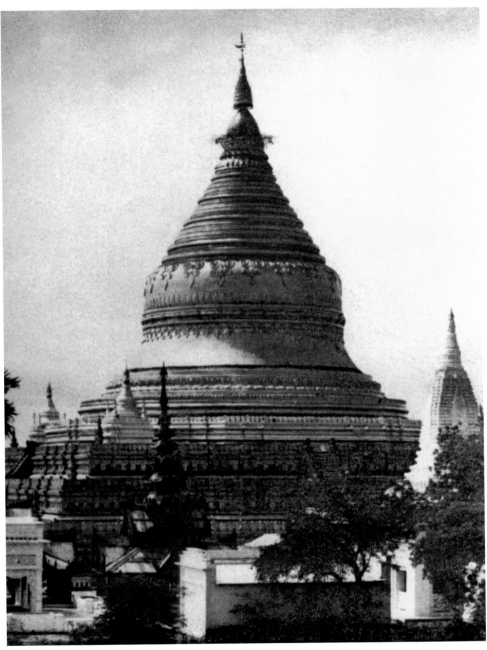

The elegant Shwezigon Pagoda near Nyaung U, built on the bend of the Irrawaddy River north of the walled city of Pagan, was begun by King Anawrahta and completed by King Kyanzittha (1084–1113).

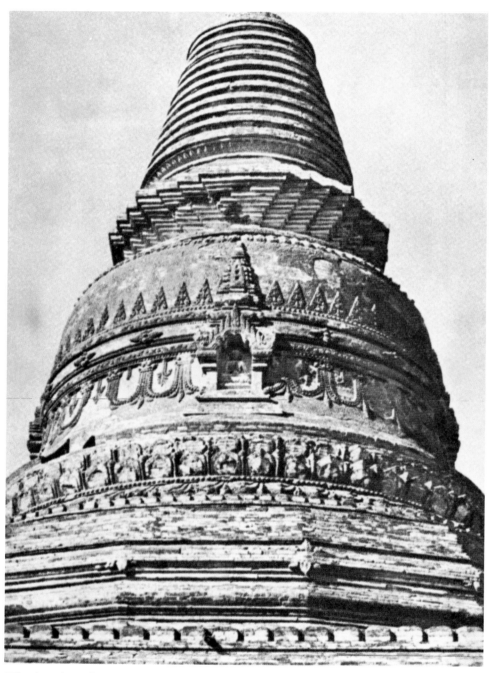

The intricately ornamented pagoda of Seinnyet Nyima, traditionally associated with Queen Seinnyet, rises from a three-stepped base at Pagan.

Small pagodas surround the Shwedagon Pagoda, Rangoon's cultural and spiritual center.

New pagodas modeled on the Shwezigon, notably the Shwe-gule and Shwenandaw pagodas, were built at Pegu during the sixteenth century, but the Sagaing Tupayon Pagoda begun by King Narapati in 1444 was never completed. Other pagodas of this period are the Dukkanthein Pagoda, built in Arakan during the reign of King Minbin (1531–53), and the Kaungmudaw Pagoda, also known as the Rajamanucula, built in Sagaing by King Thalun of Ava to commemorate the capture of the capital. Completed in 1636, the 149-foot-high Kaungmudaw Pagoda is a graceful white bubble-shaped stupa modeled after the Ruvanveli Dāgaba in Sri Lanka.

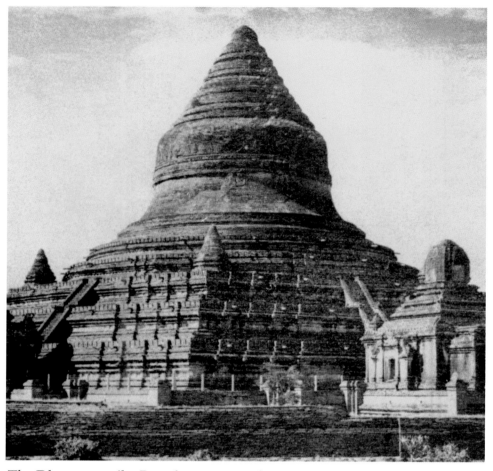

The Dhammayazika Pagoda was erected at Pwasaw by King Narapatisithu (r. 1174–1211) to honor the Buddha as Dharmarāja, king of the Dharma.

The Shwedagon Pagoda

Rising like Mt. Meru to a height of 344 feet above Rangoon, the Shwedagon, the Golden Pagoda (p. 314), is the crown jewel of Myanmaran stupas. Tradition holds that it stands on the site of a sixty-foot-high stupa built by the two disciples of the Buddha, who brought clippings of the Buddha's hair from India and established the stupa on Okkala Hill, site of present-day Rangoon. Enlarged and

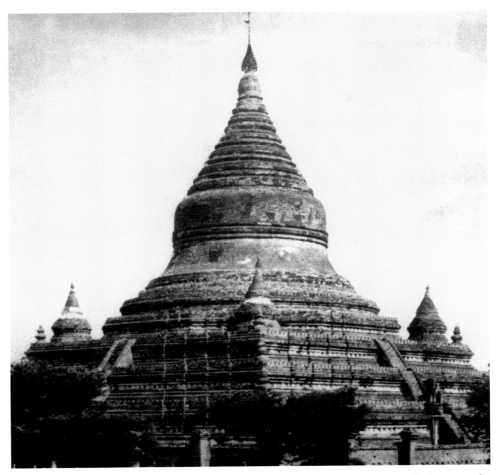

Terracotta tiles line the three-stepped base of the Mingala Zedi (Mangala Caitya), built by King Narathihapati in 1284.

ornamented through the centuries, the majestic Shwedagon became the archetype of Myanmaran pagodas. Binnuya U, king of Pegu, reconstructed the great pagoda in 1372. In 1460 Queen Shinsawbu ornamented it with terraces and walls. Shinbyushin, the king of Ava, enlarged the pagoda again and shaped it into its present form. Kings who succeeded him continued to honor the great monument with ceremonial applications of goldleaf. Today the Shwedagon measures 1,476 feet around at its base; its spire is topped with a ball

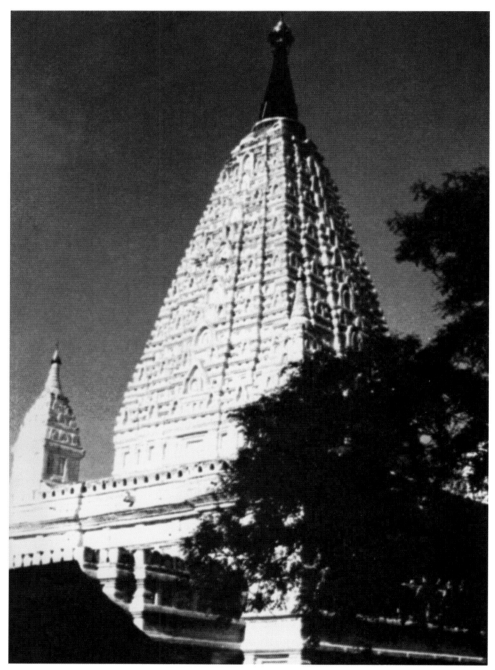

The Mahābodhi, erected in Pagan during the thirteenth century, is modeled after the Mahābodhi in Bodh Gayā, site of the Buddha's enlightenment.

of pure gold ten inches in diameter, inlaid with more than four thousand diamonds. Refreshed continually with offerings of gold, the pagoda rises above clusters of smaller pagodas and shrines like a cosmic mountain.

Reunification and Revitalization

When Myanmar was reunited in 1752, the center of power shifted to the northern cities upriver from ancient Pagan, where construction soon began on what was to be the largest pagoda in the world. The Mantaragyi Pagoda in Mingun, designed to be five hundred feet high, was under construction between 1790 and 1797. But construction was halted when the first terrace, a huge square mass of solid brick, proved unstable after reaching a height of 164 feet. Great cracks have since appeared in its sides, rendering further construction impossible.

A model of the Mantaragyi Pagoda, placed in the courtyard of a temple erected nearby, indicates the magnitude of its intended form, which would have been topped by a squared-off bell-shaped dome and a pinnacle similar in form to the Lokananda Pagoda. Massive as the unfinished base appears, it is little more than one fourth the height that was planned.

In 1816, Mingun, located on the Irrawaddy River a short distance northwest of Mandalay, became the site of another grandly-conceived and more successful monument, the Shinbyume Pagoda, built by Prince Dagyidaw to honor the memory of Shinbyume, his first wife. This stupa, also known as the Myatheindaw Pagoda, is an ornately detailed representation of Mt. Meru and the seven circles of cosmic mountains that surround it. A tall gate stands at the entrance to the staircase that allows the practitioner access to each of the seven stories, which are ornamented by rows of structures shaped like mountain peaks. At the center of the broad top of the seven storied base rises a round drum topped by a stupa of classical Myanmaran design. This sacred building was repaired in 1874 by King Mindon, a great Dharma patron.

337

King Mindon's rule signaled a new wave of support for the Dharma. The king himself revitalized interest in the scriptures by convening a major Buddhist council at Mandalay to rehearse and transcribe the Pāli Tipiṭaka. The texts were verified and engraved in Burmese script onto 729 marble slabs. The slabs were affixed to 729 stupas that surround the walls enclosing the vast compound of the Kuthodaw Pagoda in Mandalay, so that a practitioner circumambulating the entire compound performs the meritorious act of honoring (and symbolically reciting) the collected words of the Buddha. For this reason the Kuthodaw Pagoda has been called the largest book in the world. (SKB 56)

The sacred texts, preserved in Pāli until modern times, were recently translated into Burmese, Mon, and Shan languages, supporting intensified study of the teachings. Since 1886, when the British annexed Myanmar to India, the Myanmaran Sangha has suffered from lack of state support and endured more than a hundred years of difficult political conditions. Independence gave rise to further unrest that still continues today. Throughout this time, sustained by a strong tradition of scholarship, dedication to meditation, and a close connection between monks and laypeople, the Sangha has helped provide stability and continuity for the Myanmaran people and worked to preserve their nation's unique religious and cultural heritage.

THAILAND
AND LAOS

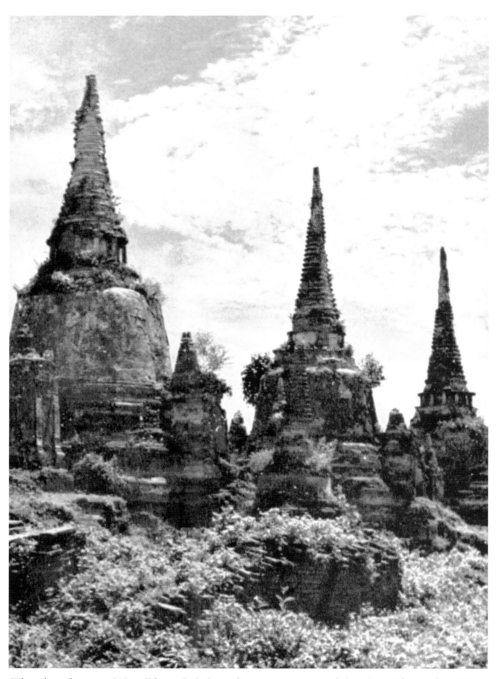

The dāgabas at Wat Phra Sri Sanphet were erected in Ayutthaya by King Ramadibodhi in honor of his father and mother.

Thailand

Buddhist monks from India arrived in the land now known as Thailand many centuries before the Thai people themselves migrated south into this region. While precise dating is difficult, archaeological evidence indicates that Buddhism was known in Dvāravatī as early as 50 B.C.E., about five hundred years after the Buddha's parinirvāṇa (543 B.C.E. as calculated by the Theravādin tradition).

Dvāravatī, a Mon kingdom located in the Lopburi region north of modern Bangkok, flourished until the mid-eighth century, a period that marks the early development of Buddhism in Thailand. Stone sculptures of the Wheel of the Dharma and the Buddha's throne and footprints, all images associated with the Theravādin tradition of Buddhism, have been found just west of Bangkok at Phra Pathom, the first dāgaba erected in Thailand. These sculptures are thought to have been brought to Thailand by Buddhists from northern India during the Gupta dynasty, about 450 C.E. A stone stupa surmounted by thirteen wheels (p. 141), discovered at Nakon Pathom, also dates to this time. (BMS 1)

Mahāyāna masters entered Thailand around 750 C.E. Bronze sculptures of Buddhas and Bodhisattvas, very similar to those found

in Java, have been recovered from caves in the Suratdhani region where they were hidden long ago. The Mahāyāna school continued in southeastern Thailand for centuries, but did not extend into Nakon Pathom, the center of Dvāravatī culture. The Great Relic Dāgaba at Jaiya in Suratdhani and the old Great Relic Dāgaba at Nakon Sridhamraj were associated with this Mahāyāna Sangha.

About 1050 C.E., a Śrī Vijayan king from Nakon Sridhamraj occupied Lopburi, and his son ruled Cambodia, to the east. From that time Lopburi became a center of Cambodian power. Much of what is now modern Thailand was governed by Cambodian kings and influenced by the Khmer culture. Inscriptions verify that some of these Cambodian kings were Buddhists, which may have facilitated the flow of the Cambodia Mahāyāna traditions into Thailand. With Cambodian Buddhism came the Khmer architectural forms. A new style of dāgaba emerged, massive and castle-like in appearance and topped with a prominent spire (prang). The Prang Sam Yod, the Three Spires Dāgaba (p. 344), is a Mahāyāna monument built in this style. Although the Theravāda and Mahāyāna sanghas coexisted in Lopburi, the shrines and dāgabas of this period generally trace to Mahāyāna origins.

In the mid-eleventh century, King Anawrahta (r. 1040–77) of Myanmar extended his kingdom northwest to Lanna and south to Lopburi and Dvāravatī. After taking over most of Thailand, he allowed the Khmers to continue to govern the southern provinces. This favored the growth of both Theravādin and Mahāyāna traditions: The Theravāda Buddhism of Pagan flowed into the northwestern provinces, while the southern provinces ruled by the Khmers appear to have remained Mahāyāna. (BMS 3)

By that time, the traditional homeland of the Thais, threatened for centuries by Chinese expansion, was absorbed into the Chinese empire. Groups of Thais began to move south and west into Thailand, settling along the Salween, Thae, and Mekong rivers and the Menam Chao Phaya Valley, where they adopted the Theravādin Buddhism of Pagan. As their numbers increased, the Thais formed their own governments, then their own state. By 1257 C.E. they had

A thirteen-ringed stone stupa discovered at Nakon Pathom marks the dawn of Buddhism in Thailand.

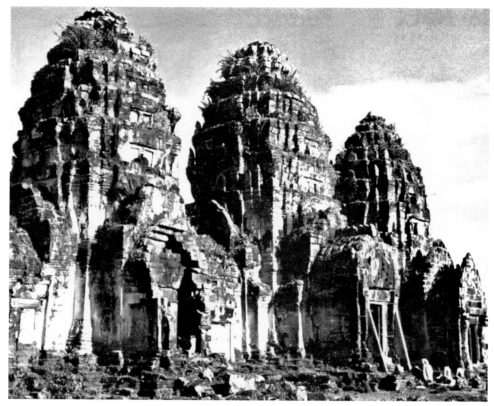

The Prang Sam Yod, the Three Spires Dāgaba, at Lopburi, an eleventh-century Mahāyāna center. The Buddha image was housed in the central spire and Bodhisattva images on the left and right spires.

expanded into Lanna and Lanchang (Luang Prabang and Vientiane), which they ruled from their capital at Sukhothai, a former Khmer outpost located in north central Thailand 280 miles north of Bangkok.

After the Mongols conquered Pagan in 1287, ending Burmese influence, the Thai rulers began to extend their power over neighboring tribes. Although the Thais of the south dominated the Khmers, they absorbed Mahāyāna Buddhism along with other elements of Khmer culture. This distinguished them from the Thais of the north, who remained strongly Theravādin.

The Phra Maha Dhatu, the relic dāgaba at Jaiya in Suratdhani, was created by the Mahāyāna Sangha during the Śrī Vijaya period.

345

Phra Dhatu Luang, the royal relic dāgaba in Lampang, was built in the eleventh or twelfth century.

Relic dāgabas at Wat Buddhaisawan, Temple of the Buddha's Treasures, a prang-topped temple built in Ayutthaya by King Uthong.

Thailand received a fresh transmission of Theravādin Buddhism from Sri Lanka during the reign of the powerful Sri Lankan king Parākramabāhu (r. 1153–86), who assembled a council to review the practices of the Buddhist schools active in Sri Lanka and united the monks into a single order. (BMS 5–6) This council, known as the Seventh Council to the Theravādin traditions, attracted the notice of the Burmese, Mon, and Thai Sanghas of Southeast Asia. Monks sent to Sri Lanka to study were reordained into the Sri Lankan tradition, forging the first direct links between Sri Lanka and Thailand. Returning home, they established a unified tradition that used Pāli as its religious language. A number of monuments built in Thailand after this time reflect Sri Lankan influence.

347

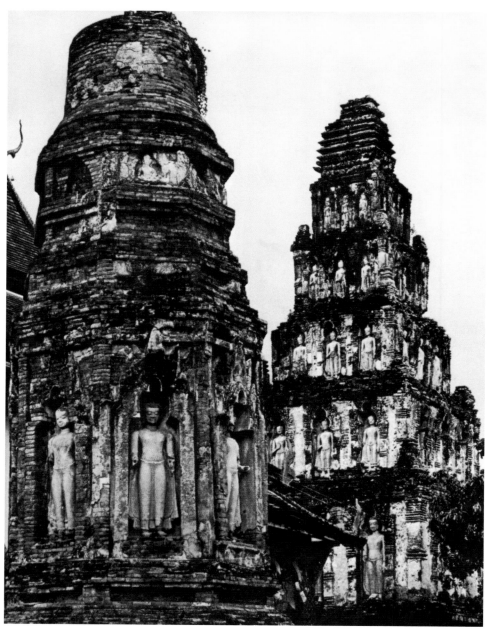

Ancient octagonal and square dāgabas stand at Wat Kukut, Lampun (Nakorn Haripunjaya). Sixty Buddhas look down from the niches on the five-storied dāgaba on the right. Originally built in 714, this pyramid-type dāgaba was destroyed in an earthquake but rebuilt in 1218. (SKB 62)

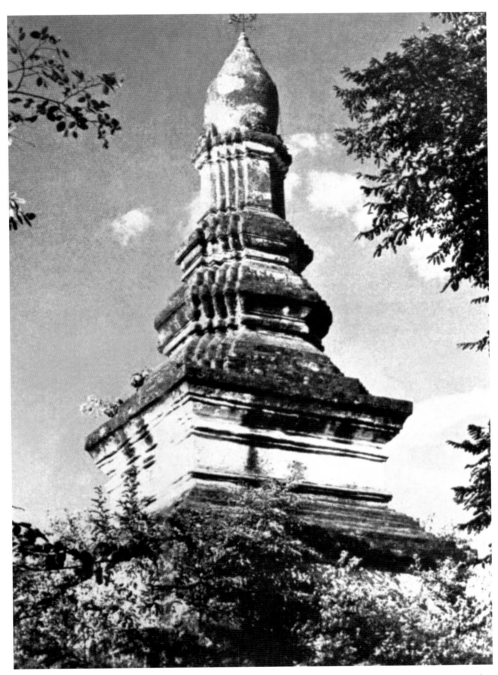

This rectangular dāgaba, located in the old Tak province, was built in the early Sukhothai period (c. 1250–1350).

Around 1250 C.E., the monks who had returned to Thailand invited the first Sri Lankan monks to assist them in transforming the Great Relic Dāgaba of Nakon Sridhamraj into a Sri Lankan style stupa. An inscription dated around 1277 relates that the Thai king Ram Kamhaeng, impressed by the Sri Lankan monks and the order established at Nakon Sridhamraj, granted them royal patronage at his capital at Sukhothai. After that, the new Theravādin order flourished and the Mahāyāna tradition declined from lack of support. For a time two Theravādin traditions coexisted in Thailand: the school reordained in Sri Lanka and the earlier school tracing through the monks of Pagan, which still used Sanskrit. Both had major centers in Sukhothai, to the south, and in the northern city of Chiengmai.

In time, when the Sri Lankan order became larger than the older tradition, monks of the older order asked that the two traditions be merged. Even after the two traditions were unified, their distinctive heritages could be seen in the contrast between the gamavāsi, monks devoted to study who lived near the cities, and the araññavāsi, the "forest monks," who preferred solitude for their meditation practice. The Pāli Tipiṭaka brought from Sri Lanka, transcribed into the Khmer script, became the only canon, and Sanskrit was no longer used for scriptures or ritual. This unified order of Theravāda Buddhism has flourished in Thailand to the present day. In the eighteenth century, when Buddhism weakened in Sri Lanka, monks from Thailand were able to restore the Sri Lankan lineage.

The Thai capital was moved from Sukhothai to Ayutthaya in the mid-fourteenth century, and Ayutthaya, a Theravādin center, supplanted Sukhothai as the cultural center of Thailand. The monuments of Ayutthaya reveal an emerging Thai style blending elements of Khmer and Sri Lankan architecture. Dāgabas of this period were built in the castle-like style of Lopburi or in the rectangular style developed in Sukhothai. Some Sri Lankan-style dāgabas were even reshaped to fit the rectangular model. The tradition of building dāgabas to enshrine the ashes of secular individuals became widespread at this time.

War with Burma erupted periodically. In 1548, Queen Suriyothai, wife of King Maha Chakraphat, died fighting the Burmese

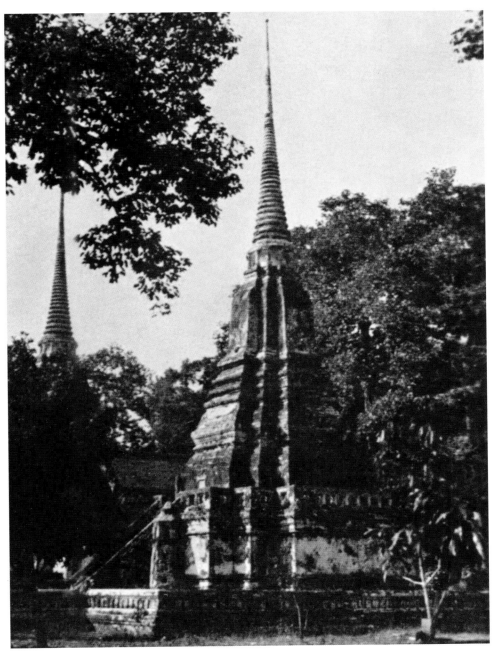

Phra Chedi Sri Suriyothai, built in Ayutthaya in the sixteenth century, is dedicated to the memory of Queen Suriyothai, who died fighting beside her husband King Maha Chakraphat in a war against the Burmese in 1548.

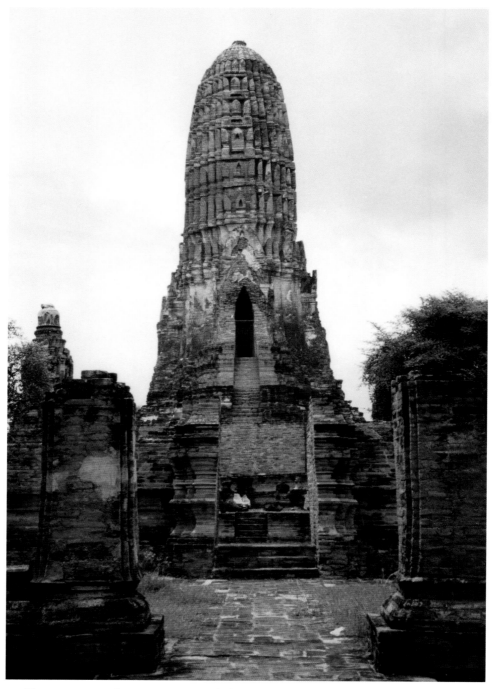

Entryway to the prang-topped dāgaba of Wat Phra Ram, Ayutthaya.

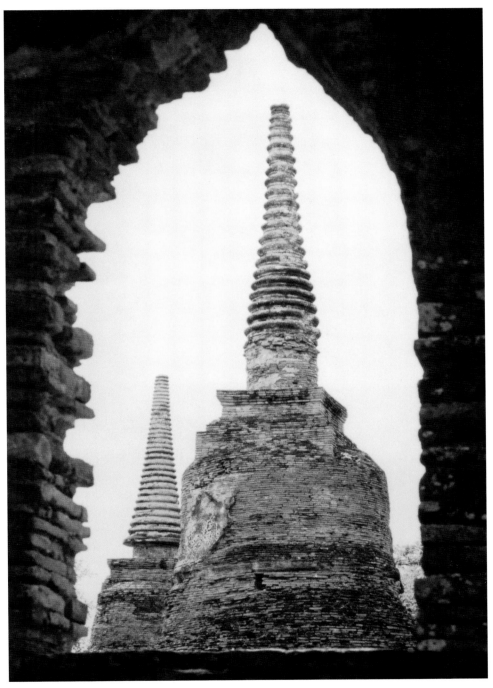

Dāgabas in the courtyard of Wat Phra Sri Sanphet, Ayutthaya.

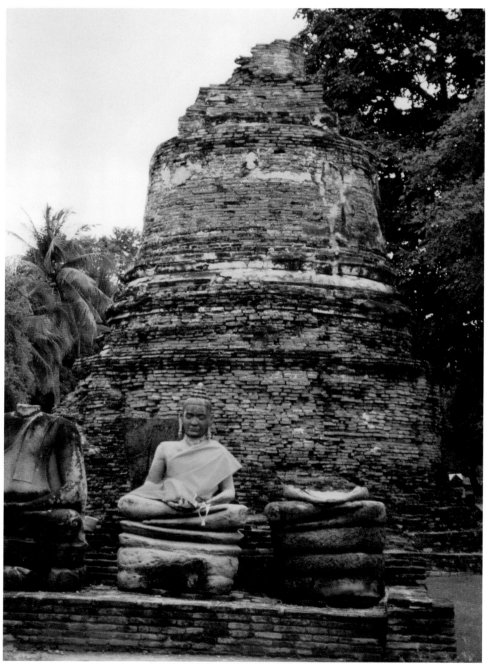

Only one of the original group of Buddhas still meditates before this Sri Lankan-style dāgaba at Wat Phra Sri Sanphet, Ayutthaya.

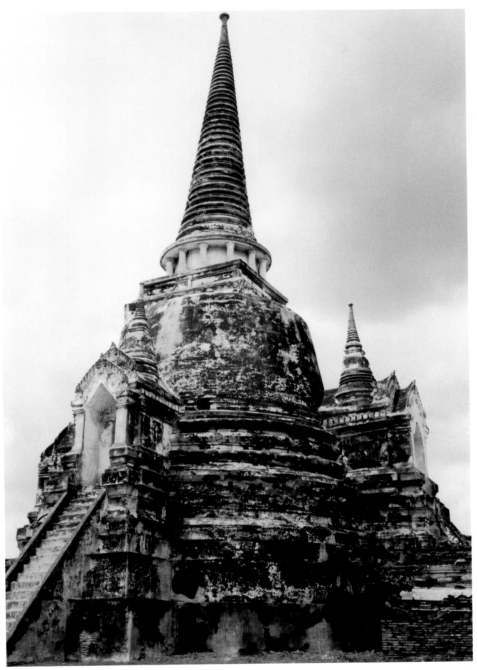

High stairways at the four directions give access to the shrines of the great dāgaba of Wat Sri Sanphet, Ayutthaya.

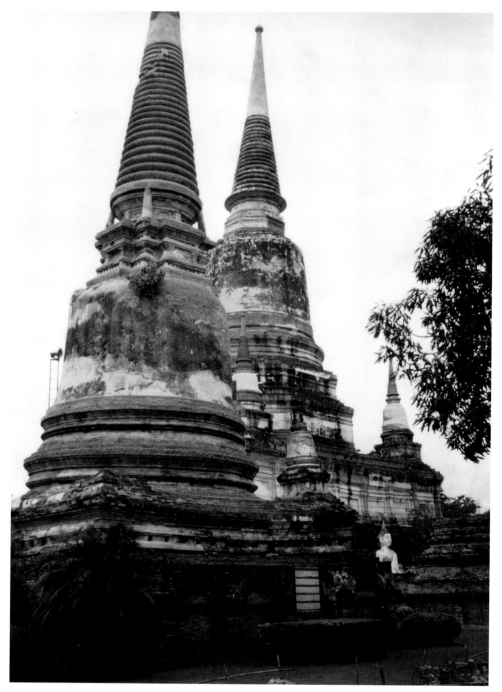

Dāgabas at Wat Phra Mahathat, Ayutthaya.

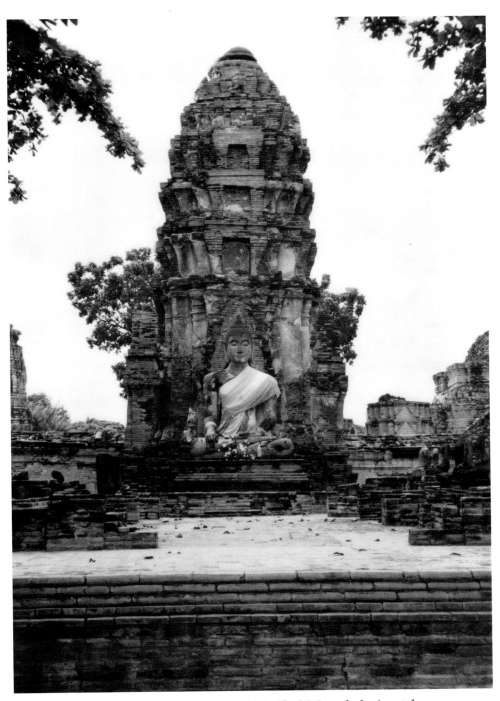

Dāgaba and Buddha at Wat Yai Chai Mongkol, Ayutthaya.

beside her husband. Her relics were enshrined in the Phra Chedi Sri Suriyothai, built to honor her memory. When Ayutthaya was finally destroyed by the Burmese in 1782, the capital was moved to Thonburi, then across the river to Bangkok. Although war continued with the Burmese, Thai kings patronized Buddhism and built numerous monasteries and dāgabas. Rama III, a great patron of the Dharma, supported the copying, study, and translation of Pāli texts. His brother, Mongkut, joined the Sangha and remained a monk until he succeeded to the throne. Mongkut, a serious scholar and practitioner, established the basis for the Dhammayutika school. He collected all available Tipiṭakas from Sri Lanka and Myanmar, and compared them with the Thai canon.

When Mongkut left the order to become Rama IV, king of Thailand, he supported the old Mahānikāya sect as well as the Dhammayutika. When the Mahāyāna Annamese from the east sought refuge in Thailand, he extended patronage to their Sangha as well. Among his contributions to the Dharma are the dāgaba at Wat Bo, a replica of the Queen Suriyothai Monument in Ayutthaya; the dāgaba at Wat Bovornives, said to be modeled on the one at the top of Mount Panom Plerng in Srisajjanalaya; the golden dāgaba at Wat Phra Kaow; and dāgabas at Wat Rajapradit and Phra Pathom.

Rama IV's son, Chulalongkorn, continued patronage of the two Theravādin and the Mahāyāna schools. In 1871 he went on pilgrimage to Sārnāth, where he took photographs of the Dhamekh Stupa and developed an interest in the Buddhist monuments of India. Thai scholars followed his lead and turned to India as a fresh resource for Buddhist studies. The king also had the Pāli Tipiṭaka edited, sponsored its publication, and distributed it to all countries where the Tipiṭaka was seriously studied. He obtained for Thailand priceless statues from the great chandi of Barabuḍur and supported Buddhism so fervently that Marquis Curzon, viceroy of India, gave him one of the most valuable treasures found in India: relics recovered from the excavations of a stupa at Piprahwa, thought to be one of the eight original relic stupas. The king distributed some fragments of these precious relics to monasteries in Myanmar, Sri Lanka, Siberia, and

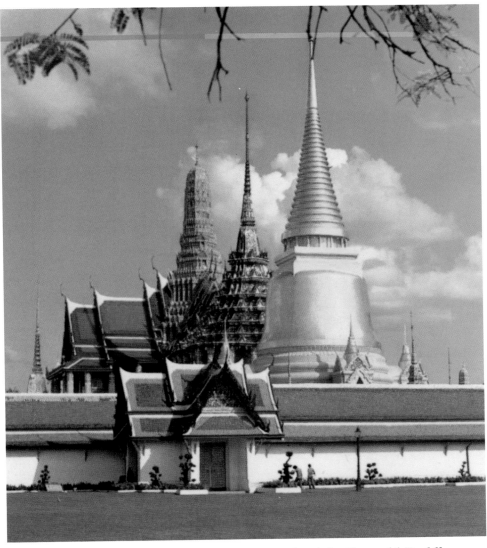

The golden dāgaba at Wat Phra Kaow, Temple of the Emerald Buddha near the royal palace, was built in Bangkok in 1785.

Japan. He had the rest enshrined in a bronze dāgaba and placed on top of the Golden Mount at Wat Sraket, which is now an object of public worship. Today the Wats Raghang, Bo, Picayat, Bovornives, Arun, Phra Yurawongs, Phra Kaow, Rajapradit, and Phra Pathom rank among Thailand's treasury of relic receptacles.

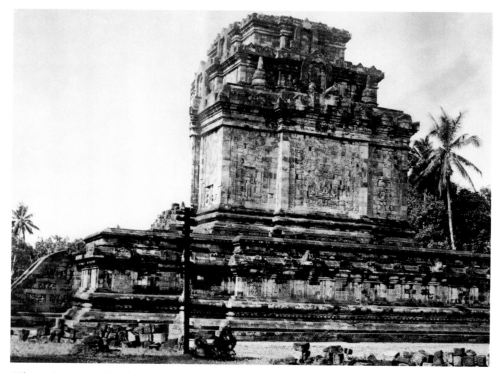

That Luong, built in Vientiane in the sixteenth century, reflects the influence of Khmer's massive, rectangular-style architecture. Stupas stand on the lower terraces and upper stories.

Laos

The Laotians who occupied modern Thailand received Buddhism as early as the first century B.C.E., but their culture was dominated and mostly absorbed by the Khmers who flourished in Cambodia between the ninth and fourteenth centuries. At the end of the thirteenth century, the Laotians settled in their present home and in the fourteenth century, founded the first Laotian state. Tradition holds that soon after the founding of Laos, a Cambodian princess converted the Laotian king to Buddhism. He then invited twenty Cambodian monks to Laos to teach the Dharma. The monks brought to Laos a copy of the Pāli Tipiṭaka and a famous golden statue of the Buddha. Theravādin Buddhism flourished under royal patronage and soon became the state religion.

CAMBODIA
INDONESIA
AND VIETNAM

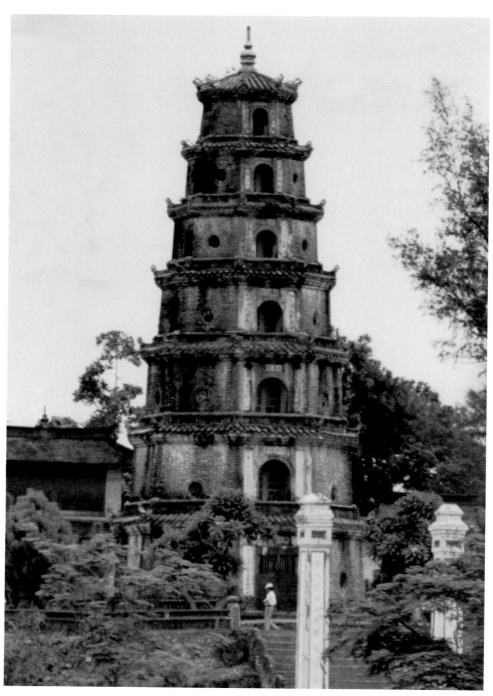

The seven-storied Phuoc Duyen Tower of Chùa Thien Mu, Hué, Vietnam.

362

Cambodia, Indonesia, and Vietnam

Theravādin teachings may have been known to the Khmer peoples of Cambodia as early as the first century C.E., and Mahāyāna as early as the second century C.E. The Chinese chronicles describe Fu-nan, the earliest Cambodian kingdom, as Mahāyānist, and fine examples of Mahāyāna art date from this period of Cambodian history. Fu-nan, a trading center, came under Indian rule during the fourth century. Although the rulers were Hindu, they accorded Buddhism some support, and the Sangha continued to develop. By the sixth century the Buddhists of Fu-nan were so well known for their scholarship that the Chinese sought their help in translating Sanskrit texts.

In the seventh century, Fu-nan gave way to the kingdom of Kambuja, founded by Hindus from India. In consolidating their empire, they severely persecuted Buddhism. I-tsing, who visited Cambodia at that time, reports that the Sangha was nearly destroyed. Early in the eighth century, Cambodia was divided, leading to a period of disruption and war. Eventually the Śailendras of Java, a Buddhist dynasty, rose to power in Cambodia. The building of Mahāyāna monuments during their reign testifies to a revitalization of the Cambodian Sangha.

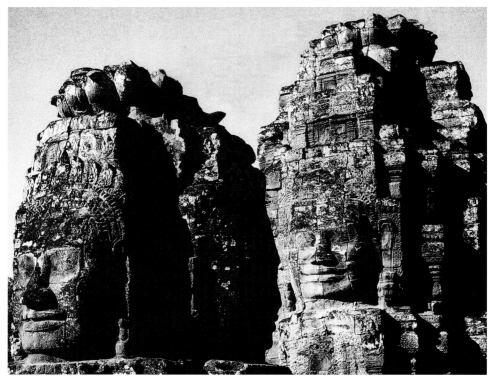

The faces of the Buddha and of King Jayavarman VII face the four directions on the Bayon of Angkor Thom, Cambodia. (Getty Research Institute, Resource Collections, Wim Swann Collection)

Early in the ninth century, Jayavarman II unified Cambodia as the kingdom of Angkor. While he and his successors were Śaivite, they followed the Indian model of righteous kingship and extended support to Buddhism as a religion under their protection. Rajendra-varman II, who came to power in the tenth century, built numerous Mahāyāna shrines. His successor, Jayavarman V, had Mahāyāna scriptures brought from India and required his officials to become familiar with them.

The magnificent complex of Angkor Wat, built in the early twelfth century as a monument to Śiva, became a Buddhist holy place after Hinduism declined. Its mandalic form, with the great temple rising from its center, recalls Mt. Meru, the mountain-pillar

of the world-system common to both Hindu and Buddhist cosmology. The lesser known but widely acclaimed Bayon, the central monument of Angkor Thom, the last Khmer capital, is more specifically Buddhist. Here Jayavarman VII (r. 1181–c. 1219) had his likeness carved together with the face of the Buddha looking outward to the four directions in a powerful conjunction of royal and spiritual power. A statue of Lokeśvara was found in the temple's central shrine, indicating strong Mahāyāna influence. (BW 77–82)

The Theravādin tradition, formally introduced in the twelfth century by a monk from Myanmar, was accepted by Cambodian rulers in the thirteenth century and granted royal support. By the middle of the fourteenth century, the Theravādins had supplanted Mahāyāna as well as all residues of Hinduism. Monks from both Cambodia and Myanmar contributed to establishing the Theravādin tradition in Thailand and Laos.

Indonesia

The Mahāyāna teachings entered the island of Sumatra in the fifth century, when the Kashmiri monk Guṇavarman, a follower of the Mahāyāna and a holder of the Sarvāstivādin Vinaya lineage, converted the Sumatran queen. During the reign of her son, Buddhism became the official religion of Sumatra. In the seventh century, a kingdom in Java, named Ho-lo by the Chinese, was a center of Buddhist culture. The Chinese pilgrim Hui-ning spent two years in Java (664–65) translating Sanskrit texts under the Javanese monk Jñānabhadra.

In 671 C.E. the Chinese pilgrim I-tsing found more than a thousand monks in Palembang, a center of the Indonesian kingdom of Śrī Vijaya, where he stayed for some time to study Sanskrit and Buddhist texts. The scholar Dharmapāla is said to have come to Indonesia from Nālandā about this time.

In the seventh and eighth centuries, Indonesia became widely known throughout the Buddhist world as a center of Mantrayāna, Vinaya, and Abhidharma, attracting prominent masters from the Buddhist universities in India. The Śailendras of Java who took control of Śrī Vijaya in the eighth century continued to support the Dharma and generally favored the Mantrayāna, which was then becoming more widely disseminated in India. Inscriptions mention that Kumāraghoṣa, a Mantrayāna teacher from Bengal, taught in Java in 782, and Vajrabodhi and Amoghavajra, who introduced the Vajrayāna to China, may have met in Java in the eighth century.

Buddhism remained a part of Indonesian culture at least until the eleventh century, when the renowned Indian master Atīśa came to Sumatra and studied the Sarvāstivādin teachings for ten years. Under later rulers the growing popularity of a synthesis of Buddhist and Śaivite teachings set the stage for decline. Late in the fourteenth century, when traders introduced Islam to the islands, the Sangha was already weakening. As Islam allied itself with the dominant political groups, the remaining followers of the Dharma retreated to the island of Bali, where a syncretic form of Tantra survives today.

Barabuḍur

The massive monument at Barabuḍur, one of the world's architectural wonders, shows the powerful impact that the Mahāyāna and Mantrayāna teachings had on the Śailendras of Java. Known locally as a chandi, Barabuḍur is the most spectacular and intricate of the ancient Buddhist centers of Indonesia. As described by Kempers, Barabuḍur has two distinct appearances. Seen from the air, the chandi appears as a giant mandala in stone: From a broad outer base rises a series of squares in diminishing sizes, topped by four concentric circular terraces with a large stupa in the center. Seen from ground level, the whole structure forms a stupa: The hemispherical

Information on pages 362–64 is largely based on A. J. Bernet Kempers, "A Buddhist Mystery in Stone." (BB 109–19)

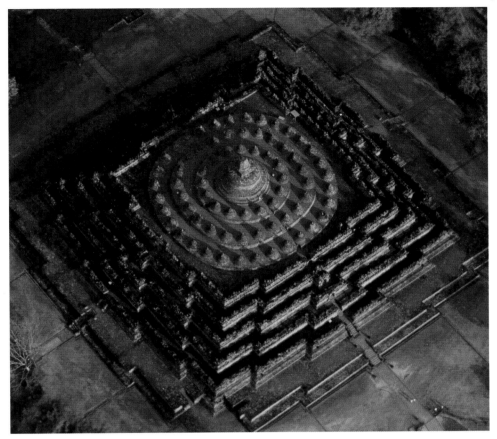

The mandala of Barabuḍur, the great Buddhist chandi of Java.

body of a stupa can be seen in the wide multi-layered lower section, topped by a traditionally-shaped upper section that rises to a height of 130 feet. (BB 111–13) The entire structure is a study in rhythmic patterns of stupas: Seventy-two small stupas along its terraces guide the practitioner to the central stupa at its top. On the balustrades of the galleries are 1,472 more stupas or stupa-shaped ornaments.

The base and lower stages of the Barabuḍur chandi form a circumambulation path leading to the highest terrace. Following this path, the pilgrim enters a series of galleries rich in sculptured reliefs designed so that each must be viewed individually, as a teaching complete in itself. Investigation of the broad base of the Barabuḍur

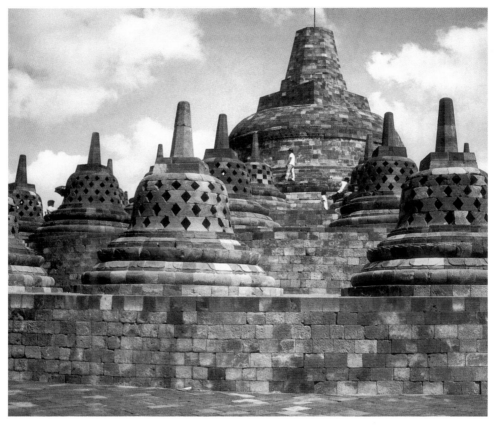

Images of the Buddha are seated inside stupas on the upper terraces of Barabuḍur. The central large stupa enshrines the Ādibuddha Vajradhara.

has revealed that it also is lined with sculpted reliefs based on teachings in the Mahākarma-vibhaṅga, a Buddhist text. These 160 sculptures were hidden when the outer wall was added, presumably to stabilize the monument's base. (Bo 14)

The pilgrim enacts the path to enlightenment by circumambulation, engaging on the first and second levels scenes from the Buddha's last and previous lives inspired by the Lalitavistara, Jātakas, and Avadānas. On the main wall of the second story appear scenes from the pilgrimage of Sudhana, a journey culminating in enlightenment related in the Gaṇḍavyūha. This theme continues

368

through the fourth gallery, when the pilgrim passes with Sudhana through the galleries of the Dhyāni Buddhas to enter the realm of Samantabhadra.

Passing through the last gateway, the pilgrim emerges into open space on the first of the four terraces. Here, enshrined in latticework stone stupas, Buddhas sit in deep samadhi. Circumambulating the terraces graced by these simple yet majestic shapes, the pilgrim approaches the central stupa that rises from the highest terrace, symbolic of the Dharmakāya realm. The statue of Vajradhara seated inside this central stupa was left unfinished, conveying a sense of the interconnection of emptiness and form, appearance emergent from the void. In all, 504 Buddhas appear in the niches along the galleries and in the terrace stupas.

Since the existence of Barabudur became known to Europeans in 1814, the great monument has never failed to evoke wonder, communicating a sense of order and harmony to even the most casual tourist. As early as 1816 the site was called a holy city, a city of the gods or Buddhas. (BB 2) A year later it was identified as Buddhist, and since that time scholars have continued to unfold possibilities for interpretation of Barabudur's architecture, sculpture, and symbolism. It is now believed that Barabudur was built around 800 C.E. by a king of the Śailendra dynasty, and may have been abandoned only a century later when the focus of Javanese culture moved east.

Restoration, recognized as necessary in the late 1800s, was carried out between 1907–08 under the sponsorship of the Dutch government. Further efforts were delayed until 1967, when UNESCO recognized Barabudur as a world treasure and agreed to assist in the restoration. After more delays, the reconstruction began in 1975 and was finished in 1982. (Bo 26–27) This work involved a major dismantling of the central monument and brought to light further information about the monument's construction. These discoveries inspired fresh efforts to locate and review all resources on the history and nature of this sacred structure. Essays in *Barabudur: History and Significance of a Buddhist Monument* (BB) emphasize the complexity of this massive chandi, which has yet to reveal all its secrets.

Vietnam

Buddhism in Vietnam developed independently of other parts of Southeast Asia. According to most accounts, the Chinese Mahāyāna monk Meu-po came to Vietnam as a refugee from Chinese political upsets late in the second century, although some accounts place him earlier. By the end of the century, a Buddhist community was active in the region. Monks from Sogdia, Central Asia, and India arrived in Vietnam in the third and fourth centuries, and the Indian monk Vararuci or Vinītaruci introduced Thien (Ch'an) teachings in the sixth century. Soon after, the Thien school arose and spread rapidly, supplanting the earlier A-Ham tradition. Pure Land Buddhism, introduced from China, was also flourishing by this time.

A second Thien sect was introduced in the ninth century. Buddhism also appears to have spread into the Hinduized kingdom of Champa, separate from the rest of Vietnam since the third century: A great shrine to Avalokiteśvara at Dong-duong dates from the reign of Indravarman II, at the close of the ninth century, and scholars mention evidence of earlier activity of Sarvāstivādin and Sammatīya monks.

After the formation of the independent Dai Viet kingdom in 939, its kings began to patronize the Dharma and frequently sought the advice of monks on secular matters. Toward the beginning of the eleventh century, when Buddhism was accepted as the national religion, the royal house obtained a copy of the Chinese Tripiṭaka.

While its neighbors turned toward the Theravādin traditions, Vietnam remained Mahāyāna. The Ly dynasty of the eleventh and twelfth centuries supported the Dharma, and King Ly-thanh Ton was a strong Buddhist practitioner. He served as the first patriarch of an important school of Thien founded during his reign and built fifty-five pagodas. Rulers of the Tran dynasty that rose to power in 1225 were also active participants in Buddhism.

The Buddhist Sangha survived a brief period of persecution in the early fifteenth century. While a stricter school of Thien became

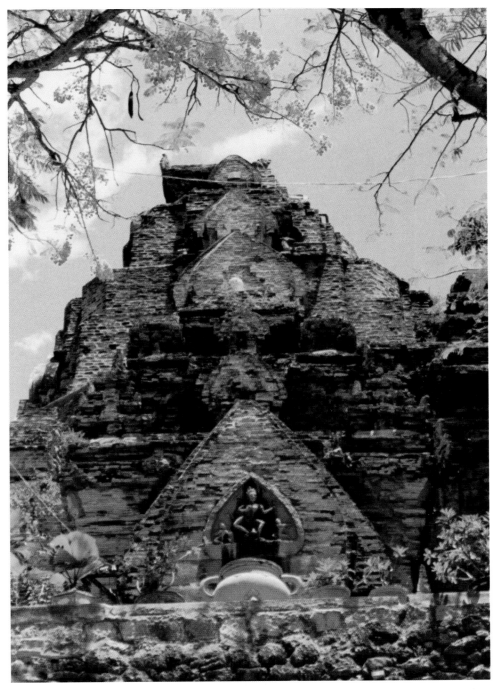

Thàp Bà Po Nagar, Nha Trang.

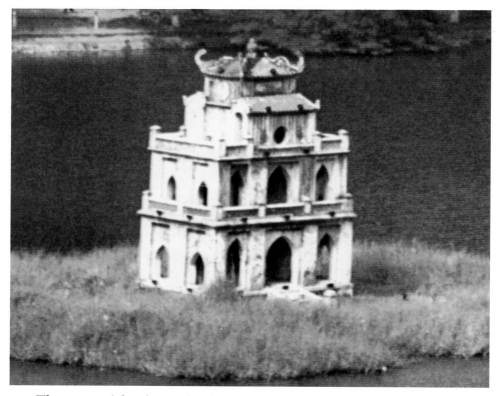

The square island pagoda-shrine Thàp Rùa Ho Hoàn Kiém, Hanoi.

popular in the seventeenth century, in practice Thien continued to incorporate the Pure Land doctrines as well as other Buddhist teachings. In this form Buddhism continued in Vietnam until the present century, when war disrupted Vietnamese culture. Thousands of refugees came to the West, where they have made efforts to preserve their culture and establish new centers for religious practice.

Phouc Duyen Tower, Thein Mu The Thien Mu (Fairy Woman) Pagoda, with its three-storied gate, Dharma Hall, and tower, stands on Ha Khe Hill a few miles west of Hué. It was rebuilt in 1601 during the reign of Nguyen Hoang, who fulfilled a fairy's prophecy that the lord who would rebuild the pagoda would bring prosperity to the land. Here, in 1844, King Thieu Tri erected the seven-storied Phuoc Duyen tower that now presides over this sacred place, long regarded as a national treasure.

STUPAS
OF ODIYAN

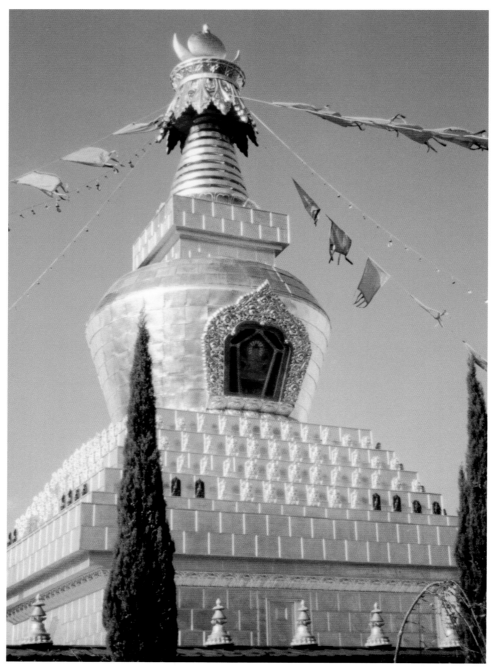

The Odiyan Enlightenment Stupa in northwestern California was consecrated on the anniversary of Padmasambhava's birth, July 22, 1980.

Stupas of Odiyan

In recent years, symbols of the Buddha, Dharma, and Sangha have been appearing in Western lands with increasing frequency. Statues of the Buddha, Padmasambhava, and the great Bodhisattvas herald for Buddhist practitioners the presence of the Buddha and the possibility of enlightenment. Small groups of practitioners who gathered around Asian teachers in houses or small halls in the 1960s have developed into communities capable of building and sustaining temples and monasteries. Some have created educational institutes and established procedures for ordination, essential steps for establishing a Buddhist Sangha.

Simultaneously, interest in the symbols of Buddhism has developed through meditation practice and also through the guidance of skilled teachers. Symbols convey teachings that lie beyond words; they enter consciousness through the doors of the senses and work below the threshold of thought. In time, meanings surface spontaneously, new concepts develop, and thoughts of enlightenment, once distorted by preconceptions and expectations, move closer to truth and realization. It is possible that a deeper understanding is beginning to awaken in the West, prompting Western Buddhist

communities to invest energy and resources in recreating the most fundamental of Dharma symbols—the stupa. Among the earliest of these expressions is the Odiyan Enlightenment Stupa, created in 1981 under the direction of Tarthang Tulku Rinpoche. The guiding vision that inspired the stupa's creation and the details of its empowerment are offered here to illustrate the factors that produce this symbol of enlightenment in a new land.

The Odiyan Mandala

Dedicated to the Great Guru Padmasambhava and the masters of the Nyingma lineage of Tibetan Buddhism, Odiyan is a living mandala, a complete expression of the body, speech, heart, qualities, and actions of the Buddhas. Founded in northwestern California by Tarthang Tulku Rinpoche in 1975, Odiyan is built on the model of Samye, the first monastery in Tibet. It is a place where the Dharma can enter the West through symbols that open heart and mind to the most subtle meanings of the Buddha's teachings. Among the most powerful of these symbols is the Enlightenment Stupa east of the central mandala.

The Enlightenment Stupa

The Odiyan Enlightenment Stupa is an essential part of the mandala, a pure expression of citta, the Buddha's heart, the centerless center of pure awareness. Overlooking a vast expanse of valley and mountain, on a site chosen for the convergence of elemental energies, the stupa stands 113 feet high on a base seventy-two feet on each side.

The design of the stupa was based on texts by Kongtrul Lodro Thaye and Jigme Lingpa, and the stupa was empowered according to instructions given in texts by Minling Lochen and Jigme Lingpa. At the heart of the stupa revolves a ten-ton prayer wheel, the world's largest. Powered by electricity, the prayer wheel turns day and night, generating four billion prayers a minute. Around the

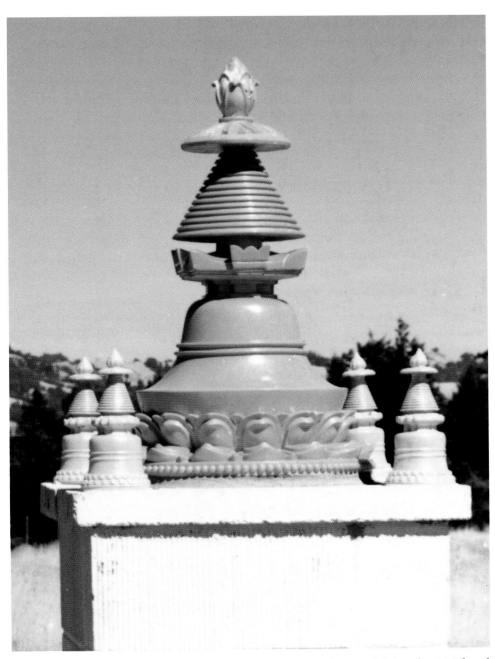

The Kadam Stupa introduced to Tibet by Atīśa is the model for the 108 land stupas and the stupas placed on the walls around the Enlightenment Stupa. All five stupas as well as the pedestal are fully empowered.

large wheel turn forty-two forty-four-inch prayer wheels. Large statues face in the four directions, and hundreds of sacred images line the walls. In the room above, a large statue of the Buddha looks out to the south, the direction of enlightenment, through a thirteen-foot-high stained glass window. Eighty seven-inch prayer wheels turn in the Buddha Room and two hundred thousand clay images line the walls.

Deep within the stupa are rare and precious relics transmitted through the enlightened lineages. Still more relics are sealed in a twelve-foot redwood obelisk carved from a tree consecrated and felled on Odiyan's land and mounted near the top of the monument. Other relics and precious objects are positioned in the parasol and the sun and moon near the top of the stupa.

Inside and outside the stupa are placed special depictions of Amitāyus, the Buddha of Unbounded Life, as well as pictures of many great Buddhist masters and statues of the eight Herukas. Holy texts from the Kanjur and Tanjur, the Tibetan Buddhist Canon, were also placed within the stupa, andmillions of repetitions of a hundred thousand mantras as recorded by Lama Mipham were sealed in prayer wheels both within and surrounding the stupa. The prayer wheels turn day and night to radiate blessings throughout time and space, protecting against disruptions and natural disasters. Special tsa-tsas, small plaques or seals bearing mantras and images, line the vase of the stupa, where they send blessings out to the surrounding area and beyond, for the benefit of the world and all beings.

On the outside of the stupa are 180 mandalas of the Gyude Kuntu tradition of Jamyang Loter Wangppo, etched onto copper plates, silverplated, and gold-leafed. The whole of the stupa was covered in gold leaf, which is regularly applied to the stupa for maintenance and as a ritual offering. Suspended from the stupa are 128 bells and 144 prayer flags, spreading their blessings in all directions. On the stupa's four steps are 216 replicas of rare Pāla dynasty statues, cast from molds prepared from the originals.

Four walkways around the stupa invite circumambulation, a practice that generates merit for all practitioners and opens deeper dimensions of meaning for those able to enter the mandala in meditation and merge consciousness with its flow of energy. During stupa ceremonies held on auspicious days of each month, three circumambulations are completed on each of the four paths.

Circumambulation begins with three prostrations at the entryway, through which the practitioner takes refuge in the Buddha, Dharma, and Sangha. Moving close to the base, the practitioner turns to the left, keeping the right shoulder toward the stupa. After circumambulating three, seven, or more times around the innermost walkway, the practitioner moves to the second walkway, then the third and the fourth, circling each the same number of times. Three prostrations at the entryway completes the practice. Depending upon their tradition, practitioners may chant mantras or prayers as they walk and count the repetitions on malas held at their sides.

The inner walkway of the Odiyan stupa is encircled with a ring of 113 forty-four-inch prayer wheels, and the outer covered walkway with 110 wheels. A ring of 120 Kadam-style stupas is mounted on the roof of the outer walkway. Eight victory banners rotate in the wind at each of the eight directions of the stupa, disseminating the blessings of mantras and dharanis that promote harmony and peace within nature and in the lives of living beings.

Odiyan Land Stupas

The land stupas of Odiyan exemplify the power of the stupa to create sacred space, bring an atmosphere of meditative peace to the land, and bring to mind the essential integration of the natural and spiritual realms. When the great master Atīśa visited western Tibet and noted the small stupas at the Toling Monastery, he recommended that small stupas be erected in groups of 108, an especially auspicious number in most Buddhist traditions. This advice was followed in western Tibet, where groupings of 108 small stupas dating to the twelfth and thirteenth centuries can still be seen.

The Odiyan land stupas, placed on sites conducive to reflection and meditation, recreate this ancient tradition in America. The land stupas, illustrated on pp. 381–89, are all cast in the Kadam style introduced to Tibet in the eleventh century by the Indian master Atīśa. Although small, each of the land stupas is empowered with mantras and dhāranīs that protect the land and enhance meditation. Around them, on each corner of the four-foot-high pedestal that supports them, are four smaller stupas, bringing the total number of Odiyan's land stupas to 540.

Balance Point of Past, Present, and Future

In our times marred by aggression, territoriality, and the increasing primacy of materialistic views, the appearance of the stupa in new lands offers hope for a new understanding of human being, an understanding that transcends concepts of self and other and opens the way for a higher bonding with all humanity. If the deeper meaning of this ancient symbol takes hold in the West, the stupa could serve generations in the future as it has in the past, a reminder of humanity's noblest aspirations and a potent force for balance, harmony, and world peace.

<div align="center">

Sarvam Maṅgalam
Blessings to All Beings

</div>

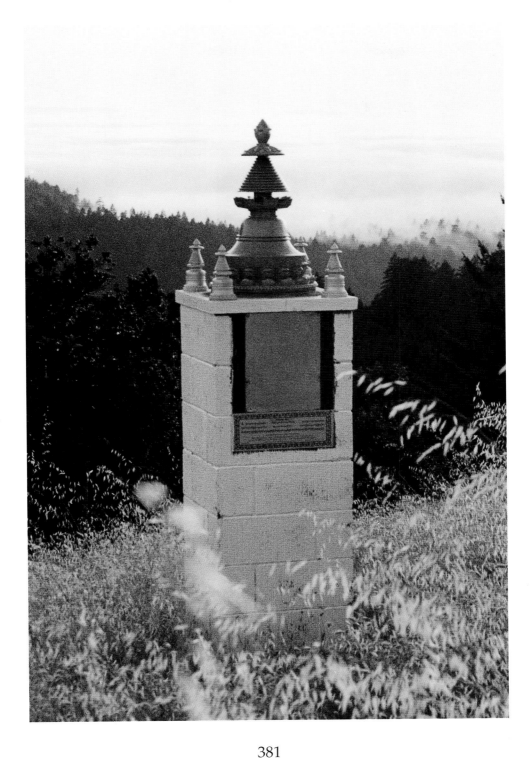

The Stupa

1. Mandala Garden
Stupa

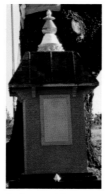

2. Copper Mountain
Mandala Stupa

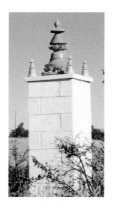

3. Southwest
Corner's Rock Stupa

4. Northwest
Corner Stupa

5. Lavender Hill
Stupa

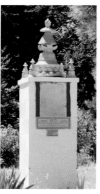

6. Vidyadhara
Lineage Peak

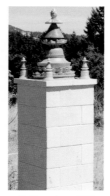

7. Cemetery Hill
Stupa

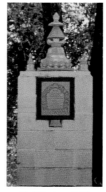

8. Tibetan Hill
Stupa

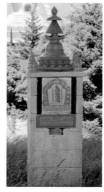

9. Big Fir
Stupa

10. North Lavender
Hill Stupa

11. Brahmaputra
Creek Stupa

12. Paramita Spot
Stupa

13. Shantideva Hill
Stupa

14. Indian Creek
Stupa

15. Swimming Air
Path Stupa

382

16. Moksha Hill Stupa

17. Liberation View Stupa

18. Destiny Spot Stupa

19. Fragrant Wind Stupa

20. Memorial Stone Stupa

21. Eastern Guardian Stupa

22. Impermanence Hill Stupa

23. Vairocana View Stupa

24. Awakening Place Stupa

25. Angel Peak Stupa

26. Ananda Valley Stupa

27. Indian Rock Stupa

28. Chilly Grove Stupa

29. Golden Valley Stupa

30. Vulture Peak Stupa

31. Bird Watch
Hill Stupa

32. Red Rock
Stupa

33. Joy Cloud Hill
Stupa

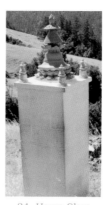

34. Horse Shoe
Equanimity Stupa

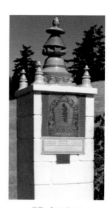

35. Loving
Kindness Stupa

36. Compassion
Hill Stupa

37. Blessing Hill
Stupa

38. Horse Meadow
Stupa

39. Visiting Point
Stupa

40. Indian Sunset
Stupa

41. Indian Ridge
Stupa

42. Magical Peak
Stupa

43. Double Dorje
Rock Stupa

44. Triangle View
Stupa

45. Crystal Ground
Stupa

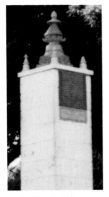

46. King's Throne
Meadow Stupa

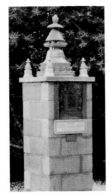

47. Madrone
Clearing Stupa

48. Central Park
Stupa

49. Indian Spring
Stupa

50. Fire Ceremony
Stupa

51. Dancing Deva
Stupa

52. Madrone Park
Stupa

53. Eastern Rock
Stupa

54. Chorten
Cemetery Stupa

55. Emerald Valley
Stupa

56. Eagle View
Stupa

57. Elephant Nose
Stupa

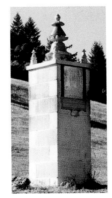

58. River's View
Stupa

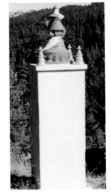

59. Jewel Rock
Stupa

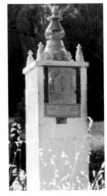

60. Copper Mountain
Mandala History Stupa

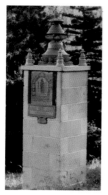
61. Blue Sky View
Stupa

62. Redwood
Corner Stupa

63. Horse Play
Stupa

64. Mountain Road
Stupa

65. Pampas Valley
Stupa

66. Tranquil
Knowledge Stupa

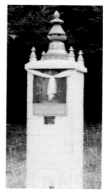
67. Beautiful
Forest Stupa

68. Piled-Up Black
Clouds Cemetery

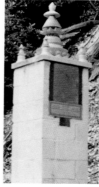
69. Far Top
Stupa

70. Picnic Fall
Stupa

71. Cozy Knoll
Stupa

72. Peacock
Feather Stupa

73. Steve's Spot
Stupa

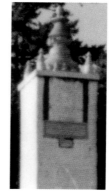
74. Dakini Hill
Stupa

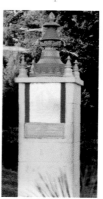
75. Transience
Stage Stupa

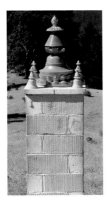

76. Coco's Corner
Stupa

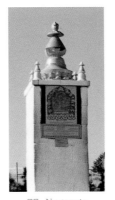

77. Nagaraja
Ground Stupa

78. Old Tree and
New Tree Stupa

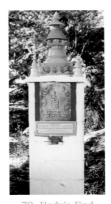

79. Body's End
Cemetery Stupa

80. Treasure Chest
Stupa

81. Deer Valley
Stupa

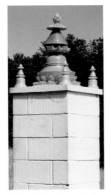

82. Jade Mountain
Stupa

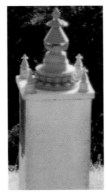

83. Resolve to
Change Stupa

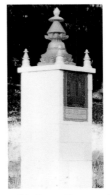

84. Inner Space
Rock Stupa

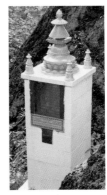

85. Mysterious Apparition
Cemetery Stupa

86. True Faith
Stupa

87. Vajra Eye
Stupa

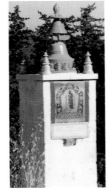

88. Rupa Rock
Stupa

89. Skillful Means
Place Stupa

90. Sky Meditation
Stupa

91. Cutting through Thought Stupa

92. Cathedral Clearing Stupa

93. Emptiness Ocean View Stupa

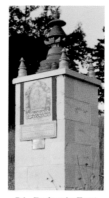

94. Padma's Foot Stupa

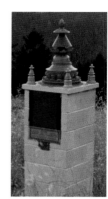

95. Skull Cup Hill Stupa

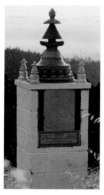

96. Kadam Hill Stupa

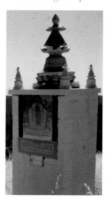

97. Eternal Vision Stupa

98. Bodhi Park Stupa

99. Lankakuta Cemetery Stupa

100. Amitayus Ridge Stupa

Whoever builds a stupa of Munīndra will be healthy and robust, without any distress. Whoever builds such a stupa will have wealth and many treasures and will withstand a myriad of foes.

"Whoever offers a central shaft for the Buddha's stupa will live in total harmony with the dharma, with virtuous conduct and most excellent patience, and will accomplish all goals in the world.

"Whoever offers layered umbrellas for the wondrous stupa will be reborn in the realm of gods or men with a body as strong as Nārāyaṇa's and all the traits evoking respect.

101. Sky King
Stupa

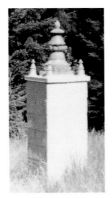

102. Dakini Circle
Stupa

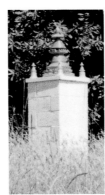

103. Gate of
Dharma Stupa

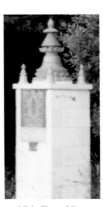

104. Tara View
Stupa

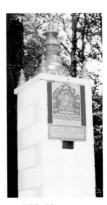

105. Harmony
Stupa

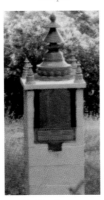

106. Vaishravana
Hill Stupa

107. New Horizon
Stupa

108. Sadhana Hill
Stupa

"Whoever applies whitewash to Munīndra's stupa will have a long life in the world of gods or men, will be free from suffering and illness in body and mind; such a one will always be blessed with wealth and happiness.

"Whoever creates a stupa of Munīndra covered with sheets of silver or gold will be resolute and resplendent in all future lives; such a being will shine with light and grace.

"Whoever, with faithful mind, offers a canopy for a stupa or a Buddha image will become the single most beneficent ruler of lands spanning the boundless oceans of the earth.

389

"Whoever joyfully suspends a broad umbrella, finely ornamented, above the stupa of the Sugata will become akin to Indra, lord of gods and men, protecting, like an umbrella, the world of men and gods.

"The stupa, with relics at its heart, is the source of stainless merit; those who fasten a variety of graceful streamers to it will gain extraordinary power and a place of honor in the three worlds.

"Whoever places a diadem upon the Sugata's stupa will obtain the glory of the most powerful men and gods and, having experienced remarkable joy, will obtain the diadem of liberation.

"Whoever offers bells to the stupa of the Conqueror will obtain a voice eloquent and illustrious, as lovely as the music of the spheres; they will possess exquisite adornments and mindfulness of past lives.

"The sage who, with faith, places garlands at the stupa of the Sugata, from such merit will have placed upon his head a wreath of gold, embellished with many jewels. . . .

"Whoever cleans Munīndra's stupa will be most beautiful, a delight to the eyes, with radiant face and form the color of a lotus; such a being will be free of all worldly faults. . . .

"Whoever offers all he can of a wealth of suitable offerings to the stupa of the Sugata will become pure and will obtain the incomparable nirvana.

"Whoever humbly offers prostrations in front of the Buddha's image or stupa will gain a position of ever greater honor among both men and gods.

"Whoever faithfully circumambulates the image of the Buddha or the Muni's stupa, in lives to come will be held in awe even by their enemies, and will be a vessel of goodness full of glorious traits.

——from Verses for King Prasenajit, NE 322

Pronouncing Sanskrit

Sanskrit is a syllabic language with fourteen vowels and thirty-three basic consonants. In transcribing Sanskrit, English-peaking scholars developed a system of diacritical marks to indicate the precise Sanskrit letter equivalent. The system formalized by Sir Monier Monier-Williams in *A Sanskrit-English Dictionary* (first published in 1899) became the standard used by English and American scholars. Although some contemporary scholars have introduced simplifications intended to assist the general reader, these are not entirely satisfactory. The editors of this book have adhered to the earlier standard used by the Library of Congress and most scholarly publications. As in Sir Monier-Williams dictionary, the vowel *ṛ* is transcribed as *ṛi* to better approximate the actual sound.

Unlike English, Sanskrit is regular in pronunciation. The sounds of Sanskrit syllables are constant and vary little from word to word. Although a student of Indian languages will need to learn and practice the distinct nuances of each type of syllable to communicate with native speakers, most English speakers can learn the

392

essential pronunciation of Buddhist terms by remembering a few simple guidelines.

Most of the consonants in the Sanskrit names in this book can be pronounced as they would sound in English. The major points to remember is that *c* is always pronounced *ch*, and *ś* and *ṣ* are pronounced *sh*. As an added refinement, the dot under t, d, and n indicates that this sound is made with the tongue curled under against the palate (retroflexive), as opposed to the unmarked t, d, and n, which are sounded with the tongue touching or slightly protruding between the teeth, producing a dental sound. The h often added to k, g, c, j, t, d, p, and b simply indicates that the consonant is aspirated, as the English dh in adhere is aspirated. Since the average English speaker does not associate retroflexive and dental or aspirate and unaspirated consonants with differences in meaning, most readers will not find it necessary to develop this particular skill. Some attention to syllabic emphasis and vowel sounds, however, can greatly improve one's pronunciation.

Syllabic emphasis: Sanskrit has no system of accented or stressed syllables. Syllables do, however, have short and long properties which English speakers may hear as accented syllables. For best results, beginners are advised to practice pronouncing each syllable as evenly (unstressed) as possible. This minimizes distortion and facilitates the refinement process. Vowels are the most critical factor in correct pronunciation. The most common vowels and their sounds are:

vowels	sounds	vowels	sounds
a	as in mica	ṛi	as in merrily
ā	as in father	ḷ	as in revelry
i	as in fill	e	as in there
ī	as in police	ai	as in aisle
u	as in full	o	as in go
ū	as in rude	au	as in owl

Abbreviations

AGI *Ancient Geography of India*, by Alexander Cunningham. New enlarged ed. Varanasi: Indological Book House, 1975.

ASC *The Stupa in Ceylon*, by S. Paranavitana. Colombo: Ceylon Government Press, 1946. (Memoirs of the Archaeological Survey of Ceylon, vol. V).

BAA *Buddhist Architecture in Andhra*, by Jithendra Das. New Delhi: Books & Books, 1993.

BB *Barabudur: History and Significance of a Buddhist Monument*, edited by Luis Gomez and Hiram W. Woodward, Jr. Berkeley, CA: Regents of the University of California, 1981. (Berkeley Buddhist Studies Series, 2)

BCE Before Common Era (= B.C.)

BG "Buddhist Guide to the Power Places of the Kathmandu Valley," by Keith Dowman. *Kailash* 8:3, 1981.

BHU *Bhutan*, by Francoise Pommaret, translated by Elisabeth B. Booz. Rev. ed. Geneva: Editions Olizane, 1994.

BKT *Art of Burma, Korea, and Tibet,* by Alexander Griswold, Chewon Kim, and Peter H. Pott. New York: Crown Publishers, Inc., 1964.

BMS *A History of Buddhist Monuments in Siam,* translated by S. Sivaraksa. Bangkok: Siam Society, 1962.

Bo *Borobudur,* by Dr. Soekmono. Jakarta: Buku Nusantara, n.d.

Bu Bu-ston Rinpoche. *History of Buddhism,* translated by E. Obermiller. Heidelberg, 1931. (Materialien zur Kunde des Buddhismus, 18)

BW *The Buddhist World of Southeast Asia,* by Donald K. Swearer. Albany: State University of New York, 1995. (SUNY Series in Religion)

CE Common Era (= A.D.)

EBA *Early Buddhist Architecture in Japan*, by Kakichi Suzuki. Tokyo: Kodansha International Ltd. and Shibundo, 1980.

FA Bhadrakalpika Sūtra. *The Fortunate Aeon: How the Thousand Buddhas Become Enlightened*. Berkeley: Dharma Publishing, 1986.

FH Fa-hsien. *A Record of Buddhistic Kingdoms,* translated by James Legge. New York: Paragon Book Reprint Corp, 1965.

HT Hsüan-tsang. *Si-Yu-Ki: Buddhist Records of the Western World,* translated by Samuel Beal. Reprint ed. Delhi: Motilal Banarsidass, 1981.

KBG *Mk'yen brtse's Guide to the Holy Places of Central Tibet,* translated by Alfonsa Ferrari. Roma: Istituto Italiano per il Medio ed Estremo Oriente, 1958. (Serie Orientale Roma XVI)

LL *The Life and Liberation of Padmasambhava*. Berkeley: Dharma Publishing, 1978.

LT Vacissara, Thera. *Legend of the Topes,* translated by Bimala Churn Law. Calcutta: Royal Asiatic Society of Bengal, 1945.

MV *The Mahavaṁsa, the Great Chronicle of Ceylon,* translated by Wilhelm Geiger. Reprint ed. New Delhi: Asian Educational Services, 1986.

NE *The Nyingma Edition of the bKa'-'gyur and bsTan-'gyur*. Berkeley: Dharma Publishing, 1981.

PGP *Pictorial Guide to Pagan*. Rev. ed. Rangoon: Ministry of Culture, 1963.

PSBS *Psycho-cosmic Symbolism of the Buddhist Stupa*, by Anagarika Govinda. Berkeley: Dharma Publishing, 1976.

R *The Life of the Buddha and the Early History of His Order*, by W. Woodville Rockhill. London: Kegan Paul, Trench, Trübner & Co., 1884.

SKB *Der Stupa: Kultbau des Buddhismus,* by Johannes W. Glauche. Köhn: Dumont, 1995.

TH Tucci, Giuseppe. *Transhimalaya*, translated from the French by James Hogarth. Geneva: Nagel Publishers, 1973. (Archaeologica mundi)

THPG Chan, Victor. *Tibet Handbook: A Pilgrimage Guide*. Chico, CA: Moon Publications, 1994.

TTK *Tibetan Texts Concerning Khotan*, by R. E. Emmerick. London: Oxford University Press, 1967.

VB Lalitavistara Sutra. *The Voice of the Buddha*: *The Beauty of Compassion*. Berkeley: Dharma Publishing, 1983.

Bibliography

Adikaram, E. W. *Early History of Buddhism in Ceylon*. Migoda: Puswella, 1946.

Ahir, D. C. *Buddhism in South India*. Delhi: Satguru Publications, 1992.

Aśokāvadāna. *The Legend of King Aśoka*. A Study and Translation of the Aśokāvadāna, by J. Strong. Princeton: University Press, 1983.

Barabudur: History and Significance of a Buddhist Monument, edited by Luis Gomez and Hiram W. Woodward, Jr. Berkeley, CA: University of California, 1981. (Berkeley Buddhist Studies Series, 2)

Barua, Dipak K. *Buddha Gaya Temple: Its History*. 2nd rev. ed. Buddha Gaya: Buddha Gaya Management Committee, 1981. (1975)

Batchelor, Stephen. *The Tibet Guide*. London: Wisdom Publications, 1987.

Bernier, Ronald M. *The Temples of Nepal: An Introductory Survey*. 2nd rev. ed. New Delhi: S. Chand & Company Ltd., 1978. (1970)

Bhadrakalpika-sūtra. *The Fortunate Aeon: How the Thousand Buddhas Become Enlightened*. Berkeley: Dharma Publishing, 1986.

Burgess, James. *The Buddhist Stūpas of Amarāvatī and Jaggayyapeṭa*. Varanasi: Indological Book House, 1970.

Burma. Ministry of Culture. *Pictorial Guide to Pagan*. 2nd rev. ed. Rangoon, 1963.

Bu-ston Rinpoche. *History of Buddhism*, translated by E. Obermiller. Heidelberg, 1931. (Materialien zur Kunde des Buddhismus, 18)

Chan, Victor. *Tibet Handbook: A Pilgrimage Guide*. Chico, California: Moon Publications, 1994.

Cook, Elizabeth. *Holy Places of the Buddha*. Berkeley: Dharma Publishing, 1994. (Crystal Mirror Series, 9)

Cunningham, Alexander. *The Ancient Geography of India. I. The Buddhist Period, including the Campaigns of Alexander, and the Travels of Hwen-Thsang*. New enlarged edition. Varanasi: IBharatiya Publishing House, 1975. (1871)

Cunningham, Alexander. *Four Reports Made During the Years 1862-63–64–65*. vol. I, Simla: Government Central Press, 1871. (Archaeological Survey of India (Series), 1-2)

———. *The Stūpa of Bhārhut*. London: W. H. Allen and Co., 1879.

Dikshit, Kashinath Narayan. *Excavations at Paharpur*, Bengal. Delhi: Manager of Publications, 1938. (Memoirs of the Archaeological Society of India, 55)

Dobbins, K. Walton. *The Stūpa and Vihāra of Kanisha I*. Calcutta: The Asiatic Society, 1971. (The Asiatic Society Monograph Series, vol. XVIII)

Dowman, Keith. "A Buddhist Guide to the Power Places of the Kathmandu Valley." *Kailash* 8:3, 1981

Dowman, Keith. *The Power-Places of Central Tibet: The Pilgrim's Guide*. London: Routledge & Kegan Paul, 1988.

Dudjom Rinpoche. *The Nyingma School of Tibetan Buddhism: Its Fundamentals and History*. 2 vols. Boston: Wisdom Publications, 1991.

Emmerick, R. E. *Tibetan Texts Concerning Khotan*. London: Oxford University Press, 1967.

Fa-hsian. *A Record of Buddhistic Kingdoms*, translated by James Legge. New York: Paragon Book Reprint Corp., 1965. (1886)

Ferrari, Alfonsa. *Mk'yen brtse's Guide to the Holy Places of Central Tibet*. Roma: Istituto Italiano per il Medio ed Estremo Oriente, 1958. (Serie Orientale Roma, XVI)

Filliozat, Jean. *Political History of India from the Earliest Times to the 7th Century A.D.* Calcutta, 1957. (L'Inde Classique, 2)

Frederick, Louis. *Temples and Sculptures of Southeast Asia.* London: Thames-on-Hudson, n.d.

Glauche, Johannes W. *Der Stupa: Kultbau des Buddhismus.* Köhn: Dumont, 1995.

Govinda, Lama Anagarika. *Psycho-cosmic Symbolism of the Buddhist Stūpa.* Berkeley: Dharma Publishing, 1976.

Griswold, Alexander, Chewon Kim, and Peter H. Pott. *The Art of Burma, Korea, Tibet.* New York: Crown Publishers, Inc., 1964.

Hsüan-tsang. *Si-Yu-Ki: Buddhist Records of the Western World,* translated by Samuel Beal. Delhi: Motilal Banarsidass, 1981. (1884)

Huntington, Susan L. and John C.. Huntington. *The Art of Ancient India: Buddhistm, Jain, Hindu.* New York: Weatherhill, 1985.

Hwui Li. *The Life of Hiuen-tsiang,* translated by Samuel Beal. 2nd ed. New Delhi: Manoshiram Manoharlal Publishers, 1973. (1911)

Imaeda-Pommaret, Francoise, and Yoshiro Imaeda. *Bhutan: A Kingdom of the Eastern Himalayas,* translated by Ian Noble. Photographs by Guy van Strydonck. Boston: Shambhala, 1985.

I-tsing. *A Record of the Buddhist Religion as Practised in India and the Malay Archipelago (A.D. 671-695),* translated by J. Takakusu. Delhi: Munshiram Manoharlal, 1966. (1896)

Jithendra Das, D. *The Buddhist Architecture in Andhra.* New Delhi: Books & Books, 1993.

Korean Buddhism. Seoul: Korean Buddhist Chogye Order, 1988.

Kumar, Dilip. *Archaeology of Vaishali.* New Delhi: Ramanand Vidya Bhawan, 1986.

Lalitavistara-sūtra. *The Voice of the Buddha: The Beauty of Compassion,* translated by Gwendolyn Bays, Berkeley: Dharma Publishing, 1983.

Law, Bimala Churn. *Rājagṛha in Ancient Literature.* Delhi: Manager of Publications, 1938. (Memoirs of the Archaeological Survey of India, 58)

Law, Bimala Churn. *Śrāvastī in Indian Literature.* Delhi: Manager of Publications, 1935. (Memoirs of the Archaeological Survey of India, 50)

Leoshko, Janice, ed. *Bodh Gaya: The Site of Enlightenment.* Bombay: Marg Publications, 1988.

Lundquist, John M. *The Temple: Meeting Place of Heaven and Earth.* London: Thames and Hudson, 1993.

The Mahāvaṁsa, or The Great Chronicle of Ceylon, translated by Wilhelm Geiger. Columbo: Ceylon Government Information Department, 1950. (1912)

Marshall, John. *A Guide to Sanchi.* New Delhi: New Society Publications, 1980. (1918)

_____. *A Guide to Taxila.* 4th ed. Karachi: Sani Communications, c.1960. (1918)

_____. *Taxila: An Illustrated Account of Archaeological Excavations Carried out at Taxila. . .* 3 vols. Cambridge: University Press, 1951.

Mookerji, Radha Kumud. "The University of Nālandā," in *Journal of the Bihar Research Society* 30 (1944): 126-59.

Mukherji, Purna Chandra. *A Report of a Tour of Exploration of the Antiquities of Kapilavastu, Tarai of Nepal, During February and March, 1899.* Delhi: Indological Book House, 1969.

Nishi, Kazuo, and Kazuo Hozumi. *What is Japanese Architecture?* Translated by H. Mack Horton. Tokyo: Kodansha International, 1985.

Olschak, Blance C. *Ancient Bhutan: A Study on Early Buddhism in the Himālayas.* Zürich: Swiss Foundation for Alpine Research, 1979.

Padmasambhava. *The Legend of the Great Stupa and The Life Story of the Lotus Born Guru,* translated by Keith Dowman. Berkeley: Dharma Publishing, 1973.

Peme Dorjee. *Stupa and its Techology: A Tibeto-Buddhist Perspective.* New Delhi: Indira Gandhi National Centre for the Arts and Motilal Banarsidass Publishers Private Ltd., 1996.

Pommaret, Francoise. *Bhutan,* translated by Elisabeth B. Booz. Rev. ed. Geneva: Editions Olizane, 1994. (1990)

Popham, Peter. *Wooden Temples of Japan.* London: Tauris Parke Books, 1990.

Paranavitana, S. *The Stupa in Ceylon.* Colombo: Ceylon Government Press, 1946. (Memoirs of the Archaeological Survey of Ceylon, V)

Prasad, Ram Chandra. *Archaeology of Champā and Vikramaśīla*. Delhi: Ramanand Vidya Bhawan, 1987.

Puri, B. N. *Buddhism in Central Asia*. Delhi: Motilal Banarsidass, 1987. (Buddhist Traditons, IV)

Rajanubhab, Damrong. *A History of Buddhist Monuments in Siam*, translated by S. Sivaraksa. Bangkok: The Siam Society, 1962.

Ramachandran, T. N. *Nāgārjunakoṇḍa 1938*. Delhi: Manager of Publications, 1953. (Memoirs of the Archaeological Survey of India, 71)

Rockhill, W. Woodville. *The Life of the Buddha and the Early History of His Order, derived from Tibetan works in the bKah-hgyur and bsTan-hgyur*. London: Kegan Paul, Trench, Trübner & Co., 1884.

Rowland, Benjamin. *Central Asia*. n.p. n.d. (Art of the World)

Sankhalia, Hasmukh D. *The University of Nālandā*. G. Paul and Co., 1934.

Sarkar, H. and S. P. Nainar. *Amaravati*. New Delhi: Director General Archaeological Survey of India, 1972.

Sarkar, H., and B. N. Misra. *Nagarjunakonda*. New Delhi: Director General Archaeological Survey of India, 1972.

Sarkar, H. *Studies in Early Buddhist Architecture of India*. 2nd ed. New Delhi: Munshiram Manoharlal, 1993. (1966)

Snodgrass, Adrian. *The Symbolism of the Stupa*. Ithaca: Southeast Asia Program, Cornell University, 1985. (Studies on Southeast Asia)

Sri Lanka. Ministry of Cultural Affairs. *A Guide to Anurādhapura*. Colombo, 1981.

Stein, Aurel. *On Ancient Central-Asian Tracks*. New York: Pantheon Books, 1964. (1933)

Stein, Aurel. *Serindia*. 3 vols. London: Oxford University Press, 1921.

Subramanian, K. R. *Buddhist Remains in South India and Early Andhra History, 225 A.D. to 610 A.D.* New Delhi: Cosmo Publications, 1981.

Suzuki, Kakichi. *Early Buddhist Architecture in Japan*. Tokyo: Kodansha International Ltd. and Shibundo, 1980. (Japanese Arts Library)

Swearer, Donald K. *The Buddhist World of Southeast Asia*. Albany: State University of New York, 1995. (SUNY Series in Religion)

Tāranātha. *History of Buddhism in India*, translated by Lama Chimpa and Alaka Chattopadhyaya. Simla: Indian Institute of Advanced Study, 1970.

Thomas, F. W. *Tibetan Literary Texts and Documents Concerning Chinese Turkestan. Part I: Literary Texts.* London: The Royal Asiatic Society, 1935.

Tucci, Giuseppe. *Stupa: Art, Architectonics and Symbolism,* translated by Uma Marina Vesci. New Delhi: Aditya Prakashan, 1988. (1932)

Tucci, Giuseppe. *The Theory and Practice of the Mandala,* translated by A. H. Broderick. New York: Samuel Weiser, Inc., 1970.

Tulku, Tarthang. *Copper Mountain Mandala: Odiyan.* Berkeley: Dharma Publishing, 1996.

Ueda, Atsushi. "The Long-Standing Mystery of Japan's Imperturbable Pagodas," in *Look Japan* 42:485 (August 1996), pp. 22-24.

Upasak, C. S. *History of Buddhism in Afghanistan.* Sarnath: Central Institute of Higher Tibetan Studies, 1990.

Vacissara, Thera. *Legend of the Topes,* translated by Bimala Churn Law. Calcutta: Royal Asiatic Society of Bengal, 1945),

Weiner, Sheila L. *Ajaṇṭā: Its Place in Buddhist Art.* Berkeley: University of California Press, 1977.

World Peace Ceremony, Bodh Gaya. Berkeley: Dharma Publishing, 1994.

Yeshe Tsogyal. *The Life and Liberation of Padmasambhava.* Berkeley: Dharma Publishing, 1978

Acknowledgments

p. 13: Stupa remains, Vaiśālī. Courtesy of John C. and Susan L. Huntington

p. 40: Stupa ruins, Aśokan lion, Vaiśālī. Courtesy of John C. and Susan L. Huntington

p. 55: Candavaram Stupa, Andhra. Courtesy of the Archaeological Survey of India.

p. 57: Sālihuṇḍam Stupa, Andhra. Courtesy of the Archaeological Survey of India.

p. 59: Stupa of Amārāvatī (model), Andhra. Courtesy of the Archaeological Survey of India.

p. 62: Monastery at Nāgārjuna-koṇḍa. Courtesy of the Archaeological Survey of India.

p. 63: Stupa foundation, Nāgārjunakoṇḍa. Courtesy of the Archaeological Survey of India.

p. 74: Central caitya of Nālandā. Courtesy of John C. And Susan L. Huntington

p. 79: Central caitya, Somapurī. Courtesy of the Archaeological Survey of India.

p. 91: Guldara Stupa, Afghan-istan. Courtesy of John C. and Susan L. Huntington

Note: Pictures not listed in these pages are from the archives of the Tibetan Nyingma Meditation Center.

p. 271: Chorten at Drigung Til. Courtesy of Raphaële Demandre

p. 274: Stupa of Kunkhyen Longchenpa. Courtesy of Raphaële Demandre

p. 277: Kadampa Chorten at Netang. Courtesy of Mary King

p. 278: Chortens at Tashilunpo Monastery. Courtesy of Will Spiegelman

p. 280: Karmapa relic chorten, Tshurphu. Courtesy of Raphaële Demandre

p. 281: Chortens at Pema Khyung Dzong, Tshurphu. Courtesy of Will Spiegelman

p. 283: Palkhor Chöde, Gyantse. Courtesy of Mary King

p. 285: Chortens, Golden Temple of Toling. Courtesy of the Lama and Li Gotami Govinda Stiftung

p. 286: The great chorten of Toling. Courtesy of the Lama and Li Gotami Govinda Stiftung

p. 287: Nepalese stupa in Ladakh. Courtesy of the Lama and Li Gotami Govinda Stiftung

p. 288: Parinirvāṇa chorten, Western Tibet. Courtesy of the Lama and Li Gotami Govinda Stiftung

p. 289: House-style chorten. Courtesy of the Lama and Li Gotami Govinda Stiftung

p. 290: Chortens at Kardze Monastery. Courtesy of the Lama and Li Gotami Govinda Stiftung

p. 291. Gateway stupa, Mount Kailaśa. Courtesy of Raphaële Demandre

p. 293: Chorten near the Chinese border. Courtesy of Mary King

p. 295: Pavilion of Kong-jo. Courtesy of Mary King

p. 294: Chorten at Talung, Eastern Tibet. Courtesy of Mary King

p. 296: Enlightenment Stupa, Kumbum Monastery. Courtesy of Mary King

p. 297: Eight Great Chortens, Kumbum Monastery. Courtesy of Mary King

p. 307: Chorten Kora. Courtesy of Guy van Strydonck

p. 309: White Chorten of Chendebji. Courtesy of Guy van Strydonck

p. 314: Shwedagon Dāgoba. Courtesy of Head Lama TNMC

p. 317: Ngakwenadaung Pagoda. Ministry of Culture, Myanmar

p. 319: Bupaya Pagoda, Pagan

p. 320: East Petleik Pagoda. Ministry of Culture, Myanmar

p. 321: West Petleik Pagoda. Ministry of Culture, Myanmar

p. 323: Myinkaba Pagoda. Ministry of Culture, Myanmar

p. 325: Pawdawmu Pagoda. Ministry of Culture, Myanmar

p. 327: Shwesandaw Pagoda. Ministry of Culture, Myanmar

Index

Śrī Vaiśravaṇa

Tarthang Tulku

About Tarthang Tulku: A Note from the Staff of Dharma Publishing

Tarthang Tulku, creator and general editor of the Crystal Mirror Series, is an accomplished Tibetan lama who has lived and worked in the United States since 1969. Throughout his life, Rinpoche has dedicated his full energy and resources to preserving and transmitting the Dharma. As his students, we have learned to find inspiration in his devotion and profound respect for the Buddha's teachings.

In the early 1960's, while teaching at the Sanskrit University in Vārāṇasī, Rinpoche founded Dharma Mudranālaya and began publishing texts he had brought with him from Tibet. In 1969, soon after arriving in America, he established Dharma Publishing and Dharma Press, incorporated in 1975 as Dharma Mudranālaya. Under his direction, Dharma Publishing has preserved more than 35,000 Tibetan texts by 1,500 Buddhist masters in 755 large western-style volumes, and

Dharma Publishing's books in English, including translations of important Buddhist texts, have been adopted for use in more than five hundred colleges and universities throughout the world.

An active author and educator, Rinpoche has written eleven books presenting teachings for the modern world, overseen translations of traditional texts, and created and edited *The Nyingma Edition of the bKa'-'gyur and bsTan-'gyur* and *Great Treasures of Ancient Teachings,* the first compilation of the Nyingma Canon together with works by masters of all Tibetan Buddhist traditions. He is founder and president of the Nyingma Institute in Berkeley and its affiliated centers, where several thousand students have come in contact with the Buddhist teachings. Rinpoche has also created and guided the construction and ornamentation of Odiyan, a country center for retreats, study, and translation.

In the midst of these activities, Rinpoche serves in the traditional role of teacher for a growing community of Western students. Always willing to experiment, he has established a form of practice for his students in which their work on behalf of the Dharma becomes a path to realization. Although many of his students do not have frequent direct contact with Rinpoche, through the institutions he has established they are able to grow in wisdom and understanding, while developing practical skills for making their way in the world.

With so many diverse demands on his time, it has not always been possible for Rinpoche to verify the accuracy of every element of the books we produce under his direction, and the staff of Dharma Publishing assumes full responsibility for mistakes that appear in our publications. We only hope that on balance we have succeeded in transmitting some elements of the Dharma tradition.

Those of us who have had the opportunity to work under Rinpoche are deeply grateful for the example he has set us. His dedication and reliable knowledge, his steady, untiring efforts, his patience and his caring enable us to direct our energy with confidence that despite our imperfections, our work can benefit others, making it possible for us to contribute in some way to the transmission of the Dharma in the west.

Books in the Crystal Mirror Series

1–3. Footsteps on the Diamond Path The writings of great Nyingma masters and modern Nyingma teachings on mind, self-image, and meditation. An inspiring and practical introduction to the Vajrayāna Buddhism of Tibet. (1969–1974)

4. Guru Padmasambhava and Buddhism in Tibet Lives of the Great Guru Padmasambhava and his disciples convey the power and scope of the Dharma transmission in Tibet. Includes the teaching of the fourteenth-century master Longchenpa on the Natural Freedom of Mind. (1975)

5. Lineage of Diamond Light A richly illustrated presentation of Tarthang Tulku's history of the Buddhist Dharma in India and Tibet, with a special emphasis on the masters and lineages of the Nyingma tradition and translations of two central teachings of the great master Longchenpa. (1977)

6. The Three Jewels and History of Dharma Transmission A traditional introduction to the Buddha, Dharma, and Sangha, including the Buddha's teachings and the philosophical schools they inspired. With biographies of 138 masters. (1984)

7. The Buddha, Dharma, and Sangha in Historical Perspective The life of the Buddha, the unfolding of the Dharma, and the growth of the Sangha, framed in the larger sweep of world history. With maps and comparative timelines. (1984)

8. Light of Liberation A history of Buddhism in India from the origin of the Śākyas to the twelfth century, based on traditional sources and modern archeological research. (1992)

9. Holy Places of the Buddha The origin and value of pilgrimage, expressed in accounts of the eight great pilgrimage places and the monuments along the ancient routes across India into Afghanistan. (1994)

10. The Buddha and His Teachings The path and qualities of the Perfect Buddhas, the life of the Buddha Śākyamuni, and openings of the Sūtras preserved in the Tibetan Canon. (1996)

11. Masters of the Nyingma Lineage Biographies of over 350 masters trace the Mantrayāna lineages from the original transmission of the Dharma to Tibet to the present day. With 31 maps and lists of important monasteries and sacred sites. (1996)

12. The Stupa: Sacred Symbol of Enlightenment History, forms, and significance of the stupa. 200 photographs, map. (1997)